GABRIELE BRANDSTETTER, GABRIELE KLEIN (EDS.)

Dance [and] Theory

with editorial assistance of Melanie Haller and Heike Lüken

[transcript]

Kindly supported by the Department for Human Movement/Performance Studies, Universität Hamburg

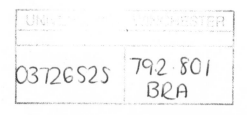

Bibliographic information published by the Deutsche Nationalbibliothek
The Deutsche Nationalbibliothek lists this publication
in the Deutsche Nationalbibliografie; detailed bibliographic data are available
in the Internet at http://dnb. dnb.de

© 2013 transcript Verlag, Bielefeld

Cover layout: Kordula Röckenhaus, Bielefeld
Proofread by Melanie Haller, Gabriele Klein, Heike Lüken
Typeset by Melanie Haller
Printed by Majuskel Medienproduktion GmbH, Wetzlar
ISBN 978-3-8376-2151-8

Contents

DANCE THEORY AS A PRACTICE OF CRITIQUE
Gabriele Klein | 137

POLITICS

Next Generation

INTRODUCTION

Dance [and] Theory. Introduction

GABRIELE BRANDSTETTER/GABRIELE KLEIN

"We don't have theories of dance in Thailand." These words were spoken by a scholar of arts and performance from Bangkok, who is very familiar with western philosophy, theory and aesthetics. In saying this, he sought to characterise the relationship between traditional Thai dance and contemporary forms of dance and performance in this age of cultural globalisation. By way of explanation, he added, "Yes... we *have* theory, but we don't present theories in a discursive way. We present them embedded within the work of art, within performance."

With his interpretation, the scholar from Bangkok illustrated the fact that the relationship between dance and theory is culturally framed, and may refer to a different historical reality in the modern West than in other cultural spheres. He also points out that not only does modern Western thinking about dance and theory perhaps tend to exert a claim to universality, but may also be connected to mechanisms of colonizing the Other. Within a colonizing framework, theory promotes strategies of 'othering' and, of course, has the power of 'othering.' This also means that theory itself may act as a colonizing practice – of art, of the body, and of movement. Hence, for example, the topos of the non-discursivity of body and movement, which marks the body and movement as 'The Other.'

These remarks underline certain aesthetic, political and social aspects of the ambiguous relationship between dance and theory, thus implicitly asking, how is theory – in different historical, cultural and aesthetic modes – inscribed in dance? Which borders, transfers, zigzags within the fields of practice/performance and theory are parts of the contemporary discourse in and around dance? How did this discourse change?

There was a time, and there were situations, when a certain 'unease,' or even a *Resistance to Theory* (Man 1986) was in the air. Early in the era of modern dance, Mary Wigman stated that dance and talking about dance have nothing to do with each other. She nonetheless wrote a book whose very title explored the relationship between language and movement, and which conceded that dance and language are not mutually exclusive: *The Language of Dance* (Wigman 1966). During the same period, theories of dance were emerging which have had a major influence on the history and aesthetics of dance, for example the spatial theory and choreutics of Rudolf von Laban (1966), who is remembered as the philosopher of Expressionist Dance. Many dancers and choreographers of west-

ern modern dance propagated, far more energetically than artists from other artistic disciplines, a clear division between dance and theory, and between practice and discourse.

Almost 100 years later, we can ask, "who today is afraid of theory?" Why is theory playing an increasingly important role for contemporary choreographers and in university courses in dance, choreography and performance? And conversely, why are so many practice-oriented programs of study in performance and dance being set up at universities in the German-speaking world, mirroring the trend in Great Britain and the USA? Why have so many art colleges been granted university status? Why is the issue of 'artistic research' discussed in such fervent and contentious terms, both by artists and academics?

In the history of dance, the relationship between practice and theory is something of a *liaison dangereuse*. Indeed, in the modern West, the relationship between dance and theory is complex and defies easy characterisation. As, through, in, out of, against, before, after, or, between – these and a multitude of other local, temporal, causal or modal prepositions may be employed to denote the complex patterns of relationship between dance and theory. The relational structure appears haphazard or at least without clear boundaries. How are we to re-think – and re-perform – a *relationship* that is by no means clear, and resists clear-cut definitions? Which idea of dance do we embrace? Which concept and tradition of theory? What kind of relationship, interaction, exchange is this *liaison dangereuse*?

The multiplicity of exchanges and transmissions between dance and theory leads us to the issue of the historicisation and archiving of dance. Michel Foucault grasped the nature of this problem when he quoted Jorge Luis Borges in his introduction to *Les Mots et les Choses* (The Order of Things, Foucault 1971). On the issue of creating categories and taxonomies, Borges refers to an old Chinese encyclopaedia. According to this epistemology, the 'order' of naming and arranging animals within a 'system' is as follows: There are animals that

"(a) belonging to the Emperor, (b) embalmed, (c) tame, (d) sucking pigs, (e) sirens, (f) fabulous, (g) stray dogs, (h) included in the present classification, (i) frenzied, (j) innumerable, (k) drawn with a very fine camelhair brush […]." (Foucault 1971: xv)

and so on. All of these groups of animals represent 'classes' within the system of this encyclopaedia, but what is the order of these bizarre categories? What is the significance of employing this taxonomy? It marks, according to Foucault, a borderline to 'our' way of thinking. Though such funny juxtapositions as those described above may not emerge from the various constellations of dance and theory, the approach pursued by this book represents an experiment of sorts. It tries to re-imagine the possibilities of order and disorder, of relations and perhaps false juxtapositions within historical or established cultural categories of dance and theory. Perhaps these constellations have a unique fascination of their own.

This anthology is a contribution to the on-going process of de- and re-thinking questions of dance and theory. The prepositions symbolise the complex juxtaposition of dance and theory. We understand these prepositions on the one hand as 'pre-positions,' indicating questions of de-positioning and re-positioning, order and dis-order, placement and dis-placement. On the other hand, the term 'pre-position' also describes a material, physical process of shifting or dislocation. This process is connected to a crisis, which entails an intermediate and undefined space. This crisis may involve risks but may also be thoroughly productive.

In *Les Mots et les Choses,* Foucault deals with the 'crisis of representation.' When we apply his ideas to the context of dance and theory, this raises the question of whether and how theory and practice are related to a crisis of categorisation in the contemporary context of a deregulated world. But what is the relationship between this fluidity of terminology and a deregulated – or more specifically, neoliberal and post-Fordian – world? 'How,' in this political and socioeconomic context, can concepts of theory and practice in dance and choreography be conceived and realised? Is a theory of practice or, as the case may be, a practice of theory, even possible? How can dance – as theory of practice and/or practice of theory – be placed within the tradition of an aesthetically grounded (postcolonial) critique of the Enlightenment, a critique of rationality, technology, science at universities without constructing binarities, and without marking dance as the Other of modernism, thereby both marginalising and enhancing its standing?

This book is the result of an international congress on Dance [and] Theory that was held in April 2011 at the Uferstudios in Berlin with the financial support of the Centre for Movement Studies at the Freie Universität Berlin and the German Research Foundation (DFG). As the organisers of this congress, we wanted to devise an approach that deviated from the typical format of international conferences: a series of lectures presenting individual research findings. Analogous to the developments in contemporary choreography and performance in relation to collaboration, process orientation, temporality, performativity and critique of representation, the aim of the congress was to provide an 'open' format that would not only reflect the relationship between dance theory and practice in a variety of ways, but would also construe these practical and theoretical reflections and de-positionings over the course of the congress as a collaborative process. To this end, we initiated a workshop one year prior to the congress, which was designed to open up a broad field of thought, to pose new questions and to develop flexible structures and open systems.

The result was a congress that consisted of an ensemble of panels, lecture performances and keynote speeches. Those invited to participate were from international artistic and academics fields. The themes discussed by the panels covered artistic research, aesthetics, politics, visuality, archives, and the next generation of key topics in dance and performance research.

In preparing for the congress, the panel moderators initiated discussions within their panels weeks and months previously, writing position papers and

developing questions and hypotheses. We would like to thank the panel modera-
tors Beatrice von Bismarck, Bettina Brandl-Risi, Susanne Foellmer, Sibylle Pe-
ters, Kerstin Evert, André Lepecki and Gerald Siegmund for their intensive in-
volvement. Most of the panel respondents only entered the discussions during the
congress, and took the trouble to formulate a more or less spontaneous response
to the discussions in the various panels.

The discussion process was sustained and carried forward in the book. The
panel moderators revised the introductory papers, which they had presented at
the congress discussions. These were distributed to all panel participants and
provided the basis for their own elaborations. The respondents, for their part, re-
ceived all of the revised panel texts and used these together with the congress
discussions to formulate their responses.

The panels included in the book by no means claim to cover the entire the-
matic spectrum of contemporary debate on dance studies and choreography.
Nonetheless, we hope that this book, which presents a collaborative array of is-
sues and fields of discourse, offers readers a variety of positions and approaches,
forms of presentation and ways of thinking. We hope it can be both an inventory
and a platform for productive and combative further development of possible re-
lationships between dance and theory.

An anthology, particularly one produced as this one has been, is based on a
collaborative process. That is why we would like begin by thanking all panel
moderators, respondents and panel participants for their productive and intensive
cooperation. We also wish to heartily thank the Berlin team who organised the
congress and ran the congress office at Uferstudios: Daniela Hahn, Kai van
Eikels, Ann-Kathrin Reimers and Inka Paul.

The book was managed and produced by the Hamburg team. Melanie Haller
and Heike Lüken were responsible for the editorial work, for which we are very
grateful. We also wish to thank Gitta Barthel and Deva Tamminga for their sup-
port in the final editing phase. We furthermore express our gratitude to the De-
partment of Movement Studies and the Center for Performance Studies at the
University of Hamburg for their financial grant of this publication. We also
thank Jennifer Niediek at our publisher, transcript, for her untiring efforts to pro-
duce this book. Finally, we are grateful to Karin Werner and the team at tran-
script for their support for Dance Studies, which they impressively and lastingly
demonstrated by establishing the 'TanzSkripte' series and the English language
series 'Critical Dance Studies.'

Hamburg and Berlin, July 2012

REFERENCES

Foucault, Michel (1971): *The Order of Things. An Archaeology of the Human Sciences*, New York: Pantheon Books.

Laban, Rudolf von (1966): *Choreutics*, London: MacDonald & Evans.

Man, Paul de (1986): *The Resistance to Theory*, Minneapolis, MN: University of Minnesota Press.

Wigman, Mary (1966): *The Language of Dance*, Middletown: Wesleyan University Press.

LECTURE

Dancing and Theorizing and Theorizing Dancing

Susan Leigh Foster

As a way of gaining perspective on current meanings of the term 'theory,' this essay first considers some very early iterations of the term. Theory's etymological roots can be found in classical Greek where it generally references the acts of looking at, viewing, and beholding. Turning to these classical Greek usages, however, we find that theory takes on successively distinctive meanings from the 6th to the 3rd centuries B.C., and also that it is intimately tied up with two other terms – aesthesis and praxis. By sketching out, very briefly, a history of these meanings, I intend to provide a perspective on current uses of the term generally and their relevance specifically to making and performing dance and to watching and writing about it.

MOVING ALONG WITH THEORY, AT A RAPID PACE

In the 6th and 5th centuries B.C., theory named an activity or procedure that consisted in leaving one's own home city and traveling to another place in order to witness an organized event – such as a dramatic spectacle, a sports competition, or religious rite – and then returning to one's city to report on what one had seen. Theorists, men appointed on the basis of their social standing and reputation, left their respective poli to survey and contemplate designated events, and then they returned home in order to attest to the occurrence of the events and verbally certify their having taken place.

An elite and male practice, theory incorporated motion as an integral part of the act of witnessing, although the moment of viewing itself seems to have been a moment when the body was stilled and surveying, but with a sense of participation or even wonderment. Vision itself was participatory since seeing was understood to consist in the act of light emanating from the eyes and blending with the light emitted by other objects and by the sun which together revealed the shapes, colors, and textures of things in the world. As a form of aesthesis, the quotidian act of sensing the world, vision was conceptualized as provoking in the viewer an experience of connection with the objects or events being viewed.

Neither passive nor objective, the act of observing instantiated a kind of kinship between the viewer and what was being seen. Theorizing partook in the same kind of empathic communing with the world, however it legitimized aesthesis by formalizing the process of observation and then certifying its having taken place. Whereas women and slaves experienced aesthesis, only men of rank could engage in theory. The verbal report issued after this journey, but as an integral part of the journey, along with the formality of the journey itself, had the effect of authenticating the events that had been witnessed.

Although it could be individually initiated, the practice of theory was typically consensual with all theorists necessarily coming to an agreement about what had been seen. Groups of theorists traveled to witness events, with each city hosting as well as sending them abroad. In this way, theorizing also served a diplomatic function by providing a mechanism for different cities to share their local practices with others. It also intimated a Pan-Helenic identity by emphasizing the commonality of a process that all cities shared.

Consensual and communal for the most part, the procedure of theorizing was profoundly embodied in every way. Theorists necessarily moved physically from one place to another and then engaged in beholding an event by physically illuminating its shape and motion. When they returned to their home city, they performed a ritualized report on what they had seen. As a form of knowledge production, theory was in itself a form of action, or praxis. Theory thus transformed aesthesis, legitimizing it as a praxis.

Then, over the course of several of his writings, Plato appropriated the term theory in order to justify his proposal for the new intellectual practice of philosophy as that of traveling to the realm of ideas. Where the earlier theorists were lovers of spectacles, the new philosopher as theorist, was a lover of the spectacle of truth. He was a new kind of intellectual ambassador who gazed upon the Forms (blessed or divine essences) in an act replete with wonder and reverence (Nightingale 2001: 37). According to Andrea Nightingale, Plato, in defining the philosopher as theorist, specifically referenced the kind of journey made to religious festivals or rituals in order to underscore the nature of theory as inclusive of a sacred dimension. However, Plato's philosopher as theorist no longer actually re-located physically from one place to another to witness events.

Before Plato, theory was not conceptualized as existing in opposition with aesthesis, since, as Eric Méchouan observes "theory was the act of legitimating aesthesis, a social and collective witness to the occurrence of an event, or more precisely, an occurrence as an event" (Mechouan 1997: 53f.).

Plato, in contrast, aligned theory with Ideas and aesthesis with Illusions, especially since aesthesis could occur in both correct and incorrect perceptions such as hallucinations, daydreams, fantasies, and dreams (cf. Sörbom 1994). Plato thus instituted a ranking in kinds of knowledge in which experience produced through the senses was less certain than that produced through contemplation. The role of the new philosopher as theorist continued, however, to have civic and political connotations, since the philosopher necessarily returned to his

city to report and implement what he had witnessed. As Nightingale argues, "his metaphysical sightseeing later leads to ethical action or praxis" (Nightingale 2001: 39).

Whereas Plato assumed continuity between theory and praxis, Aristotle argued that theoretical inquiry should be distinct from both poetical and practical investigations. Exclusively contemplative and an end in and of itself, theory was conceptualized as a domain of inquiry realized in the study of mathematics, metaphysics, and physics. In contrast, ethical, poetic, and political studies all of which derive from and generate strong implications for both social and political realms were not seen as branches of theory. Although philosophy itself embraced theoretical pursuits and also practical and political investigations, these three arenas were seen by Aristotle as separate human endeavors. Aristotle thus cordoned off theory from both praxis and aesthesis. Like Plato he stilled the theorist, erasing all physical action such that the journey he took was only and purely mental.

Following for a moment the developments of the terms aesthesis and praxis, we find that aesthesis exits the classical world and moves through Arab scholarship where, influenced by those inquiries, it is subsequently re-written into 13th and 14th century interpretations of Aristotle. Refining Aristotle's notion of a common sense, a function that integrates all the senses into a single apprehension of the world, Arab scholar Al-Haytham proposed a system of internal senses that combined and overlapped with the external senses in various ways (Summers 1998: 428-433). These 'virtus distinctivas' included fantasy, imagination, cognitation, and memory, among others, and they contributed substantially to the conceptualization of the individual soul and a spiritual individuality. Al-Haytham also distinguished these internal senses from the process of perception which he argued should be investigated using empirical methods.

It was this notion of the virtus distinctivas that Alexander Baumgarten adapted in the middle of the eighteenth century, in founding the new field of aesthetics, a field within philosophy that examined the nature of beauty, thinking about beauty, and the art of thinking beautifully in images (cf. Poulakos 2007). A century later, Karl Marx developed the concept of praxis as sensuous human activity where consciousness is an aspect or moment in praxis, and objects produced by labor could or should be seen as congealed versions of physical activity. Aesthetics and praxis thus became mature frameworks of inquiry, yet each made little direct reference to theory. Instead, theory was taken up separately in the physical sciences beginning at the end of the seventeenth century.

In one of the first uses of theory in scientific discourse, found in The Theory of the Earth from 1684, Thomas Burnet lays out a number of issues inflecting the term that continue to determine its meaning today. Defining the theoretical in opposition to the empirical, Burnet defends theory by comparing it to Romances, which like theory are replete with a "plot or mystery," that presents certain "grand issues upon which the rest depend, or to which they are subordinate" (Burnet 1684: 12). Unlike romances, however, theory offers a grand plan, which

can never be contrived but only discovered, since it accounts for the basic struc-
ture of the cosmos. In its exposition of the harmony of the universe's grand de-
sign, theory offers a kind of "masculine beauty" (Burnet 1684: 12), more sub-
stantive and truthful than any fiction. Burnet goes on to assert that theory oper-
ates collaboratively with empirical investigation that should be used to test out
and verify theoretical claims.

Thus theory, even in its first modern uses, takes on a masculine identity and
also a predictive capacity that it continues to enjoy today in the contemporary
physical sciences where it is envisioned as a system of ideas that provides a gen-
eral explanation for phenomenon that can be tested using observation and empir-
ical methods. Having originally been tied intimately to both perception and ac-
tion, theory became a term used almost exclusively in the physical and social
sciences. Closely aligned mathematics and physics, theory retained the
dis-embodied status that Plato had given it. Substantially superior to the applied
sciences that generated practical applications from its insights, theory offered lit-
tle or no relevance to the humanities and arts throughout the eighteenth, nine-
teenth, and much of the twentieth centuries.

MOVING INTO THEORY, MORE EXPANSIVELY

Theory seems to have come back into the humanities after some 2000 years with
the post-structuralist turn in the 1970s and 80s, the product of radical disagree-
ments regarding signifying practices and modes of interpreting them. As such,
theory has been implemented most often to account for varieties of difference.
Theories of the individual, of the social, of power, and of interpretation itself
have all been proposed that have overhauled or completely re-structured notions
of identity and cannons of knowledge that prevailed up through World War II. In
the U.S., for example, "feminist theory," has asserted a crucial difference be-
tween sex and gender, arguing that masculine and feminine forms of experience
do not derive from a biological destiny but rather a cultural and historical speci-
ficity. Similar arguments have been made in relation to race, sexuality, and class
identity (Godzich 1994: 19). The acts of reading in particular and of interpreta-
tion more generally have also been interrogated for the potentially diverse kinds
of interactions of which they are capable. These inquiries resulted in a strong
challenge to previous modes of scholarship and the knowledge bases that were
collected in support of their inquiries, and they proposed entirely new subjects
and methods of study for inclusion within humanities scholarship generally.

As diverse as these inquiries have been, they seem unified around their
common rejection of the theorist as a disembodied intellect who claims that truth
can be apprehended objectively. They similarly challenge the notion of theory as
generated from an omniscient or universal point of view, one that foregrounds
vision as the primary mode of perceiving and organizing knowledge. They like-

wise contest the assumption that there exists a theoretical mode of cognition separate from will, desire, and the emotions (Nightingale 2004: 8).

Conceptualizing the process of inquiry as a participatory activity, theory has made a strong claim for the need to document the researcher's own history and trajectory through the research process. Not unlike the pre-Platonic theorists, contemporary theory encourages a consideration of where and how theorists traveled to and among the subjects of their research. As part of that participatory process, theory generally emphasizes the partial knowledge that is produced by any body's journey and the multiple forms of knowledge that can be apprehended through different modes of sense perception. Even if contemporary theorists envision themselves as viscerally engaged in the act of watching, as communing with the object of one's scrutiny, they would not imagine that that object or one's perception of it could be classified in terms of pan-human, transcendent features, nor could it be categorized in terms of a set of eternal and universal forms. Rather, as numerous arguments, among others those made in anthropology, literary criticism, and feminist and queer studies, have proposed, analysis is always partial, historically and culturally specific, and dependent to a considerable extent on the history and inclinations of the observer.

According to Wlad Godzich, there has also been an assumption within the domain of contemporary theory that whatever systematic explanation is being proposed, there is a correspondence between that theoretical system and the system of the State in the social sphere, thereby giving Theory its political dimension (Godzich 1994: 21). Unlike Aristotle, who argued for theory as useless, contemporary implementations of theory, whether they focus on the operations and distributions of power or on the various abilities of readers/viewers to interpret events, are often assumed to reveal a crucial aspect of the functioning of the state and its subjects.

Yet as Méchouan has observed, theorizing in the humanities, unlike the sciences, has most often been used, not in its predictive capacity, but rather to analyze the present and understand the past. In questioning the role of literary theorists, for example, he asks:

"Why, in the humanities, has there been no claim to describe a future novel or to experiment with the poem of tomorrow? If some theorists were to claim to do so, they would simply write a novel. And actually, a few academics do just that (think of Eco or Eagleton)." (Méchouan 1997: 56)

Méchouan attributes to art the potential to anticipate and predict the course of future events. He suggestively opens up the domain of arts production as a site where theorizing might take place.

DANCING AND THEORIZING, ALONGSIDE SIDE ONE ANOTHER

What does this brief journey through the history of the term theory offer us as dance scholars? How might we want to think about the practice of theorizing specifically in relation to dance? The general critique of knowledge production sustained in contemporary theory, with its interest in the physicality and involvement of the observer, has opened up a vibrant space for dance studies. The processes of watching and writing about dance foreground the participation of the body, making it possible to envision theory as something that writers and also choreographers might generate.

Historical reflection on the evolution of the term thus provokes a series of questions about the practice of theorizing:

- Who is selected and on the basis of what criteria to be a theorist?
- What, if anything, is special about their aesthesis?
- How could theorists register and reflect on the ways that they engage physically and psychically with the dance?
- Do theorists generate a praxis and if so, how?
- How do theorists function diplomatically to create larger networks of understanding about dance?
- What is legitimized by theorists' actions?
- Can theories be translated from one investigatory practice to another?
- Can theories be predictive as well as explanatory?
- If theories can issue in formats other than the verbal, how can dances put forth or embody theories?
- What is the difference between theory and method?
- How are answers to the above questions shaped by the institutional frameworks in which dance is promoted and investigated?

In my opinion, the purpose of these kinds of questions is not to derive any single answers, but instead, to utilize them as guideposts in developing a set of debates around the relationship of theory to dance. Some of these questions address issues of accreditation, licensing, and pedagogy while others are concerned with the mobility and translatability of ideas and concepts. Underlying all these questions are issues involved with the function of verbal language and dance movement, and how each domain is perceived and valued.

Convening a debate around any one of these questions, we encounter further complications. For example, the very term 'theorist' has different meanings in different languages. In German, as I understand it, theorists and empirical researchers, whether working in the sciences or humanities are called scientists. In English, by contrast, we have three terms that refer to the different roles and responsibilities of those who write about dance – theorist, scholar, and critic. Selma Jeanne Cohen in the 1980s first introduced the distinction between critic and

scholar, based on the types of formats and venues in which their works issue. Critics, she argued, primarily write for daily newspapers and weekly magazines, whereas scholars write essays and books that are not time-dependent for their publication date and therefore can explore more deeply a given subject. (This distinction is not valid throughout the arts, since some of the most influential theories have been proposed by literary critics.) Furthermore, not all scholars or critics are theorists in that many scholars chronicle events in dance's history without proposing any hypothesis concerning their significance. Such hypotheses may be implicit in the way that they organize and present their research, but they are not consciously mobilized as an exploratory framework within which to organize information about dance.

As a result of these differences in the meanings and applications of the term theorist, the English language offers a distinction between theorizing and scholarly inquiry that may allow for theory to be applied to a wider variety of contexts. It is possible, for example, following Méchouan's suggestion, to imagine that a choreographer might be theorizing while making a dance. Nonetheless, the associations of the equation theoretical/practical with oppositions such as cognitive/physical, verbal/bodily, reflection/action are widespread in English language discourse, making it more difficult to entertain the possibility of choreographers as theorists. By contrast, in Germany, artists, although quite distant from theorists in terms of the definitions of their professions, nonetheless appear to enjoy a social status as equals that they are not typically accorded in the U.S. (although not throughout the English-speaking world). The suspicion and disregard with which artists are often greeted in the U.S. makes it more difficult to contemplate the theoretical potential of their artistic production.

A second complication with similar wide-ranging effects concerns the historically distinct institutional contexts in which training for artists and for academics has occurred. In classical Greece, theorists' training seems to have been based in the general pre-suppositions regarding eligibility to be a citizen. No special training was required, nor was it necessary to have participated in the events which one witnessed in order to certify that they had taken place. Status as a theorist depended upon the general perception of one's dedication to civic engagement. Today in Germany and the U.S. we have academies that train both artists and scholars/theorists, certifying them in various ways, although artists also take advantage of alternative opportunities for accessing the profession. We also enjoy considerable disagreement as to whether those who write about dance should also undergo training as dancers and/or choreographers.

These institutionalized training regimens have also specific histories that influence the nature of theory and the act of theorizing. In the U.S. dance came into the university through the rationale provided by pedagogical claims such as those of John Dewey who advocated for the possibility of learning through doing. Professor at Columbia University Teacher's College from 1904 until his death in 1930, Dewey saw dance as both a vital form of expression and a medium for understanding. Dance entered the university through dancers inspired by educa-

tional philosophies such as Dewey's who rationalized dance's presence in the university curriculum as a way of knowing – not necessarily a way of theorizing, but certainly a way of investigating and discovering. These educators first introduced dance technique classes, based on the assertion that the very activity of dancing offered a new and distinctive medium for understanding the world. Technique classes were followed by courses in dance composition, and these studio-based classes formed the mainstay and central focus of the curriculum for anyone pursuing dance, with courses in history, philosophy, and cross-cultural analysis, all added much later as peripheral to the main practices of dancing and making dances.

This trajectory for the development of dance within the university made it possible to argue for dance as form of research, but it also introduced a crucial dilemma concerning dance's relationship to written discourses because arguments made in favor of dance as a unique way of experiencing the world largely asserted that it was impossible to describe or analyze that experience. The processes of dancing and dance-making could be felt, but not represented verbally. On the one hand this anti-intellectual stance protected dance as an autonomous field of inquiry whose difference from other subject areas enriched the university. On the other, it constructed incommensurable differences between dance and other scholarly and creative pursuits that worked to segregate dance from the rest of the academy. It also prompted one of the most central debates within dance studies in the U.S.: how to theorize the relationship between live performance and written texts describing that performance.

By contrast, academic studies of dance in Germany have more recently entered the university system, and the training of dancers and choreographers has typically occurred in a variety of non-academic institutional situations. Although separated in terms of their institutional settings, it is my impression that German choreographers and scholars have defined more ground in common than their U.S. counterparts. Because of the strong tradition of conceptual and intellectual engagement with dance on the part of artists over the entire course of the twentieth and now twenty-first centuries, artists and scholars seem to enjoy a less antagonistic relationship than in the U.S. where the anti-intellectual bias remains a strong undercurrent. The many publications of Rudolf Laban, the investigations of *Ausdruckstanz* by *Tanztheater* artists in the 1970s and 80s, the divergent approaches to choreography manifesting in East and West Germany up through the fall of the wall, and the more recent innovations in concept dance (Konzepttanz), all engage with cultural, political, and aesthetic issues in ways that run in tandem with scholarly inquiry into dance's significance. Thus, even though dance classes have rarely been incorporated into the university as such, there was a clear set of connections to be made between investigation through choreography and investigation through scholarship.

It is also my impression that artists and scholars in Germany see greater opportunities for collaborative research than in the U.S. Both the earliest Greek notions of theory as well as Plato's appropriation of the term assumed that practical

consequences would issue from theoretical observations. The ability of the theorist to disseminate to one's own community information about events witnessed either abroad or in the realm of ideas was seen as a catalyst for potential change at home. German scholarly inquiry into dance has identified this connection between theory and praxis as a defining feature of the field. As Gabriele Brandstetter has noted:

"It is one of dance studies' tasks to provide historical research and theoretical positions for choreographers and dancers, but also for cultural studies at large." (Manning/Ruprecht 2012: 25)

Dance scholars in the U.S. have worked assiduously to foreground dance as a critical site of engagement for research in the humanities and social sciences in general, but they have been less successful in finding avenues for collaboration with choreographers. The role of the dramaturg, for example, is far more developed and utilized in Germany than it is in the U.S.

In the U.S., the roles typically assigned to the terms theory and practice imply both a hierarchy of status and a direction of influence. Theory is aligned with grand and great ideas, and practice implies a more pragmatic and pedestrian approach to problem solving that often entails the implementation of theoretical ideas. In an effort to contest these implicit connotations, I have argued at length for a consideration of choreography as a theoretical act in which decisions made about the development and sequencing of movement entail a reflection on corporeal, individual, social, and political identities (Foster 1998: 3-6). Choreography, I have proposed, can be seen as presenting a theory of what the body is, what it has been historically, and what it might become in the future. Implicit within the choices made in creating a dance is a proposition or hypothesis about who we are. Such a notion of choreography enables a re-thinking of the relationship between theory and practice by leveling the status between scholars and choreographers and by suggesting their mutual influence one upon the other.

In order to flesh out the implications of such an approach, I want to look briefly at two works, one, a dance by Thai choreographer Pichet Klunchun and the other, a book by Argentinian dance scholar Marta Savigliano. Klunchun's *I Am a Demon*, a work that had its premiere in Berlin in 2006, presents an austere, minimalist excavation of Khon pedagogy, the process of learning the classical Thai dance form. Dedicated to Klunchun's teacher, the piece begins with basic Khon positions performed in slow motion that emphasize how each part of the body should participate in creating a given shape. It then expands into the regimen of exercises that largely compose the training program, exposing the labor of constructing the powerfully expressive physicality that marks Klunchun's dancing, eventually demonstrating costuming, spear handling, and finally, how to perform a buoyant and light-hearted sequence to music. Alternating between slow motion and extensive repetition of individual exercises, all performed in stark, minimal light, the piece extracts the movement practice from the full cos-

tuming and traditional narratives that Khon presents and conducts an anatomy of the form.

The performance is framed by Klunchun's directly addressing the audience. Before beginning the dance, he describes his intensive study with his teacher and his feelings of immense loss when the teacher passed away. At the end, Klunchun describes his motivation for creating the piece, explaining that the piece began with the question he posed to himself about how to bring back someone who is gone. Since, as he notes, the only way to see classical Thai dance is to attend a performance in a restaurant for tourists, he created this piece to try to make Khon stronger, to renew it and vivify its previous meaning and impact. Captivated by the fact that he has, thanks to his intensive training with his teacher, acquired knowledge that is two hundred years old, Klunchun aspires to forge a new vehicle for sharing that corporealized culture so that it might be relevant and inspiring today. *I am a Demon* endeavors to bring back both his teacher and Khon itself. The repetitions of basic steps cry out to the audience, "feel this, feel this," as though Klunchun is endeavoring to share with them the same bone-deep knowledge his body has assimilated. Marveling at the precision and specificity of the actions, the audience learns to partake in Khon's special way of moving in the world.

I would like to propose that *I am a Demon* presents a theory about what the central tenets or constitutive elements of Khon are, and also a theory about how to revitalize those tenets for a contemporary audience. It argues for the importance of a particular way of training the body, moving energy into and through the body, as foundational to the aesthetic experience that Khon offers. In this argument, it shares with Western modern dance the thesis that movement itself, apart from music, costuming, or other aspects of the dance, bears the central responsibility for conveying meaning.

The methodology that *I am a Demon* utilizes to present this theory consists in implementing strategies from contemporary European concert dance such as minimalist repetition, stark use of lighting, non-narrative sequencing, and multiple mediums of address, (film, live talking, music, and dance). It applies these strategies to Khon vocabulary and phrases in order to achieve a completely original form of dance presentation, one that reinvigorates Khon's aesthetics by highlighting for the viewer the form's specific way of cultivating the body. Utilizing this methodology, Klunchun is able to renew interest in the form by showing the movement from a radically different perspective, one that nonetheless maintains its allegiance to Khon's movement vocabulary and aesthetic investment in the body.

In her book *Tango and the Political Economy of Passion*, Savigliano (1995) implements a similar methodology, even though her theory is quite different from Klunchun's. Her study of tango utilizes first-world post-structuralist methods of interrogation to elucidate the complex role that tango has played in Argentinian culture. Specifically explaining that she is adapting the tools of the master to forge a new kind of cultural critique, Savigliano, like Klunchun, borrows

Western techniques, in her case analyses of economy, gender, and nationality, to explain how tango was exported from Argentina as a commoditized form of passion and then re-imported as the auto-exotic symbol of national identity.

Savigliano's theory, addressing issues distinct from Klunchun's, casts the tango as the product of colonial forces of exoticization and capitalism, in order to show how passion, like physical resources, can be extracted from a land and its people. Unlike Klunchun, Savigliano does not focus exclusively on the movement of tango, but instead treats the full range of practices, musical, poetic, and so forth, as integral to the tango's identity. However, like Klunchun, the result of her hybrid application of strategies is an entirely new form of scholarly writing, one that blends multiple authorial voices, fictional and real characters, prose and playtext. Savigliano embeds a set of methods heretofore seen as foreign to the dance within it to produce a hybrid commentary about the dance. The methods of analysis illuminate how gender, class, race, and nationality are embodied within dance, but the dance also affects the methods by showing how they must continually be applied while in motion. Klunchun's treatment of Khon in I am a Demon likewise foregrounds the interplay of method with movement material, suggesting that it is through the ongoing and changing efforts to engage with Khon that the form will remain vital and relevant.

In this reading of Klunchun and Savigliano, theory and practice are taking place in both choreography and scholarship. Each author's work propounds a theory, and it also introduces, through its specific mastery of ways of either dancing or writing, a set of implications for how research could be conducted in the two fields. Endeavoring to present theories about a form of dancing to audiences outside their home communities, Klunchun and Savigliano have changed the disciplines of dancing-making and scholarship by introducing new formulations for a dance and a book into their disciplines.

DANCING THEORIZING

In ancient Greece theorists provided a verbal, not necessarily written, report of what had been witnessed. However, the status of a formal verbal pronouncement, such as the ones they provided, in relation to written documents is unclear. How was the report viewed in relation to the live events that had been witnessed? Was it viewed as a synopsis? A translation? A reduction? A re-organization? And did the verbal report carry the same weight as a written report? How did its contents become the grounds upon which changes to the polis might be considered and even executed? Were some reports recorded and others committed only to memory? How did oral formations of the historical record relate to written forms? Answers to these questions are in flux, partly as a result of the same theoretical upheavals that opened the space for critical studies of dance to emerge.

The post-structuralist theoretical paradigms developed in the late 1970s and 80s instigated new inquiries into the nature of the text, speech, and speech acts

that have de-stabilized the assumed status and function of written and oral 'events.' Who is the author, and who the reader or listener? What spoken acts have legal consequences? Contain historical veracity and legitimacy? How and when did written documents assume their role as the only source of valid information for the historical record?

Responding to these questions, Jacqueline Shea Murphy has shown how historical record is maintained in the dance practices of Native Americans and how the very fact of dancing does not necessarily represent something else, but instead, can constitute its own meaning and efficacy. Shea Murphy details how, at the end of the nineteenth century, Native Americans who were sequestered onto reservations across the western U.S. were told that they could no longer practice their ceremonial dances. The Bureau of Indian Management deemed dancing to be a frivolous and unproductive pursuit that inhibited the natives' abilities to contribute labor to the productive activities of farming and ranching. At the same time that their dancing was banned, however, the *Buffalo Bill Cody Wild West Show* was given permission to hire Native dancers to perform in its extravaganza, touring across the U.S. and eventually to Europe. In questioning how the Native dancers could possibly be willing to participate in a narrative that ultimately represented 'the taming of the West,' and the consequent triumph by the U.S. government over Native ways of life, Shea Murphy argues that Native dancers might have been willing to perform and tour because they believed that, regardless of where they were staged, their dances could be efficacious if executed with the proper spirit. In making this argument, Shea Murphy reveals the underlying assumptions of the U.S. government regarding the superfluous and trivial nature of dance performance at the same time that she demonstrates how Natives could identify meaning in their dances. She argues that their understanding of the status of their dances is similar to J. L. Austen's notion of the speech act, regardless of the frame in which they were performed. Where the government saw their actions as a form of play-acting, they experienced dancing as an affirmation and perpetuation of community values.

More recently, Native peoples in Canada have persisted in their assertions that dances and rituals contain an oral history of treaty negotiations from the time of conquest, and they have succeeded in arguing before the Canadian high courts that credence should be granted to these forms of oral history, resulting in a redistribution of lands and the establishment of the sovereign state of Ninavut. The courts were confronted with and persuaded by the argument that dance and various other ceremonial practices are versions of speech acts, a form of orature that exercises legal jurisdiction.

Like Savigliano, Shea Murphy has adapted theoretical propositions from other fields and applied them to the analysis of dance. Also like Savigliano, her subject of Native dances speaks back to those theories, expanding their compass and altering both the scope of the theory and the role that physicality plays within the theories. The economic paradigms that Savigliano utilized never considered dancing as a form of natural resource or as a variety of labor, and in reveal-

ing the tango as both, Savigliano proposes a new theory of how capital can be deployed. Similarly, Austen's theory of the speech act never envisioned speech as a form of physical action but rather as a variety of verbal discourse. In adapting Austen's concept, Shea Murphy exposes the verbal/non-verbal divide that underlies it, and at the same time, expands the realm of historical and legal documentation to include varieties of human movement.

What I want to suggest here is that theory and method are transportable from one subject matter to another, and this is certainly how Dance Studies in the U.S. has developed, borrowing theories and methods from other disciplines, and testing out the applicability and pertinence of those approaches to the subject of dance. Dance has been theorized as a text, as labor, as speech act, as rhetoric, as a form of mobilization, and as an intertextual system of signs, using methods from semiotics, genealogical analysis, and ethnography. We have also borrowed momentum from emerging interdisciplinary studies such as cultural studies, post-colonial studies, critical race studies, studies of sexuality, and diaspora and globalization studies in order to interrogate dance as a practice that generates cultural, ideological, and identificatory meanings. Any of these borrowings opens up certain lines of inquiry at the same time that it occludes others. The field can thus be seen as an ongoing process of inquiry marked by a high degree of reflexivity because the evanescence of dance itself foregrounds the theoretical dimensions of scholarly research by emphasizing the constructed nature of any object of study.

REFERENCES

Burnet, Thomas (1684): *The Theory of the Earth: Containing an Account of the Original of the Earth*, London: R. Norton, for Walter Kettilby.

Foster, Susan Leigh (1998): "Choreographies of Gender." In: Signs, (Autumn), pp. 1-21.

Godzich, Wlad (1994): *The Culture of Literacy*, Cambridge: Harvard University Press.

Méchoulan, Eric (1997): "The Time of Theory." In: SubStance, Vol. 26/No. 3/ Issue 84, pp. 53-65.

Manning, Susan/Ruprecht, Lucia (2012): "Introduction." In: Id. (eds.), *New German Dance Studies*, Champaign/Urbana: University of Illinois Press, pp. 1-16.

Nightingale, Andrea (2001): "On Wandering and Wondering: 'Theoria' in Greek Philosophy and Culture." In: Arion, Third Series, Vol. 9/No. 2, pp. 23-58.

Nightingale, Andrea (2004): *Spectacles of Truth in Classical Greek Philosophy*, Cambridge: Cambridge University Press.

Poulakos, John (2007): "From the Depths of Rhetoric: The Emergence of Aesthetics as a Discipline." In: Philosophy and Rhetoric, Vol. 40/No. 4, pp. 335-352.

Savigliano, Martha (1995): *Tango and the Political Economy of Passion*, Boulder: Westview Press.

Summers, David (1998): "History of Aisthesis." In: Michael Kelley (ed.), *Encyclopedia of Aesthetics*, Vol. 3, New York: Oxford University Press, pp. 428-432.

Sörbom, Göran (1994): "Aristotle on Music as Representation." In: The Journal of Aesthetics and Art Criticsm, Vol. 52/No. 1, The Philosophy of Music, pp. 37-46.

PANEL ARTISTIC RESEARCH

Artistic Research:
Between Experiment and Presentation

INTRODUCTION BY KERSTIN EVERT/SIBYLLE PETERS

THE STATE OF THE DEBATE

To think of artistic work as research has a long tradition reaching from the aesthetics of romanticism in the 19th century and the 'experimental stage' of the avant-garde in the early 20th century up to the present. As early as in the 1960s, the Italian philosopher Giulio Carlo Argan stated that the phrase "art as research" is "constantly repeated in the modern critical phraseology" (Vujanovic/Vesic 2009: 51). Moreover it seems to be an unavoidable part of this phraseology to describe "art as research" as a new and just recently discovered form of practice. In consequence, a lot of programmatic writing is taking place in the field of artistic research (cf. Bippus 2009). Analytical differentiations between historical developments and figurations of art as research are harder to find, though precise differentiations are needed particularly in the current debate.

For example, even in the work of a leading figure like Joseph Beuys, the tradition of romanticism and avant-garde is still alive striving for an organic reunion of art and science within the project of art as research. In contrast, artistic research today does no longer aim to reintegrate polar differences, e.g. the ones regarding mind and body, but it is about transitions and combinations between different forms of knowledge production. A multitude of knowledge-forms is appreciated instead of being seen as something to overcome.

Especially in the field of dance, hybrids between art, science and research have come into being, as well on the level of structures and institutions as on the level of procedures for work and presentation. It goes without saying that artistic research is part of discursive strategies in the struggle for public support and for the improvement of working and learning conditions. When Deleuze/Guattari wrote about the traditions of "minor knowledge" (Deleuze/Guattari 1994) and de Certeau analysed the tactics of the everyday (de Certeau 1998), it seemed to be an important cultural task to revalue forms of knowledge which for centuries had been denied the dignity of science and research. Today, the economical call for applicability and how-to-knowledge has taken over the academic institutions themselves. We entered the era of 'cognitive capitalism' (Boutang 2007). Before

this background, Ana Vujanovic and Jelena Vesic write about the "educational turn" within the arts:

"While declaring themselves to constitute production of knowledge, the arts try to ensure themselves a new legitimacy in the cognitive capitalism. [...] Production of knowledge represents one of the 'latest crazes' in today's artworld. What is characteristic of the current context is not merely an increase in the number of educational programmes surrounding artistic practice but also the fact that education turns into artistic work itself, even a work of art." (Vujanovic/Vesic 2009: 51)

At the same time, 'artistic research' is criticized as an instrument of the Bologna-process to subdue the processes of artistic education to the standards of scientific studies. Kathrin Busch comments:

"Will man einer Subsumption der Künste unter die Wissenschaften zugunsten einer gänzlich neuen Konfiguration künstlerisch-wissenschaftlicher Wissensbildung entgehen, hat man sich gegen eine Idealisierung der akademischen Welt zu verwahren und im Gegenzug auf die Zwänge und Ordnungen des 'Willens zum Wissen' zu verweisen." (Busch 2009: 148)[1]

Here we find references to a traditional configuration with art on the one hand and science/scholarship on the other hand mirroring each other in the mode of critique: In this configuration, art claims to criticize scientific rationalism while academic cultural theory is mainly produced as critique of art.

In contrast to that, the most significant feature of 'art as research' today seems to be that it is spreading beyond this mighty dispositive of mutual critique: Neither is artistic research today mainly to be understood as a critique of scientific research, nor does it help when traditional art critique is continuing to praise artistic work for intuition and genius thus denying its ability to do research. This does not mean that there is no poetry to be found within the current field of 'art as research.' On the contrary, it is closely linked to what has been called the "Wiederverzauberung der Welt" ("re-enchantment of the world") (Fischer-Lichte 2004: 360), i.e. to the re-evaluation of science as a historical multitude of artful practices, which are by no means as rational as claimed, but occupied with the production of wondrous phenomena, unpredictable effects and ever changing views of reality.

Therefore, the focus of the debate is about to shift from polar differences between art and science to the discovery of complex affinities, productive differ-

1 "To avoid a subsumption of arts under science in favour of a truly new configuration of knowledge production, it is necessary to refrain from idealizing the academic world and to refer to the compulsions and orders produced by the 'will to know' instead." (translation by the authors)

ences and possible cooperation in a broad spectrum of different forms of knowledge production.

INTRODUCTION: THE RESEARCH-PRESENTATION-DIVIDE

What does it mean to face this challenge? In organizing a panel about artistic research at a conference on dance and theory, we wished to stop the endless talk about discourse-politics and concentrate on close descriptions of recent changes within artistic practices brought about by research orientation.

"To do some smart thinking together" – as suggested by Jan Ritsema – was an important idea for the course of the discussion, which began with short statements of each of the four panel members in order to open it up to the audience as soon as possible. All participants were sitting around a rectangle, leaving the enclosed floor free for using it as a note board: As moderators, we moved around the floor on rolling boards, using differently coloured chalk for taking notes and documenting terms, which were crucial for the process of the talk. In order to introduce the main questions raised for the discussion, we noted e.g. three pairs of terms: research/presentation; divide/link; product/process.

So as to enhance this exchange of methods and experiences, we proposed to focus on the relation between research and presentation. In our introduction to this crucial relation, we wanted to give an example of how traditional oppositions between art and science can dissolve into a spectrum of complex affinities. It starts with a clear distinction: In scientific and scholarly practices, research and presentation are usually thought of as two very different sets of procedures: research comes first, whereas presentation is seen as secondary – not only in terms of 'one after the other,' but also in terms of discursive importance. While, for example, new methods of research are seriously discussed, new methods of presentation are often looked at as some kind of extravaganza. In other words: It usually is not on the academic agenda to change or specifically select the means of presentation in reference to the type of the research that has been conducted before.

In contrast, it seems quite evident that in regard to dance and the arts in general, research and presentation are closely linked: To present something in specific ways, frames, setups is obviously an important part of artistic research itself.

So, to begin with, we have a divide between research and presentation on two different levels: a simple one within the order of science itself, and a divide of the second order between forms of research linked to presentation (art) and forms of research distinguished from presentation (science). As a matter of course, when you take a closer look at things, they get more complicated: in the development of science studies, many close descriptions of scientific practices have been given, and it has clearly been shown, that there is on the one hand a difference between what is stated in research programs and reports and what scientists

and scholars really do.[2] Historical examinations of scientific research found evidence, that research is conducted by crisscrossing the research-presentation-divide again and again.[3] Science studies have proven that display and presentation play a crucial part in settings of research (Galison 1997). Moreover, it has been shown how the performance of science in the lecture theatre, far from being just secondary, has to be seen as an important part of knowledge production (Peters 2011). On the other hand, if you look closer at research orientation in artistic practices, you will find that the relationship between research and presentation is far from being uncomplicated here, too: In the long history of art as research, the field has been dominated by terms like 'experiment' and 'laboratory/lab.' These terms refer to specific settings and stages of scientific research, which are usually opposed to the public presentations of research results. For a long time, research in dance and the arts focused on the process instead of the product. So, in order to refer to experimentation in the laboratory instead of, for example, presentation at a conference, artistic practices tried to defend themselves against the pressures of artistic production.

This is where our questioning started. Our first point to be discussed with the participants of the panel can be stated like that: Are the strategies to connect process-orientation and research-orientation in the arts exhausted today – at least to a certain degree?

DISCUSSION I: TOWARDS A CRITIQUE OF PROCESS-ORIENTATION

Indeed, the panel agreed that there are good reasons for a critical re-evaluation of process-orientation in the field of artistic research. Here are some of them:

As long as 'research' in the arts is used to put an emphasis on 'process' as opposed to 'product' a certain form of the research/presentation-divide is imported from science and reproduced in the field of artistic research. Consequently, research and presentation tend to be divided here, too – one becoming process, the other becoming product. Instead of being a straightforward process of production, the artistic product turns into the attempt to present the process leading up to presentation. Though this has caused a lot of paradox tasks, it initially has been an important step. To uncouple the process from the obligation to produce some immediate outcome, it is necessary to develop a new attitude towards failure, which is crucial for any concept of research. Instead of bringing artistic and scientific research closer together, this opportunity is missed out. While the scientific divide between research and presentation is reproduced in the field of artistic research, the scientific community starts to question the very same divide. Discussions on how to present research are becoming more com-

2 This started with Latour 1987.
3 First done by Schaffer/Shapin 1985.

mon and more important. Rather than being partners in this important discussion, artists are now busy with their own version of the divide. In being complimentary, the developments in art and science fail to meet.

Moreover, the combination of process- and research-orientation within dance and the arts tends to create misunderstandings of research itself. In contrast to the opposition between process and product and its implications for artistic research, scientific research always had a crucial relation to production. This relation is a constitutively broken one, a relation of the second order: research is not production, but it helps to produce the growth of production. In other words research usually does not produce solutions for given problems, but constructs problems (Cvejić in this volume), which then enable eventually the production of new, potentially marketable solutions in the end.

In dance and the arts, this constitutive relation between research and production has notoriously been neglected and underestimated. This has two, quite different consequences for research-oriented projects in dance and the arts: First, criteria of research itself tend to be compromised, when research is used to substitute for any kind of product (Cvejić in this volume). And second, it now comes as a surprise that research-orientation in dance and the arts in the end do not provide sufficient shelter against the pressures of production. Instead, it turns out to be a new, second order logic of production itself. This becomes evident in a shifted relation between research and presentation, when research-oriented practices in the arts are confronted with a new obligation to present themselves – not in the form of a final product, but constantly, in all stages of working, rehearsing. If the process itself becomes the product, it ideally has to be presentable, marketable in all of its moments. The research paradigm seized to function as a tool for resistance against the logic of production. On the contrary it proves to be a passage into a new intrinsically performative logic of production in terms of cognitive capitalism.

The panel listed a few problems caused by this constant pressure to present research, for example the tendency to address only a specialized audience, an audience consisting of people, who are taking part in similar processes of research themselves. Or the feeling to enter an infinite infantile stage, in which one is obliged to go on learning, without ever finishing or postulating final results. In addition, the panel showed that facing these problems might make experts, being engaged in research oriented dance projects for years and decades, think about discharging the paradigm of research as a whole. To avoid that, it seems even more crucial to answer the question, what might follow from this critical review of process-orientation in artistic research?

DISCUSSION II: TOWARDS A TYPOLOGY OF RESEARCH-RRESENTATION-FRAMES

Consequently, we proposed to rethink in detail the function of presentation for research in dance and the arts. This proposal implies the conviction, that to precisely define the function of presentation within a given research project is not only enhancing research but makes the difference between 'research' on the one hand and what should better be called 'Recherche' or 'exploring' on the other. In other words, to be precise about the configuration of research and presentation in a given project might help to counteract the dangerous inflation of the term 'research' within dance and the arts. Moreover, it will hopefully enable actors in the field to deal with the general political and economic questions, raised above in a more conscious and less defensive way.

Obviously, the task cannot be to define or even to regulate the relation between research and presentation once and for all. On the contrary, a collection and close description of examples, modes and functions of presentation in a wide range of research oriented dance projects is required. The following list is meant to give an example of how such undertaking could start:

Think for example of a project like *A Mary Wigman Dance Evening*[4] (2009) proposed by Victoria Perez for discussion. Here, and likewise in most research projects dealing with re-enactments of some kind, it is evident, that the aim to perform/re-enact historical choreography on stage initially sets the frame for research in the first place. Nevertheless, the process of research itself can turn out to be the most interesting part of what is presented in this frame in the end, like for example in Martin Nachbars re-enactment-projects of German choreographer Dore Hoyer.[5] Research connected to re-enactment tends to articulate a rather simple and productive relation between research and presentation – probably due to the fact that this kind of research deals with former forms of presentation itself and explicitly engages in the problem and productivity of repetition.

Things become more complicated, when research is conducted regarding questions of spontaneous collective movements in a tension between following rules, breaking and recreating rules like for example in the project *E.X.T.E.N.S.I.O.N.S* by French choreographer Xavier Le Roys (1999-2001). On the one hand, every experiment in this field is always already a presentation to the extent that it is a test, a combination of action and observation. On the other hand, experiments of this kind cannot simply be repeated for public presentation, neither in content nor in constellation, without being heavily changed by the very fact of public presentation itself. The important feature to deal with in this type of a research-presentation-frame is the fact that any presentation of results necessarily turns into another experiment.

4 Fabian Barba: *A Mary Wigman Dance Evening*. UA: K3/Hamburg 03.11.2009.
5 E.g.: Martin Nachbar: *Urheben Aufheben*. UA: Sophiensaele/Berlin 28.06.2008.

Yet another type of a research-presentation-frame can be observed by the example of *Perform Performing (part one)* by German choreographer Jochen Roller.[6] Here, the form of the presentation enables the audience to put the stated results of the conducted research to a test: During the lecture on stage, the reported economical facts governing the work of a dance performer can be observed in reference to the economy of the presentation itself. The statements of the lecture about the economy of performing are potentially transcended by the performance of the lecture itself (cf. Peters 2011: 193 et seq.).

More possible examples of research-presentation-frames include projects of the authors themselves. This includes e.g. a serial of lecture performances in the frame of the project *Veronika-Blumstein*[7], that adapted the presentational format of the academic lecture and used it to initiate a research process focusing on the production of a fake, yet plausible, archive of documents witnessing the life of the fictional choreographer Veronika Blumstein. By collectively producing the archive, researchers are enabled to exchange, connect and materialize their views of historical developments in choreography.

Or, to name yet another, the project *Kinder testen Schule (children testing school)*[8]: where movements from everyday-life in school were collected, combined and choreographed to become a dance on stage. The audience – consisting of the children of a specific school – was then asked to become referees and blow a whistle, whenever the line between movements allowed and movements forbidden in school was crossed during the dance. The relocation school/stage and the re-enactment children/stage-performers allowed the audience to re-evaluate and question the order of movement in their school. Comparing different performances with different school-audiences, the performers could give feedback about the degree of strictness in a given school. A discussion about the order of movement in a given school started from here. Thus, the presentation was not only presenting results, but was itself a decisive part of the research process.

It goes without saying that the heuristics for a provisional typology of possible types of research projects and their specific presentation-frames is to be continued. It should aim not only at analytical cognition, but also raise a practical awareness about possible configurations of research and presentation: They do

6 Jochen Roller: *Perform Performing*, Part 1: No Money, No Love. UA: 27.11.2003, Berlin.

7 The Veronika Blumstein Group was started by an international group of artists in 2005. Since then, several activities (festivals, performances, lectures, workshops etc.), which focused on the work and life of the fictitious polish choreographer Veronika Blumstein, took place in different cities among Europe.

8 Forschungstheater/FUNDUS THEATER: *Kinder testen Schule*, 2008 bis 2010, for a documentation see http://www.fundus-theater.de/forschungstheater/projekte/kinder-testen-schule/.

not have to be invented anew in each new project, but eventually can be adapted and refined to work in other contexts.

PRODUCING PROBLEMS, POSING QUESTIONS

During the panel itself, the focus shifted from discussing actual examples to naming aspects, which are to be considered regarding the relation of research and presentation. The discussion resulted in a list of desiderata. Some of them already become evident considering the given examples some are transcending the tasks of the panel.

The most important aspect seemed to be one of reception or participation. The relation between research and presentation has to be looked at as defining the role of the audience in regard to the research process: Is the audience becoming part of the team of researchers? What is at stake for the outcomes of a research project in the participation of an audience? Is the audience able and willing to play this part? And/or is this limiting and formatting the public addressed by a given project? Two extremely different views are at stake in this part of the discussion: Some participants of the panel expressed severe doubts about the public character of artistic research as a whole. In this view, research-orientation appears as a highly questionable strategy to legitimize forms of artistic work, which are no longer able to attract the interest of public audiences. Other participants claimed the extreme opposite namely that in contrast to scientific or scholarly research, it is a specific feature and competence of artistic research to create and provide forms of research, which enable people (non-artists, non-scientists, non-scholars) to become part of the team, who are usually denied the dignity afforded to the researcher.

Closely linked to this problem is the question of 'self-sufficiency' that has been addressed during the panel discussion. Though research in dance and the arts is always also research in the means of presentation, it is not necessarily confined to the topic of presentation (nor performance, nor research) itself. Instead, it can deal with a wide range of topics relevant for society. Research-presentation-frames are by no means exclusively directed to explore themselves. To avoid this misunderstanding, the distinction between self-reflexive and self-thematic is crucial. And indeed, it often might be called a weakness of research oriented work in dance and the arts to be unclear about this distinction. Consequently, it seems to be important to show – by comparing examples – how research-presentation-frames in dance and the arts can be self-reflexive without being confined to be self-thematic.

Another task yet to be fulfilled is linked to the question of transparency. This in the end brings us back to where we started from, which is the relation between art and science and the dissolution of seemingly polar distinctions between them. Obviously, the obligation to be transparent regarding the procedures of knowledge production is closely linked to the tradition of scientific research. On the

contrary, the production of art has traditionally been associated with mystery, if not secrecy. Now, is transparency necessarily to be aimed at in research-oriented projects in dance and the arts? Or would it be promising to look closer at what scientists and scholars really do, when they produce so called transparency, and to question again, what role mystery and secrecy generally play in knowledge production in order to protect authorship?

Finally, many of the questions raised in the discussion in some way or another refer to the question of autonomy of science and of arts, which is a central feature of modern societies guaranteed in their constitutions. Nevertheless, in the current development towards a new multitude of knowledge production between arts and sciences it becomes evident that the autonomy of science and the autonomy of art, though related, are far from being the same. Instead, they seem to refer to quite different sets of rights and obligations. What does it mean to mix them? Is this mixture going to corrupt both of these autonomies? Or will both of these autonomies be severely challenged by the current development of western societies? Is the debate about artistic research in the end a debate about how to build new alliances to defend these autonomies? What is going to be left or renewed in terms of the autonomy of research in the society of knowledge?

A Few Remarks about Research in Dance and Performance or –
The Production of Problems

BOJANA CVEJIĆ

When a topic is claimed by artists, theorists, curators and cultural officials alike, the context and the purpose of discussion are more than ever determinative. In the recent discursive history of the term 'research in the arts,' three contextual registers are distinguishable.

The first register is associated with the so-called educational turn in the arts 2005-2007. It promoted art as research in exhibitions and new presentation formats under the assumption that it produces knowledge specifically different from academic scholarship, science and technology (Cvejić 2006). The claim that the arts have their own aesthetic ways, mediums and techniques of engendering thought, exploring the unknown and then making it known, was a political argument for curators and producers to defend the autonomy of non-mainstream, experimental art and legitimate its political role as a public good for the society. In the meantime, the arts are epistemologically upgraded through academic degrees, like the burgeoning artistic PhDs that also reveal new criteria for entry into the artworld/artmarket, the demand for the artist to qualify by academic credentials. The time sequence of changes thereon is cynical: no sooner than the artists are ennobled by having their work intellectually revalorized in the academic sphere, tuition fees rise, public sector for education suffers severe spending cuts and humanities and art departments at the universities are forced to shrink or close down under the aegis of 'austerity measures' (cf. Bailey/Freedman 2011; Lütticken 2011; Radical Philosophy Journal 2010).

The second register, in which 'research in the arts' has been debated, is the mode of production, associated with collaboration, residencies, and co-production schemes in Western Europe. At the time that the debate was instigated – around 2003 – this production mode was argued to be a form of 'immaterial labour' in Post-Fordist information society, or knowledge economy or, to use another term from the Post-Operaia discourse, "cognitive capitalism" (TkH/ Walking Theory 2010). There is some relevance to the remark that research reflects another economic, technological and political division of labour, no less material than it was in the Fordist times – in processes of production, dis-

tribution, circulation and consumption of performances which involve activities that do not only support or enable the 'product' of the performance, but now also substitute it. However, it is becoming increasingly difficult to uncritically praise the freedom of nomadic freelance work and lifestyles, the many 'becomings' in which artists are narcissistically consumed and disempowered to effectuate structural changes. The production of artistic research – in residencies, 'laboratories' and other temporary working situations – reads as the conjunction of information, social relations, and services in the presence, display, or the atmosphere of the artist at work and in networking. This situation did not contribute to a more rigorous epistemic culture of research. On the contrary, it served to relativize and compromise distinctive criteria of research as opposed to non-research based art. In the end, for an artist to deserve her title she can only always already claim that she is doing research, which not only inflates the term but, as I argued above, also makes work and life precarious.

That being said, why should research in the arts still merit affirmation? Don't we have enough reasons to be sceptical about the very mention of the word? Has 'research in the arts' not exhausted itself or overreached its negative implications in the ever reduced possibilities for production, playing into the hands of those who are now massively withdrawing public support for art, primarily targeting nonmainstream experimental practices? In my view, the current situation – in which research in the arts has been first inflated, in order to then be marginalized – shouldn't preclude the distinction between the art practices which have been labelled as 'research' from those that 'do not research.' The distinction should by all means be upheld under another conceptual framework of this practice that I propose here: the production of problems. I distinguish performances and processes of creation dedicated to problems that transform them and give rise to thought in the act of thinking from the art that perpetuates and accumulates value on the basis of received or verified craft through the spectatorial regime of recognition.

The production of a problem doesn't begin with possibilities. Possibilities are a matter of knowledge that we account for as the limits to be pushed. Stating a problem isn't about uncovering an already existing question or concern, something that was certain to emerge sooner or later. A problem isn't a rhetorical question that can't be answered. On the contrary, to raise a problem implies constructing terms in which it will be stated, and conditions it will be solved in. In his most rigorous ontological work, *Difference and Repetition* (1968), Deleuze defines problems as objects of Ideas. Deleuze's Ideas are problematic and differential: they engender thought in the form of problems and conceive or express the sensible by difference, rather than by identity. They are explicitly distinguished from rationalist conceptions of ideas, such as Spinoza's adequate ideas, as their function isn't to explicate a thing in its essence formulated in the question 'what is it?' but to generate variable multiplicities. Thus, the predication in the formula 'what is it?' gives way to a complex of questions – how, how many, in which case, and so on – that constitutes the object of Idea as a problem. This

makes Ideas inessential, as Deleuze writes: "In so far as they are the objects of Ideas, problems belong on the side of events, affections, or accidents rather than that of theorematic essences" (Deleuze 1968: 187).

Three defining characteristics of an Idea are comprehended by the following concise phrase: "An Idea is an n-dimensional, continuous, defined multiplicity" (Deleuze 1968: 182). First, multiplicity supposes an organization of differential elements as a heterogeneous mixture rather than unity. The elements are unidentifiable n-dimensional variables, because they have no prior sensible form, conceptual signification or function. Second, the elements being undetermined by and in themselves are then determined reciprocally by a set of relations between changes in them. Deleuze describes the reciprocal relations as non-localizable ideal connections between variable elements. In the third step, the set of such reciprocal relations must actualize itself in spatio-temporal relations, and the elements of that particular multiplicity must be incarnated in real terms and forms. An Idea thus involves a movement of genesis from the virtual to the actual, as Deleuze explains:

"It is sufficient to understand that the genesis takes place in time not between one actual term, however small, and another actual term, but between the virtual and its actualization – in other words, it goes from the structure to its incarnation, from the conditions of a problem to the cases of solution, from the differential elements and their ideal connections to actual terms and diverse real relations which constitute at each moment the actuality of time." (Deleuze 1968:183)

An Idea as a virtual differential structure is distinguished from an *actual*, incarnated and specified multiplicity as a problem is distinguished from its solutions. The virtual-actual pair replaces the possible-real because the relation between the possible and the real is one of resemblance. On the one hand, the possible pre-exists the real by negating its existence, or, on the other, the real becomes the possible by adding existence to it. The possible is then said to have been 'realized' in the real, which 'condemns' it to be "retroactively fabricated in the image of what resembles it" (Deleuze 1994: 212). The crucial distinction between the possible and the virtual for Deleuze is that the possible refers to the form of identity in a representational concept whereas the virtual designates a multiplicity that prioritizes difference over identity. Deleuze's Ideas aren't possible, awaiting their realization, but virtual, in the sense of being fully real. They are, on the one hand, immanent to the intensive processes of genesis, or in Deleuze's famous phrase borrowed from Proust, "real without being actual," and, on the other, transcendental to the actualized things, or "ideal without being abstract" (Deleuze 1994: 214). The actualization of a virtual Idea occurs by divergence and difference thus breaking with the representational logic of identity and resemblance that limits creation by a pre-existing possibility. The problem differentiates itself as the virtual content of the Idea. It is progressively determined in its conditions and terms, in a selection, distribution and evaluation of singulari-

ties, which specify a region of real relations and terms. The problem then is actualized or differenciated in solutions that don't reflect or resemble the problem which gave rise to them. I will explain what I mean by all this that appears rather abstract in the case of *Weak Dance Strong Questions*, a performance by Jonathan Burrows and Jan Ritsema from 2001.

Burrows and Ritsema state that the creation process of *Weak Dance Strong Questions* was sparked off by an Idea of a "movement neither from nor towards". T. S. Eliot's poem *Burnt Norton* from *Four Quartets* (Eliot 1968: 3) struck out as an event amongst several other poems they were reading, because it gave Burrows and Ritsema an Idea of a movement which seemed paradoxical or unthinkable from the viewpoint of their dance experience. In short, this Idea couldn't be represented in a movement they could imagine, or strive to find as if it were a possible way to 'dance' it. The Idea began to structure their creation in determining its object as a problem. The problem was posed in a series of questions, starting with "how to dance a question" (Burrows/Ritsema 2003) and ending with "how to move by questioning movement through movement itself" (Burrows/Ritsema 2003).

The problem of questioning movement by movement, or, as they referred to it, as "dancing in the state of questioning," (Burrows/Ritsema 2003) involved a set of differential elements and relations between these elements. First of all, it brought them to dance improvisation, a vast field of dance and performance today in which they progressively delineated their area of inquiry. Thus the problem required ungrounding improvisation by selecting from and eliminating a number of habits: gestures, formal-abstract movement, task-oriented movement, and personal dance style. These are differential elements of the Idea qua multiplicity, variables relating also to two different performers, their histories and all other factors that govern their disposition to move and improvise. The aforementioned elements virtually stand in reciprocally differential relations such as self-expression of the dancing subject, objectivation of self-referential movement, and communication with the audience, because they ideally connect through such regimes of dance improvisation. However, the determination of the problem – how to question movement through movement itself – is complete only when it is made actual in specific settings or arrangements of space, time and relation between the two bodies, as well as between the performers and the audience. The actual spatial, temporal and relational terms entail differenciating more concrete constraints that could then severely condition and engender real movement. Burrows and Ritsema refer to them as 'rules': not to negotiate with space, not to negotiate with time, but to relate to each other (as well as to all surrounding things and people) without physical or verbal contact, and to atomize or fragment movement by continuously questioning it. It is important to underline here that the rules are conditions or constraints that don't just exist in the heads of Burrows and Ritsema, but are objective, and as such produce certain compositions of the bodies and movement. In that way, they confirm one of the main aspects of Deleuze's definition of problem that we draw on here – they are part of the in-

vention of the problem, of its posing as 'positioning' in space. Or in Deleuze's own words:

"The positivity of problems is constituted by the fact of being "posited" (thereby being related to their conditions and fully determined). It is true that, from this point of view, problems give rise to propositions, which give effect to them in the form of answers or cases of solution. These propositions in turn represent affirmations, the objects of which are those differences which correspond to the relations and the singularities of the differential field." (Deleuze 1994: 266)

The invention of the problem by which an Idea operates entails experimentation, the probing of a path in which new compositions of movement and body are differenciated. It inserts time into the construction of the problem doubled by a sensorial and affective experience of the experiment parallel to the thought. This time could be regarded as a time of learning, which involves unlearning or undoing, ungrounding the knowledge of possibilities that reproduce rather than create new movements, bodies and their relations. Such learning implies violent training without a general method, but with a dedication to the problem that, as Deleuze describes, "demand[s] the very transformation of our body and our language" (Deleuze 1994: 192). The choreographer Xavier Le Roy explicitly refers to learning as the process of a removal of habit under the construction of constraints:

"I always worked with constructing constraints in order to produce 'new' movement or to transform the perception of the body in a situation. What can you do when you cannot do this or that, you have to look for another way, and you have to go around habits. In a way, it's making things difficult in order to explore ways outside the power of habits." (Cvejić 2009)[1]

The last important aspect about creating problems as objects of Ideas is comprised in the following: "[The problem] is solved once it is posited and determined, but still objectively persists in the solutions to which it gives rise and from which it differs in kind" (Deleuze 1994: 280). Thus "questioning movement through movement itself" (Burrows/Ritsema 2003) stopped acting as a problem once a style of personal mannerisms, consolidated and mechanically repeated 'solutions,' set in. The life of this improvisational performance ended when Burrows and Ritsema could no longer persist in their questions, in "dancing in the state of questioning" (Burrows/Ritsema 2003).

The production of problems I describe above refers to a making process, and if this is to be taken as 'research,' then every process of creation should be research per se. Its criteria are then conditions for the genesis of the new by difference and divergence, for which a problem has to be posed, positioned, invented

1 From an interview with Xavier Le Roy held on March 30, 2009.

and any presuppositions have to be swept away. There is nothing new about it, for instance, Beckett's Quad (1984) could qualify for such a creation, divergence from theatre based on text to a TV staging of a choreography, the problem of which was to exhaust all possible permutations of four figures moving in a closed space in such a way that they never collide or meet. What could be new here is to re-evaluate rigor by which we distinguish work arising from problems and also giving problems to the audience from the unproblematic work. Such work needs more public support than it is being given nowadays.

The only point to draw from the production of problems for our debate about research, is that art should be granted the conditions in which it can create by inventing problems, rather than having to comply with and to represent subsidy guidelines for research projects, received opinions, fashionable theoretical concepts. Who is going to struggle for these conditions, artists, curators, producers, independent theorists, or academics? Will it always be a matter of individuals tweaking the given limits? Or must we devise a political definition of the public good of art that poses problems without making it serve moral values?

Knowledge and Collective Praxis

VICTORIA PÉREZ ROYO

When talking about research and presentation, we are inevitably obliged to consider the relational and social aspect of research – the moment in which my personal quest does not only concern me, but also others. We are also bound to think about possible ways of organizing this moment of meeting and to weigh up the understanding of knowledge, research and research community we actualize.

In this text, I will proceed to observe and analyse some cases I consider interesting in this respect, four initiatives of collective research which have devised particular ways of articulating the relationship between presentation and research and which offer alternatives modes of thinking about knowledge, information, knowledge distribution, time and space for research. They propose an expanded notion of research, horizontal modes of collaboration with certain affinities to open source strategies and display strategies that cause a deterritorialization of the places of research and reciprocity in the distribution of knowledge. Let us observe them more in detail.

ARCHI-MOBILE – SHARED KNOWLEDGE

In the first place, I would like to reflect on Myriam Van Imschoot's and Kristien Van den Brande's project *Crash landing revisited (and more)* that started in 2007 and still takes place.

In the course of its development it ended being, as Myriam Van Imschoot puts it, a "collaborative platform for artistic research" (Imschoot 2009). The title of this project refers to its object of study: *Crash Landing*, a performance series of interdisciplinary improvisation curated by Meg Stuart, Christine De Smedt and David Hernandez between 1996 and 1999, which involved the participation of 80 artists from different fields.

The *archi-mobile,* the physical space in which this research project takes place, represented a peculiar kind of historical archive of *Crash Landing*: a nomadic archive, travelling from theatre venues (Kaaitheatre) to institutions (Jan Van Eick Academy) and festivals, an archive understood as a shared space, open to anyone interested in it, a space mixing the functions of archive, exhibition space, meeting point, space for screenings and research location. The documents

(temporary donations of any people involved in *Crash Landing*, such as video recordings, notebooks, scores or t-shirts plus documentation that was generated during the time that the *archi-mobile* was functioning, such as interviews with people involved in *Crash Landing*) were displayed on a table – and not stored, classified and put behind a glass cabinet. The main function of these documents in this context, as Myriam Van Imschoot explains (Imschoot 2010), was to trigger conversations among the people in the *archi-mobile*. In this sense, the work of the historian was shared with all visitors entering the space (professionals who had participated in *Crash Landing*, researchers interested in the event, passersby) in an informal attitude, probably very suitable to evoke remembrances of the studied events and to leave space for imagination to create hypothesis about them.

Crash Landing, the improvisational encounter and original object of study of this project, took place five times, the sixth one was planned, but for different reasons, never happened. As Myriam Van Imschoot noticed (ibid.), *Crash landing revisited (and more)* could be understood as the sixth encounter, the sixth meeting that never occurred, insofar as the original improvisational dance was continued in an *improvisational conversation* on and by means of these archival materials. In this sense, what was conceived of as a historical research project was deeply contaminated by artistic practice, transforming its methods and working procedures. Instead of following traditional academic procedures of historical research (such as gathering, analysing, classifying and storing documents, interpreting them, extracting information out of them and creating a consistent logic, if possible without fissures in which to insert them), they accepted to transform these procedures: the activities of interpreting materials, weighing up and deciding their value and meaning within a certain narrative were shared with the interested visitors people of the *archi-mobile*. The goal of these conversations was neither that much to acquire knowledge, nor about the interviewee just giving, passing or transmitting information, but rather about his or her being put in the position of the researcher. Going through the documents themselves, interpreting them together with the interviewer, the visitors of the *archi-mobile* were treated as collaborators. In this sense the *archi-mobile* created a situation in which to foster thinking together: "It was not about extracting situated knowledge, embodied knowledge in the interviewee's bodies, but about mobilizing it" (ibid.). A new type of archive was created – according to a particular epistemology, too – absolutely performative, deeply relational (in a strong sense of relationality). An archive that agrees to emotional dimensions of research inherent to every collaborative approach and that accepts and even fosters a contamination from artistic praxis to academic research.

I think that this performative and relational aspects signal a profound change in our society in respect to culture and knowledge which is fundamental in order to understand the current relationship between research and presentation. In our social historical context, there has been a shift from an understanding of culture as accumulation of information, related to the idea of knowledge transmission

(what we could call the paradigm of the museum) to an understanding of culture as a space for actively learning, incorporating culture – the paradigm of performance[1]. There is a powerful image envisaged by Benjamin in his essay *Eduard Fuchs: collector and historian* (1937: 36), in which he describes culture being a heavy load that humanity supports in its back. The solution to it, he suggests, would be to shake it off and take it in the own hands, that is, to manipulate it, to make it your own. Not to treat historical documents as monuments in the Foucaultian sense, but as materials to work with. In the *archi-mobile*, Myriam Van Imschoot and Kristien Van den Brande took the documents off the cabinet (or rather from the boxes in which they received them) and instead of putting them behind a showcase in order to preserve their identity, they chose to put them on a table where everybody could take them in their hands, manipulate them and engage with others in a collective creation of meaning. They displayed the documents on the table so that visitors could see them, but more importantly, touch them. Proposing work with historical materials in the sphere of tactility (manipulation, embodiment) rather than visuality (distance and identity) helps also to create ephemeral collectivities around a concrete problem, in this particular case, about the memories of *Crash Landing* in which it is possible to set imagination, speculation and dialogue in motion as sources of historical knowledge.

EVERYBODY'S TOOLBOX – PRACTICED KNOWLEDGE

The initiative *Everybody's Toolbox* is presented best using the description they offer at their website:

"Everybodys is a data base and a library, a toolbox and a game creator, a site for distribution and investigatory discussions. It is a platform for the development of tools and content. Everybodys is a collective effort to develop the discourses that exist within the performing arts and to create a platform where this information can be accessed by a wider audience than the practitioners it involves. Everybodys welcome" (What is Everybody's 2007)

This website constitutes a very stimulating proposal for opening research and fostering it. It offers a very interesting alternative to the traditional (and in some cases already commodified) showing of work in process. In order to briefly tackle the relevance of the process in the research-presentation divide, I would like to

1 This shift is specially visible in art education in the context of a great amount of MA programs: once the students have immediate access to any data through media such as internet, the idea of transmission of information is not interesting any more. Educational programs in art academies therefore scarcely operate on the basis of knowledge transmission; they rather focus on enabling the student to generate new productive discourses and to actively integrate in it their own research (cf. Pérez Royo 2010).

retake a question posed by an architect, Philippe Boudon, referring to the foundations of a theory of architecture: he proposed the reader to imagine what would happen if in a mathematic task, we would receive the solution only but not the key to it. This situation, which would be absolutely unfeasible in a scientific community, is common praxis in the performing arts. What the main part of the audience and the artistic community in general knows about a particular piece of research, very often only is the result, a particular articulation of the material in which methods, tools, procedures and strategies have disappeared or are only partially visible.

I am of the opinion that the recent commodification of the work in process should not lead to a complete refusal of this knowledge, but rather to a critical review of current procedures of facilitating an access to it. The process is the place par excellence in which it can be talked about the knowledge generated by dance praxis. It is the space for debate, critique and redefinition of problems in art. Whereas the piece is the place for aesthetic pleasure and other goals, the process is place where to expose, share, break down tools, methods and working procedures, premises of research.

The dispositives that *Everybody's Toolbox* presents to share and open processes of research again refers to this central question of the shift in contemporary culture from knowledge transmission to active knowledge production: They are displayed in the form of working tools with detailed instructions for usage arranged as playing rules and a short text explaining its objectives and history.

Let's briefly observe how they are formulated:

"10 statements: History and Objectives: The statements can be used to define a specific area of interest within performance, and to elaborate and develop thoughts on a certain topic. It relies on the form of manifesto where being precise to the point of excluding other possibilities is desirable. The statements do not need to have eternal value, but they should trigger you to think differently. The tool is about producing opinions and positions that can be productive within your work. The purpose of writing 10 statements is to clarify your own ideology and make it visible to others. It's also about daring to take a stand, exposing yourself to critique and put some fire in the debate. Description:

1. Choose a topic that you would like to work on, for instance 'statements on how to work,' 'statements on site-specific performance,' 'statements on spectatorship' or 'statements on what practice is.'

2. Think of the format of writing and decide whether or not you want to use a formula. For instance super short and precise, long and descriptive or starting each sentence the same way, x is.../x must.../x is considered...

3. Write the 10 statements on the topic. Try to be as specific as possible and write them in a manner that is coherent with its ideological content and don't be afraid of being categorical." (Ibid.)

There are many other tools for further purposes: The *self-interview* for example is being used by many artists and students in order to reflect about their work,

their artistic concerns and interests, to develop ideas and to question their strate-
gies. This exercise helps to clarify their position, their goals in their research
processes or to elucidate their impressions about the results of the work. The
'Impersonation game,' in its turn, can be a very efficient dispositive for collec-
tively expanding the notions of an artist's work, for gaining accurate information
about the reception it provokes, as well as for fuelling a debate between audience
members, to foster a public discussion about the work when replacing a colloquy
after the performance. All these three devices, as well as the others in *Every-
body's Toolbox*, are also very useful from the point of view of communication:
self-interviews that are stored on the web site as a result of using the tool, imper-
sonation games or its transcriptions, the manifestos generated by the ten state-
ments procedure are also illuminating for researchers who are seeking to gain an
access to research processes that may offer a different perspective about an art-
ist's work or for artists searching for strategies to advance their research.

The terms 'tool' or 'workshop kit' are essential in this understanding of
knowledge in terms of practice and to the aforementioned shift from knowledge
transmission to knowledge production. In the workshop kit of *Everybody's,* there
is no transmission in the traditional sense: information is not directly sent, but
first reformulated in the shape of a tool ready for immediate usage and appro-
priation, for adaptation and transformation (as it actually happens with utensils:
one uses them not only in the prescribed way, but according to the individual
purposes). On the other hand, the users are also invited to share their practices (in
the form of playing rules), the transformations that may have exercised using in
the suggested tools by using them or the new ones that they may have devised.
This fact points at a particular conception of knowledge distribution: following
the functioning principles of open source, there is no unidirectionality in the
transmission of knowledge in this website, but a multidirectionality. There is no
outer system of evaluation to decide who is entitled to share, create or legitimate
knowledge: the users will decide it.

EL PASO – PASSED KNOWLEDGE

El Club is a collective of ten people[2] (mainly artists from the performing arts, but
also an architect and a curator) situated in Madrid. The collective was established
three years ago for different reasons, among them: to break the isolation of artists
in their creation processes and to create a community of reflection and communi-
cation. After exploring many different formats, they created a tool, *El Paso*
(which in Spanish both means 'step' and the action of passing) as a way of think-
ing together about *El Club* as a collective, of getting to know better the work of

2 The members of El Club are: Amalia Fernández, Fernando Quesada, Laura Bañuelos,
 Tania Arias, Maral Kekejian, Cristina Blanco, Ismeni Espejel, Emilio Tomé, Bárbara
 Bañuelos and María Jerez.

the other members, as a means of mobilizing their individual practices or as a possible way of collaborating.

In a very brief text they explain how *El Paso* works:

"Get 10 people together. -Set a starting date. -Each person creates and launches a project in any kind of format and names it. -You transform the project that you have with you during a week. -Pass the project on to someone else in the group. -You receive another project. -You transform it during a week. -You pass it on. -This ends when you have passed through all the projects, when you have touched them all." (El Paso 2010)

Within *El Paso,* the spaces in which research takes place and is exposed are necessarily multiple: there are ten people who are working internationally and only rarely are able to meet in Madrid. This limitation actually led to an interesting multiplication of media for research and presentation. In one of the chains, *El abandono,* following media were used: a video piece; the creation of a group in facebook, in which some part of the performing arts community in Spain actively participated; an application for an artistic residency in Potsdam (supposedly written by the first artist in the chain, Tania Arias); a research blog about the process of this project (presumably by the same artist), live performance with her; an interview shown on a TV, cardboards, a live experience and a skype meeting of all members of *El Club.*

In this kind of proposals the spaces, activities and times which were traditionally dedicated to investigate are mixed, creating a continuum of research crossing different levels. This project makes clearly visible that nowadays the working and presentations spaces for the artists' works are simultaneously a group of spaces, not necessarily physical and not necessarily centralized or consistent in relation to each other. There, the artist investigates, works, experiences, celebrates, exchanges information as a part of a more complex system of knowledge production. All these contexts and levels (intimate, personal, virtual, public and so forth) are at the same time places for work presentation as well as for research and discussion about it. This kind of initiatives takes research into account not as something happening exclusively in the studio or in the library, but as a complex range of activities developed in many different contexts (media, everyday life, mass culture, etc.), all of them completely intertwined. These practices definitely deterritorialize traditional places for production and distribution of knowledge, considering every activity of the artist a possible platform for research and for presentation of research – the negative aspect of this continuum of course being represented by the precarization of life in postfordist capitalism. In this kind of projects, usual places for investigation and exposition of results, among others, are decentralized. This also implies, from an epistemological point of view, that there are no privileged areas of experience, that knowledge acquired under the lab lens or in the studio is not necessarily more reliable than knowledge gained through everyday experience. This research-continuum is implicitly based on the acceptance of a democracy of experiences as it is defined by

Hannula et al. (2005: 25 et seq.), as an epistemological and ontological point of departure for a mature scientific practice. It is a context in which there is no pre-defined hierarchy between different kinds of knowledge sources.

There is a second aspect I would like to underline referring to the mode of collaboration in *El Paso*. Research in this kind of proposals is done collectively, in a process of continuous exchange and interaction, dialogue and confrontation with others, which in this particular case, is based on the action of receiving, transforming and passing materials. The procedure of interaction in *El Paso* defines a way of collaboration, which could be approached with the help of the theory of the 'quasi-object' by Michel Serres (1982: 224-234). In order to explain his devised concept, the French thinker resorts, among other metaphors, to ball games in this frame: let us think about children playing with a ball in a park. A ball alone on the floor is just something insignificant, dumb, which only gains relevance as long as it is activated and mobilized by someone.

As an object, the ball depends on the actions of others to be of use.

However, a player that would retain the ball would be a bad one. Once the ball is in her hands, she has to decide to throw it in one or the other direction, to one or the other player. As far as the ball generates decision and action and brings the player into a situation of emergency, the ball is not only an object, but also also an agent, a subject or, as Michel Serres puts it, a *quasi-object*. More importantly, this *quasi-object* generates not only action, but also a particular way of relating to others that is not based on the previous creation of an individual or collective identity. Although there are certain basic – sometimes implicit – norms that are accepted in the situation of children playing in the park, the particular rules that emerge during the play are not commonly agreed upon before. Only in the moment of emergency when the player has the ball in her hands, she has to decide how to act. The individuals participating do not propose from scratch what they would like to do within this group; they do not decide who they are and what represents them before entering the play. Instead their identity and actions are decided in the very process of relating to the others through the ball.

In a similar way, the artists involved in each chain of El Paso do not participate with an idea they would like to put forward: they receive materials and have to find a position in respect to them: to deviate them, to transform and adapt them to their poetics, to reject them or turn them upside down. In this way, the quasi-object of El paso proposes is a very effective way of generating intersubjectivity. Every step, every transformation is of course determined by individuality, but the relevant point is that it is not considered as pre-existent, but as conformed and shaped by the game: this quasi-object is nothing but a way of circulation of knowledge and experience. It represents a modality of participation which has nothing to do with sharing – "when it is thought of as a divis ion of parts" (Serres 1982: 228) as Serres puts it. Moreover, it is related to an act of meeting and relation by which entities which were previously undefined are now defined and take shape, function and substance in the relation they build. The artistic individuality, in the case of El Paso is not suppressed, is not divided, but circulates

with, in and through the quasi-object. El Paso takes research into account not just as an activity developed in an individual way, but collectively. Research is not based on a genuine and original invention, but on being part of a net of knowledge production and communication, of research and dissemination, a node in a bigger net of relations in which work is presented, transformed, passed, re-elaborated, passed again and so forth.

TO BE CONTINUED – TRANSLATED KNOWLEDGE

Another case I would like to tackle is the experimental edition process initiated by Cuqui Jerez and myself in *To be continued. 10 textos en cadena y unas páginas en blanco* (*To be continued. 10 texts in a row and some blank pages*), number 14 of *Cairon. Journal of Dance Studies* in 2011. I think that this project, though following a very similar procedure to that of *El Paso*, can offer an alternative perspective from which to rethink the question of research and presentation.

This book was not based on a particular subject, but rather on a system, the working procedure of a chain – this time fixed beforehand – that has been explained with El Paso: a project travelling from one participant to the next one and in so far being transformed. Artists as well as theoreticians were invited to participate with the aim of fostering a different relationship between presentation and research: one not being based on the theoretical study of an object (dance), but also in which theoretical writing can also act as potential material for further practical research by the following artists in the chain, so that dance theory has not the final say about dance practice. The other main aim related to this decision of organizing the book based on a structure (dramaturgy of the book) rather than on a particular subject, was to make visible processes of intertextuality, of appropriation and incorporation of previous materials and, above all, the very process of collectively making a book. The book and the editing process are themselves at the same time object of study and medium of a collective process of practical research. In this respect, presentation is not something separated from research, but its very object.

In this sense, Barthes' concept of *lecture vivant* (1982) was fundamental: it refers to another way of thinking about creative reception, or in other words: that knowledge is not received but produced. In his *Theory of the text* (Barthes 1982: 31-47), he explains that the action of reading always implies the correlative act of writing a virtual text – or that reading always means writing. He articulates this idea in terms of productivity and product:

"The text is a productivity. This does not mean that it is the product of a labour (such as could be required by a technique of narration and the mastery of style), but the very theatre of a production where the producer and reader of the text meet: the text 'works' at

each moment from whatever side one takes it. Even when written (fixed), it does not stop working, maintaining a process of production." (Ibid.: 36, 37)

In the case of *To be continued,* we were interested in materializing this process of writing inherent in reading. We created a dispositive to think together about the book, not as a product of a previous research, but as a living conversation between previous texts and their transformations that would 'freeze' in the form of a book. In the course of the project, we found that the concept of translation as it was defined and practiced by the Spanish poet Leopoldo María Panero would still be more suitable than *lecture vivant* to grasp its functioning. Apart from his poetic and narrative production, Panero also worked in the field of translation, though in a very peculiar way: in a first take, he understood this activity as an extension of the translated text: "Translation has to develop – or improve the original, and not just move it, as any piece of furniture, from one room to another" (Panero quoted in Blesa 2011: 7). In this development, he aimed at revealing latent senses of the first text that would manifest in its translation. Panero, in a later period of his work, radicalized his understanding of translation, going beyond extension and arriving to 'perversion' (a play on words with 'version' and 'per-version'). Thanks to infidelity, to a perversion of the original text, the translator is actually able to be loyal to it: "Perversion is the only literal, faithful translation, and this thanks to adultery, to infidelity" (ibid.: 30). Panero conceives translating not a servile task, but as a true literary and creative operation that works through the affirmation of the difference that the translator disdains the question of preserving a supposed identity of the work: if translation is always based on reading, which is by necessity personal, subjective and different to the original, (on a *lecture vivant*) the focus is now set on explicitly fostering this difference and working creatively with it.

These two practices – *To be continued* and *El Paso* – are closely related to other concepts such as *détournement* by the *International Situationists,* insofar as all these operations are based on using what already exists instead of creating new cultural products. However, there is a fundamental difference between them: whereas in *détournement* one of the main goals of the misinterpretation of previous cultural goods was to denounce subjacent ideologies, artists nowadays use this practice not as a cultural subversion, but as a method of research, as a productive tool allowing them to redefine working procedures in collaboration that are not based on a common agreement, but on differences that are able to generate productive confrontation and dialogue. *El Paso* and *To be continued* offer a very clear image of research which, again, refers to an encounter in which practices are mobilized, experiences activated, in which the moment of communication represents a fundamental stage of development of the research processes.

LAST NOTES

The four above described research projects display very different conceptions of communicability of art as research: Myriam Van Imschoot and Kristien Van den Brande offering the visitors and interviewees of the *archi-mobile* to share their research activities by exchanging roles; *Everybody's Toolbox* displaying their practices directly in the form of tools that everybody can use; the artists participating in *El Paso* through a multiplication of spaces for research and its communication by way of a very particular way of interacting and sharing subjectivities; and *To be continued* by exposing the very process of communal creation of a book and transforming it in its implicit object of study.

Art processes are evidently not unique experiences preventing debate, but the very space in which discussion, collaboration and controversy are fundamental working tools. This four initiatives display some possible ways of opening and communicating research processes, of avoiding introversion and hermetecism, great dangers of artistic practice. This openness to critique could constitute a basis to validate research processes, to get rid of traditional parameters of assessment and understand them in different ways: as a possibility of exchanging positions, of making visible the decisions, choices and doubts along the process, just to mention two of the models that have been commented in this text. However, the mere fact of opening processes does not guarantee a critical openness: this action is always subject to the risk of being commodified, unquestionably accepted, transformed into a void format and therefore escaping a real critical exposure. This is a constant challenge of artistic practice which in the aforementioned projects led to a creative approach in the activity of finding adequate media as formats to open, expose and display the different states of development of working processes within an artistic research community.

These projects reinvented their own working conditions in order to create the spaces they needed, without following institutional or academic dictates and insofar creating new ways of researching and of conceiving research in the performing arts. The initiatives also show that, though the debate on research in the arts has a clear academic dimension, which is to a great extent determined by the Bologna reform and the debate of the doctorate in the arts, there is no doubt that artists in the field of performing arts felt a necessity of creating and devising their own contexts for research, creation and self-education. In this text, only four of them were mentioned, but nowadays there is a real proliferation of initiatives of self-education, collective learning and research which show a collective effort to reach a dynamic situation between research projects, individual production and their respective contexts. This activity of reinventing protocols of communication is not irrelevant in this discussion: whereas in other areas procedures of dissemination are more established and therefore more or less given for granted, one of the main concerns of research in the arts is precisely to explore suitable ways of relating with its peers and audience in general. Each research process in the arts not only deals with a concrete object of study, but also with the rela-

tion between process, visible result, recipient of the work and relations of production; with the task of to setting out the conditions for reception.

The common idea uniting all the commented projects is that knowledge is not transmitted following this outdated diagram of sender-message-recipient. Knowledge is produced in the relation between the two polar positions: there is no hierarchy defining who knows and who not, because all might contribute to the knowledge experience. Knowledge in this sense is neither a service nor a product, but happens through a collective practice in which the participants actively engage. Collective research is conceived as a mobilization of thought and praxis. And it is carried out by the very activity of making it public. The commented initiatives propose horizontal ways of co-working in which all participants are responsible for the collective creation of meaning. Furthermore, this organisation precisely defines to a great extent meaning, form and substance of the project. Often there is not a goal to reach, set out before the project starts, there is not a meaning defined in advanced to recover in the course of the process, but the identity and sense of the project arise from the very ways of organizing the working procedures and the forms of collaboration.

It does not matter or
The Artist Out (of the Picture)

JAN RITSEMA

Most art is about the 'me.'
I mean it is a representation of the artist in one way or the other.
As art is what the artist does.

A young group of philosophers, called the speculative realists, try to think the human out of the center of all-there-is; try to think a world without science, without laws, but with consciousness. Some of them try to think the artist out of the center of the artwork (whether this is a play, a painting, a piano composition, a publication, a pideo or a pance.) To think the artist no longer as (s)he who is the source and surface of its art.

The question is how to undo us from the artist as the center of the artwork. To think the artist as part of the contingent.

We are connected and make connections, connected in both directions, from you and towards you. This mere connection equals creation. One cannot not be connected without elaborating or travelling or meandering on the connections, the same as one cannot not do. It moves, combines, transforms, etc. all there is: it moves and all at the same time, not one connection after one and another, but a myriad of connections which are not only connected to you but also to each other and in a very dynamic mode. A lot is going on, whether you like it or not.

Just like one cannot not do. It goes. Constantly. Like a wood that grows. Do you know these photos or videos of neurons in the brain, where everything seems to be connected to everything and pulses move nervously around? The same activity and activeness is going on now, here, while you are reading this, between all there is.

Let's imagine that it would be possible just to be here, without identifying where you are, why you are here, and what you are expecting from it. To be here in some speculative mode; the mode of 'we will see' instead of in a specific mode. Imagine that you are not locked in, not by yourself, not by others, imagine that you are not you. You are spirit, like everything around you. Or better call it connectivity. We are connectivity. Connectivity without connections. Maybe

connectivity is not the right word. It is connectivity without connections, let's call this *connectiveness*.

Let's imagine that there are no laws, only contingency, what does contingency mean? That what happened could also not have happened or something else could have happened or it could have been something different. So there is only pure speculation. Speculation might not be the right word. As there is no screen, no background, no situation to speculate in or against. One cannot speculate with 'whatever,' as there is not such a thing as 'whatever.' 'Whatever,' does not represent to make a choice between all there is, but it represents exactly contingency. It represents also what is not there; and not yet there or what is there but could have been different. This is speculation without speculativity. Or call it pure speculation or arbitrary speculation or absolute speculation. May be better is to speak of *speculativeness*.

Let's imagine that in our world there is consciousness, but no science, no laws.

It is our world, but you do not recognize it. You do not identify things.

You *do*, because you cannot not do. And most probably what you do is driven by what you like to do, what you are passioned for, or maybe you are passioned to not do, that exists, yes, but then you are busy with not-doing.

It is not even a question of doing or not-doing. There is no choice: you cannot not do. You do, and this doing lasts. This does not mean that we need to speak of something like a future. There is not such a thing as future; there is the doing, whatever it is. There is the doing that does. Doing maybe is not the right word as doing presupposes a purpose. It would be better to speak from doingness. There is doingness. There is pure or arbitrary or absolute *doingness*.

It goes whether you want it or not. But that is not the same as to say that you are driven by this. It goes. There is goingness. Better to say *on-goingness*.

May be it is better to say: the doing does. Yes. Everywhere, without distinction: the doing does. Whether you like it or not. The doing does you. One can say: I am done. Ha, ha, look, I am done.

And what the doing does is defined by all there is. All there is can only do what all can do. There is no choice. There is only the necessity of what the doing does, what the doing will do is what only the doing can do. This goes beyond our will. If such a thing as 'will' would exist. Of course not: where would it be situated? Like the soul – everywhere and nowhere? The world is not will and imagination. The world is all there is: connectiveness, speculativeness, doingness and on-goingness.

The world goes. Period. And you go with it. Consciously.

Imagine that you go with it only consciously not scientifically, without identifying things, just noticing them, without also qualifying them, let alone predicting them. Imagine you take things as givens-without-giveness. Just like in fact you yourself are, and more or less like all-there-is is: *givens-without giveness*.

To imagine a world without science, without laws, we not only undo us from ourselves, from our own giveness, but we also undo everything-there-is from its

giveness. Can we try this; can we try to free us from some of the chains we attached ourselves to? Especially the chain you yourself attached you to.

You are not. This does not mean that you are something else, no,no,no, you are not.

It is very difficult to imagine for a human specimen, this 'I am not.' As a human is a specimen that appears all the time to itself. When I ask a tree, or a wood to not to be there, they have no difficulty to imagine this, they simple accept to be there and not to be there at the same time. They don't give a shit about themselves.

We scaffold our thinking on the notions of time and space and this makes it extremely difficult to imagine we are not; as we projected ourselves very clear, in many representations on this grid of time and space. On which we represent ourselves all the time *outside* ourselves. Like animals that see themselves reflected (in a mirroring surface) think that there is something else, we do the same. We constantly confirm our presence to us; we walk hand in hand: me and myself (often as enemies, but that is another story). There is me and there is the world in the mirror, as an outside, but we know better than the cat that looks at herself in the reflection, that the world and us, like the cat and the mirrored cat, are the same. We know this, but we don't realize it. We realize (literally) a split, a separation.

When states of things, things so to speak, are no longer there, then they are neither somewhere nor at a certain time. The concept of time and space, these two grids of coordination, are there to isolate. Isolation is nothing else than what the prison does. It limits, it undoes the thing from its connectiveness, in order to better control it, the lame duck. The lame duck, what of course is no longer the state of things that do and are done. It is undone from its doing. It is deglorified, has no wings anymore. Its connectiveness, speculativeness, doingness and ongoingness are reduced, chained, limited. And us, we made ourselves the guards of these heavily reduced things, while we could have enjoyed all-there-is.

Quantum theorists say that there is nothing that is identical to itself in time. The world reinvents itself continuously, or can I say: recreates itself continuously and unstoppable in its (on)goingness. Quantum theorists say there is not such a thing as matter, there is only spirit. It does look like matter but it is not. It looks like you, but it is not, you and your neighbor are spirit are pure connectiveness and speculativeness, doingness and ongoingness.

So, let's imagine that there is only all-there-is, and this all there is, is all there is, is all there could be, is all that is not yet there, is all that is not there, is all that could have been there, is all that could have been there differently.

"Contingency implies a particular relation to thought: contingency, real contingency, is that which thinking can grasp only *as event*, not as proceeding from a rational necessity – as having been in some sense, 'already written' and thus in principle, if not in actuality, 'predictable.' This is in direct violation of all dogmatic systems of metaphysics, philoso-

phies that attempt to bind in principle every event, past and future, within an account of *what must be*." (Mackay 2011: 1)

We cannot provide an ultimate ground for the existence of any being. There is no ultimate cause, nor ultimate law that includes the ground for the existence of any being. We cannot find an ultimate ground for the world being there, because: who or what invented the world and so on and so forth.

Can we try not to be a thought *of* the reality we are caught in, but rather a thought *according to* the reality we are caught in, a type of experience of the reality you are in the middle of, which escapes from self-positioning? Not a circle of thought that tries to unify, but the experience of a One that remains a One, a One that does not entail a unity in any sense, but a One that is indifferent to any characterization of unity and multiplicity. The "Real qua One" (Laruelle quoted in Srnicek 2011: 167) that the French philosopher François Laruelle described as the always-already-given-without-giveness. A given without a name. Me without naming me; or the table without naming it. What is meant here is the indifference to a reciprocal relation, the indifference towards determination, towards prediction or definition. Indifferent to the representative reciprocity but not external to it. The table, like me, is here, but not as table, not a self-positioning, but as part of all there is, as part of all that is in the middle of all-there-is. I do not know if indifference is the right word. As it presupposes some kind of separation, a between something like my world and another world to which I can be indifferent to. So, if I want it all-inclusive, I should not allow myself a distinctive thought or action. So no indifference, but to take the world as something that happens to itself every moment anew, not just by chance in the sense of 'anything goes,' but as all-there-is-already-always busy doing and ongoing in connectiveness and speculativeness.

"If we consider art as a material-driven process of production, these anonymous materials [whether we talk play, paint, piano, publication, pideo or pance, JR] enjoy an autonomy of their own; and such autonomy continuously interferes with the artwork itself regardless of the decisions of the artist – that is, whether or not the artist determines to be 'open' to their influence." (Negarestani, 2011: 11)

When the artist is open to the materials, they are still dependent of his or her capacity in how far (s)he can or wants to be open. That keeps the artist being the boss, the master of the artwork. "We cannot simply be 'open to contingency,' because our openness and consequently our modes of interaction are determined by our capacities. We can only be open within certain specific limits that we can afford." (Negarestani 2011: 13)

We can only try to exclude us from ourselves and become part, active part of all-there-is.

It is not about a way to dissolve in this all-there-is, or to merge or to submit to all this. It is not about to give up specificity, to undo yourself from yourself.

Neither it is about some complexity or about being small and modest. Where about is it then: It is about that all these concerns the artist could occupy himself with, they do not matter.

'It does not matter.' That does not mean that nothing matters, that everything does not matter. It is neither a question of chance or of 'anything goes.' On the contrary, it is all that matters and all matters very precisely, here and at this moment. At the same time it does not matter at all, neither time nor space. It does not matter that it is you. What matters is the connectiveness, the speculativeness. And what matters is that it could matter and not matter at all. And what matters is this ongoing of goingness and doingness of givens-without giveness.

What does this mean? Or better, out of what matter consists this 'it does not matter'?

What does it really mean: it does not matter.

It means that it does not matter: what happens could also not have happened or could have been different. Not in the vulgar sense of being indifferent to what happens or what does not happen and could have happened differently. Things do matter and do not, but not in the sense of being laconic or even nihilistic, or in the sense that you are untouchable. No you are not. Things matter, you are being touched, but at the same time things do not touch you.

We can only matter about something that has substance, something that is still there, identical to itself after we looked a split second away from it, but this thing does not exist. So there is nothing to matter about, as there is no matter.

Artistic Research between Dance and Theory – A Response in Six Questions

RESPONSE BY ANNEMARIE MATZKE

Chairs are put out near all four walls of the conference room. All participants of the panel, audience and panel members are sitting together in a large square. In front of them, there is a large empty space. On the floor, term pairs have been noted down. These refer to the questions which were put forth during the preparation of the conference. The moderators of the panel, Kerstin Evert and Sibylle Peters, are moving around on skateboards in the empty field, asking questions, giving the floor to the panel members as well as to the audience and noting down the terms used in the discussion.[1]

This was the spatial situation of the *Artistic Research* panel. The panel presents itself as a form of research in movement and takes the object of investigation literally. The work on theorisation is not only being presented but also staged in form of dialogue, for which the empty space is marked. This empty space was filled literally with terms and questions about art being a form of knowledge production, the position of the artist as a singular author, the relationship of process and presentation and the role of audience in artistic research. And in the end, I would like to yet add another aspect, which was only discussed in passing: the relationship between dance and the development of concepts of artistic research.

Speaking and writing about artistic research creates certain problems. Should the form of writing not be commensurate with the question itself? Does artistic research not distinguish itself through the fact that it exposes the problems of research and methods, scientific speech and scientific writing? Does the process and presentation not productively interrelate in the field of artistic research?

Therefore, as a respondent, I would like to understand my task such that I would have to read the statements and concepts of the panel participants to identify the questions that they might raise for me. In this text, self-contained argumentation is used and the debate is continued. My writing is oriented towards the concept of artistic research for which Bojana Cvejić has given an indication in her contribution: "Performances and processes of creation dedicated to problems

1 See also the description of the panel in Evert/Peters in this volume.

that transform them and give rise to thought in the act of thinking" (Cvejic in this volume: 46). Below, questions will be put forth and then explained from my perspective.

WHO IS TALKING ABOUT ARTISTIC RESEARCH?

Within the panel, discomfort was also expressed with respect to the current debate, with all interest and enthusiasm for concepts of artistic research. Both can be noticed in the contributions of the panel members in this volume as well. Two different positions can be distinguished: The first one questions and argues from the perspective of science. Here, proximity to art and science is a challenge of established positions and methods of scientific research. At the same time, it has critically been pointed out that the talk of artistic research is in itself a part of institutionalisation of changed study course programs in universities. It must be read in context of the so called 'educational turn.' It revolves less around art practice than around questions about art education and the related changes. The other perspective argues from the viewpoint of arts. Here, certain artistic forms have to be differentiated from others. The talk of research only appears to be an option here. Bojana Cvejić differentiates 'problematic art' from 'unproblematic art' (Cvejić in this volume), that means to differ art forms that produce problems from unproblematic art forms. The latter are based on traditional techniques and institutionalised rules and therefore do not rise questions for the spectators. Both positions are part of a discourse which tries to legitimate different modes of research as well as artistic practice. Both positions are part of an art legitimisation discourse. They raise questions of transparency, power and politics without trying to give a final answer.

However, it has to be noted that the artists rarely catch the speaker's eye in this discourse. Exceptions are artists who define themselves in the field of science as well as art. Their forms of expression are different. If one works with framing of science in artistic forms such as in lecture performances, then these not only aim to address institutional rules but also to circumvent an unambiguous mode of perception in the overlapping of frameworks of art, performance and science. At the end, it is also an ironic gesture: scientificity is cited, examined and asserted without being seriously meant in the sense of science. Art has become a problem for science.[2]

2 An example for this kind of lecture performance is the project Veronika Blumstein. Cf. Evert/Peters in this volume.

HOW DOES ART PRODUCE KNOWLEDGE? AND WHAT KIND OF KNOWLEDGE IS GENERATED THROUGH ART?

The basis of the debate is the definition of artistic research as a source of knowledge generation proposed by Kerstin Evert and Sibylle Peters. Artistic practice initiates processes that produce knowledge which is different from purely cognitive knowledge in the sense that it always refers to spatial, habitual or physical dimensions of knowledge as well. The talk of knowledge production in art is productive when a knowledge term is opened that distinguishes itself from that of science.

However, several panel members expressed their doubt about the definition of arts as knowledge production. They claimed that with this, arts become a part of the logic of exploitation in the context of cognitive capitalism, which defines knowledge as an exploitable commodity. One is warned against opening a discourse of legitimacy with reference to the production of knowledge. The autonomy of art is naturally questioned with this: in order to become socially recognised, it has to come up with something other than art, namely knowledge. The kind of knowledge that is brought forth through the art and the historical and political relations associated with this knowledge are not asked too often.

First of all, the question of knowledge generation is serious for the academic field, sciences and university teaching. Secondly, the debate around artistic research hence reflects a crisis of sciences too which puts its own knowledge term in doubt. There is demand for other methods of generating knowledge and other formats of presenting it. To sum up, there is a paradox: While academic discourse in confrontation with artistic practice anticipates other perspectives – the indiscipline associated with art –, work is currently going on in academic discourse on disciplining various artistic practices under the label of artistic research. How can art assert its autonomous status and still carry along with the debate? Or in the terms of Kerstin Evert and Sibylle Peters: "Is the debate about artistic research in the end a debate about how to build new alliances to defend these autonomies?" (Evert/Peters in this volume: 43) Are some forms of artistic research eliminating the artist as "source and surface of its art" (Ritsema in this volume: 63)? All the projects described in the contributions focus on eliminating the status of individual authorship in arts. Be it in the establishment of temporary collective networks (*Everybody's Toolbox, El Paso, Kinder testen Schule, Veronika Blumstein*), in the production of a collective archive (*Archi-Mobile*) or even in forms of re-enactment of choreographers (*Urheben Aufheben, A Mary Wigman Dance Evening*). With focus on the openness of the process, raising up of problems and asking of questions, the concept of the artist's subject is changing.

However, scientific writing in humanities is characterised through a strong concept of authorship. It is only the singular author who presents the text in form of a presentation even when he unfolds his references in his quotes. In the projects discussed, this position will again become thematic. The view is first of all

being focused on new concepts of thinking, on the forms of staging science as well as on the questions put forth in the presentation. Artistic research raises the problem of new forms of "connectiveness" (Ritsema in this volume: 64) with open new perspectives for arts and sciences to go beyond the concept of a singular creator-subject.

WHICH POSITION DID THE AUDIENCE ADOPT WITH REGARD TO ARTISTIC RESEARCH?

Basis of the debate was the question of differentiating between process and presentation. While artistic process is considered to be a form of research, presentation appears to portray the outcome of the process as the product. However, performing arts puts this partitioning in question: Is its production also linked with forms of presentation? When the question of presentation does not relate to differentiating the roles of actor/artist and audience in dance and other performing arts but rather every artistic production contains always moments of presentation, the door to other perspectives is opened. The process is then no longer separable from the presentation but rather consists of a certain sequence of presentations and observations and a series of performance situations. The task of the debate is to understand these performance situations more precisely in their relationship to the act of observation.

However, the position of the audience can also be described as ironic. Audience of first order can indeed be differentiated from audience of second order. There is an audience position which is inherent to the process without being tied to any individual person. The other audience position is characterised through a public sphere. It is the audience as a public that is invited to a presentation. And here, the question arises how the audience reads the presentation. In this regard, the performance may be considered as an experimental setup which puts the audience in two roles: the one of the researcher in terms of looking for new questions and the role of guinea pigs in an experiment. At the same time, the convention of theatrical practice enables it to acquire the role of theatre audience. These dimensions overlap, get shifted around depending on the framework and point towards questions of the conditions of production, position of the observer, knowledge generation and representation, and authorisation of the process. At the end of the day, the audience remains to be the unknown feature in the experimental setup.

WHICH POSITION DOES ARTISTIC RESEARCH ADOPT IN THE RELATIONSHIP BETWEEN DANCE AND THEORY?

It is quite peculiar that in the contributions of the panel participants, no explicit reference is made to any specific research approach to the relationship of dance and theory. It is also noteworthy that a large number of the projects discussed relate to the field of dance. Apparently, demarcating dance from other disciplines is not a topic of the debate. Instead, a new art term is introduced with respect to the described example which is characterised by the variety of artistic practices: between producing and procuring, between presentation and discourse.

However, if one takes a look at the examples described above, one can notice that they are characterised by interaction with re-enactment and notation, with methods of movement research and with archiving. There is a close link to the questions of the academic discipline dance studies. This could clearly be noticed in the spatial situation of the panel as well. Dance as movement and choreography – in sense of writing in space – was related to a concept of the theory as model of thought, which found spatial translation here.

Here, a new perspective may be opened to the question of artistic research as a form of knowledge generation. The concept of thought has taken place of the talk of knowledge which currently requires disciplining that corresponds to the academic discourse. This is suggested by the art critic and curator Simon Sheikh in his views about changes in art education (Sheikh 2009). Sheikh criticises the concept of knowledge. An emancipatory dimension always belongs to the concept of thought which is quite important. However, all forms of knowledge stand in a tradition that always implies placing and hence exclusion of other possibilities to act and think.

Here, thoughts about the question of the relationship between dance and theory come somewhat closer once again. Dance as a performing art and theory are in some way related. Theory can be the visualisation of the thought process. Thinking is not a static process but rather something which remains in a moving state. In this sense, artistic research can be considered as a model of interacting with the thinking process and presentation: The thought is re-attached to body. The stage in forms of artistic research creates in the displacement of traditional functions and positions a new space: "a place of thinking" (Sheikh 2009). And in these places of thinking, knowledge is always generated as well.

References

Bailey, Michael/Freedman, Des (eds.) (2011): *The Assault on Universities: A Manifesto for Resistance*, London: Pluto Press.

Barthes, Roland (1982): "Theory of the Text." In: Robert Young (ed.) *Untying the Text: A Post-Structuralist Reader*, London and Boston: Routledge & Kegan Paul, pp. 31-48.

Benjamin, Walter (1937): "Eduard Fuchs, der Sammler und der Historiker." In: Max Horkheimer (ed.), Zeitschrift für Sozialforschung, Jg. 6, München: Deutscher Taschenbuch Verlag, pp. 346-381. (In English: "Edward Fuchs: Historian and Collector," New German Critique, No. 5, Spring 1975, pp. 27-58.)

Bippus, Elke (ed.) (2009): *Kunst des Forschens. Praxis eines ästhetischen Denkens*, Zürich and Berlin: Diaphanes.

Blesa, Túa (ed.) (2011): *Traducciones/Perversiones*, Madrid: Visor.

Boutang, Yann Moulier (2007): *Le Capitalisme Cognitif. La Nouvelle Grande Transformation*, Paris: John Wiley & Sons.

Burrows, Jonathan/Ritsema, Jan (2003): "Weak Dance Strong Questions." In: Performance Research, Volume 8, Nr. 2, July, 2008 (http://www.jonathanburrows.info/downloads/W-DSQ.pdf).

Busch, Kathrin (2009): "Wissenskünste. Künstlerisches Forschen und ästhetisches Denken." In: Elke Bippus (ed.), *Kunst der Forschens*, Zürich and Berlin: Diaphanes, pp. 141-158.

Certeau, Michel de (1998): *The Practice of Everyday Life*, Minneapolis: University of Minnesota Press.

Cvejić, Bojana (2006): "Learning by making and making by learning how to learn." In: Angelika Nollert/Irit Rogoff/Bart De Baere/Yilmaz Dziewior/Charles Esche/Kerstin Niemann/Dieter Roelstraete (eds.), *Academy*, Frankfurt: Revolver Verlag, pp. 193-197.

—————— (2009): Interview with Xavier Le Roy, unpublished.

Deleuze, Gilles (1968): *Difference and Repetition*, London and New York: Continuum.

—————— /Guattari, Felix (1994): *Anti-Oedipus: Capitalism and Schizophrenia*, Minneapolis: Unversity of Minnesota.

El Club (2010): "El Paso," July 7, 2012 (http://inpresentableblog.com/content/el-paso.html)

Eliot, T. S. (1968): *Four Quartets*, San Diego and New York: Harcourt Inc.

Fischer-Lichte, Erika (2004): *Die Ästhetik des Performativen*, Frankfurt am Main: Suhrkamp.

Fundus Theater: "Kinder testen Schule," 2008 bis 2010 (http://www.fundus-theater.de/forschungstheater/projekte/kinder-testen-schule/).

Galison, Peter (1997): *Image and Logic: A Material Culture of Microphysics*, Chicago: University of Chicago Press.

Hannula, Mika/Suoranta, Juha/Vadén, Tere (2005): *Artistic Research – Theories, Methods and Practices*, Gothenburg: Academy of Fine Arts and University of Gothenburg.

Imschoot, Myriam Van (2010): "Talk on October 1," at Azala-centro de creación (Vitoria, Spain) (not published).

Latour, Bruno (1987): *Science in Action: How to Follow Scientists and Engineers through Society*, Cambridge: Harvard University Press.

Lütticken, Sven (2011): "A Heteronomous Hobby: Report from the Netherlands." In: e-flux journal, April 2012 (http://www.e-flux.com/journal/a-heteronomous-hobby-re-port-from-the-netherlands/).

Mackay, Robin (2011): "Introduction: three Figures of Contingency." In: Robin Mackay (eds), *The Medium of Contingency*, Falmouth: Urbanomic, pp.1-9.

Negarestani, Reza (2011): "Contingency and Complicity." In: Robin Mackay (eds), *The Medium of Contingency*, Falmouth (UK): Urbanomic, pp. 10-16.

Pérez Royo, Victoria (2010). "The researcher-creator profile in postgraduate performing arts studies." In: Victoria Pérez Royo/José A. Sánchez (eds.), *Practice and Research*, Madrid: Ediciones de la Universidad de Alcalá, pp. 125-151.

——— /Jerez, Cuqui (2011): *To be continued. 10 textos en cadena y unas páginas en blanco*, Madrid: Ediciones de la Universidad de Alcalá.

Peters, Sibylle (2011): *Der Vortrag als Performance*, Bielefeld: transcript.

Radical Philosophy Journal (2010): "Universities," Vol. 162 (Jul/Aug).

Schaffer, Simon/Shapin, Steven (1985): *Leviathan and the Air Pump. Hobbes, Boyle and the Experimental Life*, Princeton: Princeton University Press.

Serres, Michel (1982): *The Parasite*, London and Baltimore: Johns Hopkins University Press.

Sheikh, Simon (2009): "Objects of Study or Commodification of Knowledge? Remarks an Artistic Research." In: Art & Research, Vol. 2, Spring (http://www.artandresearch.org.uk/v2n2/sheikh.html).

Srnicek, Nick (2011): "Capitalism and the Non-Philosophical Subject." In: Id./Levi Bryant/Graham Harman (eds.), *The Speculative Turn: continental materialism and realism*, Melbourne: Re Press, pp. 164-181.

TkH/Walking (2010): "Exhausting Immaterial Labor in Performance," ("Epuiser le travail immatériel dans la performance," "Iscrpljujući nematerijalni rad u izvedbi," in English, French and Serbian), co-editor with A. Vujanović, Joint Issue of Le Journal des Laboratoires and TkH Journal for Performing Arts Theory vol. 17, October.

Vujanović, Ana/Vesic, Jelena (2009): "Performance as Research and Production of Knowledge in Art." In: Kölner Kunstverein (ed.), *Lecture Performance*, Köln: Revolver, pp. 42-54.

WEBSITES

"Inpresentable," June 22, 2012 (www.in-presentableblog.com).
"What is Everybody's (2007)," June 22; 2012 (www.everybodystoolbox.net).
Imschoot, Myriam van (2009), July 31, 2012 (http://archived.janvane-yck.nl/4_4_cv/cv_t_ims1.html)

PANEL AESTHETICS

Aesthetic Experience

INTRODUCTION BY GERALD SIEGMUND

BACKGROUND

In dance, aesthetics and aesthetic criticism have been frowned upon for a long time. Dance professionals and scholars alike mistrusted aesthetic positions, suspecting that a grid system of canonical forms and movements merely served as a pretext to marvel at the beauty of the dancing bodies without taking into account the critical potential of art in general and dance in particular. For over two decades questions of aesthetics have not played a significant role since many dancers and choreographers defied the accepted codes and conventions of contemporary dance. Repudiating traditional forms and normative dancing techniques, dance professionals sought to establish a different relationship with the audience and tried out new modes of production and reception, thus expanding the limits of the genre with the aim to create an open situation where perceived notions of beauty and the category of the autonomous did not apply anymore. Influenced by cultural studies theory, American dance scholars defined dance as a socio-cultural practice, focusing on questions of agency articulated in specific choreographic practices of communities, groups and subjects.[1] Aesthetics, it seemed, had served its time. Lately, however, on dance conferences and conventions, scholars and critics revived the idea of the beauty of the moving body, and raised the question of the lasting values of a performance. Often, this culminates in a problematic endeavour to simplistically reduce the beautiful to formal categories like proportion or the symmetrical (Scarry 1999).

Yet if the aesthetic is on the agenda once again, it is not, as a rule, taken up from the viewpoint of formal or stylistic analysis but under the heading of aesthetic experience, which, precisely, is not reducible to the universalising power of reflexive judgment. In her 2001 book *Aesthetic Experience* Erika Fischer-Lichte argues that the aesthetic subject is intricately involved in the constitution process of any piece of art, making a case for theatre performances, the constitution of which crucially depends on the co-presence of spectators and actors.

1 See for example: Banes 1998. This statement is, of course, only indicating a tendency. Two prominent counter-examples trying to combine aesthetic reflexivity and the social are Foster 1986, and Hewitt 2005.

However, the subject of aesthetic experience is not just engaged in perception or interpretation processes, but simultaneously takes part in the very creation of the object of knowledge, and, for that matter, art. By means of their cognitive, affective and bodily participation spectators are inextricably entwined in the emergent event (Fischer-Lichte 2001). Experience in a first approach to the meaning of the term, thus, needs to be understood in opposition to the traditional function of art as a system of representation.

Hence, theories of aesthetic experience contradict the structural linguistic methodologies of semiotic approaches to art because they do not take into account the physical and affective dimensions of the reception process. On the other hand, they can draw on a well-established body of theories of aesthetic experience with a long tradition in the twentieth century. With this in mind, one could argue that the prerequisites for the development of a critical aesthetic theory open to lived experience and its contexts have always been there. Yet aesthetic thinking disappeared from the agenda – as Juliane Rebentisch has pointed out – owing to a fallacious equation with a particular modernist aesthetics of autonomy, which is indeed blind to the social and historical contexts and effects of the production and reception of art (Rebentisch 2011).

In the following I shall sketch a brief summary of significant lines of division in the discussions centring on the aesthetic since the 1960s. This might help to better assess current debates on aesthetics, aesthetic experience and difference. Begging the question of what can be reclaimed from past discussions for a fresh reflection on aesthetics, it also provides a contrasting foil for contemporary aesthetic theories, which focus on the critical potential and questioning nature of art.

HISTORICAL THEORIES OF AESTHETIC EXPERIENCE

In the 1970s a pragmatic turn took place in both German and French literary studies. Focusing on the reception context, these schools of thought – albeit in different ways – pushed aside past formalist approaches that primarily dealt with the representational side of art. Art works, and literature in particular, were henceforth considered not so much as autonomous aesthetic objects with a hidden meaning to be retrieved, but as a creative, cognitive and affective achievement of the reader who actualizes the text's meaning potential in the act of reading. The artistic object is thus constituted through an interaction of textual structure and acts of cognition on the part of the reader. In this sense, art is defined as aesthetic experience.

In the wake of these developments, modernist theories emphasising the autonomy of art like, for instance, Clement Greenberg's notoriously famed criticisms in the field of visual arts (Greenberg 1961), or Wayne C. Booth's essay on *The Rhetoric of Fiction* within literary studies (Booth 1961), were rejected on the grounds that these theories reduced the qualities of art works to more or less elaborate exercises in organising art-specific means and procedures – for in-

stance, colour and canvas, or artistic language use and rhetoric structure. This resulted in defining the properties of each genre of art in an essentialist and universal way.

Theories of aesthetic experience, on the other hand, adopted critical attitudes towards these modernist theories of purity. Their approach was similar to those which – in the context of the 1960s minimalism movement in visual arts that was conceptually and personally closely connected with New York's experimental dance scene of that time – came from the advocates of "anti-art." In her famous essay from 1962 *Happenings: An Art of Radical Juxtaposition*, Susan Sontag claimed the surrealist heritage for the then new form of art that targeted the audience's response rather than the creation of a coherent whole (Sontag 1989 [1967]). Hal Foster's collection of essays *The Anti-Aesthetic* from 1983 repudiated classical notions of the aesthetic as a separate sphere without purpose in which, through the concreteness of individual works of art, a symbolic totality reconciling contradictions may be created (Foster 2002). In 1986, British artist and critic Victor Burgin argued against the metaphysical notion of presence put forward by dominant art theories since the Renaissance and argued for an "absence of presence" (Burgin 1986) that would open up the work of art to the specific contexts of artists and audiences alike.

In the German context, the Constance School around the literary scholars Hans Robert Jauss and Wolfgang Iser repudiated theoretical approaches, which focused on aesthetic autonomy and concomitant assertions to show the transcendent, timeless aesthetic value of a work as manifest in the structure of the text in plain disregard of the social context of interpretation and historical experiences of its recipients. During a 15-year time span between his 1967 book *Literary History as Provocation* (1970) and his 1982 volume *Aesthetic Theory and Literary Hermeneutics* (1982), Jauss' main objective was the historical reconstruction of reader responses to literary texts analytically conceived as readers' 'horizons of expectations.' Yet unlike Hans-Georg Gadamer who, in his hermeneutic classic *Truth and Method* (1960), promotes a harmonious reconciliation of the text and the reader's horizon of expectation as the desired outcome of the act of reading, Jauss supports a different notion of response based on dissent and rupture, emphasising the provocative surplus of experience, which is capable of breaking the horizon of expectation. In his seminal book *The Act of Reading* (Iser 1980), Wolfgang Iser structurally positions the reader within the text itself. Governed by the structure of the text, the 'implied reader' is called upon to fill in blanks and gaps and project expectations, which may be fulfilled or disappointed, thereby successively realising and concretising the work of art through cognitive acts. Hence, for the reader to experience art has always meant to be right in the thick of things. By assuming the position of an implied reader, the actual reader is allowed to make both an experience and at the same time to reflect upon his or her construction of a literary world. The US-American reader-response approach, as suggested by Stanley Fish in his criticism of Iser, would reject precisely this double bind of engagement and distancing in favour of a purely subjective con-

struction of meaning.[2] By denying the objective status of the text, Fish is concerned with "selfing," whereas Iser's notion of structure allows him to be concerned with "othering."

Aesthetics of reception of German provenance characteristically refer back to Russian formalists and the Prague School of structuralism, who, in contrast to modernist formalists in the context of Anglo-American theory construction, foster a different notion of aesthetics based on the idea that art is invariably concerned with and entangled in lived experience, as the works of Jurij M. Lotman on cultural semiotics (2010) and Jan Mukařovský's studies on literary norms (1989) suggest.

From a US-American angle, John Dewey very early challenged the idea that art was the sole creation of the artist, contending in *Art as Experience* (Dewey 2005 [1934]) that the art object was created by the artist alone but that the work of art was ultimately accomplished in the perception of the recipient. Appealing to the senses, it spontaneously causes the recipient's social experience and everyday meanings to condense, thus triggering aesthetic experience. Aesthetic pleasure, then, is prompted by means of conflation of experiences.

This experience has, without doubt, physical aspects as John Martin argues from the 1930s onwards. In his pivotal texts vitally important for modern dance studies and most influential for recent phenomenological theories of the body, Martin contends that the communication between dancers and spectators is founded in a kinaesthetic transferal of muscular tensions and rhythms (Martin 1965). These kinaesthetic reactions then trigger the same kinds of emotions in the audience as experienced and expressed by the dancers. Despite sitting on a seat in the auditorium, the spectators dance along with the performers. They react and respond in physical ways mirroring the dancing bodies on stage. In Martin's case, as has often been criticised,[3] the idea of aesthetic experience, however, falls neatly alongside Clement Greenberg's notion of a universal transcendent true for all experience of the work of art regardless of the specific context or identity of the individual spectator. Most modern approaches to aesthetics therefore imply that there can be no question of the autonomy of the art work. Rather, it is the performative quality and processuality of art that constitutes aesthetic experience. The work and the lived experience of the recipient are closely intertwined, and aesthetic pleasure is derived from interference effects.

On an internationally more significant level, French poststructuralist theories developed in the context of *Tel Quel* magazine began to flourish by the end of the sixties. Scrutinising a short story by Balzac (Barthes 1990 [1970]), Roland Barthes advanced a radically new method of analysis, cutting up the textual and narrative coherence instead of seeking hermeneutic unity (Barthes 1976; 1990). He itemises five separate codes of cultural, generic and medium-related sets of

2 For a summary of this debate see Thomas 1982.
3 See for instance Foster 1998.

conventions used in reading. From this point of view, the literary text appears as a mere hub, an intersection for social discourses, radically open in every respect.

More open still than Umberto Eco had argued in his 1962 classic *The Open Work*, because the text seems indefinite not only from the point of view of its interpretive potential due to varying contexts and historical and social conditions of its reception. Henceforth, the text is also radically open in terms of its being a text, a fabric with loose ends embedded in the ever changing structures of the real world, never identical with itself. In Roland Barthes' or Julia Kristeva's semiological analyses, the text gradually dissolves into a polylogue of intertextual links and traces (Kristeva: 1977).

Yet it is not only the notion of text that differs greatly in German and French theoretical dealings with the productivity of the reader and, hence, with aesthetic experience. As Barthes argues in *The Pleasure of the Text*, the subject of aesthetic experience needs to be thought in radically new ways, too (Barthes 1974; 1975). In the act of reading, the subject who rationally responds to a text simultaneously takes pleasure in the detective work searching for inter- and intratextual traces. French poststructuralist thinking posits the reader-author as a fissured subject in the psychoanalytic sense of the word, decentred by his or her desiring enjoyment, which is set off by the chain of signifiers. Expanding the limits of the subject, the act of reading opens up the possibility of new experiences and desires, and, hence, of being other.

In the German context, reception theory comprises a strong critique of the aesthetics of negativity, i.e. the proclaimed negative relationship of art works to everything that is not art advanced by Adorno's aesthetic theory (1970; 1984). In Adorno's purist understanding an art work needs to remain dissociated from social reality and any pragmatic, activity-oriented context in order to be authentic art. Jauss repudiates Adorno's aesthetic negativity and his claim that only by repulsing the contaminating, compromising effects and demands of the culture industry art can assert itself as truly autonomous and progressive.[4]

French theorists, however, retain another concept of Hegelian negativity, as expressly stated in Julia Kristeva's *Revolution in Poetic Language* (Kristeva 1978; 1984). Whereas Adorno's idea of negativity quotes Hegel's notion of an abstract negation, Kristeva refers to the negativity of the 'unconscious,' stressing its potential to challenge the symbolic order of language and shake up patterns of perception and emotional cathexis to signifiers to make way for new countercultural variations on reality, a potential she solemnly – and in no way inferior to Adorno's radical and emphatic statement – describes against the backdrop of the social dislocations in the 1970s, as 'revolutionary.'

4 For the Jauss-Adorno debate see Jonson 1987.

STATE OF THE ART

In his 1982 book, Hans Robert Jauss refers to the socially valuable potential of aesthetic experience as follows: "What is meant is the capacity of aesthetic experience to compensate the loss of experience in the modern industrial society" (Jauss 1982b: 11). This statement brings us back to the question of the significance of the aesthetic today. Any attempt to answer this question must be negotiated between the conflicting poles of an autonomous conception of art quintessentially represented by Jean-François Lyotard's aesthetic of the sublime (Lyotard: 1994), and a conception of art that is closely linked to the material situation of the performance, as, for instance, articulated by Nicolas Bourriaud under the name "relational aesthetics" (Bourriaud 2002).

This dichotomy has recently been re-addressed by Jacques Rancière in his studies on the relation of aesthetics to the political. He maintains that contemporary art must position itself within the conflicting poles of autonomy on the one hand and heteronomy or situation-relatedness on the other without succumbing to either of the two sides (Rancière 2006a; 2006b). In its radical departure from social reality and its potential to address the non-representational, which can only be experienced as alienation from conceptual knowledge, autonomous art is essentially political. Modern dance in its distantiation from 'logos' tends towards this pole, as Hans-Thies Lehmann has suggested in his book on post-dramatic theatre (Lehmann 1999: 372). However, the situation is also part and parcel of the political dimension of art, it is the tie to social reality relating art to life, thereby enabling social relations which, in everyday contexts, are often experienced as deficient. To both Bourriaud and Jauss, the aesthetic also fulfils a compensatory function.

A third option that, to many dance scholars and performers, seems promising is Gilles Deleuze and Félix Guattari's conception of art as producing blocs of sensations by means of a compound of affects and percepts, provoked by the shaping of the material (Deleuze/Guattari 1994: 163). Deleuze und Guattari, here, are steering a middle course between the poles of autonomy of the art work and the open situation. To them, art must be seen as interplay of form and affect, a theoretical position they share with most of the approaches introduced at the outset of this essay. Implicitly drawing on ideas of the Russian formalists and their famous definition of "art as technique" (Šklovskij 1994: 260-272), Deleuze and Guattari try to develop a theory of art producing its own (non-representational) reality in the affects it generates and stores through the use of formal procedures and the moulding of the material. According to Deleuze and Guattari, the general aim of art is to produce a sensation, and the principles of sensation are, at the same time, the principles of composition for works of art; conversely, in works of art these conditions of sensibility are revealed. If it is in and through the structuring of the work that affects are created, generated and preserved, then the recipient is literally 'affected' by these affects via participating in the unfolding of a work in time and space.

AGENDA

The collaborators of the panel *Aesthetic* take it for granted that a distinctive quality is inherent in aesthetic experience and communication that sets it apart from everyday communication and experience. Dance, from an aesthetic point of view, is neither a ballroom practice nor a mere manifestation of its socio-cultural conditions and struggles, but a dynamic performance practice that generates its own rules while at the same time being able to absorb contexts. In this respect, dance as a genre is never entirely determined by conventional patterns of perception, to which it conforms, nor does it simply mirror the social discourses it is fuelled by. Every dance performance has its own specific procedures of producing and organising bodies and movements, always in conjunction with other theatrical means. Hence, a stage event must be understood as a materialisation of bodies, as a generating practice bringing into being bodies and movements, yielding a product, which is neither causally determined by, nor traceable to its material and discursive conditions. If it is only in the interaction between performers and audiences in which a dance performance can find accomplishment, then the result is always something which has, in that particular form, not existed before – a singular event. The theatre provides the crucial frame for that experience, permitting close encounters and, at the same time, holding recipients at a reflexive distance. The theatrical frame, which enables the interaction of performers and spectators may thus either be set or subject to a process of negotiation. It is, however, the condition sine qua non of aesthetic communication. If the 'aesthetic' can be defined as a differential quality to both autonomous and heteronomous definitions of art, this difference finds its material manifestation in the proscenium. Connecting and separating the public and the dancers, it promotes, in the very act of an engaging and affective reception, a critical reflection on what is seen, heard, understood and experienced during the performance. Understood as difference, the aesthetic must be negotiated depending on the context it works in. Consequently, the constitutional process of the performance itself must be regarded as an essential part of the performance. In a self-reflexive twist, the performance refers back to its own artistic means and procedures, mapping the represented on to the representation, interweaving form and content. As a result of this opening up to a reflexive level, the material and semantic dimensions of the performative components as well as the conditions of formation and production are held in suspense, and acquire an uncertain status.

If we want to maintain that a dance performance is a materialisation process and, hence, an articulation of a reality in its own right, different dimensions of the stage act should be distinguished:

- The material dimension: every enactment has a material side and therefore a phenomenological dimension. Yet if we want to rule out a mere concentration on the bodily aspects of the performance, the materiality of the remaining components must also be taken into account. Dancing on stage is, then, a

confrontation of the body with other, heterogeneous systems of different orders – the binary-differential code of language on the one hand, and the analogous order of the visual on the other hand. The material incommensurability of these systems opens up the representation to that which cannot manifest itself.

- The (closely related) dimension of intermediality: how and in what way do different materialities interfere with each other? What happens if the human body with its own rhythm and corporeality has to play against language and visual images which are governed by different modes of materialisation?
- The representational dimension: the referential aspect of representation testifies to the semiotic dimension of a performance. But how can the relationship between lived experience and represented reality be defined? Paradigmatically, this complex relation is addressed in dance performances by the difference between the choreography as 'pre-scription' and dancing as concrete activity performed on stage.
- The dimension of embodiment: dance is an embodied art form and the moving body is assumed to exemplify lived experience. Yet in the reception situation of the theatre context, the staged body of the dancer is subject to a metonymical shift in the imagination of the observer. In what way is the embodiment to be regarded as disembodiment and, hence, a kind of spectralisation of the body according to the contexts it produces and entails?
- The narrative dimension: performances extend over time. Their components and artistic means constitute a unique pattern of syntactic sequences. Can narrative structures be discerned in dance performances? How and in what terms could that narrative organisation be conceived?

Translated from the German by Dr. Bettina Seifried

The Question of the Aesthetic[1]

Juliane Rebentisch

I will try to pick up some of the points Gerald Siegmund has laid out for the members of the panel 'dance aesthetics' as 'agenda.' Let me start with a description of the dichotomy between the modernist conception of aesthetic autonomy on the one hand and "relational aesthetics" (Bourriaud 2002 [1998]) on the other. I think this is a false alternative. What is at stake in this alternative might best be addressed in pointing to the respective notions of participation.

Within the framework of a very influential strand of modernist aesthetics, ranging from Theodor W. Adorno to Michael Fried[2], participating in art means transcending one's subjectivity and partaking in something that possesses universal validity. Universality is a core element of the respective notion of autonomy, which seeks to set art apart from the world of consumable things as well as from its reduction to the expression of empirical subjectivity. The notion of autonomy of art thus possesses an ethical dimension; in modernist tradition, autonomy is conceived as art's emancipation from the ascendancy of the subject. By transcending individual expression and eluding consumption, the autonomous work demands that the subject adopts an attitude other than that of willful disposal vis à vis the work, namely an attitude of recognition. This constitutes the quasi-subjective dignity of the autonomous work. To the extent that the work can attain the quality of a subject in its own right, this quality must not be reducible to the empirical subjectivity of the artist or recipient. Consequently Adorno (Adorno 1991 [1953]) believed that the ideal artist is one who brings out an aspect within the work that both frees it from the artist's individuality (its expression) and defies the logic of subjective command over the material. This is also the reason why the sublime and not the beautiful is the central category for modernist aesthetics. Art is no longer defined as the product of trained skills applying rules of symmetry and proportion, but as an event that transcends the logic of mastery. But however appealing this idea still might be, it has to be taken into account that modernist aesthetics understands the respective event as a manifestation of universality. According to Adorno, the subjectivity that shows through

1 The following is partly based on Rebentisch 2012a.
2 For a detailed analysis of this line of ethical-aesthetic thinking in modernism cf. Rebentisch 2012b [2003].

in the 'work-subject' must be free of all the limitations incumbent upon empirical forms of life and – hence – truly universal. Participation in art thus must be conceptualized as partaking in this universality: The beholder, listener, spectator, or reader, by relating to the work, likewise overcomes her own empirical situatedness. Under these conditions, a tinge of utopia accrues to aesthetic experience. For to have an aesthetic experience then means to partake in a truly universal, a reconciled subjectivity.

Contemporary art, by contrast, quite explicitly opposes the modernist overburdening of art with the utopian project of anticipating the nonexistent subject of a nonexistent total society. This project strikes many of today's artists as corrupted – modernist universalism has turned out to be a particularism in too many respects.

If this crisis of the utopian determination of art is indeed constitutive for many developments in art after 1960 that today fall under the rubric of 'contemporary art,' what are the consequences to be drawn? The theory of "relational aesthetics" (Bourriaud 2002 [1998]) concludes from this crisis that the very idea of aesthetic autonomy must be regarded as irrelevant both for the theory and the practice of contemporary art. Instead of isolating art from life and utopia from politics, the advocates of relational aesthetics argue that both need to be transposed into a communicative practice that, by virtue of being immediately intersubjective, counteracts social isolation (Bourriaud 2002 [1998]: 8 et seq.). In other words, instead of asserting art's autonomy in order to represent a utopia unattainable to any concrete politics, art is to become an instrument of the practical-political realization of what is micro-topically possible: assisting in achieving social participation. In effect, however, this theoretical shift merely implements a paradoxical sublation of art into life that once again cements the difference between the ideal practice of art and a less-than-ideal reality. However, this difference can no longer be conceptualized as aesthetic difference, but reinstalls itself as social difference. For the communicative practice of art still operates in the sheltered space of the art institution, relating to its other – a non-ideal reality – from the distance of privilege.

Reducing art to a practical-political instrument of social integration means eschewing any attempt to elaborate a concept of critical art that would enable us to think the fact that today's art largely rejects the modernist utopian pathos along with its aesthetic quality. By the same token, this reduction also blocks access to an alternative conception of what it means to participate in art, a different understanding of aesthetic participation. To approach this conceptual task and to get beyond the conceptual dichotomy described by Gerald Siegmund (Siegmund, in this volume), however, we must first seek to form a more accurate picture of the artistic opposition to modernism. The modernist-utopian definition of art is tied to the presumption that the work possesses a "second reality" (Bubner 1989: 33) divorced from all other reality. Contemporary art, by contrast, undermines this presumption. If the highly variegated developments of 'contemporary art' can be reduced to a common denominator at all, it is that they radically call the

system of the arts and the self-containment of the work into question. In most instances, we are confronted with decidedly 'open' works that destabilize the boundary separating the aesthetic from the non-aesthetic. Yet such destabilization, far from obviating the question regarding the specificity of the aesthetic, raises it anew.

Now, as I see it, the conceptual turn towards the category of aesthetic experience took place at least partly in reaction to this challenge and might indeed offer an alternative to the alternative of modernist aesthetics with its problematic universalism on the one hand and relational aesthetics with its problematic sublation of art into life on the other. Whereas modernist aesthetics begins with the assumption that the work is an objective given, understanding aesthetic experience to be the subsequent reconstructive apperception of the work's structure, theories of aesthetic experience conversely define the work as a product emerging from the process of aesthetic experience. Art, in other words, is not an objective given but comes into existence in and by virtue of the experiences it releases – which also means that the difference between the aesthetic and the non-aesthetic is no longer conceived as that between a self-contained work and what is external to it.

According to this view, the aesthetic does not constitute a special domain separate from the non-aesthetic at all. The aesthetic exists instead in the process, or the event, of becoming aesthetic. The aesthetic and the non-aesthetic do not relate to each other as mutually external; instead, the aesthetic consists in a reflexive transformation of the non-aesthetic. This also allows us to envision the aesthetic point of open work-forms. For the many fragments of ordinary life that can be found in today's art do not simply dissolve that art into life. To the contrary, the pieces of reality incorporated into art become dissimilar to themselves. They are neither simply reality, nor unambiguous signs for (another) reality. Precisely this ambivalence releases their representational potential: how and as what they appear to us is then inseparably tied up with us and with the imagination's share in our experience. The subject of such experience is no longer the subject of modernism, transcending its particular situation by participating in art. Conceived instead as decidedly concrete and situated, this subject does not transcend her own empirical conditions but rather reflects on them in a specific fashion. If art can indeed effect a change in consciousness that may spill over into political attitudes, it does so not because it breaks with our finite worlds, but because in the semblance of art we encounter these same worlds in a different way.

Let me now try to address the implications of this for some of the points Gerald Siegmund has assigned to us for discussion (Siegmund in this volume: 87 et seq.).

- *The material dimension.* Because semblance cannot be cleaved from the aesthetic object, any meaning the work may acquire must always also withdraw back into the material from which it had emerged. This allows the materiality of the work to come to the fore. Aesthetic materiality is an effect of its tense relation to meaning and not its obtuse opposite, mere matter. The same holds

true for the performing body no longer subjected to the task of representing a role. For we are faced here not with a simple subtraction; the bodies are not simply left standing in their facticity. The reference to meaning, to something they potentially represent, remains essential to post-dramatic performance bodies even if this meaning can no longer be fixed unambiguously. They thus develop a certain "spectrality," as Derrida (Derrida 1994 [1993]: 18) put it, they are always more, and something other, than what they are. In his 'Butoh-piece' *Product of other circumstances* (2009), Xavier Le Roy momentarily, sometimes even simultaneously, appears as an insect, a fragile wrinkly, a tender blossom, a mesmerizing diva – his body swollen with meaning. Yet, such aesthetic spectralization is not dematerialization, not spiritualization, to the contrary such spectralization is internally linked to a heightened aware-ness of the physis of the performing body.

- *The dimension of intermediality.* The fact that we normally do not just con-centrate on an isolated performing body, but on everything that is happening on stage simultaneously does not conflict with this logic, but intensifies its dynamic. It extends to the other elements as well. It certainly adds to the rep-resentational potential of the body if we relate it to other theatrical elements: other bodies, stage props, music, or language. But this holds true for all theat-rical elements in a post dramatic setting (including language which becomes the equal of the other elements). Divorced from their dramatic or narrative function, they enter into an open horizon of possible interrelations, each ele-ment thereby coming to the fore in its materiality and medium specificity. The hybridisation of the traditional arts in new intermedia formats such as performative situations, theatrical installations, or installational theater that include music, film, or video thus does not slur the differences between the media involved, but stresses them. Whereas traditional dramatic theater only integrated different aesthetic media at the cost of restraining their specificity (subjecting them to the service of the drama), new intermedia works bring out the respective differences precisely by letting the various media interact at eye level.

- *The relation between art and reality (lived experience and representation).* Participation or partaking in art means acting out tensions – the tension be-tween materiality and meaning, but also between two incompatible attitudes that, taken as extremes, both designate exits from aesthetic experience: a 'contentist' attitude on the one hand, and a 'formalist' one on the other. That the tension between these two possible attitudes remains present within con-temporary art is particularly evident in performance situations that know nei-ther the distinction between stage and audience, nor a clear ontological sepa-ration between the real and fictional world. For such situations will not only render the physical presence of the actors more intensely. This intensity will, in a reflective movement, extend to the spectator as well. The latter is then no longer a consumer hiding in the dark, but rather an individual whose presence – and that includes his physical presence – influences the performance by vir-

tue of his position in the room. A possible disruption of the event marks the remote horizon of the responsibility for the situation imposed upon the spectator (Lehmann 1999: 122 et seq.). One only needs to think of performances by Yoko Ono, Santiago Sierra, or Christoph Schlingensief for vivid illustrations for the viability of this option. Yet any disruption of the performance, however moral its motives may be, inevitably cancels the aspect of theatrical production, negating the performance. On the other hand, it is just as unhelpful to suggest, regarding performances that play with their own boundaries, that they are merely art and should thus be considered in purely formal terms. Something else is truly at issue: the creation of a tension between two attitudes that will inevitably disintegrate the unquestioned safety of the spectator's position, and will do so to the degree that the boundary between the aesthetic and the non-aesthetic, between art and non-art, between reality and fiction becomes the focus of aesthetic play. Yet such forms of contemporary performance art only dramatize a paradox that permeates the contemplation of all art: that it demands both an element of immediate belief in the world it opens up and an attention to its being art, its being mediated (cf. García Düttmann 2009). Art takes place to the extent that the paradoxical union of immediate belief in the world disclosed by the work on the one hand and advertence for the mediated character of the artwork on the other is acknowledged, and carried out.

- *Affect and reflexive distance.* This double nature of participation in art becomes acutely important regarding the emotional – or, affective, a term often misleadingly used as though it were synonymous – dimension of aesthetic experience. Unlike instincts and reflexes, emotions are not part of a stratum located, as it were, beneath the plane of meaning. Rather, emotions are themselves meaningful. They are interwoven in a great variety of ways with our assumptions about the world, informed by a normative praxis that is always linguistically mediated. We have learned to be ashamed, to feel revulsion; and we have learned to do so in relation to specific situations or objects. Emotions, that is to say, are not independent of the situations or objects that trigger them – or of our assumptions about them. On the contrary, interpretations of situations and objects usually constitute the significance of our emotional agitations. Without knowing what someone's emotions are about, or rather, without knowing her interpretation of what they are about, we will hardly be able to determine her emotional state (cf. Voss 2004). Now, aesthetic experience will by necessity subject the connection between emotions and our normative orientations to a distancing re-presentation. First, it will do so, because the attention art demands to its mediated-ness conflicts with the immediacy of the emotional response it nonetheless provokes. Second, it will do so, because the semantic openness of the work of art bends any interpretation, however immediate and even obtrusive it may seem to the recipient, back toward itself. In a certain way, emotions triggered by art works must then indeed, as Deleuze and Guattari put it, "become zero" (Deleuze/Guattari

1994 [1991]: 169), making the energies of affective agitation potentially available for other semantic modulations, which is to say: for a different emotional meaning.

- *Participation.* Participation in art thus acquires a specifically aesthetic meaning. Its specific reflectivity distinguishes it from understanding as much as from acting. Accordingly, interpretations fall short that misread the fact that open works sometimes challenge their recipients to participate in their production as the expression of a practical 'democratization' of the production of art. As Umberto Eco (Eco 1989 [1962]) has insistently pointed out, the open form does not abolish the asymmetry between the artist and her audience. Instead, the audience's interventions into the work are part of the artistic calculation; they take place within a horizon delineated by the artist even when the very frame separating art from non-art becomes the object of engagement. Open works reflect not a pseudo-democratic impulse to invite citizens to produce art themselves, but rather a fundamental insight into the constitutive function of processes of interpretation for the autonomous life of the work of art itself. Any work of art, Eco writes is constitutively open "to a virtually unlimited range of possible readings" (ibid: 21). As open works illustrate with particular vividness, this does not imply that the individual interpretation is doomed to arbitrariness. Instead the tension between the aspiration to fidelity and the awareness of contingence that accompanies any attempt to live up to that aspiration is a specific feature of the engagement with art in general. Participation in art, then, implies more than the literal-practical fabrication of one of its manifestations or the establishment of a meaning. Participating in art always also means partaking in the potentiality – or spectrality – of the work. It means experiencing its infinity.

- *The dimension of time.* For the time based arts – and that means for the ephemeral art of dance as well – the experience of the work's infinity implies that its time must be out of joint. The time of aesthetic experience cannot be reduced to the chronometric time in which a performance is executed. Neither is aesthetic experience ever entirely synchronous to the course of events on stage – it is always too distracted by the spatial simultaneity of the various theatrical elements to be able to perfectly keep pace with the temporal course of the events, nor does it necessarily begin or end with the performance. Compared to the regulation of objective time aesthetic experience rather performs eccentrically, it has no measure and can therefore potentially always return afresh to its object – e.g. to a documentation of a performance on film. The experience of art's infiniteness entails a confrontation with our finiteness; we are never finished with works of art. At the same time this is an aspect of the freedom in our relation to them. They can never be conclusively known but always only recognized. This holds true for works, to which we can return (like literature, painting, sculpture, photography, film, or video) as well as for singular performances. In the former case it is endurance in the

latter fugitiveness that highlights an ethical dimension in the experience of art that takes us back to the modernist notion of autonomy with which we started.

The modernist idea of a quasi-subjective dignity of the work now returns transformed. Whereas modernist aesthetics recognized the autonomous dignity of the work in its self-sufficient closure, theories of aesthetic experience stress its potentiality. The work attains a quasi-subjective character not by possessing this or that determinate quality, but on the contrary by forever exceeding the determinations it may take on in relation to any beholder, listener, spectator, or reader. That is why we sometimes return to works of art as though to good friends – why they mean more to us than mere objects, and why we can in their presence be more, as well as something other, than subjects who dispose of objects.

The Resistance to Dance Theory.
Being-With, the Aesthetic Event

KRASSIMIRA KRUSCHKOVA

> "Nothing can overcome the resistance to theory
> since theory *is* itself this resistance." (Paul de Man
> 1993: 19)

There is a word, a conjunction which informed the working title of the *Dance [and] Theory* conference concept: the word *and*. Not by chance, this intriguingly endless *and* was broken down to *as, but, in, from*: *"Dance and/as/but/in/from Theory"* (Brandstetter/Klein 2011: 3).[1] In the sense of the collaborative conference concept and in the sense of the fields of tension our Aesthetic Panel has opened up, I would like to propose merely another preposition: the *with*, which includes *and, through, by, along*, etc. at the same time. A disjunctive togetherness under the sign of discerning each other, of the incommensurable – informs the aesthetic tension of the scenic event between materialities, media, participants, registers, directions, narratives on the stage and in the auditorium: a *with* as tension between bodies and media and parallel worlds moving along next to each other. *With* as synaesthesia instead of synthesis. Also, w*ith* as an ethical optic, *with* which we are able to cast a glance on dance aesthetics: not thinking the One and the Other, but rather the One *with* the Other. And also in order to avoid any apodictic claim to knowledge by combining several styles of thought disjunctively, true to difference, resistant.

With also as a being-with of theory and resistance – in the sense of Paul de Man's *Resistance to Theory* (de Man 1993). Let us try to go *with* de Man's thoughts on literary theory and think about dance theory today. After pointedly formulating: "Nothing can overcome the resistance to theory since theory *is* itself this resistance," de Man continues:

"The loftier the aims and the better the methods of literary theory, the less possible it becomes. Yet literary theory is not in danger of going under; it cannot help but flourish, and

1 Cf. the preface by Gabriele Brandstetter and Gabriele Klein in the conference's programme.

the more it is resisted, the more it flourishes, since the language it speaks is the language of self-resistance. What remains impossible to decide is whether this flourishing is a triumph or a fall." (Ibid: 19 et. seq.)

The issue is the triumphantly falling indecidability between a text's theoretical statement and its rhetorical practice; it is the resistance against the rhetorical or tropological dimension of language. According to Paul de Man's *Allegories of Reading* (de Man 1982), the text does not practise what it preaches, because its figurative practice and its meta-figurative theory do not converge. This non-convergence, the oscillation between literalness and figuration influences the figurative practice of dancing as well as its meta-figurative theory.

The aesthetical and political implications of this oscillation today strongly put the collaborative interference between dance and theory into question: does the performative promise of participation presume consent with regard to the aesthetics of production or reception? Or does it rather let the scenic impartation as well as those participating in the scenic event divide into parts themselves, into plural singularities? How does being-with (as separated and shared being) distribute and foil any fixed community? In order to enable joint exposedness via its irredeemability. In order to distinguish direct participation and sharing in the term of metexis. As practices of collaboration, contemporary dance and its theory open up with regard to the aporias of being-with. And exactly this opening-up makes their elements float, knowing about the lack of consensus, in all the heterogeneity of the participants, as a plural promise of the singular, as an aporia of community: the impossibility of community obviously at the same time is its constitutive moment.

Regarding this, let us recall – also following the gesture of thought in postmodern dance –, e.g., Xavier le Roy's *E.X.T.E.N.S.I.O.N.S.* (1999), his *Project* (2003) or his latest group work *low pieces* (or *title in process*) (2010), Meg Stuart's *All Together Now* (2008), Ivana Müller's *While We Were Holding It Together* (2007), *WE* (2008) by Amanda Piña and Daniel Zimmermann, *Reportable Portraits* (2007) by deufert+plischke, the works of Cooperativa Performativa or The Loose Collective –, just to name a few working methods exemplary for the problem of being-with which influences the research of many of the most interesting artists in the field of dance and performance. "How did you come together, how did you get together?," a spectator asked during an audience discussion at Tanzquartier Wien (October 2010) which *low pieces* begins with. "By train," was Christine De Smedt's answer. This much, this little on the ironic resistance against the troplogical dimension of language, on the indecidability between the literal and the figurative aspects of a coming together. As if togetherness could only exist where no reason for it can be considered given, rather an itemising, paratactical togetherness instead of a taxonomical one. (I will come back to the allegedly taxonomical in Foucault's *Order of Things* (1971) later).

Thought of the collaborative is thought of instable countermovement, which exposes itself to its own irreplevisability, which only knows momentary stabili-

sations instead of permanent equilibrium. The idea of being-with, of a communi-ty of those who do not belong to any, does not – if we think of the pertinent works by Maurice Blanchot (1988), Jacques Derrida (1997), Giorgio Agamben (1993), Jean-Luc Nancy (2003) – require the common denominator of a group, no invariable plural. It exposes itself to its lack. Only through this exposure of togetherness does it become possible to think about the holding-together of the separated, parted, the different. Without symmetry, redemption, recompense. Like in the audience's laughter, in the vibration of which the aesthetic event can-cels out the automatisms of community.

So Tim Etchells instructs:

"Split the audience. Make a problem of them. Disrupt the comfort and anonymity of the darkness. Make them feel the differences present in the room and outside of it (class, gen-der, age, race, power, culture). Give them the taste of laughing alone. The feel of a body that laughs in public and then, embarrassed, has to pull it back." (Etchells 2001: 113)

In the tricky rhythm of disagreement, laughing paradoxically short-circuits the parallel levels of articulation and problematizes the unquestioned machinery of community and representation, slowing it down by making it stick – as if in its throat, in the sense of an 'I prefer not to.' Laughing as the lonely trick of abol-ished belongings and conjunctions, as the trick of parallel lists, which splits and frustrates the control and relief functions of collective laughing. Laughing as a "chaos of articulation," as Walter Benjamin argues (Benjamin 2002: 956). Laughter as embodied disarticulation, as a tension between language and body, between figuration and literacy in disjunctive practice and theory, influences dance and performance today – and their theory, too. It forms their critical poten-tial.

The comical as well as the performative certainly mark the aporias of con-ventions, the missing of place and time, the chances of possible failure, the body's doubting of the language and vice versa, the lapse as an indicator of the repressed, the power of the diffuse, the racy standstill of the punch lines and all the crisis symptomatics of the performative, in which body and language upend each other, talk at cross-purposes, pass each other by, and collide with one an-other. As a reaction to a rhythm collision, laughter marks the vibrating aesthetic interval between the parallel worlds to which we funny people simultaneously belong. As funny as the list or impossible taxonomy in Jorge Luis Borges' text, cited in Michel Foucault's *The Order of Things*, which lists animals as follows:

"(a) belonging to the Emperor, (b) embalmed, (c) tame, (d) sucking pigs, (e) sirens, (f) fabulous, (g) stray dogs, (h) included in present classification, (i) frenzied, (j) innumera-ble, (k) drawn with a very fine camelhair brush, (l) et cetera, (m) having just broken the water pitcher, (n) that from a long way off look like flies." (Foucault 1971: xvi)

At least since Michel Foucault's formulas of disjunctive practice, there has been a practical – one could also say paratactic – turning point when we are talking about the chiastic interleaving of practice and theory, about the oxymoron of 'theoretical practice.' Let's recall Xavier Le Roy's *Product of circumstances* (1999): "And maybe theory is biography, presenting it is a lecture, and doing a lecture is performing" (Le Roy 2005: 92). In all the radical contingency of the contaminated other, the one is seen and thought *with* the other's optic. And this interference, this contamination is what distinguishes the aesthetic event from everyday experiences and daily communication.[2]

Let us recall *Product of circumstances* with Adorno's *Marginalien zu Theorie und Praxis*: "Thinking is an action, theory a shape of practice; only the ideology of the purity of thought deceives us about it" (Adorno quoted in Felsch 2011: 205). And in a conversation between Michel Foucault and Gilles Deleuze, published in 1972 in the magazine *L'Arc* under the title *Les intellectuels et le pouvoir,*

"the two theoreticians agree on one decisive point: Deleuze: 'There is no representation any longer, there is only action: the action of theory and the action of practice.' Foucault: 'Theory is not the expression, the application, the translation of practice, it is a practice itself.'" (Ibid: 205 et seq.)

So, no translation, symmetry, redemption, recompense either in the politics of friendship between practice and theory.

The aesthetic event thinks every discursive reason *with* the next one's logic – in the name of the little differences, the in-between, be it for the price of losing the reason again and again. The issue is the collaborative aesthetic inter-est as being-between, it is a continuously differentiating and non-oppositional oscillation in the in-between, an interest in co-understanding, in understanding-with which is none, in available agreements, in covenants that do not think the contracts but their breaches. It is about the aporias of the simultaneous and the synaesthetic, about tremulous comparisons and parallel contacts. Thus the contact between dance and theory touches their heterogeneous surfaces. "Everything that is touches everything that is, but the law of touch is separation," Jean-Luc Nancy writes in *Being Singular Plural*, "and more than that, it is the heterogeneity of surfaces that touch each other" (Nancy 1996: 25).

The biggest, most touching differences touching each other are the smallest ones – even in the reflective engagement *with* dance and theory, *with* a dancing thinking. Especially since dance today exercises theory as an aesthetical practice – however, always under the sign of separation in that dance and theory each

2 On this, Gerald Siegmund writes: "The collaborators of the panel *Aesthetic* take it for granted that a distinctive quality is inherent in aesthetic experience and communication that sets it apart from everyday communication and experience." (Siegmund in this volume: 87)

singularly lay open their blind spot. And the responsibility of the singular as re-
sponse, as echo here corresponds with the interest in small things, in minorities,
in the – according to Gilles Deleuze – affectionate potentiality of minority, i.e.,
in the emotive's becoming null in order to think aesthetic affects in their potenti-
ality: a Deleuzian becoming-machine *with*, becoming-intensive, becoming-
animal, potentially.

The question of potentiality in the relationship between dance and theory
which always marks the aesthetic event – also in the sense of Paul de Man's re-
sistance which theory potentially 'is' – is a question concerning its 'I-prefer-not-
to' mode, which continuously exercises a renunciation of action, an abstention –
and at the same time evokes the longing for a common meaning equally valid for
everyone exactly through its continuously relinquished promise. Like in the con-
tinuously withdrawn spectral legibility of spectral scenic bodies, which marks
just the longing for impartation but goes on to part itself instead of imparting it-
self. The being-with question – also as a question concerning audience participa-
tion or the intermedial mode of contemporary dance – is marked by the longing,
yearning and cunning of the different to which we are beholden in all its facets:
the same will not put the differences out of its mind – even if threatened with los-
ing the latter. An understanding-with will always remain potential instead of ef-
fective because of the intentional instability between figurative practice and me-
ta-figurative theory.

Thus the aesthetic dance event discontinues again and again, potential, unde-
liverable, uncalled (cf. Gareis/Kruschkova 2009) in its indecidability,
irreplevisability, instability, as overboarding order – and at the same time is un-
conditionally bindingly addressed, in as precise as possible an engagement *with*
the possibility conditions of the performative. "One reaches a boundary not by
traversing it but by touching it," Jean-Luc Nancy writes in *Corpus* (Nancy 2008:
17). The aesthetic event as this touching of the boundary also between the figura-
tions of practice and theory, touching the boundary without traversing it, without
"breaking the ice/the mirror (glace)," as Jacques Derrida points out in *La double
séance* (Derrida 2002: 137). Or: breaking the immediacy and continuousness of
touch, as Derrida says in *Le toucher: Jean-Luc Nancy* (Derrida 2002). Also in
Derrida's sense of the spectral, of becoming a spectre.

The *with* mode is marked by touching interruptions and interrupted touches,
by bindingness and vulnerability at the same time. It parts up to the smallest de-
tail, so that its bindingness, its commitment becomes more compelling the more
it evades – as posture and position of brokenness, beyond apodictic claims to
knowledge. The break is always co-originary to this mode of *with*. It does have a
weakness, a weakness *for* the Other's potentiality, a weakness *for* options not
given, unprovided, *for* the parataxis of parallel worlds.

Beautiful Affects in Choreography

STEFAN HÖLSCHER

"The philosophy of organism aspires to construct a critique of pure feeling, in the philosophical position in which Kant put his *Critique of Pure Reason.* This should also supersede the remaining *Critiques* required in the Kantian philosophy. Thus in the organic philosophy Kant's 'Transcendental Aesthetic' becomes a distorted fragment of what should have been his main topic." (Whitehead 1987: 113)

"The drusy, in awakening our interest in beauty, points us in the direction of a non-cognitive aesthetics: aesthetics as a kind of *empiricism* involving itself with *real conditions of emergence*, under-with cognitive conditions, or conditions of possibility. Drusiness points to the post-Kantian dimension in Kant, or what Deleuze will call a 'superior empiricism.'" (Massumi 1998)

Although Gilles Deleuze famously referred to Kant as an "enemy" (Deleuze/Parnet 1987: 6) once, in an early treatise however he acknowledges the latter's concept of beauty:

"The accord between imagination as free and understanding as indeterminate is therefore not merely assumed: it is in a sense animated, enlivened, engendered by the interest of the beautiful." (Deleuze 1984: 93)

As well in more recent debates, in the wake of a rather Deleuzian thought, and in a final step due to Jacques Rancière's so-called 'aesthetic regime' (Rancière: 2006b), considerations on beauty, as they were undertaken initially by Immanuel Kant and Friedrich Schiller in the second half of the 18th century, have been returning, after their general condemnation in the 1980ies, not only to the various fields of visual art, but also to the ones of choreography.

Against a postmodern privileging of the sublime, as proposed by Jean-François Lyotard in his later works, and in contrast to an orientation toward the irrepresentable as a constitution beyond (ap)prehension, Rancière emphasizes what were at stake in beauty was something else than, as still taken for granted frequently, just a *consensus of reflective judgement* or the conservative confirmation of a transcendental subject's faculties. Beauty is not about definite schemes and terms and supports the opposite of a reactionary stabilization of already giv-

en relations between forms and contents. Its most important aspect is, according to Rancière, its dissensual moment. Already in Kant it provokes an opening between the faculty of understanding and the faculty of imagination and by this means produces a gap between terms we have been using habitually and intuitions which hitherto have been framed correspondingly. Beauty generates intuitions without terms already being constituted. It brings forth new concepts and implies the always open determinability of the relation itself[1] between understanding and imagination (Kant), respectively the relation between form drive and material drive (Schiller 2004).

As we experience our relation to the world as determinable and as the scene of an experiment, we feel lively and enlivened when we are joyfully affected by beauty. We then do not subsume contents under already completed forms but generate both of them, without fixed rules and procedures, without any foundation telling us what to do beforehand. Although we schematize, we do not inhabit pre-given terms because we leave our habits behind and start to *invent*.

This is beauty: Everybody has the potential to create and to relate equally ever new matters to unforeseeable forms. The common form of our dances is not yet determined, it remains, as Schiller wrote in his *Letters Upon the Aesthetic Education of Man* (Schiller: 2004), determinable within a never ending *play* between bodies.

"The object of the sensuous instinct, expressed in a universal conception, is named Life in the widest acceptation: a conception that expresses all material existence and all that is immediately present in the senses. The object of the formal instinct, expressed in a universal conception, is called shape or form, as well in an exact as in an inexact acceptation; a conception that embraces all formal qualities of things and all relations of the same to the thinking powers. The object of the play instinct, represented in a general statement, may therefore bear the name of living form; a term that serves to describe all aesthetic qualities of phenomena, and what people style, in the widest sense, beauty." (Schiller 2004: 31 et seq.)

Both, us and the relations between us are not constituted yet. As living forms we have to rather feel processually than to think determinately: At the beginning of the 20th century, Alfred North Whitehead, following a very different track, developed also a beautiful in-betweeness in his *Critique of Pure Feeling*.

"The word 'object' thus means an entity which is a potentiality for being a component in feeling; and the word 'subject' means the entity constituted by the process of feeling, and including this process. The feeler is the unity emergent from its own feelings; and feelings

1 Petra Sabisch, although she develops her argument rather in front of David Hume's empiricism than with regard to Jacques Rancière's aesthetical regime, offers a series of delightful observations on the choreography of relations (Sabisch 2011).

are the details of the process intermediary between this unity and its many data. The data are the potentials for feeling; that is to say, they are objects." (Whitehead 1987: 88)

Affective determinability has a couple of impacts on traditional notions of 'choreography as an assemblage' and on 'dance as the activity of bodies': Confronted with beautiful in-betweenness their juxtaposition cannot be regulated anymore by fixed styles or ruled by ready-made techniques. Beautiful bodies invent their own techniques. Originally stated by a sovereign order, they open up toward anybody, any procedure, and any old sujet which equally enter the dance floor.[2] Although the body of the sovereign has been resurrecting in the shape of certain women throughout so-called modernity, choreography is crisscrossed by lines of flight and perforated by unpredictable practices. What is adventured in beauty is a boundless extension of what is presentable and indefinite ways of how bodies can be presented. The aesthetical adventure, unlike so many new techniques and styles that captured dance in modernity, leads toward irregular revolutions of choreography. Nothing is irrepresentable then. Every material becomes expressive potentially in unlocked choreographical procedures – pedestrian movements as much as the dance of atoms in landscapes before or after a certain idea of the (dancing) body. Beauty is a joyful affect and as such exceeds our definite bodies. It makes us play with what is beyond the edge of already existing schemes and terms. When we play with what is beyond the already defined, we do neither speak with the tongue of an established language nor do we adjust our dances to ruling ideas of the body. We do not simply reproduce an existing world but add something new to it. We make speak what previously had been considered mute matter. We give form to what is still formless but on its way toward a form and toward a presentation. We are on the way to *a* body.

2 On choreography as an open procedure see Cvejić 2009.

Intertwinings: The Dis/Positions of Dance Aesthetics

SABINE HUSCHKA

It is the contention of the panel 'Aesthetics' that the relationship between the art of dance and the field of aesthetics has unjustly been neglected in the last decades. What have emerged instead are isolated theoretical, philosophical and critical discourses on dance that do not pose the question what makes dance into an art form.[1] Performing practices and artistic strategies of embodiment are often explored from a cultural studies or philosophical point of view, thus pushing the boundaries of the discipline. As a consequence, most contributions argued that performative dance was a culturally shaped bodily practice. The predominantly Anglo-American approaches and concepts tended to imply 'anti-aesthetics' attitude, analyzing the body merely as the reflecting surface of deeper socio-cultural patterns. Artistic practices, movement techniques and choreographic procedures were conceived in terms of cultural production processes constituting (ethnic) identities and gendered subjects. Aesthetic experience and the key question of "how art presents itself to us" (Küpper/Menke 2003: 8), which Joachim Küpper and Christoph Menke take as vital in their introduction to *Dimensionen ästhetischer Erfahrung* (Dimensions of aesthetic experience, Küpper/ Menke 2003) rarely came into focus. From a philosophical and historical perspective, the panellists Juliane Rebentisch and Gerald Siegmund both have provided detailed accounts of how and why aesthetics should be reformulated as aesthetic experience, stressing that aesthetic research does not necessarily depend on the concept of artistic autonomy. Following this fruitful and complex discussion, which seeks to define the aesthetics of dance as a practice-formed mode of reflection – a model long overdue in German academic discourse – I shall single out a few aspects worth examining.

The recent trend in dance studies, to draw once more on the notion of the aesthetic, has two important consequences. On the one hand, the aspect of the beau-

1 One exception is certainly Gerald Siegmund's worthwhile attempt at reconceptualizing and challenging conventional aesthetic figures of thought. With reference to absence as a constitutive element of presence, he provides a fresh view on performing arts and aesthetic experience (Siegmund 2006).

tiful in art is revived by referring to the creative potential of the bodies in performance. On the other hand, research on dance becomes firmly grounded on aesthetic perception in the sense of kinaesthetic empathy. Against the backdrop of neurological findings and technological processes, recent studies have highlighted the kinaesthetic response of the spectators, defined as affective and aesthetic experiences of pleasure.[2] Recurring on Theodor Lipp's psychological notion of empathy (Lipps 1903/1906) and John Martin's concept of metakinesis (Martin 1965 [1933]), a new dance aesthetics is about to develop emphasizing the inter-sensorial potential and effects of artistic movements in performance. By incorporating hitherto neglected modalities of perception conceived as the sensory experience of empathizing kinaesthetically with the dancers, the interactive process of understanding and theorizing dance is extended to include the physical dimension. In contrast to the theories of the 1930s, however, this novel approach does not advocate a universal model of communication between bodies, but operates on the basis of correspondence and imitation. I shall address this issue below.

In a dance aesthetic perspective, another vital question must be asked: How and in what way can kinaesthetic, empathy-driven approaches help us to better conceive the idea of the 'other reality,' which is, according to Siegmund (Siegmund in this volume: 87), always immanent in the materialisation of bodies in performance as the experience of difference? In other words: What is the function of the kinaesthetic within a framework of aesthetic experience, if the kinaesthetic is defined as vitalising impact on the part of the spectator? Will such a theory cut itself off from a rational approach grounded in understanding? Or does it, on the contrary, add an important aspect to the concept of aesthetic experience by paving the way of a practice-formed theorizing in which the synthesis of the reflective subject and the object prompting questions is finally achieved? There is no easy answer to it, but I shall take a closer look at the potential of the kinaesthetic to open up a pathway to aesthetic research that critically reflects dance as an embodied process.

DIS/POSITIONS – DANCE AESTHETICS

In order to theorize dance as an embodied process, an aesthetic approach based on experience is needed. We are not only confronted with the phenomenological interrelations of self and other immanent in any representation of bodies in per-

2 The research project *Watching Dance-Kinesthetic Empathy* is currently carried out at the School of Languages, Linguistics and Cultures at the University of Manchester, led by Dee Reynolds. For the research design see Watching Dance Mind Map, www.watchingdance.org/Mind_Map/ Interactivemindmap/index.html (Reynolds 2007). Susan Foster's recent publications also explore the relationship of choreography, kinesthetics and empathy (Foster 2011).

formance. Understanding dance as an embodied process also implies the shifting of meaning processes on to the plane of physically structured experience without, however, recurring on the idea of sameness or resemblance on a practical level. It rather is the difference, the un-likeness of embodied processes that prompts the observers to reflection. Aesthetic experience unfolds from a mixed mode of theoretical and practical perception of the object and operates on the basis of difference. Dance performance is thus structured by a dispositif of perception which has physical as well as theatrical aspects. Linked to material conditions, this dispositif is constrained by historically determined ways of arranging and guiding the gaze of the spectator and eliciting affective and interpretive processes, thus articulating a – as Siegmund has shown (Siegmund in this volume) – multidimensional reality in its own right. As an arena where movements are created, arranged in spatiotemporal sequences and integrated into a theatrical order of visibility, dance materializes as a temporally structured event which is, by its nature, transitory. As a dramatic event, a potentially narrative, but doubtlessly compositorial aspect is inherent in any choreography. Most of all, the choreographed hence intentionally designed theatricality of bodies in performance, is ultimately based on an aesthetic transposition of physical movements.

This rather complex, theatrically framed physical disposition of dance has always unfailingly raised the question whether dance is an art genre in its own right with its own distinct perceptual dispositif. Which framework should be applied to describe, analyze and interpret dance? In an aesthetic perspective, the modalities of understanding must be clearly specified: As *what* exactly does dance enter into our perception? Historical as well as cultural norms and dispositions govern our perception according to the sensuous, affective and interpretive paradigms of the time. That means, aesthetics always articulate historically variable methodologies for determining what counts as valid perception or understanding.[3]

In an analogy, this might prove equally true for the semantic relation between 'dance' and 'aesthetics' – for example in the compound 'dance aesthetics.' On the one hand, dance aesthetics means reviewing, analyzing and interpreting dance decoded as a 'genitivus objectives.' As the object of a reflective process, it is being talked and written about, and in that sense, aesthetics involves the objectivation, verbalization and textualization of physical movements and bodies in performance. Dance becomes a reading matter. On the other hand, dance aesthetics can literally signify the reverse, in the sense of the 'genitivus subiectivus.' As

3 Until the 20th century, dance aesthetics followed enlightenment conceptions dating back to the *ballet en action*, assuming that dance was an expressive art form which communicated psychic moods by somatic practices. Jean Georges Noverre's reforms of dancing and ballet introduced aesthetics of presence and established a different order in the 'knowledge culture.' From then on the 'emotionally moving body in motion' became the prominent mode of performance. Its momentary nature made dance into a transitory, ephemeral form of art (Huschka 2009a, 2009b).

the specific quality of dance can never be fully represented in language and since an object-like status of dance is not given because of its transitory nature, 'dance aesthetics' cannot really refer back to an entity, but only to a methodology of describing and analyzing movement techniques, choreography and staging design. In short, dance aesthetics is accomplished by scrutinizing the formal qualities of the dance performance and the kind of knowledge it generates.[4]

Although this distinction introduces a novel perspective on thinking dance, the perceptually relevant question of how art of dance presents itself to us remains unsolved. Yet it becomes all the more important because dance operates under different modalities of understanding,[5] incorporating the 'différance' between knowledge derived from bodies and movements, and knowledge derived from language and texts. If aesthetic experience means opening up to embodied aspects of reflection as access points to the aesthetic, it is important to keep in mind that

"what is being shown in or through the aesthetic object is not what can be understood in the sense of meaning concepts, but what *remains* to be understood (yet never will be) as a consequence of the disintegration of aesthetic communication and understanding." (Menke 1991: 81, translated by B. Seifried)[6]

The concept of kinaesthetic empathy seems promising if we want aesthetic theory to include the physical dimension. It might even revive a modernist utopia, because it brings into focus a transcultural and transhistorical, communicative potential of mankind that bodies in performance can set free (Foster 2011: 14).[7] Defining and understanding dance as kinesthetic experience means steering the attention to a specific perceptual modality that can initiate critical reflection.

4 The distinction between 'genitivus objectivus' and 'genitivus subiectivus' is borrowed from Jörg Huber. Drawing on the semantic presuppositions of genitivus subiectivus, the art critic outlines an epistemology of the visual that rejects the language- and text-based knowledge culture in art. (Huber 2007)

5 "[D]ance studies are always confronted with the epistemological problem of analyzing a dynamic form of art. That means, one must try to get a hold on the transitory, ephemeral, volatile, absent somehow, and fix it, freeze it in order to conceptually grasp it." (Brandstetter/Klein 2007: 12) Cf. Brandstetter 2005.

6 Es geht um die Anerkennung, dass "das im ästhetischen Objekt Gezeigte nicht das [ist], was es im Sinne eines Begriffs ästhetischer Bedeutung zu verstehen gibt, sondern was als Resultat des Zerfalls ästhetischen Verstehens immer erst noch wieder ästhetisch verstanden werden muß (und nie verstanden werden kann)." (Menke 1991: 81)

7 One of the leading research questions is: "Are there ways in which a shared physical semiosis might enable bodies, in all their historical and cultural specificity, to commune with one another? Are there techniques of knowledge production that invite us to imagine the other without presuming knowledge of the other?" (Foster 2011: 14)

Even though the access points to aesthetic understanding are (individual) physical responses to choreographed movements, the difference between self and other, the visible and the palpable, between what can be said and what can only be felt, is never blurred. On the contrary, it is precisely this difference which recurrently prompts further acts of perception and understanding, "that is why we sometimes return to works of art as though to good friends" (Rebentisch in this volume: 95), as Juliane Rebentisch has dry-wittedly remarked in this volume. The crucial question is thus: What is the benefit of introducing kinaesthetic empathy as an approach to aesthetic experience in a dance context?

THE KINAESTHETIC AS A CUE TO THE AESTHETIC – JOHN MARTIN

Current research on kinaesthetic empathy as a sensory-driven approach to knowledge and understanding is firmly rooted in scientific evidence from neuroscience. In comparison, John Martin's aesthetic approach to modern dance seemed much more fanciful, as he himself acknowledges in a comment on his suggestion to use kinaesthetic understanding as a point of departure for aesthetic experience: "When reduced to theoretical statement, all this sounds a little strange and perhaps even esoteric, yet it is simple and eminently familiar in practice" (Martin 1989: 19).[8] Developed from the perceptual concept of 'inner mimicry,' the American dance critic heavily relied on the psychological and kinesiological research of Theodor Lipps or Mabel Ellsworth Todd. In *The Thinking Body*[9] (Todd 1968) Todd points out that observers tend to empathize with motor activities of others, mirroring neuromuscular patterns as though the movements were their own. This imitation seems to reflect a kind of somatic understanding, a subconscious 'movement intelligence,' which would explain many remarkable neurobiological phenomena such as the bodily ability to respond to sensory input from the mental or physical environment by kinaesthetically coordinating balance, muscular tension, gravity orientation and posture. With regard to dance performance and its constitutive feature of physically bringing together dancers and spectators, Martin translates the kinaesthetic experience into a model of understanding: metakinesis is based on an inter-sensorial experience of movements. By physically transposing the muscular tensions of the dancers to the spectators,

8 John Martin (1893–1985) worked as an art critic for the *New York Times* from 1927–1965, before he was appointed professor for dance studies at the University of California in Los Angeles. His most important works include *The Modern Dance*. New York 1965 [1933], where four seminal lectures held at the *New School for Social Research* in 1931 and 1932 were published. See also his *Introduction to the Dance* (1939), reprint: New York 1965. In parts republished in: Martin 1989.

9 During the 1920s and 1930s Todd taught kinesiology and body therapy at the *Columbia University Teachers College* in New York (cf. Todd 1968 [1937]).

the expressive intention of movements is perceived and identified, while motor activities are mirrored and echoed kinaesthetically. On an inter-muscular basis, the emotive content of the movements is thus directly conveyed.

From a dance aesthetics point of view, however, this is only the first step. To be able to qualify the performance, the next step must involve analysis in order to determine its character as art. According to Martin, the compositional structure is the key to the felicitous communication of emotive content.

"He [the choreographer, SH] must organize his material so that it will induce those specific reactions in us that will communicate his purpose. [...] With the desire for communication, then there comes the necessity for form and the beginning of art." (Martin 1989: 24; 59 et seq.)

In a sense, the kinaesthetic is the 'sounding board' of the aesthetic judgment articulated in the formal analysis of the choreography. Dance can only be characterized as art, if the internal disposition initiating the movement is successfully projected as the 'inner mood' of the choreography. Its theatrically framed dispositif of perception is shaped by clear compositional principles and rules. Dance is an arrangement of coherent dramatic and musical elements consisting of spatially dynamic, rhythmical movement sequences and selected phrases and movement motifs, which may only divert in different directions, if the heterogeneous motifs do not occur simultaneously. In brief, it is precisely in the form-giving process of choreographing a performance that the inner motivation structuring the movements manifests itself.

Martin's somatic approach thus prefigures an ultimately universal model of communication that incorporates the kinaesthetic dimension, without, however, offering a theoretical outline of aesthetic experience. What it does take up, though, is the modernist idea of dance as a generic art form in its own right. In the final analysis, dance aesthetics depart from a formal description of the artistic means employed in bodies and movements and their arrangement in time and space, to evaluate dance as a coherent compositional system of motivated movements. In this regard, kinaesthetic perception provides a point of departure for, a cue to further reflective processes and is not merely a subjective experiential moment on the part of the spectator granting his or her participation in the artistic production process. On the contrary, kinaesthetic empathy is a perceptual cue granting reflective access to the artwork, which, by means of metakinesis, reveals the emotive substructures of its choreographic system.

AESTHETIC EXPERIENCE: PASSAGE AND RESPONSE TO MOVING BODIES

If we define dance as the art of movement, then the temporal dimension and its transient mode of expression become crucial to theory construction. Perception and aesthetic reflection take place against the background of a transitory, momentary and quite literally 'passing' form of art. Dance unfolds and elapses in time and is therefore, in the true sense of the Latin word 'transitorius,' "a thoroughfare, proper for passing through" (Wahrig-Redaktion 2009). The temporal and compositional structure of dance contains experiential key moments that – albeit transitory – carry a reflective potential. By stressing that aesthetic experience has its own time that is not chronometrically identical with the duration of a performance or dependent on the physical presence of the recipient, Juliane Rebentisch already points to this important fact (Rebentisch in this volume). The transitory opens up a passage, lets us pass through a transitory moment of experience and reflection, from which aesthetic knowledge can unfold. This would also imply that the perceptive frames and discursive practices structuring the aesthetics of dance are themselves 'thoroughfares' and passages constituting the object of perception against the backdrop of individual. These frames and practices are also performatively created, transient and passing kinaesthetic moments that give rise to meaning and signification processes. In opening up the possibility of 'passing through,' the transitory provides a productive experiential access to knowledge.

Unexpected Horizons of Meaning

KATJA SCHNEIDER

It can be assumed that dance in a theatrical frame enables the interaction of performers and spectators. It is, as Gerald Siegmund points out, "the condition *sine qua non* of aesthetic communication" (Siegmund in this volume: 87). It also can be assumed that theatrical situations are defined in terms of theatrical frameworks basing on cultural agreements. These agreements differ according to cultural, social and artistic contexts. And, last but not least, it can be assumed that dance performance must be understood as a process of materialisation of bodies, movements, energies et cetera and can be understood as a specific aesthetic event and experience.

How do we participate in this specific situation? How is the interference of cognitive, affective and physical dimensions of the reception process cogitable? Hence, I want to outline semiotic and phenomenological approaches to dance not as alternatives to each other but as complementarities.

In my opinion, all elements of a (dance) performance cannot be reduced to the status of a 'given' or emergent materiality/phenomenology but as they are being formatted. On the one hand, rules within and around an aesthetic event can be directed and framed by the art work itself and, on the other hand, they are institutionalised (buying a ticket for example). Moreover – since the avant-garde – it is common practice to break these rules. The body itself has to be seen as culturally formatted as well.

"It is therefore interesting to examine the modalities through which 'materiality' and 'physicality' interact with and are inscribed by language, whereby both leave traces and cause certain effects: how materiality and the body determine semantic and discursive fields and, vice versa, how discourse appropriates the body." (Volli 2002: 366, translated by K. Schneider)[1]

1 "Darum ist es interessant, die Modalitäten zu untersuchen, durch die 'Materialität' und 'Körperlichkeit' mit der Sprache interagieren und von dieser eingeschrieben werden, wobei sie Spuren darin hinterlassen und bestimmte Wirkungen auslösen: in welcher Weise Körper und Materialität semantische und diskursive Felder determinieren und umgekehrt, in welcher Weise der Diskurs sich den Körper aneignet." (Ibid)

According to this, the dance performance is not reducible to being considered phenomenological and material but is marked through cultural attributions: attributions of standards and values. What we consider dance is set up by representations in various media, that means dance is not only given on stage but is present in conceptual frameworks, pictorial and verbal paratexts (cf. Schneider/Frank 2002: 298).

Focusing on the early avant-garde, the paratextual apparatus (discourses, texts, reviews, pictures) constituted a codified 'new dance.' Incidentally, one can observe comparable discursive efforts disseminating and establishing "collaborative choreography as critical practice" (Husemann 2009; Ruhsam 2010) – or in projecting a new definition of "the interplay between dance movement and movement of thinking" (preface by Gabriele Brandstetter and Gabriele Klein in the conference's booklet).

Aesthetic approaches perceive dance as a performative act – both presentation and perception – as much as a cultural institution. The signification process too, is based on perception on the one hand and, on the other hand, on communication between something that is perceived, noticed, sensed, observed and something that is perceptible, noticeable, sensible, observable to the one who perceives on the other hand.

Accordingly, the potential of a performance to generate meaning depends on conditions and possibilities of internal and external contexts and contextualization. Individually experienced reality forms the 'referential context' (Verweisungszusammenhang) of aesthetic perception and experience in the dynamic interplay between (principally) available and conceivable cultural codes. The German term 'Verweisungszusammenhang' implies a semiotic dimension without purposively representing reality, as signs not only represent something else but produce much more than that. In a dynamic process, signs develop differentiations and 'offer' them, as something to see, to hear, to our perception yet are not congruent with perceptions (Rustemeyer 2009: 87). Following the philosopher Dirk Rustemeyer, I understand signs as a dynamic relation, "a distinction that is also a transformation – for instance, of a perception, a concept and an action" (Rustemeyer 2009: 11).[2] Surrounded by media, our perception is as much personal/individual as tinctured with preformed symbolic structures:

"Even the natural body-centered perception is saturated by symbolic and media-related modes of representation. It is not only a perception of something, but always a perception of something as something in something else." (Rustemeyer 2003: 183 et. seq.)[3]

2 "eine Unterscheidung, die zugleich eine Transformation darstellt – etwa von einer Wahrnehmung, einem Begriff und einer Handlung." (Ibid)

3 "Noch die natürliche leibzentrierte Wahrnehmung ist von symbolischen und medialen Repräsentationsmodi imprägniert. Sie ist nicht nur Wahrnehmung von etwas, sondern stets Wahrnehmung von etwas als etwas in etwas." (Ibid)

Within the scope of dance theory, it makes sense to strengthen a semiotically orientated approach as opposed to a philosophical perspective once again. This offers the opportunity to avoid reducing the semiotic approach to the reconstruction of a purported inherent meaning of an artwork, which correlates to a one-dimensional concept of meaning. Usually (in the field of dance studies) semiotic analysis is identified with a fixed meaning, such as denotation, which is rejected.

Yet in the handwritten notes of Ferdinand de Saussure (cf. Saussure 1997), one can find "a performative idea of the sign" (Jäger 2008: 62)[4], because there is "no determining the identity of a sign outside the space of its discursive use in social semiosis. Both the instances and the identity of a sign are dependent upon its use" (Jäger 2008: 56).[5] For this proposition another source is even more relevant: Charles Sanders Peirce's open concept of essential differences can be distinguished from a system of representation. This semiotic approach does not contradict aesthetic experience. On the contrary, it is expandable and can be linked to phenomenological concepts, taking into account the physical and affective dimensions of the reception process. As Rustemeyer reasons:

"The abductive path creates a meaning that is more than a representation of sensory experience. Abductions form new relationships between systems of differentiation that do not need to be denotative in the strict sense. [...] Abductive semiosis 'mediates' not between concept and idea but between shapes both sensual and intelligible." (Rustemeyer 2009: 194 et seq.)[6]

Rustemeyer's concept opens up the function of the sign, making it an 'event' that allows multidimensional links and transitions (Rustemeyer 2009: 19).

Dancing on stage is, as mentioned before, a confrontation or interplay of the body with other, heterogeneous systems of different orders. The orders or codes may be different, the symbolic order they refer to is not. The body and language or image follow "different modes of materialisation" (Siegmund in this volume: 88), but the different formats and perceptions, with their relations and resonances, enable unexpected horizons of meaning. As the meaning is formed in a multicentric way, it can only be perceived and described in terms of multicentricity. The human body does not play against other medialities and materialities, it plays with them. And so does the recipient. This elicits pleasure in the detective

4 "eine performative Idee des Zeichens" (ibid).

5 "keine Bestimmung der Identität des Zeichens ohne den Raum seiner diskursiven Verwendung in der sozialen Semiose. Der Gebrauch ist es, dem sich sowohl die Momente des Zeichens als auch das Zeichen in seiner Identität verdanken." (Ibid)

6 "Auf abduktivem Weg entsteht eine Bedeutung, die mehr ist als eine Repräsentation der sinnlichen Erfahrung. Abduktionen bilden neue Beziehungen zwischen Unterscheidungs-systemen, die selbst nicht im engeren Sinne denotativ sein müssen. [...] Anstatt zwischen Begriff und Anschauung 'vermittelt' die abduktive Semiose zwischen Formprofilen, die sowohl sinnlich fundiert als auch intelligibel sind." (Ibid)

work of searching for inter- and intratextual traces, as Gerald Siegmund explains by referring to French poststructuralist thinking. It also confronts the recipient with a huge variety of emotions, reminiscences and connotations that are individual, but not random.

The interferences evoke spaces of possibilities beyond dichotomies or oppositions like logos and affect, representation and non-representability. And it is here that the opportunity presents itself to blend emotionally invested thinking with reflective participation without being inextricably entwined in an event. In taking that to mean aesthetic experience, perception and reflection constantly correct, confirm or reject each other, and produce sense loops. In this respect the performance situation arises from the interaction between the theatrical event and the recipient. Simultaneously the self-reflexive configuration of the performance is accompanied by an encounter with oneself, a concurring reflexivity of the audience. A reflexion, which elicits the wealth of possibilities, the artwork – the perceiving, thinking and describing – has. Accordingly, a potentiality of aesthetic experience would be the poetic act of the practice of observing oneself.

Parallel Universes and Aesthetic Dis/Balance: Theory Interrupted, Dance Distracted

RESPONSE BY KATHERINE MEZUR

"It is not only the attention that is distracted; the image of the body in movement is also distracted, displaced and criss-crossed by fissures of reflection. Kleist's *Marionette Theatre* is a text on crises of categorisation in the relationship between (dance) praxis and theory. Balance and dis/balance in these (changing) relationships are no longer controllable – and perhaps therein lie the fascination and potential of a relationship between both *in* motion." (Brandstetter in this volume: 207)

"Choreography is crisscrossed by lines of flight and perforated by unpredictable practices. What is adventured in beauty is a boundless extension of what is presentable and indefinite ways of how bodies can be presented. The aesthetical adventure, unlike so many new techniques and styles that captured dance in modernity, leads toward irregular revolutions of choreography." (Hölscher in this volume: 105)

The panel *Aesthetic* struggled with the many fissures and crises between dance and theory. This panel worked brilliantly with the 'dis/balance.' Gabriele Brandstetter's examples of Beckett's Pozzo and Lucky of *Waiting for Godot* and Kleist's *On the Puppet Theatre* drive what she calls the 'dis/balance' of the aesthetic and political of dance and theory. Brandstetter's examples are difficult and even violent or cruel when we think of puppets and the yoke that makes Lucky jump and dance like a puppet (Brandstetter in this volume). But here our dance and theory negotiation with the aesthetic must be violent, because we have so much at stake. Brandstetter's thesis can be seen as a subtext or background to the aesthetic panelists' dis/balancing and interruptions: that we are implicated in these acts of the aesthetic.

Participants never complacently approached a balance of aesthetic theory and dance, but instead, vigorously engaged with the complex dynamics of their crisscrossed interactions. 'Betweenness' stands out as a noteworthy concept of dis/balance and as a resonant claim of many panelists: that somehow clarity on aesthetics and dance is really not possible. That traversing among modern, post-modern, neo-colonialism, even the post-dramatic makes any progress impossible unless we truly break away from certain vocabulary, theorists, and even certain

dance forms. But this panel worked beyond the easy oppositions, the comfortable hybrids; instead they ripped open the 'betweenness.' This is not safe territory, and there is still a lot of debris to clear. How do we get to what Juliane Rebentisch names "aesthetic participation" (Rebentisch in this volume: 90), which suggests a very direct way of engaging *Dance [and] Theory*?

I would like to write this 'aesthetically' and use some kind of disappearing ink or digital transparency that would dissolve my words over the quotes I have chosen to re-iterate these dance theorists' concerns. I would like to communicate the sense of how aesthetic theory or theories of aesthetics or dance/theory/aesthetics kick, twist, bind, and slip with and through each other (not unlike a tango couple). This response is not an easy dance of aesthetics-theory-movement. I will begin with my own thoughts to position my response that follows.

NO TO THEORY WITHOUT LABOR

I think what is at stake here is the productive tension between aesthetic theory and dance, which are both imbedded in our diverse, dynamic, and mostly violent world. Before I can adequately reflect on the panel papers, I have to state my position in relation to the dance and the theories we are 'working' here. First, I think theory has to 'work.' That is, the writer of aesthetic theory must show the labor of the theory in its relationship to the movement, forms, and bodies of the dance under analysis. Thus, Gabriele Brandstetter works Kleist's puppet example, changing it, manipulating it, working it into a new configuration with contemporary dance. They meet in theory. I work in several worlds of dance: I am a choreographer and dramaturge of mixed forms, dance theatre and new media. I physically study ballet and butoh. My research spans Asian traditional and contemporary dance theatre forms. My area of concentration is in Japanese contemporary performance, dance theatre, and new media. The dances I study are not on the agenda here, and neither are the theories they require, which must reflect the overlapping of Euro-American aesthetics with Japanese-based visual and kinaesthetic theories. Having studied dances in Indonesia, China, Japan, Korea, and in the United States, I physically understand what aesthetics and dance mean, and how they function is terribly specific, local, and 'naturalized' in that context of that locality of time and space. I would suggest that every essay, no matter how clearly written, gives some explanation of the specific dance culture to which they are referring in the theory and/or analysis section. I think we need to clearly position our papers, dances, and theories, making no assumptions that the aesthetic or the dance or our voice is inclusive.

Aesthetic theories (plural) and dances (plural) move together, define each other, break away from each other, and die off together. To really discuss and question and shed light on this relationship, I think we need to work with examples, with the actual stuff of the dance, or the theory, the dancing bodies in the

place, the time, and the moment of the dance right in front us and the theory opened up and situated. The papers of this panel, by and large, assume a shared sense of 'aesthetics' and 'dance.' For me, this is a problem that could be easily resolved by naming and weaving, literally, the sentences concerning aesthetics with the dances themselves. I do not belief in a 'world' dance approach, but I think the specific example must be worked and pressed into a kind of theoretical labor, making the dance show what it does and theory illuminate its own biases and strategies. I am left wondering if we assume that Euro-American concert dance is the 'Dance.' This 'Dance' is often related to a narrow regime of aesthetics that assumes a kind of pure body, a young body, a drilled, and technically perfect body, and a body with the consciousness of utter devotion to the discipline of this aesthetic movement, no questions asked.

Aesthetic theory [and] with dance can move from this generalizing sense to a diverse and provocative act of critical inquiry. I think 'aesthetics' should launch questions and flurries of 'what ifs?' and the taste and temperature of the bodies and movement itself need to be present in a description or reference, dance, forever carnal and messy, deceptive and disruptive, articulating the ends of life, before it has slipped away, and aesthetics, at once so nuanced and singular. Both can leave us breathless and moved, however differently, painfully and with labor.

THE FRAMING

I would like to frame this panel, with the challenge, that this be a daring discussion, according to Brandstetter's and Klein's challenge from the introduction, that we should risk, experiment and even disorder our ways of working with dance and theory (Brandstetter/Klein in this volume: 12).

When Brandstetter/Klein used the example of the dance scholar from Thailand, who stated that theory was always already present or embedded in the dance, she moved beyond the hegemony of Western theories and asked the question: "How is theory – in different historical, cultural and aesthetic modes – inscribed in dance? Which borders, transfers, zigzags within the fields of practice/performance and theory are part of the contemporary discourse in and around dance?" (Brandstetter/Klein in this volume: 11)

I will keep this in the background as a reminder that we are indeed positioned in the Western space of theory and dance and that we are experimenting and risking, taking chances with new ways of thinking dancing. We take Brandstetter's and Klein's challenge to de-rail our careful routes and take a zigzag or spin, fall, and look at the world differently because these papers challenge any comfortable or fixed aesthetic.

The shared thematic among the aesthetic panelists was the interweaving of the political and the aesthetic. Our negotiations with dance and the aesthetic must be violent and passionate because we have so much at stake. Our dis/balancing and interruptions implicate us all in this struggle. The panel's collective 'aesthet-

ic' moment, caught now in texts, reflects the chaotic, disparate, and fragmented notions of 'beauty' in our twenty-first century climate of violence, surveillance, and connectivity. Within the papers and the discussion there was a sense of unease and dissatisfaction. Perhaps many un-asked questions between the stated arguments remained hanging in the air. They did not set up a new aesthetic vista for dance studies. Instead they propelled our inquiry forward into the unknown. The panel did the work, the real labor of pushing aside older ideas and showing how certain modern aesthetic theories are inadequate and contemporary 'social performative aesthetics' are also lacking. While the presenters laid out the field of aesthetic dance theory, we only briefly moved into possible methods for aesthetic inquiry. Perhaps the problem is that we work with the past to move forwards. We might dare ourselves to start with the new questions, which arise in the dance we have just seen? Perhaps the vortex of this panel was in the questions and comments surrounding aesthetics. Perhaps the 'aesthetic turn' of this panel starts the action of a whirlpool or tornado: swirling and pressing bodies of information together and apart. We engaged in spinning off the excess about *Dance [and] Theory* to get to the materials of praxis and its reception.

In the following examples of the in-motion actions of the aesthetic and dance, I focus on only a few of our many rich and provocative encounters. My response reflects my participation in the moment of listening and choosing the ideas that press and agitate between and among the different scholars. This is not a close reading, instead it is an immersion into the dynamics between their voices, which will resound and compliment and add to the final outcome of this live gathering, now translated into text. I am honored to be with the live and text presences of Stefan Hölscher, Sabine Huschka, Krassimira Kruschkova, Juliane Rebentisch, Katja Schneider, and Gerald Siegmund. Gerald Siegmund set the frame for this panel and we will hear/see the resonances of his outline throughout my encounter/response.

I wish to make one comment on the condition that the papers were delivered in German and in this volume they are in English. The two versions are different. My commentary joins both the live panel performance and the post-show texts, but without the German this is inadequate. I am reminded of how languages work differently in speech and writing: how their structures of arguments, evidence, and conclusions are particular to each language. When all papers were delivered in German, they shared this commonality of German language rhythm and logic. The experience of the live presentations was dense and driven by the careful nuanced differences in the ways that dance and 'the aesthetic' are articulated and then make meanings. In the live presentation, there was little time for questions and response and that was given to the presenters. These rich, banquet-like papers, created an atmosphere of reflection and hesitation, because each presenter was asking for a shift and expansion of 'aesthetic' across a minefield of social, cultural, political, and philosophical contingencies within any contemporary 'dance.' While I caught glimpses of meaning and arguments in the German presentations, reading the papers in English provides another and more explicit

encounter with our theme of *Dance [and] Theory*. I enjoyed the gaps in my understanding and the mixture of media: in print and in memory.[1]

VOICES AND THEIR PROVOCATIONS

Gerald Siegmund's contribution, *Aesthetic Experience*, begins by foregrounding reception focusing on the interaction of physical and affective responses and challenges everyone to consider the workings of critical aesthetic theory, which is porous to contexts and experience. (Siegmund in this volume). Siegmund then outlines the divisions between aesthetic arguments that have dominated since the 1960s. The papers sometimes echoed his points and then sometimes ran vicariously in different directions. One of the shared premises was that all the presenters were thrilled to focus on aesthetics and dance, without any apologies. Everyone 'worked' dance and aesthetics, with muscle to the bone. Each person cared deeply about this interplay, contradiction, and volatility of theory and aesthetic and dance in performance. The intensity of our own thinking hardly left space for commentary between papers. Each presenter took us on a journey with ghosted bodies in dances running alongside and interacting with Gerald Siegmund's double edged aesthetic act that is simultaneously a vibrant dance practice and a social act, which may appropriate, transgress, and create new scales of art and consciousness.

Perhaps everyone should let himself or herself be driven into a variety of time/space/thought collisions. There is no order of priority or narrative intended among these voices. Welcome to the new radical dance planet, the panel of aesthetic collisions. Stefan Hölscher's text begins with this challenge that we can only go beyond the established dance making and its associated rules to the unknown (Hölscher in this volume). This is complicated by Katja Schneider's idea of the sense looping of perceiving and reflecting and her sense of how meanings arise from the implosion of multiple inputs from multiple sources. Here, dancing bodies, medialities and materialities interact with each other (Schneider in this volume). Juliane Rebentisch, however suggests that these expanded and variegated valences of acts and theories might also be questioning the premise of any aesthetic system or discipline (Rebentisch in this volume).

Perhaps if this panel could be conceived of as a choreography, we can best encounter this shake-down of aesthetics 'with' dance. There is this constant interplay of tension in the triangulation of sensual, contextual, and theoretical. Sab-

1 'Betweenness' stands out as a noteworthy concept of dis/balance and as a resonant claim of many panelists: that somehow clarity on aesthetics and dance is really not possible. That traversing among modern, postmodern, neo-colonialism, even the post-dramatic makes any progress impossible unless we truly break away from certain vocabulary, theorists, and even certain dance forms. But this panel worked beyond the easy oppositions, the comfortable.

ine Huschka suggests a turn to empathy and the witnessing through the body (Huschka in this volume).

Huschka opened up the 'passing' of dance and aesthetics: First and foremost, theory here in its 'aesthetic turn' is in motion. I would consider that these scholars' works are also in motion, as they were in the roundtable, weaving in and out of each other, interrupting each other and sometimes urging each other on, further, without pause. Huschka added how the sensuous and discursive are also 'thoroughfares' perhaps foregrounding their dynamic relationship to the movement and transience of kinaesthetic moments in the danced process of signification. (Huschka in this volume: 113). Krassimira Kruschkova delightfully trips over the '[and]' between *Dance [and] Theory* and recommends the more inclusive 'with,' "a disjunctive togetherness" (Kruschkova in this volume: 97). We could keep going and see how Kruschkova dances 'with.' Because these simple parts of speech, these seemingly unremarkable prepositions like 'with' clearly state a relationship, Kruschkova emphasis on 'with' allows the earlier congestion of aesthetic oppositions and tensions to act alongside each other or 'with each other.' 'With' keeps the resistance of theory and practice moving productively, Kruschkova's example of the visceral laugh that reverberates through bodies, takes us to where bodies and ideas meet in parallel projects:

"Laughter as embodied disarticulation, as a tension between language and body, between figuration and literacy in disjunctive practice and theory, [...] marks the vibrating aesthetic interval between the parallel worlds to which we funny people simultaneously belong." (Ibid: 99)

Perhaps these bodily acts of laughter rip open the discursive 'veil' and suggest much more could be done with such corporeal gestures. Kruschkova also dealt with the concept of spectral bodies, which reoccurs in other presentations. I do not want to forget it as it is a reminder of the many questions still floating across all these presentations.

I keep wondering how dances and their makers would respond to these theories. Writing the theories comes after the dances. These theories slip like loops and knots around the dance event or materialization of the dance. So here we find the impossibility of any simple aesthetic 'with': for dance with the aesthetic? Kruschkova argues for a discontinuing and indecidability and more ...but does this leave us in another limbo? How much *Dance [and] Theory* continues to toss and turn might become productively entangled. Like Kruschkova, I also think that dancers use aesthetic theory in practice, but there are holes or 'blind spots' in what dance and the aesthetic do to each other. Sometimes the theory dances, and I might argue in the 'with' mode that we are still blocked in theory from what we can dance. That is the Kruschkova's 'touching interruptions and interrupted touches' and 'bindingness and vulnerability' are already in practice, but only partially in our articulations.

During the panel meeting, one could feel the shock of the differences among the scholar's passionate articulations. While they had some idea of each paper's content and the author's earlier scholarship, this was the first time they had the live, out loud, performed concepts and arguments crashing next to each other in live space and time. Even when there were polite disagreements and some repetitions, the fissures between the aesthetic and 'aesthetic and dance' created something like a topographic map with ghosted figures of spectators and performers.

Sabine Huschka went directly to the debate of the kinaesthetic and suggests a "practice-formed" theorization for "the potential of the kinaesthetic to open up a pathway to aesthetic research that critically reflects dance as an embodied process" (Huschka in this volume: 109). While Huschka takes us to this meeting of kinaesthesia and event, what I still question is the overuse or misuse of the theatrical and its proscenium, deployed by Siegmund, in our contemporary dance aesthetics debate. Of great importance is how Huschka emphasizes the shaping of the perception that many assume and how she shapes this into a kind of formula for a dance aesthetic 'experience' process. Again, we meet the material but with still another regulating process, the theatrical.

Katja Schneider, along with others, dives into the experience and materiality foray of bodies, experience, and codes. She emphasizes how the body is "culturally formatted" (Schneider in this volume: 166). Schneider calls on Ugo Volli's ideas of materiality and physicality, which indicates how powerful these are in how much and how often they are appropriated. This reminds me again of how 'with' might activate this discourse with material bodies. Schneider focuses on semiotics and perception in performance but especially in the contexts of performance. Schneider brought forward one of the most important problems for this contemporary aesthetic turn. In our constant state of 'migration,' we have to be constantly aware Schneider's "'referential context' (Verweisungszusammenhang) of aesthetic perception and experience in the dynamic interplay between (principally) available and conceivable cultural codes" (ibid: 116). While I often feel like an outsider in my studies of Asian artists in and out of Asia, I wanted to add to this 'referential context' the comments of the dancer and choreographer Faustin Linlekula, who asks himself, "Where am I from? Which Congo? When?" or Yuko Kaseki, "I live in Berlin, but I am from Japan." Even the contexts of the dancing bodies are not fixed in all these theories in motion. Their materiality of place or nation is unfixed. Further, in contemporary communication, new media has intervened with our perception of our material contexts, and the very materiality of the perceiving body.

Stefan Hölscher also suggests that the 'aesthetic' is something that is returning to power, if differently, and challenges with some of Rancière's 'dissensual moment.' I am always asking 'whose aesthetics?' just as 'whose politics?' While I may see the arguments between the autonomous and the implicated in the material conditions aesthetic streams as sincerely part of a Western European and North American discursive history, it is very difficult to not question assumptions outside of these narrow spaces of the 20th century aesthetic highways. For

example, especially in dance, where do we put the aesthetic 'preservations' of South Indian dance forms like Bharatanatyam, which is an invented re-invention of a traditional dance? Or what do we do with 'autonomy' of an art work when we see 'Classical' Chinese Dance of the 21st century, which is deeply embroiled in its own archaeological dig for Chineseness in gesture and form in the pre-communist dynasties? How does collective aesthetics fit into the always West-ern-based 'beauty' paradigms? Perhaps we could go back to Siegmund's "inter-ference effects" as another simultaneous connection. Siegmund's emphasis on "the performativity and processuality of art" reverberates here again and again (Siegmund in this volume: 84). I suggest that this spectator/listener/roamer with her or his multimedia interferences, and yes, her or his material contexts of place, time, and corporeality could actually amplify the interference, productively. I keep wondering if it is the time and place of contextual futures or even aesthetic futures.

Or could we take up Siegmund's use of Umberto Eco's, *The Open Work* to get at aesthetic experience differently? What is it like to be 'radically open' in our present surveillance society? Of course I love the idea of "a fabric with loose ends embedded in the ever changing structures of the real world, never identical with itself." (ibid: 85) But is this possible?

Going back to the underlying debate, Rebentisch restates the modernist 'au-tonomy' argument and contrasts this modernist gridlock with another theoretical shift in which, yet another sublation, this time art into life, takes place and as Re-bentisch writes, "cements" differences that stagnate any of our aesthetic move-ment 'with' dance (Rebentisch in this volume: 90). Rebentisch takes us further into the explicit politics of aesthetic experience by naming the universalism of modernist aesthetics. Perhaps here when Rebentisch makes the aesthetic act the action of art, she does what we have been waiting for: "a change in conscious-ness that may spill over into political attitudes." She says this doesn't mean there "it breaks with our finite worlds" (ibid: 91), but I would go further and press her to consider how art and art makers must 'break' and re-invent reality.

I will end with an example taken from Juliane Rebentisch. I will imagine Stefan Hölscher responding to it. Rebentisch offers the example of Xavier Le Roy's 'Butoh-work' *Product of other circumstances* (2009), in which Le Roy dances an "insect, [...] a tender blossom, a mesmerizing diva – his body swollen with meaning" (ibid: 93). Here, I would intervene and argue along with Hijikata Tatsumi, a famous Japanese Butoh creator, that that the spectral, kinaesthetic, spiritual, and discursive may indeed 'break' into something else at these mo-ments when desire expands the physis of the body. (Baird 2012: 51, 103) Putting this next to Hölscher's use of Rancière's dissensual moment, I suggest that with this expanded physis of Le Roy, we encounter what Hölscher keeps demanding. We must be not on the edge but beyond it, where Le Roy (like it or not) silences his shivering skin (Hölscher in this volume).

Perhaps the 'aesthetic' in all these presentations is an act of intervention, an act of shaking. Perhaps I could suggest, like Kleist's *Marionettentheater* and

Beckett's Pozzo, that dance with the aesthetic are moving, parallel universes, which may collide or intersect, or undermine each other. One is not without the other, but in motion, and always in dis/balance. Unfortunately, the papers had to end, with the expectation and agitation of the in-complete, aesthetic act. I keep thinking of William Forsythe's *Three Atmospheric Studies*, where in the second act, a performer keeps trying to tell her story but she is interrupted and interrogated over and over again. It is shocking: her story, her shivering speech, her realization, her shaking and vibrating: her aesthetic act thickens the air we breathe, the breath, our living tissues 'break with.'

References

Adorno, Theodor W. (1970): *Ästhetische Theorie*, Frankfurt am Main: Suhrkamp.

—— (1984): *Aesthetic Theory*, London and New York: Continuum.

—— (1991 [1953]): "The Artist as Deputy." In: Id., *Notes on Literature*, vol. I, New York: Columbia University Press, pp. 98-108.

Agamben, Giorgio (1993): *The Coming Community*, Minneapolis: University of Minnesota Press.

Baird, Bruce (2012): *Hijikata Tatsumi and Butoh, Dancing in a Pool of Gray Grits*, New York: Palgrave MacMillan.

Banes, Sally (1998): *Dancing Women. Female Bodies on Stage*, London and New York: Routledge.

Barthes, Roland (1974): *Die Lust am Text*, Frankfurt am Main: Suhrkamp.

—— (1975): *The Pleasure of the Text*, New York: Ingram International.

—— (1976 [1970]): *S/Z*, Frankfurt am Main: Suhrkamp.

—— (1990 [1970]): *S/Z*, Oxford: John Wiley & Sons.

Benjamin, Walter (2002): *Selected Writing*, Howard Eiland/Michael W. Jennings (eds.), Cambridge: Harvard University Press.

Blanchot, Maurice (1988): *The Unavowable Community*, Barrytown: Station Hill Press.

Booth, Wayne C. (1961): *The Rhetoric of Fiction*, Chicago/IL: Univ. of Chicago Press.

Bourriaud, Nicolas (2002 [1998]): *Relational Aesthetics*, Dijon: Les presses du réel.

Brandstetter, Gabriele (2005): *Bild-Sprung. TanzTheaterBewegung im Wechsel der Medien*, Berlin: Theater der Zeit.

—— /Klein, Gabriele (2007) (eds.): *Methoden der Tanzwissenschaft. Modellanalysen zu Pina Bauschs "Le Sacre de Printemps,"* Bielefeld: transcript.

—— (2011): *Tanz und/als/aber/in/aus Theorie*, Konferenzflyer.

Bubner, Rüdiger (1989): "Über einige Bedingungen gegenwärtiger Ästhetik." In: Id., *Ästhetische Erfahrung*, Frankfurt am Main: Suhrkamp, pp. 9-51.

Burgin, Victor (1986): "The Absence of Presence: Conceptualism and Postmodernism." In: Id., *The End of Art Theory. Criticism and Postmodernity*, London: Palgrave Macmillan, pp. 29-50.

Cvejić, Bojana (2009): "Schnittverfahren und Mischungen." In: tanzjournal Vol. 5/2009, p. 29.

Deleuze, Gilles (1984): *Kant's Critical Philosophy*, London: The Athlone Press.

────── /Guattari, Félix (1994 [1991]): "Percept, Affect, and Concept." In: Id., *What is Philosophy?*, London and New York: Verso, pp. 163-199.

────── (1996): "Perzept, Affekt und Begriff." In: Id., *Was ist Philosophie?*, Frankfurt am Main: Suhrkamp 1996, pp. 191-237.

Deleuze, Gilles/Parnet, Claire (1987): *Dialogues*, trans. Hugh Tomlinson/Barbara Habberjam, New York: Columbia University Press.

Derrida, Jacques (1994 [1993]): *Specters of Marx: The State of the Debt, the Work of Mourning, and the New International*, New York: Routledge.

────── (1997): *Politics of Friendship,* New York: Verso.

────── (2002): *Le Toucher: Jean-Luc Nancy*, Paris: Galilée.

Dewey, John (1987): *Kunst als Erfahrung*, Frankfurt am Main: Suhrkamp.

────── (2005 [1934]): *Art as Experience*, New York: Perigee Trade.

Eco, Umberto (1989 [1962]): "The Poetics of the Open Work." In: Id., *The Open Work*, Cambridge, Mass.: Harvard University Press, pp. 1-23.

Etchells, Tim (2001): "Not Part of the Bargain. Notes on First Night," Forced Entertainment Contextualising Pack, June 29, 2012, (http://www.forced entertainment.com/page/144 /First-Night/92#-readmore).

Felsch, Philipp (2011): "Homo Theoreticus." In: Azzouni, Safia/Brandt, Christina/Gausemeier, Bernd/Kursell, Julia/Schmidgen, Henning/Wittmann, Barbara (eds.), *Eine Naturgeschichte für das 21. Jahrhundert. Hommage à Hans-Jörg Rheinberger,* Berlin: Max-Planck-Institut für Wissenschaftsgeschichte.

Fischer-Lichte, Erika (2001): *Ästhetische Erfahrung*, Tübingen: Francke.

Forsythe, William (2007): "Three Atmospheric Studies," Berkeley: CAL Performances, Zellerbach Auditorium.

Foster, Hal (2002): *The Anti-Aesthetic. Essays in Postmodern Culture*, New York: New Press.

Foster, Susan Leigh (1986): *Reading Dancing. Bodies and Subjects in Contemporary American Dance*, Berkeley, Los Angeles and London: California Univ. Press.

────── (1998): "Danses de l'écriture, courses dansantes et anthropologie de la kinesthésie." In: Littérature, La littérature et la danse 112 (12), pp. 100-111.

────── (2011): *Choreographing Empathy. Kinesthesia in Performance*, London and New York: Routledge.

Foucault, Michel (1971): *The Order of Things. An Archaeology of the Human Sciences*, New York: Pantheon Books.

Gadamer, Hans-Georg (2004 [1960]): *Truth and Method*, London: Continuum.

García Düttmann, Alexander (2009): "QUASI. Antonioni und die Teilhabe an der Kunst." In: Neue Rundschau 4, pp. 151-65.

Gareis, Sigrid/Kruschkova, Krassimira (2009) (eds.): *Ungerufen. Tanz und Performance der Zukunft/Uncalled. Dance and performance of the future*, Berlin: Theater der Zeit.

Greenberg, Clement (1961): "Modernist Painting." In: Arts Yearbook 4, New York: Art Digest, pp. 103-108.

Hewitt, Andrew (2005): *Social Choreography. Ideology as Performance in Dance and Everyday Movement*, Durham and London: Duke Univ. Press.

Huber, Jörg (2007) (ed.): *Ästhetik der Kritik oder Verdeckte Ermittlung*, Zürich: Edition Voldemeer, pp. 95-108.

Huschka, Sabine (2009a): "Kompositorische Ordnungen der Affekte im ballet en action. Zur Wirkungsästhetik bei Jean Georges Noverre und Gasparo Angiolini." In: Jens Roselt/Clemens Risi (eds.), *Koordinaten der Leidenschaft*, Berlin: Theater der Zeit, pp. 51-77.

————— (2009b): "Szenisches Wissen im ballet en action. Der choreografierte Körper als Ensemble." In: Id. (ed.), *Wissenskultur Tanz. Historische und zeitgenössische Vermittlungsakte zwischen Praktiken und Diskursen*, Bielefeld: transcript, p. 35–54.

Husemann, Pirkko (2009): *Choreographie als kritische Praxis: Arbeitsweisen bei Xavier Le Roy und Thomas Lehmen*, Bielefeld: transcript.

Iser, Wolfang (1980): *The Act of Reading. A Theory of Aesthetic Response*, Baltimore: Johns Hopkins Univ. Press.

————— (1984): *Der Akt des Lesens. Theorie ästhetischer Wirkung*, München: Fink.

Jäger, Ludwig (2008): "Aposème und Parasème: Das Spiel der Zeichen – Saussures semiologische Skizzen in den 'Notes.'" In: Zeitschrift für Semiotik Vol. 30/1-2, pp. 49-71.

Jauss, Hans Robert (1970): *Literaturgeschichte als Provokation*, Frankfurt am Main: Suhrkamp.

————— (1982a): *Ästhetische Erfahrung und literarische Hermeneutik*, Frankfurt am Main: Suhrkamp.

————— (1982b): *Aesthetic Theory and Literary Hermeneutics*, Minneapolis and London: Univ. of Minnesota Press.

Jonson, Pauline (1987): "An Aesthetics of Negativity/An Aesthetics of Reception: Jauss's dispute with Adorno." In: New German Critique No. 42. (Autumn), pp. 51-70.

Kristeva, Julia (1977): *Polylogue*, Paris: Seuil.

————— (1978): *Die Revolution der poetischen Sprache*, Frankfurt am Main: Suhrkamp.

————— (1984): *Revolution in Poetic Language*, New York: Columbia Univ. Press.

Küpper, Joachim/Menke, Christoph (2003) (eds.): *Dimensionen ästhetischer Erfahrung*, Frankfurt am Main: Suhrkamp.

Le Roy, Xavier (2005): "Product of Circumstances." In: Klein, Gabriele/Sting Wolfgang (eds.): *Performance. Positionen zur zeitgenössischen Kunst*, Bielefeld: transcript.

Lehman, Hans-Thies (1999): *Postdramatisches Theater*, Frankfurt am Main: Verlag der Autoren.

———— (2006): *Postdramatic Theatre*, New York: Routledge.

Lipps, Theodor (1903/1906): *Ästhetik. Psychologie des Schönen und der Kunst*, Hamburg: Voss.

Lotman, Jurij M. (2010): *Die Innenwelt des Denkens: Eine semiotische Theorie der Kultur*, Berlin: Suhrkamp.

Lyotard, Jean-François (1994): *Lessons on the Analytic of the Sublime*, Palo Alto/CA: Stanford Univ. Press.

Man, Paul de (1982): *Allegories of Reading*, Yale: Yale University Press.

———— (1993): *The Resistance to Theory*, Minneapolis: University of Minnesota Press.

Martin, John (1965 [1933]): *The Modern Dance*, New York: Princeton Book Company.

Martin, John (1989): *Dance in Theory*, New York: Princeton Book.

Massumi, Brian (1998): "Deleuze, Guattari, and the Philosophy of Expression." In: The Canadian Review of Comparative Literature Vol. 24/No 3, March 9, 2011 (http://www.anu.edu.au/HRC/first_and_last/works/ crclintro.htm).

Menke, Christoph (1991): *Die Souveränität der Kunst: ästhetische Erfahrung nach Adorno und Derrida*, Frankfurt am Main: Suhrkamp.

Mukařovský, Jan (1989): *Kunst, Poetik, Semiotik*, Frankfurt am Main: Suhrkamp.

Nancy, Jean-Luc (1996): *Being Singular Plural*, Stanford: Stanford University Press.

———— (2003): "The confronted Community." In: Postcolonial Studies 6 (1), pp. 23-36.

———— (2008): *Corpus*, Fordham: Fordham University Press.

Rancière, Jacques (2006a): *Die Aufteilung des Sinnlichen. Die Politik der Kunst und ihre Paradoxien*, Berlin: b_books.

Rancière, Jacques (2006b): *Politics of Aesthetics. The distribution of the sensible*, London: Continuum.

Rebentisch, Juliane (2011): "Über die Allianz von Anti- und Erfahrungsästhetik." In: Texte zur Kunst 21, pp. 112-115.

———— (2012a): "Participation in Art: 10 Theses." In: Alexander Dubadze/Suzanne Hudson (eds.), *Contemporary Art: 1989 to the Present*, West Sussex: Wiley-Blackwell, forthcoming.

———— (2012b [2003]): *Aesthetics of Installation Art*, Berlin: Sternberg.

Reynolds, Dee (2007): *Rhythmic Subjects. Uses of Energy in the Dances of Mary Wigman, Martha Graham and Merce Cunningham*, Alton, Hampshire: Dance Books.

Ruhsam, Martina (2011): *Kollaborative Praxis: Choreographien. Die Inszenierung der Zusammenarbeit und ihre Aufführung*, Wien: Turia + Kant.

Rustemeyer, Dirk (2003): "Medialität des Sinns." In: Id. (ed.): *Bildlichkeit, Aspekte einer Theorie der Darstellung*, Würzburg: Königshausen & Neumann, pp. 171-194.

———— (2006): *Oszillationen. Kultursemiotische Perspektiven*, Würzburg: Königshausen & Neumann.

———— (2009): *Diagramme. Dissonante Resonanzen: Kunstsemiotik als Kulturtheorie*, Weilerswist: Velbrueck.

Sabisch, Petra (2011): *Choreographing Relations – Practical Philosophy and Contemporary Choreography*, München: e_podium.

Saussure, Ferdinand de (1997): *Linguistik und Semiologie. Notizen aus dem Nachlaß. Texte, Briefe und Dokumente*, Gesammelt, übersetzt und eingeleitet von Johannes Fehr, Frankfurt am Main: Suhrkamp.

Scarry, Elaine (1999): *On Beauty and Being Just*, Princeton: Princeton Univ. Press.

Schiller, Friedrich (2004): *Letters Upon the Aesthetic Education of Man*, trans. Elizabeth M. Wilkinson/L.A. Willoughby, Whitewish: Kessinger.

Schneider, Katja/Frank Gustav (2002): "Tanz und Tanzdebatte der Moderne als Voraussetzungen für Leni Riefenstahls *Das blaue Licht* (1932)." In: Gabriele Klein/Christa Zipprich (eds.), *Tanz Theorie Text*, Münster: LIT, pp. 289-311.

Siegmund, Gerald (2006): *Abwesenheit. Eine performative Ästhetik des Tanzes. William Forsythe, Jerome Bel, Xavier Le Roy, Meg Stuart*, Bielefeld: transcript.

Šklovskij, Viktor (1971): "Die Kunst als Verfahren." In: Jurij Strieder (ed.), *Russischer Formalismus*, München: Fink, pp. 5-35.

———— (1994): "Art as Technique." In: Robert Con Davis/Ronald Schleifer (eds.), *Contemporary Literary Criticism. Literary and Cultural Studies*, New York and London: Guilford Publications, pp. 260-272.

Sontag, Susan (1989): "Happenings: Die Kunst des radikalen Nebeneinanders." In: Susan Sontag, *Kunst und Antikunst*, Frankfurt am Main: Fischer.

———— (2009 [1967]): "Happenings: An Art of Radical Juxtaposition." In: Susan Sontag, *Against Interpretation*, London: Penguin.

Thomas, Brook (1982): "Reading Wolfgang Iser or Responding to a Theory of Response." In: Comparative Literary Studies 19, pp. 54-66.

Todd, Mabel E. (1968 [1937]): *The Thinking Body. A Study of the Balancing Forces of Dynamic Man*, Princeton and New Jersey: Dance Horizons.

Volli, Ugo (2002): *Semiotik. Eine Einführung in ihre Grundbegriffe*, Basel: UTB.

Voss, Christiane (2004): *Narrative Emotionen: Eine Untersuchung über Möglichkeiten und Grenzen philosophischer Emotionstheorien*, Berlin: De Gruyter.

Wahrig-Redaktion (eds.) (2009): *Wahrig, Herkunftswörterbuch*, hrsg. von der Wahrig-Red., Gütersloh [u.a.]: Bertelsmann (www.wissen.de).

Whitehead, Alfred North (1987): *Process and Reality*, New York: The Free Press.

LECTURE

Dance Theory as a Practice of Critique

GABRIELE KLEIN

Since the 1990s, the notion of dance and/or choreographic practice[1] as critical practice has played a major role in dance studies. Pirkko Husemann's description of artistic methods of working as critical practice (Husemann 2009), Susan Foster's theorem of embodied politics i.e. the politics of embodiment (Foster 1996; 2002), Randy Martin's theory of mobilisation (Martin 1998) or André Lepecki's topos of kinaesthetic politics (Lepecki 2006) are all prime examples of this tendency.

All of these texts were written in the 1990s, like the artistic practices that they refer to – in other words in an age in which society radically began to change. Global society, unrestricted capitalism, the reputed end of class society, the end of the welfare state, neoliberal politics are the main keywords used to describe the changes that society is still going through and to explain the establishment of post-Fordian politics. These rapid and radical social transformations also seemed to herald in *After Enlightenment* (Klein/Naumann-Beyer 1995) and *The End of Criticism* (Schödbauer/Vahland 1997). Accordingly 'the end,' the prefix 'post' and the concepts of 'limitation' and 'boundaries' were central topics of cultural and social academic discourses in the 1990s.

These dance theories, which identify choreographic practice as being critical or political (or even occasionally use 'criticism' and 'the political' as synonyms), seem to stem themselves against the apocalyptic mood. They are not only paradigmatic for a contextualisation of the (in the academic and artistic context) still quite young field of dance theory as a critical theory or political philosophy of dance, but also – and closely associated therewith – for a turn towards artistic practice. On the one hand, this is due to the author's biographies. Many of these authors are themselves – as dramaturges, performers, dancers or choreographers – also practicing artists and have not, like many of an older generation, fully switched from artistic practice to theory. On the other hand, the relationship between theory and praxis in dance itself has also experienced a historical trans-

1 This paper uses the term 'practice' in terms of Pierre Bourdieu. 'Practice' is here generally used for the actual application or use of an idea, belief, or method as well as the customary, habitual, or expected procedure or way or mode of doing something. 'Practice' is in contrast to 'Praxis' not generally distinguished from theory.

formation over the last years due to changes in how dance, choreography and theory are taught and subsequently practiced: here the boundaries of dichotomous thinking have likewise become more fluid.

Dance theory, so the implicit and sometimes explicit assumption of these texts, can only be conceived as a theory of practice, as a theory, which does not exclusively or primarily concentrate on a product, but also – and foremost – on a process, i.e. by reflecting the methods used and the forms of collaboration. Dance theory is thus only conceivable in the context of a form of dance studies that defines itself as an empirical science (Erfahrungswissenschaft), as a 'science of reality,' as a 'practical science.' Dance theory, and this is the second premise, should be generated by the experience-guided reflection of artistic practice. Dance theory thus lies somewhere 'in-between,' in a realm between artistic and scientific practices and their respective forms and methods of reflection. From this perspective, it is simultaneously the premise, instrument and effect of artistic practice.

Based on this realisation that dance theory formulates itself in and through dance or artistic practice, I would like to reverse the perspective by focusing on dance theory and asking how it can take place and define itself as critical practice. Therefore I would like to expound some fragmentary thoughts on the extensive subject of a praxeological critical theory of dance, i.e. a critical practice of thinking.

Two questions are of particular interest: How can we define 'critical practice' in dance and choreography? And: What is the frame of reference for this 'critical practice'?

1. DANCE AND CHOREOGRAPHY AS CRITICAL PRACTICE

In her dissertation, Pirkko Husemann analyses the working processes of French choreographer Xavier Le Roy and the German choreographer Thomas Lehmen. Her conclusion is that choreography is a critical practice. She defines it as "practice immanent criticism in the mode of the aesthetic" (Husemann 2009: 29), as criticism that is bound to artistic practice, especially to working methods and which therefore reveals itself via and through experience. Husemann shares this concept of a partial and immanent understanding of criticism with a handful of authors, who have, as dramaturges, emphasised the artistic process in particular as a 'modus operandi and realm of criticism.'[2]

In their argumentation, they are – implicitly – of the opinion, that critique cannot, contrary to the classical concept of critique as defined by Kant, be reduced to judgment alone. Instead they define critique as a mode of working that facilitates other experiences. Certain artistic methods of working are critical in the sense that they test new forms of community, friendship, and complicity, as

2 Cf. e.g. Marianne van Kerkhoven, Bojana Kunst, Bojana Cvejić, Ana Vujanović.

well as experiment with new forms of production. These experimentally structured spaces of experience are also, in a different light, fields for experimenting with alternative social practices. Therefore, they also deal, so my main argument, with a different mode of socialisation, the communitarisation of subject formation. But:

What does it mean to exercise practice-immanent critique?

This question is, somewhat modified and expanded by the phrase 'practice-immanent,' a question posed by Judith Butler in *What is Critique? An Essay on Foucault's Virtue* (Butler 2002) in response to Foucault's *What is Critique?*[3] (Foucault 1997). Foucault's essay, which anticipated his probably more famous article *What is Enlightenment?* (Foucault 1984), was motivated by the idea of finding a way out of the deadlock into which, in his opinion, critical and also post-critical theory had maneuvered itself. According to Butler, he was attempting to rethink criticism as practice by questioning the limitations of accustomed forms of thinking. In principle, exercising what Horkheimer and Adorno called the critique of ideology in their reflections on Marx and their elaboration of Georg Lukács' concept of reification (Horkheimer/Adorno 2002).

Butler emphasised three aspects, which I regard as important in the debate on choreographic modes of working as critical practice: the concept of practice, the realm of critique and its framework. She writes: "Critique is always a critique *of* some instituted practice, discourse, episteme, institution, and it loses its character the moment in which it is abstracted from its operation and made to stand alone as a purely generalizable practice" (Butler 2002: 212). The practice of critique is thus always particular, although it is also generalizable, i.e. it always refers to a concrete context, but allows conclusions to be drawn that apply other realms and frameworks.

Although, Plato defined critique as the 'skill' or technique of differentiation required in order to be able to pass judgement, Butler and Foucault nevertheless insist that critique is actually far more and something other than judgement. However, it would be historically oversimplified to claim this to be a genuine position of post-structural thought. As Kant stated in his demarcation of critique from the medieval monopoly of exegesis: "The critical method suspends judgment" (Kant 1969: 459). But in the case of Kant, suspension takes place with the goal of reaching a verdict. In the case of Butler and Foucault, there is utter suspension, because critique is a practice that can only generate a new ethical practice based on that very suspension. In this respect, they are also in agreement with authors of critical enlightenment such as Raymond Williams or Adorno. Adorno, for example, demanded: "when cultural criticism appeals to a collection

3 This essay was originally a lecture given at the French Society of Philosophy on 27 May 1978 and subsequently published in Bulletin de la Société française de la philosophie (Foucault 1990b).

of ideas on display, as it were, and fetishizes isolated categories" (Adorno 1983: 23), it must reflect "the ways in which categories are themselves instituted, how the field of knowledge is ordered, and how what it suppresses returns, as it were, as its own constitutive occlusion" (Butler 2002: 213). In contrast to judgement, which takes place within constituted categories (e.g. in the categories classical, modern, contemporary), critique directly deals with how a field is constituted, to paraphrase Pierre Bourdieu, e.g. the field of contemporary dance and its historical epistemes and respective dispositifs. Critical practice is thus a practice that questions those principles of constitutions and figures of thought, which themselves determine the field. It questions the respective knowledge generated there and reveals the mechanisms behind practices of inclusion and exclusion. Critical practice is thus always also a practice of experiencing liminality, both epistemologically and ontologically. These definitions of critical practice apply both to artistic, as well as academic practice. Butler says:

"One does not drive to the limits for a thrill experience, or because limits are dangerous and sexy, or because it brings us into a titillating proximity with evil. One asks about the limits of ways of knowing because one has already run up against a crisis within the epistemological field in which one lives." (Butler 2002: 215)

The crisis of the epistemological field of dance in modernity began with the so-called cultural crisis around the turn of 20th century. The history of dance can since boast of a number of epistemological disruptions and fractures, such as those inflicted e.g. by American postmodern dance in the 1960s (e.g. the use of non-places of dance, the integration of 'non-dancers,' the performance of everyday movements and gestures) or in the 1970s by *Tanztheater* ('dance theatre') (e.g. by focusing on the dancer himself/herself as the embodiment of knowledge, establishing the role of dramaturges in dance and emphasizing the processual character of choreography, Pina Bausch not only developed a new aesthetic and compositional structure, but also challenged the epistemological stability of the dance field) (cf. Lepecki 2006). To say nothing of the influences of popular dances, which have opened up the field of dance to the realm of the everyday in very different ways than contemporary dance – thus producing a new crisis of its own. The critical practice has since always been locked into a landscape defined by the crisis of the epistemological field. And this landscape of crisis is contingent. According to Niklas Luhmann, contingency is something that excludes

"necessity and impossibility. Something is contingent insofar as it is neither necessary nor impossible; it is just what it is (or was or will be), though it could also be otherwise. The concept thus describes something given (something experienced, expected, remembered, fantasised) in the light of its possibly being otherwise; it describes objects within the horizon of possible variations." (Luhmann 1996: 106)

To be, in principle, open for the future also means, that – contrary to the occasionally observable historical amnesia of dance theory and dance practice – critique's frame of reference must also always be historical. It must reflect respective current structures of thinking, forms of knowledge and cognition against the historical backdrop of the epistemological crisis of dance, which is in turn related to the social order that I will refer to in more detail later on. From this perspective of historical reflection, I would like to state the following: The critical moment in current artistic practices is particular, can only be identified in its concrete form and must always be regarded in relationship to historical predecessors. How do current choreographic practices relate e.g. to modes of working – taking into account only West German dance history – such as Gerhard Bohner's collective methods of working in Darmstadt end of the 1960s or to the disruptions of dance history caused by Pina Bausch's mode of working? How is critical practice possible today in the contingent unstable space that dance is situated in since the 1960s? This question brings us to the concept of practice itself.

What does the term 'practice' mean?

In various discussions of theory and praxis, the term 'practice' is sometimes used colloquially. In such cases, practice means artistic creation and is generally considered to be 'praxis,' that which comes first, theory being 'the other.' Or the debate cites the tradition of a 'philosophy of praxis,' based on the early writings of Karl Marx (Marx 2004 [1844]; 1969 [1845]). Marx defines praxis as the sensual or concrete activity of mankind, as a subjective, material transformation of objective reality, which involves productive, political, experimental, artistic, and other material acts. Praxis is thus established as the criterion of reality versus theory.

In contrast, we have a theory of practice, which first came up in the 20th century in form of a social-theoretical approach. In other words, it questions the dual construction theory and praxis that is historically often discussed in dance as the binarity of body and mind. This concept of critique moreover distances itself from dualism-based notions that favour praxis over theory by arguing that artistic practice is the real and thus privileged place of critique. If we follow the dualistic line of thought, it is very difficult to regard artistic practice as being capable of critique. Dualism itself moves within established epistemes, within fixed forms of thinking, knowledge and action, which on the one hand, establish theory as an act of reaching a verdict and praxis as the site of experience and on the other hand, stipulate the concept of practice as an essential or ontological category. Practice therefore would solely be allocated to the field of dance and theory would be located outside this field.

From a sociological perspective, especially from the perspective of Bourdieu's praxeology, this use of language not only signifies a confusion of the term 'practice' with that of the term 'field.' Such a use of terminology, also favours essentialism and neglects to take into account the fact that practice is a

constructivist term, which describes processes of subjectification, is oriented on materialities, i.e. bodies and objects and situates the social in the actual practices themselves (Reckwitz 2003). Theory of practice defines collective knowledge not as 'knowing that' but rather as 'knowing how,' i.e. as an ensemble of techniques, as practical comprehension, as 'being skilled at.' And this knowledge is, again paraphrasing Bourdieu, 'incorporated': it is mimetically and performatively produced by concrete, specific practices. 'Practice' is here thus meant less as an emphatic totality, but rather as an accumulation of procedures that follow a 'logic of practices' and are connected by 'practical skill.' And this is always tied to two material instances: to the body and the artifacts. Be it practices of organisation, of friendship, of artistic creation, of reading and writing, of handling the body or tools – from this perspective, practices must always be "understood as the 'skillful performance' of competent bodies" (Reckwitz 2003: 290, translated by Elana Polzer), even when they involve intellectual practices.

Practices constitute subjects. If we follow Foucault, practice is a pool of techniques and arts for the formation of the self and this always takes place in relationship to a field, for example to the field of dance and its subfields of artistic or popular dance, of modern, contemporary or postmodern dance, etc. and their rules, norms, conventions and orders. In other words: practice is the respective field-immanent modus operandi of the socialisation of the subject revealing itself in routine practices. This formation of the subject cannot simply be understood as an introduction into social structures via socialisation. It always also entails 'desubjugation' (Foucault) or de-surrender. This is, according to Foucault, the case, when the practice of self-formation takes place as critical practice. From the perspective of self-cultivation, critical practice can never be described as something general or even uniform. It only exists in a particular relationship to something other than itself.

From this perspective of a theory of practice, practice should not be differentiated from theory, but instead regarded as a collective term for the techniques and practices prevalent in the field of dance – and its subfields. They are produced in those working methods and forms of collaborating and producing knowledge, by which dancers turn themselves into dancers, choreographers into choreographers, theorists into theorists, etc.

How can practice thus articulate itself as critical practice?

Foucault has a clear answer to this question:

"Critique doesn't have to be the premise of a deduction which concludes: this then is what needs to be done. It should be an instrument for those who fight, those who resist and refuse what is. Its use should be in processes of conflict and confrontation, essays in refusal. It doesn't have to lay down the law for the law. It isn't a stage in a programming. It is a challenge directed to what is." (Foucault 2000: 236)

For Foucault, critique is "the *art* of voluntary subordination, that of reflected intractability" (Foucault 1997: 47). It is not by coincidence that Foucault here uses the term art. For him, the practice of critique is based on a way of life, on what he has famously called the "art of existence" (Foucault 1990a: 10). For Foucault, this art of existence takes place in the modus operandi of the aesthetic *and* the ethical, because for him, critique is also a virtue. It produces "techniques of the self" by which men seek

"to transform themselves, to change themselves in their singular being and to make their life into an *oeuvre* that carries certain aesthetic values and meets certain stylistic criteria." (Ibid: 10 et seq.)

Critique itself is an art that reveals the limitations of the epistemological field and sets itself in relation to this limitation. Critical practice in the field of dance is accordingly that which refuses to adhere to a category – in terms of: theory here, practice there, knowledge here, experience there, etc.,

"but rather constitute an interrogatory relation to the field of categorization itself, referring at least implicitly to the limits of the epistemological horizon within which practices are formed." (Butler 2002: 217)

It focuses on the relationship between the limitations of ontology and epistemology, i.e. the limits "of what I might become and the limits of what I might risk knowing" (ibid). Critical practice thus always also means risking the definition of oneself as a subject, as dancer, theorist, choreographer, etc. and assuming an ontologically precarious, risky and crisis-laden position.

This position requires a degree of reflexivity, which cannot only be described in terms of critical theory as defined by the Frankfurt School, but must also be seen as an 'objectified reflexivity' (Bourdieu 1993; Bourdieu/Wacquant 1992); in other words, not only reflecting one's own point of view, but also the immanent limitations of the field of art. "We are trapped in our field" (Fraser in Raunig 2006), says artist Andrea Fraser. In the case of art criticism, formulating critique in terms of limitations thus also means, as Jens Kastner has written, "to reject the phantasm of captivity as restricting self-description and to insist on never thinking about critique without also taking into consideration social battles" (Kastner 2010: 127). Social battles here first and foremost mean the exemption of art from politics and the declaration of art as an autonomous field – thus radically questioning its a priori synthesis as a community of critique. For with this separation, as Iris Därmann has convincingly illustrated "community becomes a mere concept and fantasy that has revoked its connection to conflict and the political and ceded the rules of distribution and division to the law and the state" (Därmann 2008: 32, translated by Elena Polzer). This is exactly where Därmann sees the policy-making character of political philosophy: when it doesn't infringe on these inequalities and by doing so suppresses the political, "i.e. that power of the

ensemble of cultural practices to establish sociality, which produces the separate coexistence of a singular that no form of politics is capable of producing" (ibid: 36, translated by Elena Polzer).

2. WHAT IS THE FRAMEWORK OF CRITICAL PRACTICE?

In her dissertation, Pirkko Husemann emphasised that practice-immanent critique in dance can only be recognised as critical practice when distinguishable not only as an aesthetic, but as a social practice (Husemann 2009: 61). However, it would be overly simplified – and also somewhat outdated – to define 'the social' merely as a general framework for the aesthetic. Various authors – from Bourdieu to Rancière – have pointed out the inseparability of the aesthetic i.e. aisthetic from the social or rather political. The social, so a basic assumption of performative concepts in the wake of Bourdieu, can only be experienced as sensuous, embodied, habitualised practice. It reveals itself even in modus operandi of the aesthetic, i.e. in the way it is produced, perceived and experienced.

If the social and the aesthetic are so inseparably related in the moment of experience, what can and must immanent critical practice in dance and choreography refer to in order to be political?

This question is very complicated, when taking into consideration that not every critical practice is inevitably political and vice versa. The political is not necessarily critical. If we stick to political theory, the political is always related to politics, which can in turn be defined as the practice of institutionalizing social norms. The political can be seen as the vanishing point of politics. Take away the connection and the political is unrecognizable. From the perspective of critical social theory, critique can only then be conceived as political, when it formulates itself as 'social criticism,' i.e. references the institutionalisation of social norms.

Various post-Marxist theorists such as Lefort, Laclau and Mouffe, Balibar, Rancière, Badiou or Hardt/Negri and in their wake, Virno, have addressed this identification of the political with 'social criticism.' Unlike liberal, communitarian or deliberative political concepts, they emphasise the constitutive schism of the social. This forms the premise for determining the place of the political. For them, it manifests itself reactively, as well as situational in the mode of action and here in the articulation of dissent, of disruption, of the incident. The distinct and not the shared is the site of the political and it contains the possibilities for a political practice of critique. For while assertions of the shared lead to hegemonic categories and a closed concept of community, which unquestioningly assumes a group 'us' that is capable of action, the distinct is the only space that really provides opportunity for critique and a sense of common-unity. And this, if we follow the arguments of post-Marxist authors, finds its expression in a

practice of 'disordering,' 'dis-ordinance.' It destabilizes, irritates and dis-places an existing order.

In doing so, it is not so much 'circumvention,' a subversive strategy against a stable order, as e.g. André Lepecki has hinted at in his theory, which defines movement as kinaesthetic politics against the order of the kinetic – thereby positing the relationship of order and movement as that of microstructure and macrostructure (Lepecki 2006). Instead, the political expresses itself in the irresolvable potential for conflict that is contained in the social and stored in its schism. It is not the 'against' or the 'outside,' the 'independent' against the institution, praxis against theory, movement against choreography, which can be identified as the (normative) site of the political against instituted politics. The practice of the political instead means placing oneself in relation to the hegemonic character of a social system and grasping it, as Chantal Mouffe writes "as the product of a series of practices whose aim is to establish order in a context of contingency." For Mouffe, "every order is the temporary and precarious articulation of contingent practices" (Mouffe 2008).

As a framework for critique, 'social order' – and social order also means forms of incorporating these orders, such as e.g. the order of ballet or other dance epistemes – can thus be conceived as an 'emerging order' as defined by Luhmann, i.e. as a fluctuating, temporary, even performatively produced order, whose genesis cannot ultimately be reconstructed. It is always shaped by the inclusion and exclusion of other options and by power relations that are always specific. It is an order that is contingent and whose articulation is preceded by confrontation, whose outcome is not predetermined.

The idea that systems can be thought about as emergent and performative is by no means new and was already expressed in the 1930s by Norbert Elias in his theory of figuration sociology (Elias 1978). One vivid conceptual example for emergent choreographic orders, which are always precarious and contingent, can be found e.g. in works made by William Forsythe and Dana Caspersen. One example of these 'choreographic objects' is the installation *White Bouncy Castle* (1997) commissioned by Artangel, London. "The *White Bouncy Castle* transfers the various states of physical-spatial organization, which choreography is concerned with, into a state of autonomy, which requires no further channeling influence," says Forsythe (Forsythe in Rietz 2010). If we define participation as the act of 'taking part,' the audience is active, but moves beyond the mere framework of a conceptual 'pre-scription.' Instead, the audience takes an active role in performatively shaping the choreographic structure through corporeal practice within the framework of the material provided. *White Bouncy Castle* is a project that questions the concept of choreography, the substance of art and the artistic space itself in and through the participation of all persons involved. By moving around in the 30x11 meter *Bouncy Castle*, the visitors produce a choreographic order of the ephemeral, which is unique in every one of its moments and cannot be repeated. A community is produced that is open, unpresuming in its identity and continuously redefining its 'we.' The *White Bouncy Castle* is a political pro-

ject in the sense that it symbolizes a practical critique of the order of choreography as a firmly established system, conceived by one person and implemented by specialists. It is political, because it applies a model of democracy that in principle allows anyone to take part. And it is simultaneously related to politics in as much as that it is nevertheless marked by principles of inclusion and exclusion – not everyone has access to the 'art-space' in which the *White Bouncy Castle* stands and not all visitors take part, some preferring to watch or to only participate in a certain way. The 'power balances' created when jumping, the order of configuration is performative and situational, but as a structure of power, it is necessary in order to be able to create movement at all.

What could be a place of critique?

In a study based on Max Weber's *The Protestant Ethic and the Spirit of Capitalism* (Weber 2001) and the theories of Bourdieu and Robert Castel, Luc Boltanski and Ève Chaipello (Boltanski/Chaipello 2007) have demonstrated that the driving force behind the tranformations, which the 'new spirit of capitalism' has undergone, has been a critique of capitalism as formulated by specific social groups. A particularly impelling moment of change came from what they call 'artist critique.' They demonstrate that artists' lifestyles have been especially decisive in establishing a 'new spirit of capitalism.' This new spirit of capitalism rejects all institutions and forms of the social that draw up and seek to retain boundaries. Instead, it is based on a concept of a world that exists as 'the Net,' as a 'Project.' Words such as 'teamwork,' 'vision,' 'competency,' 'flexibility,' 'innovation,' 'self-organisation,' immaterial work, (re)production of affects best represent this idea.

A similar problem of the affirmation is evident in choreographic practice (Klein 2009). The structures of post-Fordism demand creative, flexible human beings, communicative, cooperative and affective forms of working, as well as intellectual, immaterial work. How can radical dissent and intervention take place in artistic practice, if these same artistic strategies and ways of life are appropriated by neoliberal politics as proto-types and as feedback to optimize the system? How can the 'artist/theorist subject' transform itself, when the aesthetic modus operandi of self-formation, as Foucault demonstrated, is framed by ethic practices, which in turn require a political context i.e. normative politics? And finally, how can the 'artist/theorist subject' transform itself, when this very act of transformation is, although accomplished by the subject himself/herself, nevertheless confined to a framework of subjectification practices, which are de facto submitting to neoliberal positions?

These questions are not only relevant for artistic practice, but also for the practice of dance theory: how can critical theory be possible as critical practice when standardisation, de-intellectualisation, constant re-evaluation and the fabrication of conceptual consensus, which manifests itself in rankings, provoke particular forms of thinking and practices?

If the political is understood as a practice of social criticism, which "changes the very framework that determines how things work" (Zizek 2000: 199), then the political – especially in the academic field – has become rare or even impossible in the context of new forms of a hegemonic order (of knowledge). Dance theory, understood as a practice of critique, is those required, on the one hand, to operate along the immanent borderlines of the epistemological field of dance and, on the other, to take the risk of entering the space of crisis in the institutions. "A properly political intervention is always one that engages with a certain aspect of the existing hegemony in order to disarticulate/re-articulate its constitutive elements" (Mouffe 2008). Dance theory is a practice that can and must operate out of a large number of places. It should not however form itself outside of institutions, but instead intervene in them from various standpoints with the goal of changing them. We should seek to develop "a riskier practice that seeks to yield artistry from (the) constraint(s)" (Butler 2002: 226) of the institutions and develop forms of "the practical theorist/theoretical practitioner," which (can) create dissent versus the politics of (knowledge) institutions. This task could also be part of the critical practice encouraged in the many academic BA and MA-courses that have recently sprung up in Germany for dance, performance and choreography. According to the trains of thought followed above, this too could be part of a practice of critique spawning a critical dance theory of practice.

REFERENCES

Adorno, Theodor W. (1983): "Cultural Criticism and Society." In: Prisms, transl. Samuel and Shierry Weber, MIT Press, pp. 17-34.

Boltanski, Luc/Chaipello, Ève (2007): The New Spirit of Capitalism, London: Verso.

Bourdieu, Pierre (1993): "Narzisstische Reflexivität und wissenschaftliche Reflexivität." (Narcissistic Reflexivity and Scientific Reflexivity) In: Eberhard Berg/Martin Fuchs (eds.), Kultur, soziale Praxis, Text. Die Krise der ethnografischen Repräsentation (Culture, Social Praxis, Text. The Crisis of Ethnographic Representation), Frankfurt am Main: Campus, pp. 365-374.

———— /Wacquant, Loic (1992): An Invitation to Reflexive Sociology, Chicago/Ill.: University of Chicago Press & Cambridge/UK: Polity Press.

Butler, Judith (2002): "What is Critique? An Essay on Foucault's Virtue." In: David Ingram (ed.), The Political: Readings in Continental Philosophy, London: Basil Blackwell, pp. 212-226.

Därmann, Iris (2008): Figuren des Politischen (Figurations of the Political). Frankfurt am Main: Suhrkamp 2008.

Elias, Norbert (1978): What Is Sociology?, Columbia University Press.

Foster, Susan Leigh (1996): Corporealities, Dancing, Knowledge, Culture and Power, London: Routledge.

———— (2002): *Dances That Describe Themselves*, Middleton/Conn.: Wesleyan University Press.

Foucault, Michel (1984): What is Enlightenment? In: Rabinow, Paul (ed), *The Foucault Reader,* New York: Pantheon Books, 1984, pp. 32-50, July 19, 2012 (http://foucault.info/documents/whatIsEnlightenment/foucault.whatIs-Enlightenment.en.html)

———— (1990a): *The Use of Pleasure. The History of Sexuality*, Vol. 2, Vintage Books.

———— (1990b): "What is Critique?" In: Bulletin de la Société française de la philosophie 84:2, pp. 35-63.

———— (1997): "What is Critique?" In: Sylvère Lotringer/Lysa Hochroth (eds.), The Politics of Truth, New York: Semiotext(e), pp. 41-81.

———— (2000): *The Essential Foucault: Selections from Essential Works of Foucault,* 1954-1984, New Press.

Raunig, Gerald (2006): Instituent Practices. Fleeing, Instituting, Transforming, July 19th, 2012 (http://eipcp.net/trans-versal/0106/rau-nig/en).

Rietz, Christina (2010): Hüpfen als Kunstform. In: Zeit Online, July 19th, 2012 (http://www.zeit.de/lebensart/2010-08/huepfen-deichtorhallen).

Horkheimer, Max/Adorno, Theodor W. (2002): *Dialectic of Enlightenment,* trans. Edmund Jephcott, Stanford: Stanford University Press.

Husemann, Pirkko (2009): *Choreographie als kritische Praxis (Choreography as Critical Praxis)*, Bielefeld: transcript.

Kant, Immanuel (1969): *Kants gesammelte Schriften, Handschriftlicher Nachlass, Logik*, Akademie-Ausgabe (*Kants collected works, Handwritten Notes, Logic*, Academic Edition) Vol. 16, Berlin: de Gruyter.

Kastner, Jens (2010): "Zur Kritik der Kritik der Kunstkritik. Feld- und hegemonietheoretische Einwände" (*A Critic of the Critic of Art Criticism. Objections from the Perspective of Field Theory and Hegemonic Theory*). In: Stefan Nowotny/Gerald Raunig/Birgit Mennel (eds.), *Kunst der Kritik (The Art of Criticism)*, Vienna: Turia und Kant, pp. 125-147.

Klein, Gabriele (2009): "Das Flüchtige: Politische Aspekte einer tanztheoretischen Figur." (The Ephemeral: Political Aspects of a Figuration of Dance Theory) In: Sabine Huschka (ed), *Wissenskultur Tanz (Cultural Knowledge Dance)*, Bielefeld: transcript, pp. 199-209.

Klein, Wolfgang/Naumann-Beyer, Waltraud (1995) (eds.): *Nach der Aufklärung? Beiträge zum Diskurs der Kulturwissenschaften (After Enlightenment? Thoughts on Current Discourse in Cultural Studies)*, Berlin: Akademie.

Lepecki, André (2006): *Exhausting Dance. Performance and the Politics of Movement*, New York: Routledge.

Luhmann, Niklas (1996): *Social Systems*, Stanford: University Press.

Martin, Randy (1998): *Critical Moves. Dance Studies in Theory and Politics*, Durham: Duke University Press.

Marx, Karl (2004 [1844]): Economic and Philosophical Manuscripts. In: Fromm, Erich (ed.), *Marx´s concepts of man*, London: Continuum, pp. 78-132.

———— /Engels, Friedrich (1969 [1845]): *The German Ideology*, New York: International Pub.

Mouffe, Chantal (2008): "Critique as Counter-Hegemonic Intervention," July 19th, 2012 (http://eipcp.net/transversal/080 8/mouffe/en.)

Reckwitz, Andreas (2003): "Grundelemente einer Theorie sozialer Praktiken." (Basic Elements of a Theory of Social Practices) In: Zeitschrift für Soziologie (Journal for Sociology), Vol. 32, Nr. 4, pp. 282-301.

Schödbauer, Ulrich/Vahland, Joachim (1997): *Das Ende der Kritik* (The End of Criticism), Berlin: Akademie-Verlag.

Weber, Max (2001): *The Protestant Ethic and the Spirit of Capitalism*, London: Routledge.

Žižek, Slavoj (2000): *The Ticklish Subject: The Absent Centre of Political Ontology*, London: Verso.

PANEL POLITICS

Dance and Politics

INTRODUCTION BY ANDRÉ LEPECKI

As a starting point for the panel *Dance and Politics*, a simple statement of fact: it seems incontrovertible that over the past few years we have been witnessing a recuperation of a quasi-ontological association between art and politics, thanks mainly to the writings of Jacques Rancière and Giorgio Agamben. This association, derived from the identification of a certain regime of the arts Rancière has called "the aesthetic regime" (Rancière/Corcoran 2010: 173), would promote "partitions of the sensible, the sayable, the visible and the invisible" (ibid.) which, in turn, would initiate "new collective modes of enunciation" (ibid.), along with unsuspected vectors of subjectivation. The act of partitioning and the affirmation of the new would define art's relation to politics and thus turn both into co-determined, corresponding activities aimed at the formation of 'dissensus' – a concept (or 'element') that for Rancière is at the core both of art and politics, since it is tied to the rupturing of daily habits, to the creation of on-tological-perceptual disjunctions, eccentric movements in language and sensation, to the disbanding of circulatory imperatives tied to linguistic and behavioral clichés for subjectivity. Dissensual events are the properly constituted artistic-political acts within the "aesthetic regime": "if there exists a connection between art and politics, it should be cast in terms of dissensus, the very kernel of the aesthetic regime" (ibid: 140). This is why Rancière can define the political in aesthetic terms, to claim the political literally as "an intervention in the visible and the sayable" (ibid: 37).

As for Agamben, the political would be intimately associated with art because both are human activities preoccupied with opening up potentials for living life. As he wrote: "Art is inherently political, because it is an activity that renders inactive and contemplates the senses and habitual gestures of human beings and in so doing opens them up to a new potential use." (Agamben 2007: 204)

Given the direct invocation by both philosophers of the body and its capacities, and given the direct implication in their propositions on the political-aesthetic continuum of the formation of gestures and habits, it seems obvious that such developments in political philosophy as it approaches and assesses contemporary art practices to identify in them what would be the *truly* political has deep implications for current dance making and for current dance theory. It should be reminded however, that in terms of political philosophy, Agamben's

and Rancière's propositions both recuperate what Hannah Arendt considered a necessary, yet lost understanding of politics. Particularly important to Arendt was how a properly reconstituted notion of politics must have the characteristics not of the arts in general, but of those most particular of the ephemeral arts, dance and theater. As Arendt reminds us in the chapter on "Action" in her classic *The Human Condition*:

"Politics is a techné, belongs among the arts, and can be likened to such activities as healing or navigation, where, as in the performance of the dancer or play-actor, the 'product' is identical with the performance act itself." (Arendt 1998: 207)

Such an ephemerality and performativity, such an understanding that "politics is always of the moment and its subjects always precarious. A political difference is always on the shore of its own disappearance" (Rancière 2010: 39) is what places dance right at the very core of current philosophical reflections on the political.

It should also be reminded however, that several dance scholars, including Mark Franko, Randy Martin, Susan Leigh Foster, Gabriele Brandstetter, Gabriele Klein, Frédéric Pouillaude, Franz Anton Cramer, Gerald Siegmund and the contributors to this panel, have proposed, in different ways, and at least since the mid-1990s that it is the often foreclosed, but very clear fact that dance theorizes its social context as it practices itself which constitutes perhaps its most significant political trait and force. As Randy Martin put it succinctly in his book *Critical Moves*:

"Unlike most political practice, dance, when it is performed and watched, makes available, reflexively, the means through which mobilization is accomplished. In this regard, the relation of dance to political theory cannot be usefully taken as merely analogical or metaphorical." (Martin 1998: 6)

Indeed, dance's immanent capacity for theorizing its social context of emergence would add to its political ontology a powerful critical force, supplementing with it those other traits dance shares with the political. Those common traits between dance and the political are: the ephemerality of its gestures, the self-fulfillment of its goals by the sheer enactment or actualization of its performance, and the unpredictability of its outcome.

In 2005 Andrew Hewitt pushed the theoretical-epistemological-political-choreographic nexus to a limit, when he reintroduced and redefined the very concept of 'choreography' (as opposed to dance in general) precisely through a non-metaphorical vector similar to the one advocated by Randy Martin. For Hewitt, choreography is the modality through which dance reflects and theorizes the social order and by doing so theorizes and activates the particular nexus linking art and politics. As he puts it in the introduction of *Social Choreography*: "As a performative, choreography cannot simply be identified with 'the aesthet-

ic' and set in opposition to the category of 'the political' that it either tropes or predetermines" (Hewitt 2005: 11). He continues:

"choreography has provided a discursive realm for articulating and working out the shifting, moving relation of aesthetics to politics and for thinking about questions of semiotic 'motivation' in systems of representation [...] What I am calling 'choreography' is not just a way of thinking about social order: it has also been a way of thinking about the relationship of aesthetics to politics." (Ibid)

Crucial to Hewitt's position is his insistence that a 'choreographic' relationship between art and politics should be seen as being strictly 'antimetaphorical': choreography should not to be understood as an image, an allegory, or metaphor thanks to which a certain understanding of politics could be derived. Rather choreography is, in itself, the very matter, indeed, the very matrix, of politics' 'function': "its disposition and manipulation of bodies in relation to each other" (ibid).

Non-metaphoricity begs for a closer examination of the ways through which choreography is put into practice, how it is actualized. And it begs closer examination on how through its actualization choreography interweaves a plurality of very concrete social, political, linguistic, somatic, racial, economic, and aesthetic domains into its own plane of composition. Indeed, choreography harnesses body techniques with architecture (think of the specificity of what kinds of dances and what kinds of bodies are produced by choreography once it co-produces with architecture a dispositif called 'studio' in order to reproduce itself?); gender dynamics with economy (think of how is it that the relation between a dancer and a choreographer may be already gendered, already reproducing an economy of subjection and authorship, of obedience and command, of vocalizing orders and following orders?); affects with materiality (think of how the ephemerality characteristic of dance propels the choreographic project from its very beginning in the 16th century along with its regimes of body-formations thanks to the melancholic drive defining modernity); politics with mobilization (think of how Peter Sloterdijk's diagnosis of the self-mobilization of subjectivity that defines modernity would situate choreography directly at the core of modernity's massive project of subjectivation); ethics with micro-fascisms (think of how the choreographic opens up at least two vectors of imperatives: commanding speech-acts, which must be followed so that a choreographic composition comes into being; and immanent imperatives on the plane of composition, which derive from the ethical commitment to actualize a work's will), racial and racist formations (think of what kind of bodies dance displays? Think of what kind of bodies is perceived as dancing the 'contemporary'?).

The formations of the choreographic are many, expanding beyond the field of the aesthetic. Which means, finally, that to understand non-metaphorically the nature of choreographic practices is inevitably to embrace what Paul Carter once called "a politics of the ground" (Carter 1996: 302) – one that is always attentive to the concrete placing of all the elements that constitute and form, animate and

orientate the dance situation (including supposedly a-signifying elements, such as accidents, gusts of wind, slips of the tongue, blinks of the eye, ringings of the ear and slips of the foot, the atmospheric temperature and the dancers' and audience's temperaments).

Given these non-metaphoric problematics one of the possible lines of inquiry proposed to the panelists participating in the session dedicated on Dance and Politics was exactly this one: how does dance, understood as a praxis of theorization – a praxis constantly being incorporated and excorporated, that is to say, a praxis constantly exchanging actuals and virtuals – may inaugurate new (desirable or not) configurations of the political? Within this quite broad, quite general question, several lines of inquiry were proposed for discussion. Below, I am invoking briefly a few of those lines which were explored during the panel's several presentations, as well as approached during the follow-up discussion.

If 'the political' is a zone of generative 'dissensus' (to use the expression by Rancière), how, where and when can we understand dance as a dissensual practice? Particularly given dance's relation to power (mass dances as spectacles of nationhood) and to normative subjectivity (think of "Dancing with the Stars" TV shows)? In the logic of choreographed dance, would dissensus emerge as the expressive, indetermined gap between the pre-given organization of movement (choreography) and the impossibility of its absolutely exact actualization by a dancer?

If 'the political' requires a profound engagement with social, cultural, historical, economic, artistic, and discursive realities that inform a given situation, how can dance contribute to this engaged cartography of the present that it simultaneously makes, delineates and traverses?

Recently, Mark Franko proposed that "politics are not located directly 'in' dance, but in the way dance manages to occupy (cultural) space" (Franco et al. 2007: 13). In this view, politics would be extrinsic to dance, it would be seen as the 'effects' dances produce onto the broader social sphere. As dance practitioners, as choreographers, as theoreticians, as audience members, how do we take this assessment? Is it possible to think of the political happening also 'in' dance? Within its compositional structure and manifestation?

The recent proliferation of 'the political' in all sorts of discourses on and about current artistic practices may be reaching a level of consensual saturation. This could be a good sign: one of increased political awareness among art practitioners and theorists and of increased awareness of the necessity for art to engage itself against the total colonization of subjectivities and bodies we now live in under the gentle name of globalization. However, this proliferation of the word 'political' in its relation to 'art' also brings the risk of a fad of 'the political.' What are the words, concepts, choreographic imaginations, steps, modes of embodying, modes of inventing bodies, modes of assembling bodies, modes of moving and of not moving that could maintain the political power of dance active, generative, generous, inventive, acute – against facile and fashionable in-

strumental uses of 'the political' as an empty refrain in artistic discourses and critical discourses about art?

How is it possible that in current continental discourses on dance, the political fact of colonialism, of colonization and post-colonization, of racism and its interpellations, of racism and its capacities to produce bodies and movement-effects are constantly being 'forgotten' from critical discourse and from choreographic practices? Is it possible that the political unconscious of European dance and European Dance Studies be the repressed strata of its recent and its current colonizing histories and colonizing modes of subjectivation? As if post-colonial theory was a matter exclusive to former or currently colonized populations; as if post-colonial theory were to be absurdly assimilated to a kind of 'resentful' minoritarian discourse (if one would ever say that Marxist theory had relevance only to the 'poor proletariat' and psychoanalysis only to the 'neurotic' patient), and were irrelevant to question of contemporary formations of body-images, (political and aesthetic) movements, and counter-movements.

In our age, described by Luc Boltanski as one where the political left has given up its belief on all notions of revolution (Boltanski 2008), how can we reassess Randy Martin's hopes, expressed ten years previously, that because dance understands from within what it is to mobilize, dance may very well be the privileged articulator for new ways of social transformation? Since, historically, we have testimonies of how dance concerts were believed to lead directly (via direct energizing of the 'masses') to actual revolutionary practices, what does current dance practices have to say now about our momentary political subjectivities?

If political theory is also a theory of social action, and if choreography theorizes and explores how to invent actions, could dancing be that theoretical practice and that practical theory that would allow for political theory to understand itself more pragmatically? What can dance, understood as a practice of corporeal inventiveness and social mobilizations (even if this mobilization is without displacement, even if it is a mobilization of intensities), offer to contemporary critical theories of political action? What can dance offer to the notion of 'political movement'?

Is it possible to think of the non-metaphorical ties between the political and the choreographic, without accounting for the history of colonialism and its formation of bodies, and of semantic systems of 'body-reading'? How can we account for the theoretical turn in European dance over the past two decades (most prevalent since the late 1990s), and the recent concern with 'the political' in art practices, when these consecutives 'turns' seem to neglect at all levels discussions on racial formations and racist formations in contemporary Europe?

These questions, or variations of them, were either directly approached by the panel's participants during their presentations, or addressed in the exchanges and discussions between them and with the audience. In the following pages, you will be able to read their interventions. But not before I finally name them, and take this moment to express my sincerest gratitude to all five for having accepted the invitation to come to Berlin, and to offer to the conference their generous and

thought-provoking contributions and interventions. They were: Franco Barrionuevo Anzaldi, Bojana Kunst, Bojan Manchev, Avanthi Meduri and Martin Nachbar.

Pitfalls of 'the Political.' Politization as an Alternative Tool for Dance Analysis?

FRANCO BARRIONUEVO ANZALDI

I. INTRODUCTION

In recent dance studies dance is sometimes seen as something inherently political. This trend has been important insofar as it sensitized practitioners, theorists and government agents alike to reflect on dance in terms of power effects and of its implications for social order. But as André Lepecki observed, this 'consensual saturation' might inflate the meaning of 'the political' (Lepecki in this volume). As I would add, this trend does not just soften the analytical force of the concept but it is the very concept in itself that reduces the multifaceted meaning of politics to just one dimension of it. Being considered as mainly dissensual, the concept of 'the political' overemphasizes respectively overestimates the genuine possibility of dance to act politically.

I read this trend as the culmination of at least two strands of thinking: one that suggests that dance has due to its supposed distinctive epistemological status a privilege affinity of being dissensual; the other that opposes normatively the usually nominated field of politics to an apparently 'true' enunciation of 'the Political,' consisting primary in dissensual actions that claim to transform the normative groundings of the social order. Both strands of thinking favour a conceptualisation of dance as something immanently 'political.' Despite the underlying philosophical richness, this thinking is – so the here proposed main argument – insofar restrictive as it closes itself before the empirical analysis of the rather potential interface between dance and politics – far more than it claims to enlighten it.

A critique of the concept of 'the Political' might rehabilitate an analytical perspective in which dance is seen in respect to its ability to articulate itself politically as a social field like others, in which the question of its being political is related to the state as the main normative body of a society and in which this question is in first instance considered as being an empirical one. As it finally should be argued, 'politization' might, though its normative weakness, be a fruitful term in offering a heuristic framework for a more historic-saturated and sociological analysis of dance. 'Politization' is not restricted to a strong normative grounded conception of 'the political,' it does not suggest any remarks to the

epistemological status of dance and it emphasizes more the processual relation between dance practices and the specific normative order of the state – which would be, eventually, the primary object of those kind of empirical analysis.

II. A POLITICAL IDEOLOGY OF DANCE

At first glance, one could argue that dance is predestined for political mobilization due to its emphasis on the body, on the corporal movement and on performance. It seems to be that these circumscriptions of dance potentiate its ability to 'resist,' to 'subvert,' in synthesis to articulate itself 'politically.' But this is more a universalizing ideology of what dance should be than what diverse dance practices actually are. The body as a key element of dance is often conceptualized (for example by many practitioners of popular dance cultures) in the liminality of the social, and sometimes directly outside of it. But even then, when the body is explicitly seen as part of the meaning-producing world, it is suggested that it has a distinct epistemological status. There are supposed to be meanings that the language is incapable to say but that the body would 'demonstrate.' It is believed that there is an unbridgeable gap between 'discourse' and 'praxis,' and that 'in' praxis the social world would be transformed though much more subtle, much profounder than discourse ever would do.

At the same time, dance is not seen as any kind of 'praxis,' but as one that privileges through 'movement' the 'presence,' the 'instant' and the 'fugitive,' thus, the performative aspects of praxis. Despite the existence of an always-underlying social choreographic script, it is supposed that dance has an intrinsic quality of unrepeatability that hypostatises it as a performative art par excellence. Debates about the possibility of archiving arise from the assumption that dance is due to its performativity difficult to capture and not accumulative. Dance seems to be inseparable with the act of dancing, with its doing, with its continuous enactment. The before and the after, then, would not be the proper 'dance,' but just the reflection on it, the record, the thinking and the notation of it. To emphasize dance's ephemerality, fluidness and fugitiveness suggests that social control is somehow suspended. Dance seems to have an intrinsic quality to escape from its choreographic script and thus from the normativities that any social order requires for its reproduction.

To equate dance with its mere performance means to see it primarily as a continuous enactment, foremost as a sequence of contingent acts. Dance would be the genuine capacity to produce contingency grounded just in the condition of being born in this world as a human being. A choreography that is not danced would probably not be called 'dance.' It is this anthropologically founded contingency that presupposes dance to have a privilege affinity to 'the Political.' The possibility to be at the liminality of the social seems to give dance the genuine quality to transform the social, to escape from its choreography, thus, to be per se in potential 'dissensus' with the social order.

III. The Anthropological Foundation of Post-Foundational Politics

It is quite interesting that the concept of 'the Political,' formulated in different ways by political philosophers like Jacques Rancière (1999), Philippe Lacoue-Labarthe and Jean-Luc Nancy (1997), Claude Lefort (1990), Giorgio Agamben (2002) and Chantal Mouffe (2005) has a similar pitfall in respect to the social as the enactment of dance has to its underlying social choreographic scripts. Though 'the political' is thought by those authors just in a way to evade foundational groundings of the social, in the end they fall back into an essentialist argument. A post-foundational thinking of the social introduces, as Oliver Marchart describes it, the presupposed *Political Difference* between 'politics' and 'the political' (Marchart 2010). The schematic and overall idea of a post-foundational thinking is that the normative groundings of the social are not founded in universal and incontestable metaphysics but within the social realm. It is the continuous instituting of the difference between 'politics' and 'the political' that re-actualize the social. But as I would like to argue in the following this instituting of the difference presupposes in itself a universalistic grounding outside the social realm. It is founded on a universalized matrix that is inherently antagonistic or dissensual. The 'political difference' is not within the social realm but grounded on an anthropological idea of 'the political' extrapolated either from the philosophical tradition of Carl Schmitt (Schmitt 1933) or from a neo-Aristotelian tradition of Hannah Arendt (Arendt 2008 [1958]).

This anthropological claim can be illustrated for example in Jacques Rancière's political theory. He differentiates between 'police' and 'politics' (Rancière 1999: 21-43). For Rancière politics is not just the institutions and regulation forms related to the state, but the social order as such, the so-called 'police' that reproduces 'society.' But 'society' cannot be closed to a totality because it is grounded on a normative 'wrong': "Politics begins with a major wrong: the gap created by the empty freedom of the people between the arithmetical order and the geometric order" (Rancière 1999: 19), an injustice that is inherent to the logos and enacted by the 'police.' The logos partitions – paraphrasing Foucault's *Archeology of Knowledge* – the historical 'archive' (Foucault 2002: 142-151) in the 'sayable' respectively 'visible' and in the 'non-visible.' The 'police' as a guardian of the logos produce 'members' of the 'society' and 'non-visible' 'non-members' without an identity:

"The police is thus first an order of bodies that defines the allocation of ways of doing, ways of being, and ways of saying, and sees that those bodies are assigned by name to a particular place and task; it is an order of the visible and the sayable that sees that a particular activity is visible and another is not, that this speech is understood as discourse and another as noise." (Rancière 1999: 29)

The subjectivizations arising from those policing strategies are for Rancière not political. Rather, they produce through the mentioned partition of the logos a contingent space in which a political act might be constituted. 'The political' as the genuine political act is for Rancière the enactment of 'dissensus' inasmuch as it re-configures that what is 'sayable' and 'visible':

"Political activity is whatever shifts a body from the place assigned to it or changes a place's destination. It makes visible what had no business being seen, and makes heard a discourse where once there was only place for noise; it makes understood as discourse what was once only heard as noise." (Rancière 1999: 30)

The political moment is for Rancière a dissensual moment, establishing a non-political new sensual order of the 'visible' and 'non-visible.' This difference is not grounded in the social realm but on an anthropological assumption. Recurring to Aristotle it is the logos as a human condition that splits for Rancière the 'sayable' from the 'non-sayable.' It is the anthropological fact that a human being was born with language which makes the social world falling into the state of injustice, splitting it in a binary conflict between those who are seen and those who are invisible. Against a pragmatist approach to speech theory, as is for example represented by Jürgen Habermas, language can never be consensual due to the irony that the performative dimension of the speech acts implicates:

"In the logic of pragmatism, the speaker is obliged, for the success of their own performance, to submit it to conditions of validity that come from mutual understanding. Otherwise, the speaker falls into the 'performative contradiction' that undermines the force of their utterance. 'Do you understand?' is a performative that makes fun of the 'performative contradiction' because its own performance, its manner of making itself understood, is to draw the line between two senses of the same word and two categories of speaking beings." (Rancière 1999: 45)

Thus, the difference between 'the police' and 'politics' is not a political arising from the contingency of the social realm but an anthropological one.

This anthropological assumption is leaned on Carl Schmitt's philosophical tradition of thinking politics in terms of antagonism. 'The political' is specifically seen by Schmitt as the instituting between 'friend' and 'foe.' The contingent space within the social realm is always a matrix that is structured as antagonistic. Schmitt's paraphrased term of 'the political' is a matrix that constitutes the differentiation between 'politics' and 'the political' or, in terms of Rancière, between 'the police' and 'true' 'politics.' The contingencies are always conceptualized as potentially antagonistic. There are no non-antagonistic contingencies. Thus, it is not a social but an anthropological figure that constitutes the foundation of the post-foundational thinking.

At the same time, 'the political' arising from the 'logos' and embodied in a concrete political act of dissensus is 'fugitive,' non-lasting. It is just the explicit

performative moment of intervention, not its product. It is the instant of trans-
formation through the dissensual practice, the moment through which the visible
and sayable order is suspended to end up in a reconfigured 'society,' in a new
'police's' regime. The political moment is the non-yet-'visible' and -'sayable.'
This non-yet is very close to the above mentioned conceptualization of dance as
something non-sayable that escapes the underlying social choreography. 'Dance'
and 'the political' are linked by their emphasis on performance as something
completely contingent. Moreover, this focus on contingency is thought in binary
terms, in opposition to the social order instituted by the policing 'language,'
'theory' or 'discourse.' This binary thinking in both, in the conceptualization of
dance and in that of 'the political,' is grounded on anthropological assumptions
that precede the social world.

IV. AN EMPIRICAL APPROACH TO THE ANALYSIS OF POLITICS AND DANCE

This very strong anthropological presupposition hinders, in my argument, the
empirical analysis of the just potential interface between politics and dance. But
the relationship between both fields is preferable to be seen as an empirical one
and thus as something to be demonstrated case by case. As stated above, the con-
cept of 'the political' obscures the empirical analysis of the interface between
dance and politics insofar as it always takes the existence of a political moment
in dance – and this constricted to the idea of dissensus – for granted.

There are good reasons to abandon the two anthropological assumptions, one
that dance is predominantly performative and, the other, that 'the political' is dis-
sensual. Dance should be seen as a social field like others. Every social occur-
rence has a performative and 'fugitive' side, even the most habitualized prac-
tices. Sociability is always grounded on contingency and demands the perform-
ance. This does not lead to rest dance's specific performativity and to ignore the
fact that dance has its own norms, believe systems and modes of structuring
sense, but it means that dance practices are in reference to their epistemological
status equal to every other social event. Due to its condition as a social field, it is
subjected to structuring forces that stabilize dance as a differential social subsys-
tem and makes it functional to the reproduction of the social order in general.
Dance might then be seen in first instance as an integrative force for the repro-
duction of social order. From this perspective, one could even provocatively say
that dance is very seldom dissensual.

In respect to the other anthropological assumption, politics should not be
constricted to the idea of 'the political.' To think 'true' politics in terms of 'the
political' implicates taking over an analytical framework that narrows the per-
spective to find other maybe more interesting relationships between politics and
dance. There are two important aspects that the term of 'the political' cannot cap-
ture. First of all, political moments might be affirmative as well and not just dis-

sensual. Second, not every dissensual practice is just because it is subversive to be called political. From my perspective as a political scientist the enunciation of a phenomenon as 'political' should be in one sense more restrictive and in another, seemingly paradoxically, more open. The quality of 'political' should be constricted in the sense of the old idea of the polis to aspects related with the public, in the modernity usually manifested in the nation state. The state consists of an agglomeration of normativities that regulates the public affairs of its citizens. But not all social normativities are traceable back to the state. Naturally, this distinction between public and private is highly doubtful, but I think it is important to take this distinction as a guiding normative horizon. It is more fruitful to take this distinction as a point of departure than to assume that every private aspect is inherently political just because there might be power involved. Taking this distinction as a starting point of analysis is more fertile insofar as the assumed political dimension of the private occurrence has first to be shown empirically.

In concordance to this distinction, not every dissensual practice has to touch the public concern beforehand. But in the other way around, not every practice that is related to the public is necessary dissensual. There might be a lot of dance practices that affirms the grounding normativities of the social order. It would be highly normative not to call these practices 'political,' just because they do not 'subvert' the social order. In terms of research a political analysis of dance would not focus on this affirmative relation between politics and dance.

V. POLITIZATION AS A CONCEPTUAL TOOL

In contrast to the above mentioned normative implications of the term of 'the political' a good term for a non-anthropological grounded and more empirical-oriented perspective might be 'politization.' This term emphasises the social process of getting something political without falling back to anthropological assumptions about politics. Even more, the term does not need the normative concept of the political, neither from a tradition of Carl Schmitt nor from one of Hannah Arendt. Politization might be a conceptual tool through which the link between dance practices and the hegemonic norms, embodied by the state, would be isolated. The term would provide a paradigmatic framework that started with the two pragmatic, but not epistemological assumptions that dance is not a priori political and that an activity must be connected with the hegemonic normativities in order to be called 'political.' Politization could be, then, a research tool that aims to 'politize' a specific dance phenomenon inasmuch as it invites to reconstruct the meanings of historical situated dance practices in relation to the hegemonic norms. By means of a reciprocal condensing approach between deconstruction and historical reconstruction the embodied or contested hegemonic normativities within a specific dance field can be isolated. The aim of such an analysis would be to detect how dance practices in a specific historical moment

have touched the socially hegemonic norms of that moment, how the discourse about and the practices of dance were perpetuating or contesting the normative groundings of the hegemonic social order, eventually, to detect the specific political meaning of a particular dance field within a specific social order.

VI. CONCLUSION

Finally, politization offers an opposite research strategy other than the term of 'the political' would suggest. It started with the belief that 'in' dance there is nothing immanently political, that politics is not constricted to dissensus but that it is related to the distinction between public and private, the polis, enunciated mostly by the hegemonic normativities embodied by the nation state. But it does not necessarily neglect the philosophical understanding that post-foundational thinkers propose. That the social order is grounded on the continuous instituting moment of contingency is strongly comprehensible. Moreover, to think these moments of contingency in terms of contestation might be also reasonable.

But for a sociological and empirically grounded analysis the concept of 'the political' is too normative. The term of politization might counterbalance this strong normative emphasis of 'the political' by asking empirical questions: When, where and how do dance practices be dissensual and when, where and how are these dissensual practices contesting hegemonic norms fomented mostly by the state?

The Politics of Time

BOJANA KUNST

I.

Since contemporary post-politics renounces the constitutive dimension of the political, many philosophers see the political as within a deep caesura that, according to Chantal Mouffe (2005), takes place as an ontic/ontological difference. She therefore proposes a differentiation between 'politics' and 'the political,' politics concerns daily political practices within which order is created while the political concerns the manner of constituting society with antagonism as an essential characteristic. The difference between politics and the police is also discussed by Jacques Rancière (1999). According to him, the police is "organised as a set of procedures whereby the aggregation and consent of collectivities is achieved, the organisation of powers, the distribution of the places and roles, and the system of legitimising this distribution" (Rancière 1999: 28). Contrary to that, politics is an activity that breaks up this unity of processes and interferes with the orderly configuration of the sensual. Therefore,

"*politics* is the very *conflict* over the existence of that space, over the designation of objects as pertaining to the *common* and of subjects as having the capacity of a *common* speech it is first and foremost a conflict regarding the scene in common, regarding the existence and status of those who are present there." (Rancière 2009: 24)

This differentiation presents an interesting conceptual problem when discussing about politics in relation to dance practice. First, it is important to challenge the direct translation of the differentiation in recent political theory to dance practice, the differentiation which in the field of dance often appears between the dance practice itself ('real politics') on one side and structures of production of dance (politics as organisation of interests) on the other. The differentiation, if we follow Rancière, namely does not divide between 'politics' and 'police,' but splits politics into itself and police. The consequence of that is that no pure politics exists but rather politics as continuous revolving around the properties of space and possibilities of time, a continuous sensual distribution of visibility, audibility and perceptual presence, a continuous negotiation and articulation of the practice in order to be perceived and heard as present. In that sense, the differentiation is the

movement in-between contingent practices and not the division between political (practice, work, aesthetics) and 'political' (forms of organization, production). In the recent debates about politics and dance, it namely happened very often that this differentiation was directly translated into the difference between modes of production and practice, the differentiation between 'political' and political, collaboration and 'real collaboration,' production and 'real production.' The problem of this stable division is namely that it is producing never-ending longing to grab the real notion at work, to practice real politics that would be something else than its apparent misuse (done by example by the institutions, market economy, fashionable criticism etc.).

It should then not be forgotten, that there exists no division as such, but that at the core of political exists continuous processes of differentiation, politics is actually established through constant process of articulation, taking the place and demanding singularity. To be political then does not mean that there exists something more real than the relations in whom we are actually implemented, more real than reality in which we are actually working, collaborating and creating dance. Reflection about politics in the last decade reached the point of saturation especially since many discourses about political in the relation to art in general (not only dance) are often overlooking the real implementation of one's own life in the current relations and modes of living and working, the implementation of life in the practice itself, when searching for the 'realness' of the political itself. Not only that political in that way can be put into the 'protective custody' by artistic practices and finds itself in the field of so-called 'critical art,' but also the continuous relating between politics and dance constantly deposit the political to some other place (the institution towards which it is necessary to resist, to the procedures of making the practice visible, to negotiation of interests, to the value of collaboration etc.). It is important to recognize that political relation is already established with the ways in which we are present and working in the present, and it is articulated through continuous revolving around the issues of the common.

II.

The basic question regarding the relationship between politics and art therefore does not concern the autonomy of art and how it is subordinated to politics, but especially the antagonistic and the inevitable place of the common, which concerns the possible material and sensory ways of life that is yet to come and processes of subjectivization. Here, not only dance, but art in general is closely connected with the questions on the conditions and possibilities of life and touches on the disclosure of the potential modes of common reality. Art is therefore not articulated within the discursive texts of self-referential and critical distance to itself, but directly challenges and demolishes a colourful range of contexts in which it appears and becomes visible; at the same time, it does not agree to the

unique reduction of art to a moral and didactic stance. Art is a mode of life, opening up life's sensory and aesthetic power, the ways yet to come. It is those ways that radically change the conditions of common life, the intensity of co-being and the existing paths of subjectivization. Here, we can agree with Rancière that politics does not consist of "relations of power, it consists of the relationships between worlds" (Rancière 2004: 57). In this sense, the political subjectivization that can take place in performance, for instance, is not the recognition of the community as it already is, of recognizing those who are right or the things we already have in common. Subjectivization gives rise to a certain new multitude that calls for a different kind of enumeration. Political subjectivization divides anew the experiential field though which everyone's identity and share has been bestowed. Every subjectivization is therefore also a dis-identification, a painful and paradoxical process of being torn out of the place of usual political order. If we approach to dance from that specific perspective, than its relation to politics is not possible to grab without tackling the notion of the exploitation of the life forms of the common, the exploitation which experiences its apotheosis today, in the time of intense political antagonisms and visible dis-empowerment of democratic spectacle of organizing activity and interests.

III.

The reflection on the relation between dance and politics has to be intertwined with the specific temporality to which work in dance nowadays is generally subjected, because this temporality is very tightly linked with the experience the commons. With the articulation of the relation between politics and dance, many other notions appeared and accumulated excessively, and it is no coincidence that almost all of them are related to the modes of working: like collaboration, research, production, experimentation, working together, process, etc. There is an anxiety springing from their overuse, and it is connected to the fact that these notions actually start to signal more than they actually perform; anxiety is therefore springing exactly from their political dis-empowerment.

The experimentation with the visibility of work and working modes is namely today tightly connected with contemporary modes of production in contemporary capitalism; it is standing in the core of production of value. The affective and creative work stands in the centre of exploitation and the establishment of a limited autonomy is necessary to produce even bigger dependency. In that sense the processes of work are somehow robbed of their political effect. To maintain the relationship between dance and politics it is not enough to reflect about conditions and the ways in which dance is organized as a sphere, because only with re-arrangement of interests no political effect could be actually produced. Politics is then not so much related to the conditions in which someone is working, or to the different modes of production, but to the constant differentiation and articulation of the practice of dance itself: the modes of common prac-

tice and subjectivization through which dissensus is produced. The political is in the strong relation to dance when dissensus springs from the different modes of working and various ways of creating, and when there is a strong tendency maintained not to erase the differences with immediate commodification of invention and experimentation. Or to say it differently, the relation between dance and politics is the result of the continuous care for enabling different ways of working and living around the possibilities of space and time.

Therefore it is becoming very important today to reflect upon how dance practice and art practice in general are subsuming under a specific temporality, which I name 'projective temporality,' a temporality that is abstracting and generalizing practices in the constant actualization of what they have to become and how they have to become. Projective temporality of work has multiple baffling consequences on the lives of the ones who are involved in the continuous creation of projects, especially in the cultural and artistic field. It seems that its abstract omnipresence is literally absorbing the experience of artistic work and work making, and at the same time forming the peculiar temporality of the subjectivity which is involved in the completion of it. Projective temporality is namely tightly intertwined with subjective experience of time. It can be argued, that contemporary subjectivities are more and more experienced as simultaneity of many projects, let it be private, public, social, intimate ones. It seems as if temporality of the project is also influencing the rhythm for the transformation of subjectivity, which has to be flexible however at the same time moving towards an accomplishment, a realisation, an implementation. The projective temporality of work and activity is intertwined with the acceleration of that same activity, where the unexpected happens only because of the outburst of crisis, exhaustion and withdrawal. Such continuous movement to completion and consummation is also stiff and destructive movement of progression; its flexibility is actually destructive for subjectivity and its collaborative surrounding. The subjectivity is abstracted from the contexts of work, making them more and more the same, erasing the differences between the communities of work and with that disempowering its political strength.

IV.

In this sense the problem of the relationship between dance and politics touches also one of the proposals in Andre Lepecki's text, where he is asking how it is possible that colonization and post-colonization effects to produce bodies are constantly forgotten from critical discourse on choreographic practices. Dance practice today is very often created in the ways, which are continuously erasing the differences and nuances between expressions and subjectivizations. For example, dance practice at least in Europe in the last decade became subjected to the illusion of constant flexibility and collaborative production, to the mobility for its own sake, where artist's subjectivities have to become disembodied in or-

der to maintain connection and realize possibilities. It seems there is something in the temporal modes of contemporary work, which, with its immateriality and flexibility, erases the variability of modulations in the forms of living, the needs for different temporal articulations of the lived and the potentiality of life. Exactly here, the political has to be related to dance as a continuous revolving of a particular practice in the relation to the commons and to the power of its mobilization between singular and the plural.

Dance practice is taking place through a continuous persistence of contingent materiality of the practice and work, through mobilizations and creations of political subjectivities, which are related to dissensual temporal modulations and articulations of life, assemblages and movements which cannot be planned or projected, differences which cannot be abstracted through an acceleration of movement. I would like to conclude these fragmentary reflections from one short sentence from the wonderful book of Jonathan Burrows *A Choreographer's Handbook* about the importance of „releasing the grip on the desire to do, enough that I can do" (Burrows 2010: 103). Burrows is writing about the importance of the artistic process starting always from a contingent situation, from the situation which cannot be projected, already given, planned, which is never 'the chosen one.' His advice to young artists could also be read from a broader perspective. When thinking about dance and politics, dance is in the relation to politics and politics in relation to dance, when they are relaxing a grip how they should be related. When following that advice in the process of creating, we enable the contingency of the process to appear: the way is given to a practice where materiality is constantly rearranged and change can be only expected when it is actually being made. When following this advice and thinking about politics in the relation to dance, we possibly enable the contingency and singularity of dance practice to appear and disclose the potentiality of dance to relax the grip of subjectivity implemented in the constant acceleration of production and projective temporality.

Contemporary Dance and the Critical Ontology of Actuality[1]

BOYAN MANCHEV

Let me start by scanning my statement in a dialectical mode.

Thesis: Contemporary dance appears as a field for experimentation and mobilisation of the possibility for the unforeseen to happen and, consequently, of the praxis of transformation: of freedom.

Antithesis: At the same time, contemporary dance seems to become an exemplary field of what I call 'performance capitalism' and consequently is a privileged example of the processes of absorption and appropriation of the becoming subjectivities by the dominant regimes of production and consumption, of the becoming of forms of life.

1 "Ontology of actuality" is a term, which appears marginally in Foucault's late writings. In his 1982-1983 seminar at Collège de France Foucault states: "Il faut opter ou pour une philosophie critique qui se présentera comme une philosophie analytique de la vérité en général, ou pour une pensée critique qui prendra la forme d'une ontologie de nous-mêmes, d'une ontologie de l'actualité." (Foucault 1984: 39). I borrowed Foucault's term and tried to clarify and develop it in my work in the past years not at all as all-encompassing descriptive category concerning the condition in which we live (and which is of course composed by multiplicity of particular historically determined cultural, social and political conditions), but as a critical tool to approach the multiplicity in question and its hypothetic common denominator. The concept is meant to express my conviction that we still need ontological categories in order to deal with the current political situation(s). By this I don't mean some new heavy metaphysics, some total categories – always risking becoming totalitarian – but experimental critical tools in order to face and operate into the complex tissue of the real. Elaborating a critical ontology of actuality not only means mobilizing critical forces and critical practices but also elaborating critical tools, or even, why not, critical arms. My theoretical proposals are evidently inspired by the close relation to artistic and political practices, which are still trying to answer the demand of what I call the 'crisis of aesthesis,' the 'sensitive becoming-world of the world.'

Synthesis: Because of the first two reasons, contemporary dance appears as a field of exemplary aesthetic struggle – which is also, I will claim, a struggle for the possibility of the event of freedom.

Argument: If we proceed from the hypothesis that contemporary dance opens a space for experimentation of the modes of life, of processes of subjectivation through *tekhnai*, ways-of-doing not reducible to a standardized form, today it faces inevitably the task to deal with the possible breaks through the agencies of new biocapitalism, commodifying progressively the forms of life themselves, thus standardizing the processes of subjectivation. In the 1960s and the 1970s, the emerging artistic practice of performance art and contemporary dance engaged a radical critical work on the rigid models of body representation and functionalisation of the subject through technologies, related to the (post-)industrial production in the time of post-Fordist capitalism, striving to return for some original experience of freedom of life and of presence of body, before any social, economic or cultural constraint. In the 1990s the emerging new 'conceptual' tendencies had to face an entirely new situation – the rapidly changing modes of production and exchange, related to a new political economy: the one of the supposedly victorious global capitalism. As if its practices were affirming: there is no way out of the technical devices of representation, no way out of the technologies of production of the subject, nothing like an originary organic substance or some beyond of technique. In this perspective the only possibility for resistance seemed to be the immanent transformation of the techniques themselves. Not surprisingly, a series of emblematic works from the last decade of the last century were focused on examining the conditions of possibility and the structure of different techniques of production (and therefore of production of subjectivity). Thus contemporary dance tried to make again possible the experimentation with the (technical) modes of life, and in that way to re-appropriate its driving force.

Counter-Argument: However, there is a new tension at stake, taking place between the insistence of contemporary art on the impossibility to step out of technique (and of transformation as original condition of technique), and biocapitalism's assault over the force of transformation intrinsic to life, its experimentation with the techniques of becoming of life.

Today we all know: the world, 'our' world, lives a radical and perhaps irreversible transformation. The world alters before our eyes.

Indeed, transformation is the very core of the contemporary condition: the ultimate horizon of the economic and political crisis we are going through. New forms of economical production and exchange are emerging; the fields of the political and the aesthetical are also affected by a radical transformation, putting in question the modern concept of their autonomy. Thus, the transformation of forms of life and modes of subjectivation – or rather the production of a flexible subjectivity adaptable to the heterogeneity and diversification of market, of vir-

tualisation and standardisation of forms of life – appears as the main feature of performing society of global capitalism, the society of economic performances and stock exchanges. Biocapitalism means commodification of forms of life. In that way life itself, through the appropriation of forms of life, is reduced to a commodity production, to standardisation as commodity. That's what I call "performing capitalism" or "perverse capitalism" (cf. Manchev 2006; 2009). "Perverse capitalism" prostitutes life.

If this transformation is unprecedentedly radical, that is because today's biocapitalism appropriates the potential for transformation of human beings, their original transformability, the transformability, which makes possible the multiplicity of the forms of life. Having become flexible and inventive, 'creative capitalism' has started to appropriate the transformability of life in order to inscribe it in the circuit of production. From that point of view, "performing capitalism" could be seen as the appropriation and the universalisation of alternative models of experience developed in the last decades in the artistic practice, and in performance art at first place. From that point of view, Nicolas Bourriaud's theses on the *Relational Aesthetics* of the 1990s (Bourriaud 2002 [1998]) could be seen as disturbingly close to the ideal of 'creative capitalism,' exalting mobility, flexibility, plasticity, fluidity, open connections, networks, leisure productivity, experimentation with the techniques of the subject etc.

Then the paradox lies in the fact that in the performing capitalism, (performance) art risks not only to see its critical potential weakening but also to find itself, against its will, in the position of exemplary figure of performing capitalism. Apparently performance in the traditional sense of the term could not accomplish any longer its critical function, which brought it to life as a pioneer artistic practice few decades ago. Yet, precisely for that reason (performance) art appears today as a field of exemplary aesthetic struggle. What are the dimensions of this struggle?

Final Hypothesis, or Critical Task: If I paraphrase the famous final phrase of Walter Benjamin's *The Work of Art in the Age of Mechanical Reproduction*[2] (Benjamin 1980 [1935]), the task at stake today is not to bio-aestheticise politics but to (re-)politicise aesthetics, or rather to follow its immanent political rhythm. This is an aesthetic struggle but it is also a struggle for the 'aisthetics'[3] which is an alterating expression of the resistance proper to sensible experience. Against the actual aesthetic hysteria, there is also an emerging an-aesthetics, i.e. an aisthetics irreducible to a transcendent principle, or, to put it simply, of matter. This an-aesthetics has its singular contemporary modes: it experiments itself first through the aesthetical practices in the narrow sense of the term, which try to

2 "So steht es um die Ästhetisierung der Politik, welche der Faschismus betreibt. Der Kommunismus antwortet ihm mit der Politisierung der Kunst." (Benjamin 1935: 469)

3 The word aesthetic comes from the Greek word aisthesis, "sensible experience," from which Alexander Baumgarten coined the term aesthetics.

transform the field of sensible experience, by reaffirming in fact its transformative potential while subverting the reactionary assaults of the hegemonic regimes today. This means nothing less but reopening and re-mobilising the transformative power of the artistic and conceptual praxis, of our 'praxis' itself, not in order to pose again the exigency of transforming the world but in order to transform its transformation. At that moment, when the forces of the global capitalism are absorbing further each day the potential for transformation in order to submit it to the imperatives of the (economic) growth, which resulted in the alteration of 'our' world, the transformation of the transformation is our task: artistic, philosophical, political.

If I am trying to formulate a sharp and provocative critical question, it is not in order to homogenize and stigmatize contemporary artistic practices, but in order to delineate a critical horizon which imposes urgent critical praxis, and therefore 'krisis' (crisis; distinction, judgment) – a critical distinction, which is the elementary not only aesthetical but also political operation. My critical question is not an expression, neither of some late or new (or both) cultural pessimism nor of some bored or hyperactive activist nihilism, both stuck in a dead end. My aim is to provoke clear critical and therefore political distinctions, also concerning contemporary artistic practices and dance in particular. If I have to put my position in one word, the word will be 'Yes' and not 'No.' Nevertheless, the strong affirmation, the 'Yes' is impossible without strong 'nihilist' stance, without clear negation.

Therefore the critical question is the starting point, and our critical practice is dedicated to the articulation of an answer, that is to say to the transformation of the conditions in which the question was formulated.

Thus, my final affirmative statement would be the following: in the era of neoliberal cult of performance, which reduces sensible matter to exploitable resource or to a matter of production – production of forms of life as commodity –, performance and dance could only matter as an affirmative counter-act, reopening the potential of sensible matter, disorganising commodified bodies, transforming the standardised modes of production of subjectivity, inventing new emancipatory tools, new techniques and forms of life, giving new flesh of emotions – rage, true pleasure or irreducible joy. Their only sovereign should be the irreducible drive for freedom.

Geo-Politics, Dissensus, and Dance Citizenship: The Case of South Asian Dance in Britain

AVANTHI MEDURI

This paper takes as example the case of Indian dance forms relabelled as South Asian dance genres, to discuss questions around political mobilization of dance in Britain in the late 1980s. I use Jacques Rancière's concept of 'dissensus' (Rancière/Cor-coran 2010) to elaborate my preliminary thoughts on the inter-connections between politics, aesthetics and political subjectification and draw on my initial research (Meduri 2008a; 2008b; 2010; 2011a). This paper can serve as case study to explicate issues raised by André Lepecki, Bojana Kunst and Franco Barrionuevo in this book.

FROM THE 'POLITICAL' TO EVERYDAY POLITICS

The large-scale socio-political mobilization and globalization of Indian dance traditions, under the new classificatory label of South Asian Dance, has been un-derway in Britain since the late 1980s. This mobilization, articulated by British state ministries including Arts Council England, was beneficial as it enabled the self-conscious integration of Asian, non-western expressive traditions into Brit-ish mainstream culture, albeit under the new classificatory label. The newly con-stituted South Asian Dance Community, which is not monolithic but diverse, and comprising Indian, Sri Lankan, Pakistani, Bangladeshi communities, welcomed these initiatives towards integration, but express reservation about the new label because the nomenclature falsely projected South Asia as a single, monolithic country, which it is not; and orientalized Asian forms within familiar East/West binaries described by Edward Said in his book *Orientalism* (Said 1979).

Briefly, South Asia is a geopolitical label referring to a bloc of Asian nations, including the countries of India, Pakistan, Sri Lanka, Bangladesh, Bhutan and Nepal. The term emerged as a post-war geopolitical label in US State Depart-ment and Foreign Policy discourses, following British decolonization and the Partition of India in the 1950 (Meduri 2008a). While the term found favor in Ar-ea studies programs of research established in the US and UK in the 1950s and

1960s, it was also used as a bureaucratic and administrative label to police and safeguard the geographical area demarcated as South Asia (Meduri 2008b).

If bureaucrats focused their attention on the geopolitical area, Area Studies scholars used the generic label to particularize their researches and studied the arts, cultures, histories, and languages of key nations within South Asia, including India, Sri Lanka, Pakistan and Bangladesh, to name a few. These researches, inscribed in Imperial histories of colonialism and Orientalism are archived as such in University, and Public archives including the British Library, the British Museum and the Victoria and Albert Museum. In these national archives, Kathak, Bharatanatyam, Odissi, and Kathakali, are not catalogued as 'South Asian' but rather as 'Indian' national forms inscribed in multilingual Indian cultural, literary and heritage histories, traditions, and practices.

Arts Council administrators appropriated this academic and bureaucratic label in the 1990s, and used the South Asian label as a catch all, geopolitical unifying term to articulate a large-scale, Asian multicultural and diversity arts movement in Britain. This dual focus on 'homogeneity and diversity' created what I describe as a double-voiced, Indian/South Asian dance phenomenon in Britain, about which I will say more later. By the 1990s, key British dance organizations including Akademi: South Asian Dance and Sampad, funded by Arts Council Britain, used the geopolitical label to promote Indian performing arts in the UK (Meduri 2008b). In 1998, the Imperial Society of Teachers of Dance (ISTD) devised a new syllabus for *Bharatanatyam* and *Kathak* (Prickett 2004; 2007). Both dance genres were institutionalised not as Indian but as South Asian Dance genres. The South Asian label has achieved worldwide currency today. It manifests itself as an immigration term and is used to refer to the dances, literatures, theatres, folk forms, cultures, cuisines, film, and music of the people of South Asia (Meduri 2008b).

DOUBLE-VOICED DISSENSUS

Although British South Asian choreographers and dance teachers object to the South Asian label, they articulate their dissent creatively by splitting the label and using it selectively as a flag of convenience to integrate into British mainstream culture, and also to ethnicize and historicize their cultural identities and both simultaneously. While South Asian dance teachers teach Bhartanatyam as an 'Indian' form inscribed in multilingual traditions, they re-stage it selectively as a British-Indian and/or British South Asian representation in the public domain (Meduri 2010). I learned to recognize this double voiced cultural negotiation as representing a performative act of dissensus, one that articulates resistance in the private and compliance in the public, and both simultaneously.

According to Jacques Rancière, dissensual event moments are the properly constituted artistic-political acts within the "aesthetic regime": "if there exists a connection between art and politics, it should be cast in terms of dissensus, the

very kernel of the aesthetic regime" (Rancière/Corcoran 2010: 140). For Rancière, dissensus, or disagreement is not a conflict of interests, opinions or values; it is a division inserted in 'common sense': a dispute over what is given and the frame within which we sense something is given, is at the core both of art and politics (ibid: 69). Dissensus, he explains

"is the putting of two worlds in one and the same world. The question of the political subject is not caught between the void term of Man and the plenitude of the citizen with its actual rights [...] The very difference between man and citizen is not a sign of disjunction [...] it is an opening of an interval for political subjectivation. Political names are litigious names, whose extension and comprehension are uncertain, and which for the reason opens up the space of a test or verification. Political subjects build such cases of verification. They put the test power of political names – that is their extension and comprehension – to the test. [...] construct a relation of inclusion and a relation of exclusion." (Ibid: 69)

By objecting to the South Asian label in public forums, even while using it selectively to enable integration, South Asian dance communities historicize this moment of their ambivalent integration into British mainstream culture and mark it as the 'given' common, heterogeneous, and conflictual ground of their incorporation into British mainstream culture and diasporic practices. By referring to this moment of the relabeling in public forums and performances, practitioners memorialize the collective moment of their ambivalent incorporation into British mainstream culture, relocate this moment within the social ground of their aesthetic practice, and use it to mark their specific enunciations, agency and individuality within the field of performance. By dissenting creatively, practitioners also point to the importance of historical memory in cultural performance and urge us to historicize political mobilization movements as ambivalent, partial, institutional processes, subject to revision, change and transformation.

POLITICAL SUBJECTIFICATION AND IDENTITY FORMATION

Drawing on Jacques Rancière's theory of dissensus, I marked this moment, when the Indian/Bharatanatyam dancer takes on the South Asian identity label, bestowed on her by British nation-state, and state funding agencies including Arts Council England, as representing a rupturing, paradoxical moment in her career as artist. I marked this as such because it is here in this place of label-taking that the Indian dancer splits her artistic identity, and consents to live in two or more worlds. Not British-not Indian but British-Indian or British-South Asian, this is the new hyphenated identity that the Indian dancer embraces in the British diaspora.

Elsewhere, I have described this moment as analogous to the life in the UK Citizenship Test which every aspiring British citizen must accede to and pass in order to be granted legal status as a British resident (Meduri 2010). After the la-

bel taking moment, the British Bharatanatyam dancer is empowered to join the British Indian/South Asian dance community, and is able to check assigned boxes and apply for British grants to support her artwork.

Here, we can agree with Rancière's argument that at the heart of art and politics resides a paradox. Art and politics, he explains, defines a form of dissensus: a dissensual re-configuration of the common experience of the sensible. If there is such a thing as an aesthetics of politics' it lies in the reconfiguration of the distribution of the common through political processes of subjectivation which then effectuates a change in the distribution of the sensible (ibid: 141). If we apply this theory to South Asian dance production, we find that the sensible that is enforced upon the Indian/South Asian dancer is not based on her originary identity as Indian dancer-teacher but on her ability to claim common ground with other Indian/South Asian dance-teachers in the British Diaspora and her capacity to articulate herself variously as a British-Indian, British Asian Indian, and or British South Asian dancer. If and when the British Indian/South Asian dancer-teacher understands and accepts her double-voiced paradoxical incorporation into British mainstream culture and dance production, she is inserted into a global dance milieu and empowered to embrace flexible notions of dance citizenship and present herself strategically as British-Indian and British Asian simultaneously in the world at large.

In Britain, Shobana Jeyasingh's choreographies have challenged audiences to think outside of identity categories and we see this complex British Asian subjectivity embodied in *Faultline* (FL) (2007) and *Bruise Blood* (BB) (2009), two of her most famous choreographies. Featured as part of the GCSE dance syllabus in Britain, it is also part of curriculum at Roehampton University and we teach these two works not as Indian but rather as 'British-Asian-Indian' choreographies and situate the work within a dual British-Asian framework. While both choreographies deal with Indian-Asian and African themes of alienation and disaffection in London's Southall communities, they also use a hybrid vocabulary drawn from many dance histories as basis for movement generation in the studio (Meduri 2011a).

Further, her staging conventions reference wide range of influences including opera and film genres. Equally, music choices have ranged from a commission from Tamil film maestro Ilayarajah to Hip Hop. 'Not-British, Not Indian,' Jeyasingh's choreographies articulate themselves in new spaces and location, urging spectators to embrace real and imaginary homelands as new markers of identity and creativity in the age of globalization (Meduri 2011a).

FROM POLITICS, TO AESTHETICS, TO THE SOCIAL

Although the political mobilization movement underway since the late 1980s, sustained critical reflection on the integration movement was articulated after Andree Grau completed her Leverhulme funded research project entitled *SADiB*

(South Asian Dance in Britain) in 2001. In this report, Grau noted the arrival of the Indian dance community in mainstream of British dance culture, identified it as a British South Asian Dance phenomenon and examined questions revolving round identity formation. In her own words,

"the research focused on issues of identity, a concept that many artists were reluctant to see as being central to their practice, primarily because they do not want to be marginalised as they see that Western theatre dance – be it ballet or the numerous contemporary genres – is rarely given this 'cultural' treatment." (Grau 2002: 9)

Following the publication of the *SadiB* report, *Akademi: South Asian Dance in the UK*, a flagship arts organization based in London, organized two major conferences focused on what I have described as label politics. The first seminar entitled *South Asian Aesthetics Unwrapped* was organized in 2002, and the second titled *No Man's Land: Exploring South Asianess* came two years later in 2004.

The *No Man's Land* seminar gathered a diverse group of international scholars, journalists and artists to grapple specifically with questions around 'South Asianness.' The aim of the seminar was to critically debate the origin, application and relevance of the idea of 'South Asianness' to the regions and their diaspora (Pinto 2004). The objectives were to arrive at an understanding of what 'South Asianness' is, on the basis of that understanding, accept, recommend or reject its use (Pinto 2004). Both seminars debated the implications of the new label, but no action plan or memorandum was submitted to change the label. Both events appear to have been organized with the double goal of raising public consciousness about the South Asian label, and were intended to also mobilize consensus for the new label.

Presenting a paper at the second conference, Grau suggested provocatively that the South Asian label can be seen to be providing a sheltering sky for the dance community and as being more neutral and liberating than the Indian label. In her paper entitled *A Sheltering Sky? Negotiating Identity through South Asian Dance*, she suggested "that within a diasporic context, one could argue that the South Asian label was more neutral than the Indian one as the former removes the dance from any notion of a clear-cut lineage and a nostalgic notion of lost heritage." (Grau 2004) She stated that decontextualizing dance forms in this way might be useful as it could conceivably encourage a discourse about dance forms like Bharatanatyam as less rooted in culture and ethnicity and more in technique, thus rendering the form(s) trans-national (Grau 2004).

Shobana Jeyasingh agreed with Grau, but pointed to the rupturing and contradictory effects of the South Asian label. She explained that when the Arts Council used the South Asian label to describe her work in the 1980s, she thought it to be "less contentious" (compared to "ethnic arts"), resting as it did "safely in the objective arms of geography" (Pinto 2004: 4). However, being "pinned down" (ibid) within such a rubric was discomfiting for Jeyasingh, causing her to "wriggle" creatively, an exercise she identified as a "supremely

diasporic ritual" (ibid). Jeyasingh's wriggle metaphor is useful to think with as it sheds light on the political moment of integration but relocates it cleverly within the domain of aesthetics, choreography, dance teaching and performance.

Grau's Leverhulme research, led to the launching of the South Asian Dance MA, offered today as one among a suite of eight dance MAs at the University of Roehampton, London. As convener of the South Asian Dance MA, I developed on Grau's anthropological research and envisioned a global South Asian dance pedagogy by historicizing the political mobilization movement which I encapsulated as the "moment of emergence" (1980s), "moment of transition" (1990s), "moment of Arrival" (2000) (Meduri 2008a). I developed this new pedagogy by focusing specifically on the South Asian label and by universalizing Jeyasingh's wriggle metaphor and extending into the broader dance practice, including Dance Teaching in Communities, Dance Production in Mainstream Performance, and Dance Research and Teaching in Higher Education.

Several dance scholars since the 1990s, including Mark Franko, Randy Martin, Susan Leigh Foster, Gabriele Brandstetter, Gabriele Klein, Frédéric Pouillaude, Franz Anton Cramer, Gerald Siegmund explained "in different ways, and at least since the mid-1990s that it is the often foreclosed, but very clear fact that dance theorizes its social context as it practices itself which constitutes perhaps its most significant political trait and force" (Lepecki in this volume: 154). I have extended this critique to show how Indian/South Asian dance practitioners in Britain theorize the social context of their incorporation into British culture by wriggle creatively with the South Asian label and by using the label creatively to theorize diverse social and political contexts in which they make art today (Meduri 2010). Randy Martin has argued that

"unlike most political practice, dance, when it is performed and watched, makes available, reflexively, the means through which mobilization is accomplished. In this regard, the relation of dance to political theory cannot be usefully taken as merely analogical or metaphorical." (Martin 1998: 6)

I extend Martin's critique and suggest that large scale political mobilization movements create complex disjunctures in the social world of dance making and performance. To engage this complex field, we must enlarge our narrow definitions of choreography and focus attention on training sites and dance studios because resistance, innovation and creativity is rehearsed here in these spaces, hidden from the gaze of the public. This return to training sites and dance studios as new locus of study enables us to embrace what feminist scholars have described as the "politics of location" which is also "a politics of the ground" (Lepecki in this volume: 155) – one that is always attentive to the concrete placing of all the elements that constitute and form, animate and orientate the dance situation.

Resilient Bodies, Stirred. Political Anecdotes from the Field of Contemporary Choreography

MARTIN NACHBAR

Making and performing dance, I have never been too concerned about these dances being political. To me, there is something very pragmatic about making dances and about choreographing: the need to organize time, space and money to work; the desire to work with people that intrigue me; the question how to spent time with them in a way that will be somewhat productive in terms of making dances or choreographing; the urge to not let any sensation occurring during this time slip my attention; the necessity to organize all the activities and movements that come up during a rehearsal period, so that they become actions and gestures and possibly make sense as a piece; the question whether or not to tour this piece, and when to stop performing it, which is, when to announce it dead. Having said this, I am aware that these questions and concerns are already also political questions.

But I am not sure in which ways, as much as I am not sure how to define the political or how to define dance. As André Lepecki points out in this volume, what politics and dance share are their performativity, their ephemerality and their open-ended-ness or partial contingency of their effects. As it is, these are traits that make definitions hard. They ask for a readiness to keep hanging in mid-air, to be ready to jump and fly or to fall and break a leg at any given moment, dancing, choreographing or writing.

Still, I get suspicious when I hear that dance is political. I quickly assume that academics use the terms 'dance' and 'choreography' just as metaphors to describe the gestures, affects and effects of politics in ways they possibly haven't been described before. With every public enunciation – may it be a dance performance in a theatre, a political statement in parliament, or a theoretical text in an academic publication – there is always, besides the sincere concerns, desires, curiosities and urgencies that have provoked their authors to go public, an interest of claiming territory – artistic, political, academic. Which makes the enunciation political but in a rather blunt way: How can the enunciator survive – in his or her respective arena of enunciation – in order to survive socially and economically? At the same time, the mere proliferation of the 'political' in current

dance-making and thinking about it, addressed by André Lepecki, seems indeed to make it inevitable to face its effects on my own choreographing and dancing.

I would like to develop some open-ended thoughts, re-iterating some of my and my colleagues' praxes, taking my doubts on board and hoping not to formulate an artistic manifesto or scientific argument but rather an anecdotal account of how I relate the corporeal experience of making, performing and watching dances, to the political and also to the experience of language.[1]

POLITICAL AND OTHER ORDERS SUBTLY STIRRED: REPEATER – DANCE PIECE WITH FATHER

First, I would like to have a look at *Repeater – Dance Piece with Father* (2007) and see whether we can trace political forces within it and see or maybe feel how they might converge with political forces outside the field of dance. I made this piece in collaboration with dramaturge Jeroen Peeters and with my father Klaus Nachbar, with the full support of the Federal Fund for Culture of the Capital of Berlin and with several national and international co-producers. Before the premiere, we had already organized a tour with about 20 performances. Later, about 10 more invitations came in. In other words, this production was made in full consensus with the various institutions and decision-makers in the field of dance and was in this sense fully recognized and accepted by the field's reigning political orders.

On the other side, *Repeater* seemed to stir forces that we might want to call political in the sense that an order gets disturbed or even changed. First of all, there was the question of how to work with an amateur, who is closely related to me. How could I make the outspoken and even more so, the underlying feelings, tensions, and joys of the relationship to my father productive in and through our bodies dancing together? The solution was twofold: a literary reference to Don DeLillo's novel *White Noise* (DeLillo 1985) found by my collaborator Jeroen Peeters that described the dialogue between fathers and sons as laconic; and the use of Rudolf von Laban's *Moderner Ausdruckstanz* (Laban 2001), a manual for teaching dance to amateurs, especially his description of his eight basic movement qualities. Both enabled my father and me to dance together. And it allowed us to propose to an audience that it was possible to shape family relations through the embodied practices of dance.

Dancing with my father in the premiere in November 2007 in Berlin, I literally felt how the almost 200 spectators projected their own family relations onto us, asking themselves: 'Can I do this with my father/mother? Would they dance with me like this? Would they or would I be able to engage in the embodied and

1 During a seminar of the Amsterdam Master of Choreography, Myriam van Imschoot once refered to the anecdote as one of the appropriate modes, in which artists can talk about their work.

sensual practices shown here?' Watching and projecting, they engaged in my father's and my laconic embodied dialogue, focussing on how the relationship felt rather than on what it meant. This might have stirred reconfigurations of some of the family relations involved or at least enabled the spectators to imagine such a reconfiguration virtually.

Thus, *Repeater* was somewhat political in an almost paradoxical way: On the one hand it was fully part of the order of the field of contemporary dance, using the order of the reigning heterosexual nuclear family matrix. On the other hand, *Repeater* was able to stir and ever so slightly re-calibrate the actual or virtual family relations of its spectators and workshop participants, including my father's and mine.

RESILIENCE RATHER THAN RESISTANCE – *ON FALLING*

In a different role, namely the role of spectator, I was stirred by the performance *On Falling* (2011) by my colleague Ehud Darash. I have never seen this performance live but only in videos online. After a series of workshops during spring 2011, in which Ehud Darash worked with the participants on falling and on ideas around a resilient – rather than a resistant – body, they went onto the streets of Tel Aviv to slowly go to the ground.

By chance, this was the time of the demonstrations against the inflation in Israel. *On Falling* took place in the midst of demonstrating Israelis and the performance provoked strong reactions among some of them. The performer's bodies falling and giving into the force of gravity formed a curious counterpoint to the bodies demonstrating and resisting to political and economic powers.

This performance was political in several ways: first, it left the safe boundaries of the theatre and took to the streets, which I tend to think of as places of political enunciation rather than the theatre; second, *On Falling* subverted the idea of resistance as being the assumedly most effective political mode of people not in political power. It replaced this idea with an action of giving in without giving up, thus creating something we might call resilient bodies; third, it happened to take place in the midst of political enunciations in public; and forth, it stirred the involuntary spectators the demonstrators became to react to the unusual performance. Maybe they even reconsidered their ideas and feelings about what it means to be political.

NOT-KNOWING AS A MODE OF SHARING –
THE MAGIC OF BELIEVING

At the moment of writing this text, I am in a two-week break of the production of *The Magic of Believing* (2011), a multi-media performance with teenagers under the direction of Ingo Toben. I have been invited to participate as a choreogra-

pher, which, in the context of artistic production with teenagers, also means to be some kind of pedagogue. By this, I don't mean so much a teacher that leads the way by pretending not to know (Rancière 1991). I am rather thinking of someone that has lived through the somewhat scary process towards an unknown performance a few more times than the teenagers have. I could put up frames, in which learning by doing and also by resisting became possible. The shared object of inquiry was the unknown piece (Cvejic 2010). The main task was an artistic one. I could not escape the fact that some of the teenagers chose me either as an example for life, others as an episode quickly to be forgotten – which is what I would identify as the fate of a pedagogue.

Ingo Toben has organized and led such projects for several years now, besides his activities as story-telling facilitator for primary school pupils and as film-maker of filmlets with youth. He has always seen himself as an artist that tries to make art with kids. At the same time he dealt with the institutions one has to deal with when working with youth: schools and their administrations, state education offices, funders and theatres. This insistence on facilitating frames and on looking not only for complicit artists and administrators but also and especially for teenagers complicit with his artistic focus, makes Ingo Toben's work political in a very direct sense: it might make a difference in some of the teenager's lives to have worked on one or more pieces with artists that took them for serious enough not to teach them anything but to share with them the unknown that every artistic process tends to be.

SOME KIND OF CONCLUSION

In an attempt to conclude this inconclusive series of anecdotes, I would like to derive from them a few notions, which might help think artistic praxes as potentially political practices that address the bodies involved through sensation, curiosity and application of method as much as of self. These notions are: weakness or vulnerability in the face of the seemingly unsolvable, letting the problem move you rather than you controlling the situation (Burrows 2010); insistence on the practices that feel right once the problem has moved you; resilience through these practices; complicity with like-minded as much as with disagreeing colleagues, audiences and circumstances; and a sense of open-endedness of any practice applied...

Remarks Concerning the Ontology of Dance

RESPONSE BY GUNTER GEBAUER

At the centre of most of the papers in this panel lies the desire for a politicisation of dance. The various meditations repeatedly refer to Rancière (1991, 1999, 2009, 2010), in particular to his term "dissensus." It is immediately evident that a current politicisation of dance is critical of salient developments within contemporary society – "for experimentation of the modes of life, of processes of subjectivation," as practised by "biocapitalism" (Manchev in this volume: 174). The papers, however, do not yet achieve a political theorisation of dance. What makes it so difficult to develop a clearly elaborated concept of the political in dance?

The first thing that one notices is that the authors, to whom almost all of the papers refer (Arendt 1998, 2008; Agamben 2002, 2007; Benjamin 1980; Rancière 1991, 1999, 2009, 2010), highlight the aesthetic and the sensual aspects of artistic phenomena. Yet the essential feature of dance, the significance of the body, has no place in their theories. In order to render dance accessible to the political theories that are currently being discussed, a few more steps are necessary.

(1) What theoretical problem is posed by the body in the theory of dance? One notices this in almost every paper in this section: it is generally assumed that dance – the dancers' bodies, their movements, the choreography, the setting – has a political content. This assumption can only be affirmed. Yet how is the political made manifest within dance? How is it possible that we feel dance to be politically charged, if it does not contain a single element that is usually considered (even by the mentioned authors) to be political? Dance does not portray political actions, does not make political statements[1], is not concerned with the politically correct, does not generate role models, does not voice criticism, in short: it does not take to the street like a crowd in revolt. It is assumed that the concept of dissensus breaks with an established practice, that it creates a critical distance, withholds itself, and enables a re-appropriation of something that has been lost. Yet how can it accomplish this?

(2) Dance is characterised by a refusal of certain physical practices of daily life, which are indeed politically charged in so far as they are pervaded by structures of domination and subject to rigid norms and demands. It thus refers to a

1 Cf. Klein in this volume.

corporality of the everyday. The bodies of the everyday, however, are not the ones that normally appear in dance. This difference between the bodies of daily practice and the bodies of dance is essential; it is constitutive of artistic practice; it is my impression that in André Lepecki's text this is not taken into consideration.

Due to this difference, the ontology of dance is unlike those of other aesthetic fields. This becomes apparent if one compares it to theatre.[2] The actor is not what he acts: his movements do not belong to him but to his role. It just seems as if the movements he adopts for his role are his own. In dance, this 'as if' does not exist. The dancer does not act out the movements that he dances – he just moves.

Through his performance on stage the actor becomes another. The dancer also transforms himself when he begins to dance – he does not become another: he becomes a dancer. Even his simplest movements, like standing and walking, are different from his everyday motions, regardless of their phenomenological similarity. They are movements on a stage, executed by a dancer.

Dance usually takes place on a stage – real or imaginary: in a special space, removed from everyday life. If someone enters this space and stands or walks like a dancer, this is an action that one pays attention to, in contrast to everyday standing and walking.

(3) Inserted into this performative realm, everyday movements acquire a demonstrative, suggestive function. It is the latter that may be instrumentalised for a politicisation of dance. At the same time, these movements are removed from everyday practice. Yet it is precisely in this context that they acquire their political significance. Thus, the pressure of social normalisation in contemporary work relations becomes tangible if one is subjected to them. This also applies to the modern service industry's demand that employees should display affection towards their customers. The effect this has on the employees can be observed in their bodily behaviour. If one, however, detaches this behaviour from its everyday context and transfers it to the stage in the form of dancers' movements, its integration into the network of necessities, constraints, subjection, fear of losing one's job etc. disappears. Yet this is not due to the insecure position the dancer may find himself in; very often this is precisely not the case. Even though the theatre company might also be subject to constraints and necessities, the stage does not create the same sort of situations as everyday work relations.

(4) How can the demonstrative function of movement in dance be made political? Its mere execution does not render this possible: the political does not exist without content, without generating meaning. Yet this content does not necessarily have to be conceptual; dance, after all, does not make propositions, does not form declarative statements. There is, for example, a political significance in rituals, gestures, bodily postures, in spaces and images. Prohibitions and precepts may also be expressed other than through conceptual language. Political actions,

2 I must leave aside the special form of dance theatre as it complicates my argument, without contradicting it, however.

like the dissensus, depend on political meanings – otherwise one would be unaware of what is being opposed or rejected. Meaning, the way I understand it, is generated, as Ludwig Wittgenstein (1953) infers, by the use of motions in specific contexts. One cannot resolve the constitution of the political in dance without reference to the context.

(5) If the practice of dance should become political, if, in other words, it is a question of the political significance of normal bodies in daily routines, of their flexibility, acceleration, discipline, their subjection to norms etc., the political content, such as the political significance of the dissensus, for example, has to be reconstructed on stage: in dancing, the body of the dancer acquires a demonstrative form, which reveals the political, displays it. This display needs a context. The latter, however, does not need to be very elaborate; it can be minimalistic – it can be generated through the audience's expectation or the expectation evoked by the title.

(6) According to most of the papers in this section, the dissensus provokes a rupture. Such a rupture takes place when an expectation is frustrated. The political appears in a context, which essentially involves an anticipation of the future. Thus it is not only organised spatially, as a network of necessities, but also temporally. The political, by means of its rupture, disrupts the isolated context of everyday activity in so far as it enables an opening: actions do no longer function smoothly; friction and dissonance emerge. A genuine ability of dance to evoke political effects is the disruption of ingrained times and rhythms. Such a dissensus is noticed because one is referring to the conventional world and the expectation of the conventional: the political is caused by the dissonance between a model, namely the anticipation of the everyday, and the destruction of this model in dance. This relation is mimetic, yet not in the sense of an imitation but as a reenactment of the given world. In dance motions, rituals, gestures, postures, everyday movements, whose variety one is already acquainted with, are carried out once again but in a different manner. This difference is the foundation of the political.

(7) The alteration and the invention of rhythms, do they not belong to the subversive potential of dance, operative at the deepest level? Could it not, in this way, disturb the existing order and throw orderly formations into anomie? Could a loss of order not give rise to a new, a different order? All the more so since social orders are always revealed and experienced by the bodies of social subjects. The loss of a familiar feeling and the adoption of new patterns of order in dance seem to be able to activate a significant political potential. With these questions I would like to encourage the theoreticians of dance to utilise the emotional force of dance for its politicisation.

References

Agamben, Giorgio (2002): *Homo Sacer. Die souveräne Macht und das nackte Leben*, Frankfurt am Main: Suhrkamp.
——— (2007): "Art, Inactivity, Politics." In: Joseph Backstein/Daniel Bierbaum/Sven-Olov Wallenstein (eds.), *Thinking Worlds. The Moscow Conference on Philosophy, Politics, and Art*, Berlin and New York: Sterberg Press (co-published by Interros Publishing Program, Moscow), pp. 197-204.
Akademi (2006): "Retrospective 1980-2006: A Look back at 26 years of Akademi History," August 24, 2007 (http://www.akademi.co.uk/retrospective.htm).
Arendt, Hannah (2008 [1958]): *Vita Activa oder Vom tätigen Leben*, München: Pieper Verlag.
——— (1998 [1958]): *The Human Condition*. 2nd ed. Chicago: University of Chicago Press.
Benjamin, Walter (1980 [1935]): *Das Kunstwerk im Zeitalter seiner technischen Reproduzierbarkeit. (The Work of Art in the Age of Mechanical Reproduction.)* In: Walter Benjamin: *Gesammelte Schriften* Band I, Werkausgabe Band 2, herausgegeben von Rolf Tiedemann und Hermann Schweppenhäuser, Frankfurt am Main: Suhrkamp, pp. 431-469.
Boltanski, Luc. (2008): The Present Left and the Longing for Revolution. In: Daniel Birnbaum/Isabelle Graw (eds.), *Under Pressure. Pictures, Subjects, and the New Spirit of Capitalism*, Berlin: Sternberg Press, pp. 52-71.
Bourriaud, Nicolas (2002 [1998]): *Relational Aesthetics,* Paris: Presses du réel.
Burrows, Jonathan (2010): A Choreographer's Handbook, Oxford: Routledge.
Carter, Paul. (1996): *The Lie of the Land*. London: Faber and Faber.
Cvejić, Bojana (2010): "The Ingorant Dramaturg." In: Maska, Vol. 25, Number 131-132, Summer, Ljubljana, p. 43.
Darash, Ehud (2012): About Resilience, January 22, 2012 (http://about-resilience.com/).
DeLillo, Don (1985): White Noise (novel), New York: MacMillan.
Foucault, Michel (2002): *The Archeology of Knowledge*, London: Routledge.
——— (2008): *Le Gouvernement de soi et des autres. Cours au Collège de France, 1982-1983*, Paris: Seuil.
——— (1984): "Qu'est-ce que les Lumières ?" In: Magazine Littéraire, no 207, pp. 35-39.

Franco, Susanne/Nordera, Marina/Centre National de la Danse (France). (2007): *Dance Discourses : Keywords in Dance Research*. London ; New York: Routledge.

Grau, Andrée (2002): "South Asian Dance in Britain: Negotiating Cultural Identity Through Dance (SADiB)." Unpublished report, Leverhulme Research Grant n. F/569/D.

———— (2004): "A Sheltering Sky? – Negotiating Identity through South Asian Dance." In: No Man's Land: Exploring South Asianness, Symposium Report. June 25, 2012 (http://www.akademi.co.uk/media/downloads/NML_-report.pdf).

Hewitt, Andrew. (2005): *Social choreography : ideology as performance in dance and everyday movement, Post-contemporary interventions*, Durham, NC: Duke University Press.

Laban, Rudolf von (2001): *Der moderne Ausdruckstanz*, Wilhelmshaven: Noetzel.

Lacoue-Labarthe, Philippe/Nancy, Jean-Luc (1997): *Retreating the Political*, London: Routledge.

Lefort, Claude (1990): "Die Frage der Demokratie." In: Ulrich Rödel (Hg.): *Autonome Gesellschaft und libertäre Demokratie*, Frankfurt am Main: Suhrkamp, pp. 281-297.

Manchev, Boyan (2006): "Transformance: The Body of Event." In: Martina Hochmuth/Krassimira Kruschkova/Georg Schollhammer (eds.), *It Takes Place When It Doesn't: On Dance and Performance Since 1989*, Frankfurt am Main: Revolver Verlag.

———— (2009): *L'altération du monde*, Paris: Lignes.

Marchart, Oliver (2010): *Die politische Differenz. Zum Denken des Politischen bei Nancy, Lefort, Badiou, Laclau und Agamben*, Berlin: Suhrkamp.

Martin, Randy. (1998): *Critical Moves : Dance Studies in Theory and Politics*. Durham: Duke University Press.

Meduri, Avanthi (2008a): "The Transfiguration of Indian/Asian Dance in the United Kingdom: Contemporary Bharatanatyam in Global Contexts." In: Asian Theatre Journal, 36, 2 (Fall 2008b), pp. 298-328.

———— (2008b): "Labels, Histories, Politics: South Asian Dance on the Global Stage." In: Dance Research, Vol 26, 2 (Winter), pp. 223-244.

———— (2010): "Global Dance Transmission(s) in London." In: Susanne Franco/Marina Nordera (eds), *Memory and Dance*, Novara: De Agnotini Scuola SpA.

———— (2011a): "Traces and Trails: Bruise Blood and Faultline in London and India," June 25, 2012 (http://www.rescen.net/Shobana_Jeyasingh/Hm-H/).

———— (2011b): "Enhancing Dance Careers through Research and Reflection." In: Pulse, 113 (Summer): p. 18.

Mouffe, Chantal (2005): *On the Political. Thinking in Action*, New York: Routledge.

Nachbar, Martin (2007): "Repeater – Dance Piece with Father" (dance piece), Berlin.

Pinto, Shiromi (2004): "No Man's Land: Exploring: South Asianness." June 25, 2012 (http://www.akademi.co.uk/media/downloads/NML_report.pdf).

Pricket, Stacey (2004): "Techniques and Institutions: South Asian Dance in Britain." In: Dance Research, 22:1, pp. 1-21.

―――― (2007): "Guru or Teacher? Shishya or Student? Pedagogic Shifts in South Asian Dance Training in India and Britain." In: South Asia Research, Vol. 27, No. 1, pp. 25-41.

Rancière, Jacques (1991): *The Ignorant Schoolmaster*, Stanford: University Press.

―――― (1999): *Disagreement: Politics and Philosophy*, Minneapolis: University of Minnesota Press.

―――― (2004): *The politics of Aesthetics. The Distribution of the Sensible*, London and New York: Continuum.

―――― (2009): *Aesthetics and its Discontents*, Cambridge: Polity.

―――― /Corcoran, Steve (2010): *Dissensus: on Politics and Aesthetics,* London, New York: Continuum.

Said, Edward (1979): *Orientalism,*. New York: Vintage Books.

Schmitt, Carl (1933): *Der Begriff des Politischen*, Hamburg: Hanseatische Verlagsanstalt.

Toben, Ingo (2011): *The Magic of Believing* (multi-media youth performance), Düsseldorf.

Wittgenstein, Ludwig (1953): *Philosophical Investigations*, Oxford: Blackwell.

LECTURE

Dis/Balances. Dance and Theory

GABRIELE BRANDSTETTER

Returning, once again, to the matter of dance [and] theory:

In the course of my preparations for this paper the sketches, theses and examples concerning dance and the theory of dance soon began to mount up. The complicated and manifold links between dance and/as/in/through/with/against theory soon manifest themselves in a chaos of 'links,' which of course is a 'liaison dangereuse,' at least for one who intends to give a reasonably cogent talk *about* this very 'liaison.' Which theories? And what relation to dance does one have in mind? What attractions or repulsions between a *theory* and a *praxis* of dancing manifest themselves, and how can this changing relationship be viewed? Is one to despair and adopt a skeptical position, like the 18ᵗʰ century natural philosopher Georg Christoph Lichtenberg, who once wrote about a new theory in psychology that it was about as relevant as the well-known theory "in physics [...] that attributed the Northern lights to the reflected gleam of herrings?" (Promies 1968: 292, translation: Brandstetter).

And what dance? What concept of dance? Contemporary dance has generated an immense variety of references to theories: body theories, philosophical theories, political theories. Anyone who thinks about it will soon find plenty of examples: William Forsythe in *Artifact* (1984), for example, has worked with post-structuralist linguistic and textual theories; Jérôme Bel has drawn upon Roland Barthes' body theory and Guy Debord's *Society of the Spectacle* (*Pichet Klunchun & myself,* 2005); the Hamburg based LIGNA Group, taking its cue from Walter Benjamin's theory of media (for instance in: *Das Unbewusste der Sterne,* 2008[1]), weaves political theories into its works; and the Hamburg/Berlin based collective She She Pop has adopted – among other things – Judith Butler's theorems of gender and queer theory. Many examples could be added to this list. Equally important, however, is the excellent work done on dance by those institutions and practitioners that follow in the tradition of works on the history of dance, whether ballet companies or dance theatres like those of Pina Bausch. The knowledge of ballet masters and choreologists is also theory-based, drawing both on an oral tradition of knowledge of the physical aspects of dance and on the historical research by those engaged in dance studies.

1 See the documentation: LIGNA (2009).

But does this mean, some will ask, that we have *already reached* the field of theory or that we never left it? Where are the generalizing, analytical, reflexive dimensions which distinguish a theory of art in the narrower sense? And in what way, others will ask, would one associate dancing, not in the sense of a staged performance, but as a kind of movement in other social contexts, intermingled with theories and discourses?

Once again my attempts to clear the thicket of associations have come to a standstill. It seems to be difficult to find a balance. Wherever one tries to take a balanced view from, a dis/balance is generated. An emphasis on *dance* theories dealing with the making of dances and choreographies, causes an imbalance in relation to those theories which are used – by scholars of dance, for example – in the analytical and hermeneutic consideration of the aesthetic or political signifi-cance of a dance or dance piece. Do we not see here (once again) in these appar-ently unavoidable dis/balances the gap between praxis and theory: that praxis which, as action, as active intervention in reality, Aristotle opposed to the theo-retical, purely cerebral way of observing and explaining reality in such a dis/balanced way as to place the theoretical mode of existing, the "vita contem-plative," over the practical one, the "vita activa" (cf. Arendt 1958)?[2] The ques-tion would then be: what action? And is it not so that new, and different "negoti-ations," as Stephen Greenblatt (1988) calls them, are being conducted between theory and practice at this very moment? Such as those that see – in the rethink-ing of approaches from Hannah Arendt's political theory in "The human condi-tion" (1958; cf. Virno 1996) – action *in* observation (e.g. that of the active spec-tator, cf. Rancière 2007) as praxes of theory; and on the other hand such 'negoti-ations' as see observation and reflection *in* the action of the practitioner/dancer as *praxeology*, i.e. as theoretically 'informed' praxis.[3] A chiasmus like that would create a balance. But how does this unsteady balance, at closer or further inspection, maintain itself in movement? Is it not a rhetorical artifice, an act of 'ponderation'[4] – to borrow a term from the tight-rope walkers – and the next step falls ineluctably out of balance for a moment? So what are we to do? Wait/observe? Or act/dance? In Samuel Beckett's *Waiting for Godot* (1964 [1952]) there is a scene that occurred to me as I was trying to get out of the trap of my 'ponderation.' Pozzo wants to put on an act for Vladimir and Estragon in

2 Arendt draws on these basic terms of Aristotelian Philosophy.

3 Although they have not yet been introduced to the discourse on 'theory and practice', I use the concepts 'praxes of theory' (which is the title of a project of dance and thea-tre studies at the Freie Universität Berlin in cooperation with the Richard and Mary L. Gray Center for Arts and Inquiry at the University of Chicago) and 'praxeology' in order to make it clear that these complex interlockings are not just forms of transfer or applied theory. It is more of a reflexive breach, a 'kinetic epoch' that has to be imag-ined in both directions in this process.

4 The term 'ponderation' is used in the double sense of equilibrium, keeping balance and the reflexive state of the mind.

order to dispel their boredom. His servant and porter Lucky, on a leash, like a dog – or like a dancing bear – is to perform something. Pozzo asks Vladimir and Estragon: "What do you prefer? Shall we have him dance [...] or think" (ibid: 39). Vladimir and Estragon quarrel over whether Lucky should dance first or think first. They agree that "he could dance first and think afterwards," which, as Pozzo comments, is "the natural order" (ibid). *"Lucky puts down hat and basket,"* as the stage direction says, and *"dances. He stops"* (ibid). When Estragon asks: "Is that all?" (ibid) Lucky at Pozzo's command, *"repeats the same movements, stops"* (ibid) "Estragon: Pooh! I'd do as well myself (*He imitates Lucky, almost falls.*) With a little practice" (ibid: 40).

Lucky's simple movements,[5] mechanically repeated, nevertheless make Estragon, when he imitates the dance, lose his balance; he *"almost falls"* (ibid). Lucky's performance of thinking also has such an effect: his interminable, arhythmical and mechanical speech, reeled off as a *"monotone lecture"* (Beckett 1976 [1952]: 46, translation: Brandstetter) without full stops or commas, strings together theological and scientific theorems as though they were theatrical properties; constantly interrupted by hesitations, stutterings: this too a mechanism that is losing its balance until we are left with the *"[s]ilence of Lucky. He falls."* (Beckett 1964 [1952]: 44) Thinking and dancing, dancing and thinking appear alternately; a 'ballet mécanique' driven off balance to the point of collapse. A scene which also, inexorably, unveils a power mechanism which forms as it were the 'yoke' (rope) between thinking and dancing, between theory and dance movement: namely in the master-servant relationship between Pozzo and Lucky; and in the relationship between performer and spectator (in which the spectators are divided into an immobile part, Vladimir, and a mobile part, Estragon). The observer whom the transition from observing to praxis – an imitation of movement – throws off his balance, out of his contemplation: the chiasm of theory in praxis, praxis in theory is in itself constantly deferred. In and out of balance.

Let us go back again, or further on, as the attempt at exploring the possible negotiations between theory and practice of dance resembles the Echternach Spring Procession (two steps forward, one step back):

'Theoria,' from the Greek in the meaning of view, investigation, and the concept of 'theatron,' i.e. 'room for viewing,' suggest (by virtue of this etymological affinity) a proximity between theory and a 'showing,' self-showing praxis. Seen in this light, the actions and motions of dance and performance would be, (as with theatre and music) incorporated in such a frame of reference. What is decisive here – as a meta-figuration, so to speak – are the relevant laws, forms and power structures that make up this framework – for example the manner of dancing/showing the dancer-spectator constellation (as the scene from *Waiting for Godot* demonstrates).

5 Pozzo explains that Lucky "used to dance the farandole, the fling, the brawl, the jig, the fandango, and even the hornpipe. [...] Now that's the best he can do." (Beckett 1964 [1952]: 40)

It must be clear by now that a reliable, stable meta-position for a systematic view of the relationship between dance, theory and praxis cannot be achieved (and may not even be desirable). A dis/balance, a loss of control, is always looming on the horizon. So why not implicate movement in the viewing process? It will only involve a few changes in position (at the risk of slipping).

But first allow me to make a brief excursion into the history of theories of dance; proceeding from the hypothesis that dance has always – in practice – incorporated theory/theories. The body concepts of a culture, the traditions of representing movements, the *joy* of movement, the desire and the disciplines that deal with them (which operate in theories and discourses), become performative; are incorporated in different historical, aesthetic forms of dance. As Paul Valéry aptly put it: "What clearer expression of dancing do you want than dancing it-self?" (1956 [1923]: 44)

According to a conception of the relationship between dance and theory – which, though still relevant today, has undergone several versions in the history of dance – theory is implicit in dance and dancing. The balance of a relation between these two aspects – dance theory and dance practice – is thus relegated to the actions of dancing and choreographing. Thus a *praxeology* of dance in the sense mentioned above does not mean an understanding of dance as 'applied theory,' there is no 'utilization' or illustration of theorems. It refers rather to what might be called an extended concept of dance, which does not confine the practice, the action or, yes, the 'work' of dancing to the performance of a dance, but sees it as a dynamic process. By the nature of things the historical concepts of such a praxeological understanding of dance are subject – in the context of art – to great social and political changes. A comparative study of such concepts in, say, the 18th, 19th and 20th/21st centuries would have to pursue the change of paradigm of such involvements of theory *in* dance, for example, on the basis of criteria that would shed light on the relevant understanding of bodily movement, gender and space as well as the representational contexts and models of the 'order of knowledge' (cf. Foucault 2004 [1966]). In the 18th century, in the period of transition from the Enlightenment to a 'sentimental,' expression-oriented conception of (dance) movement (in the sense of 'movere'), such a change of paradigm clearly manifests itself in the opposition between the idea of dancing as a 'learned art' and that of movements designed to 'touch the feelings.' In his treatise *Beschreibung wahrer Tanz-Kunst* (Description of a True Art of Dancing, 1707) the Leipzig dancing and fencing master Johann Pasch wrote:

"The true art of dancing is in *theoria* a science that sets or gives nature's urge towards more than highly necessary/or joyful movement (*per disciplinas philosophicas*) such rules/as enable the movement to be performed in *praxi* (*in specie per disciplinas mathematicas*) rationally/and also naturally and humanly/and used for one purpose or another." (Pasch 1978: 16, translation: Brandstetter)

Since the mid-18th century such an understanding of dance, which is "in *theoria* a science" (ibid), as a regulator of an (aesthetic) upbringing in and through movement,[6] has confronted a concept of dance as an art of expression. A *resistance to theory* (de Man 1986) manifests itself *inter alia* in relegating the disciplining function of a *theoria* as an ordering of our knowledge of dancing and 'shifting' the momentum of the movement into the relation to and through the (non-regulatable) expression. The claim of a non-artificial art of dance movement as understood by Gasparo Angiolini, Jean-Georges Noverre and Friedrich Schiller consists in touching the feelings of the spectator.

A leap into the modern phase in the history of dance is marked by a clear break in the relationship between the theory and practice of dance. If the 18th century models that defined 'dance' itself as a form of "*theoria*" (Pasch 1978: 16) were still variants of a systematic and rational concept of the nature of human beings and their environment, by the beginning of the 20th century general narrative theories of dance were becoming obsolete. For this very reason in this period of social, media and aesthetic upheavals a clear caesura, a dividing line between dance theory and practice is no longer even discernible. As in 20th century *theatre*, new concepts and aesthetics of dance succeed each other at ever shorter intervals in the history of dance: In the end it is the scientific and philosophical findings about movement on the one hand and the concepts of influential dance practitioners on the other that mutually influence each other – see the researches of Hermann von Helmholtz, the philosophy of Henri Bergson, or the dance and choreographical concepts of Rudolf von Laban and as well the body and movement theories of the great phenomenological philosophers Edmund Husserl and Maurice Merleau-Ponty. The reflection takes place in dance itself. Highly variegated models of self-reflectivity mark the dance of the avant-garde and the multifarious character of the dance and performance scene from the 1960s to today's contemporary dance. It would take us too far afield to broach all this here even in summary fashion. It should be noted, however, that this 'implication' (enfolding) of theory *in* dance refers not only to a – however defined – self-reflectivity of the performers' own modes of presentation. Even the processes of production, the work of drafting and rehearsing, the media, the (self-) promotion discourses are part of a praxeological, a theoretically 'informed' form of contemporary dance: Where should we seek the caesurae between theory and dance (praxis) here? It may be significant that the im-balance itself is ironically overplayed, e.g. by the fact that the endless discourse, the blurb, the project description and literary reviews are calmly incorporated in the dance production as a textual supplement in the form, for example, of *self-interviews* (Ingvartsen/Chauchat 2008), which a number of contemporary dancers and choreographers – e.g. Frédéric Gies, Jefta van Dinther, Mette Ingvartsen, Alice

6 It is a concept of dance which even Plato regarded as the regulator of a physically healthy upbringing: somewhere between military exercises and disciplined actions in the public sphere.

Chauchat, Isabelle Schad, Xavier Le Roy – have declared to be a genuine element of their artistic work. The relationship between dance and theory is one that has to be perpetually renegotiated in frictions and disruptions.

As in a mobile in which the threads and manifold '(im-)ponderabilia' are constantly and unpredictably dancing and shifting in space and time – one finds oneself surrounded by a multitude of contemporary works of 'dance theory' and unable to take a step further.

A shift of perspective is called for: I want to step to one side and, instead of taking historical approaches to concepts and discourses on the relationship between dance and theory, I would now like to interrogate *aesthetic* models representing aesthetics that stand in a special relationship to dance and dance discourses and can be considered part of the history of reflection on this relationship. I shall choose two such aesthetic models – and attempt to read them as 'figurations' of a balance (or: dis/balance) of dance and theory. The first is Paul Valéry's *Philosophie de la danse* (*Philosophy of the Dance*, 1936) and the other is Heinrich von Kleist's text *Über das Marionettentheater* (*On the Marionette Theatre*, 1810).

Valéry whose writings entangle poetic practice and theoretical reflection coined the concept "l'esthésique" ("esthesics") – in contrast to the conventional concept of 'esthétique' (aesthetics); and he defines "esthesics" as a "study of sensations" (Valéry 1964b [1937]: 61). In so doing Valéry (very much in keeping with the thinking of his time) not only links the idea of aesthetics to perception theory; he also abandons (once again, as if in passing) any attempt to view theory as work on a concept (see Hegel's 'Arbeit am Begriff,' Hegel 1970: 65). Instead there is opened up – in the kinaesthetic sense – a place of viewing and feeling, which is virtually saturated with 'theoria.' In *L'Âme et la danse* (*Dance and the Soul*, Valéry 1956 [1923]) a Socratic reflection is attributed to the female dancer: movement is an activity that gives food for thought, and the dancer is in her *action*, in her dancing, Socratic: "[A]ccording to you," says Phaidros in Valéry's text, which is in the form of a dialogue, "this dancer would [...] have something Socratic – teaching us, in the matter of walking, to know ourselves a little better" (ibid: 38). Taking walking as an example, the "simple [...] walk" (ibid: 37) of the dancer, this praxis of moving oneself is described as a form of Socratic reflection, a 'theoria' of knowledge that reveals itself in interaction, dialogue, movement. A simple walk, the walk of the dancer: "She begins with her art as its highest; she walks naturally on the summit she has attained. This second nature is what is farthest removed from the first, but they must be so like as to be mistaken the one for the other" (ibid). The aesthetic paradigm of mimesis and art, which conceals her artifice and appears to be (second) nature, is surpassed at this point. It is a mimesis of a movement in (and of) itself, a reflection of walking and the walk simply in walking.[7] It is precisely this (apparently wholly self-related)

7 The ekphrasis of this movement of walking becomes an explication of this kind of 'thinking' without concepts: "But consider the perfect progress of Athikte [...]. Upon

reflexivity that unfolds her potential – a 'theoria' without a concept – for relating. It is, if one wants to be 'Socratic' about it, an apostrophizing, an addressing of the Other/Others in dialogue. The walk, "which has but itself for end," becomes "an universal model" (ibid: 39), which causes us "to know ourselves a little better" with regard to the walk (ibid: 38). Thus this dancer's way of walking turns out to be not only an exploration and mediation, but also the production of a theory – an "universal model" (ibid: 39) of the movement of walking.[8] The movement also turns itself – dialectically – into its opposite. Socrates muses: "I contemplate this woman who is walking and yet gives me the sense of the motionless" (ibid). Between mobility and immobility 'stillness' can be experienced as momentum, as 'ponderation.' Stillness as "contradiction" (ibid: 40); and stillness as "suspense of breath and of the hearth!" (ibid) – a moment of weightlessness.[9]

Valéry's text not only deals with the Socratic potential of dance. It also speaks of the constitutive significance which the frameworks and (institutional, social, cultic) contexts possess for the dance; and also the pro and contra of hermeneutics, versions, knowledge-attributions will be discussed in dialogue by the observer of the resulting dance. The question of a philosophical, phenomenological purpose – "But what then is dance, and what can steps say?" (ibid: 44) – is not followed by any essential designation, but by a truly Socratic twist: an infiltration of the dance movement – its "subtle displacement" (ibid: 49), its physical, liberating dynamism and power of transformation *into* philosophical thinking. The shift in weight between dance and theory is translated into an image of flame[10] and its transformation of matter into self-devouring movement. The body gets into a state "comparable to flame, in the midst of the most active exchanges. […] We can no longer speak of 'movement' […] nor distinguish any longer its acts from its limbs" (ibid: 57). Valéry's text itself describes a constant transformation of dancing and philosophical/theoretical enunciations into each other – a kind of parallelism of the acts of dance and theory: "She is dancing yonder and gives to the eyes what here you are trying to tell us" (ibid: 58).

Valéry's text can be read as a phenomenology of movement; as a theory of action hanging in the balance between activity and passivity, movement and

that mirror of her forces she places with symmetry her alternating tread; the heel pouring the body towards the toe, the other foot passing and receiving the body, and pouring it onwards again; and so on and on; whilst the adorable crest of her head traces in the eternal present the brow, as it were, of an undulating wave." (Valéry 1956 [1923]: 38 et seq.)

8 On the reflection of 'walking' in art theory and philosophy in the 19th century cf. Hahn (2012).

9 Socrates: "Gravity falls at her feet." (Valéry 1956 [1923]: 40-41)

10 On the flame image with regard to dance, as an image of transformation, cf. Rainer Maria Rilke's sonnet "Spanish Dancer" (Rilke 1986 [1907]; Brandstetter 1995: 282-289; Schuster 2011).

stillness. And it demonstrates the *transposition* of dance and theory as a 'movere' in the observer who (in a psychic, mental, physical, sensory sense) is 'set' in motion.

Most interesting of all, however, are the tropes that occur as figurations, as media and 'movens' of transformation. In Valéry they are flame and vortex. And the notions of lightness and heaviness. In the aesthetic discourse of body and movement these images have a long and ramified tradition (Brandstetter 2003).

Balance, and dis/balance, light and strong, gravitas and anti-gravity movement are also the subject of Heinrich von Kleist's dialogue *On the Marionette Theatre* (Kleist 1972 [1810]). The conversation in the first of the three narratives, which make up the treatise turns on the movement of puppets. A dialogue arises out of a series of theses and narrative proofs between a professional dancer and the first-person narrator, who has a dilettante's interest in art. In his reading of Kleist's *Marionette Theatre* Paul de Man (1984) highlights the trope of proof: In the course of the narrative, proof, assessment, uncertainties constantly emerge in the *movement* of the dialogue; dis/balances of comprehension and knowledge transfer. As in Valéry's dialogue on dance, when Socrates describes as potential his "uncertainty" (Valéry 1956 [1923]: 48) about what dance movement is, Kleist's text also plays with the "loss of hermeneutic control" (de Man 1984: 269). This uncertainty is what drives the act of proving: "When a persuasion has to become a scene of persuasion one is no longer in the same way persuaded of its persuasiveness" (ibid) concludes Paul de Man.

Here I want to concentrate only on the first, the *Marionette Theatre* story of the treatise, albeit it should at least be remembered that Kleist's whole text (with the thorn extraction episode and the story of the fencing bear) is an ironical, indeed bitterly pointed comment on the aporias of an aesthetic education of idealism.[11] Instead of directing aesthetic education towards freedom, the lightness of play, as in Schiller, Kleist focuses on doubts, the – as de Man puts it – "heavy breathing of a self that remains incapable of such disinterestedness" (ibid: 279). On the other hand there are the puppets, which execute movements that do not originate with each other but are only passed on to them by the movements of the puppeteer, to whom they are linked by a system of threads and strings.

"All their aesthetic charm stems from the transformations undergone by the linear motion of the puppeteer as it becomes a dazzling display of curves and arabesques. [...] The aesthetic power is located neither in the puppet nor in the puppeteer but in the text that spins itself between them. This text is the transformational system, the anamorphosis of the line as it twists and turns into the tropes of ellipses, parabola, and hyperbole." (Ibid: 285 et seq.)

11 Cf. de Man 1984; Brandstetter 2007a; Brandstetter 2011a; Theisen 1996; Blamberger 2011. For an overview of related research see Marwyck 2010: 149.

"Tropes," according to Paul de Man, "are quantified systems of motion" (ibid: 286).[12]

The place of the patterns of expression is taken by mathematics: a *mathematics of dance* (*Tänzerische Mathematik, 1926*), as Oskar Schlemmer was to explain a hundred years later in his text of the same title (also dealing with dance theory), a 'Bauhaus' dance, in which he refers to Kleist's *Marionette Theatre* (Brandstetter 2008).

Herr C., in Kleist's text, presents himself as a dancer and theoretician of motion, who sees the ideally graceful movement realized not by the human body or the expressive art of dancers, but in the lines of the mechanical movements of puppets. These puppets have, Herr C. argues, a decisive advantage over human beings when it comes to movement: They are "immune to gravity's force"[13]: "They know nothing of the inertia of matter, that quality which above all is diametrically opposed to the dance, because the force that lifts them into the air is greater than the one that binds them to the earth" (Kleist 1972 [1810]: 24). And their grace consists in the fact that their movements follow the centre of gravity which is controlled in the limbs by the puppeteer. To the queries of his puzzled interlocutor the dance theoretician and practitioner, Herr. C. replies: Seen from a mechanical point of view, this process is "simple" (ibid: 23):

"The line that the centre of gravity must describe was, to be sure, very simple, and was, he felt, in most cases a straight line. In cases where that line is not straight, it appears that the law of the curvature is at least of the first or, at best, of the second rank, and additionally in this latter case only elliptical. This form of movement of the human body's extremities is natural, because of the joints, and therefore would require no great skill on the part of the puppeteer to approximate it." (Ibid)

From the other point of view, however, the dancer continued, the movement of this line was "very mysterious": "For it is nothing other than the path to the soul of the dancer, and Herr C. doubted that it could be proven otherwise that through this line the puppeteer placed himself in the centre of gravity of the marionette; that is to say, in other words, that the puppeteer danced" (ibid). This dance-like transposition or dis/placement is the precondition for the movement: 'transposing oneself' to another centre of gravity. In Kleist's 'mathematics' this elliptical movement is a broken, an interrupted movement. An ellipse is a geometrical figure with two centres of gravity. Thus what happens is always relational – a movement that implicates both the puppet master *and* the puppet – or the actor *and* the observer. The mover (operator) does not remain unmoved. The mechanical dance cannot, Mr. C. admits, "be managed entirely without some feeling"

12 "The indeterminations of imitation and of hermeneutics have at last been formalized into a mathematics that no longer depends on role models or on semantic intentions." (de Man 1984: 286)

13 See also the German expression of "antigrav" in the original text (Kleist 1962: 342).

(ibid). The operator is also an aesthete who must have an "understanding of the aesthetic of the dance" (ibid), and a moved mover. In rhetoric ellipsis also means a trope of omission or interruption. Thus the hesitancy, the *shifting* of the balance in the centre of gravity would also be inscribed in the most graceful movement?

Finally let us pause again one last time: Why the reference to Kleist's *Marionette Theatre*, a 200-year-old text? Can this text shed any light at all on the current questions concerning the relationship between dance and theory? Has not the discussion on the grace of line in dance been obsolete since the beginning of the 20th century at the latest? Yes, and no! In *dancing praxis* and aesthetic *theory* the centre of gravity has shifted here too: Nijinsky's *Crime against grace* (Hodson 1996) marked a historical caesura since which the problem of the relationship of (human) bodily movement to *form* has constantly had to be renegotiated. Kleist's *Marionette Theatre* marked for the first time the profound crisis of these fundamental aesthetic and political questions concerning body and movement. This is what makes the text topical; it can be read as an allegory of the difficult relationship between dance and theory. In conclusion I should like to highlight a few more recurring aspects that are still explosive:

Kleist's *Marionette Theatre* marked a crisis in the discourse on grace circa 1800. The text demonstrates – in dialogue form (a dialogue conducted with the reader as well)[14] – an experiment on the limits of the movement of the human body. The puppet is used to exemplify an aesthetic of the mechanical, of the 'non-human' (or, nowadays, of the 'pre-' or 'post-human'): a dance "operated by means of a handle" (Kleist 1972 [1810]: 23), in which the "final trace of the intellect" (ibid) has been removed from the puppet-dancer body. In the culmination of mechanization and formalization of a 'non-human' dance the aporia of the control of movement and violence breaks forth. The phantasm of a "Über-Marionette" (Edward Gordon Craig), whose dance would be so perfect that even Vestris could not match it (cf. Kleist 1972 [1810]: 23), is after all the product of a prosthetic grace. The "craftsman" who makes the artificial limbs, the "mechanical legs" for those "unfortunate people" (ibid) who have lost their own legs should be the producer of that ideal dance figure. Here the wound referred to in Kleist's text remains open: What place is there for the disabled body in the theory and practice of dance? And how precarious is the aestheticisation of violence, injury and loss – through war, perhaps? In his experiment on the limits of human movement, which Kleist pursues to the point of crisis, he also examines the *How*, the form and question of the possibilities of mediation – this also being a problem that nowadays is referred to in the discourse of dancers and theoreticians with the (somewhat hackneyed) formulas of (trans-) mediality, 'agency' and institution or 'institutional critique.' The questions of 'light/easy' and 'heavy/difficult' which Kleist's 'antigrav' puppets raise in a literal sense, have not lost any of their weight. They have cropped up elsewhere, shifted to other

14 The concepts (originating with Bakhtin) of "intertextuality" and "dialogicity" should be borne in mind here (cf. Lachmann 1982).

contexts: 'Heavy/difficult' – e.g. as a shifting of weight, as 'give and take weight' in contact improvisation – has become an important criterion of kinaesthetic (self-) exploration (cf. Reynolds 2007; Foster 2011: 6 et seq., 73 et seq.; Nora Heilmann quoted in Manning 2009: 232, note 27) – in a meshing of the praxis and theory of contemporary dance in the sense of 'sensory awareness' practices. In addition, however, the 'heavy/difficult' and the 'light/easy' have also undergone a shift in meaning with regard to the question of 'ability,' performance and their (stage) representation. The model of a virtuosity (cf. Brandstetter/Neumann 2011b; Brandstetter 2007b) that makes the 'heavy/ difficult,' the heaviest and most difficult seem 'light and easy,' indeed like child's play, has (more or less) disappeared from contemporary dancing and thinking. The choice of subject is rather how laborious, strenuous, painful the 'heavy/difficult' can be – e.g. a form of discipline, 'work' and/or alienation. And equally the question of the 'light/easy' arises in new contexts: Is it easy to choreograph everyday movements, movements that 'come easily,' as dance? The association with 'easy come' (as in 'easy come, easy go') signalizes a possible trap – and yet variations of the experiment with such an aesthetic of the 'light/easy' variety have always been with us from the postmodernists up to contemporary artists such as for instance the *Praticable* group with Isabelle Schad, Frédéric Gies and others. There is also the question of 'negotiations' about what is recognized as 'light/easy': Douglas Dunn sees in this idea of understanding a dance, e.g. in *Walking Back* (1981), from the stratification of different attentions, a form of freedom which releases both actors and observers of the "obligation to take the same view of this experience" (Dunn 1983: 55, translation: Brandstetter). The text, or image, which emerges in the course of such a play of attention between actors and observers certainly follows a different pattern than Kleist's tropes of movement. Yet there are connections. The first-person narrator in Kleist's *Marionette Theatre* confesses at the end of the narratives, theses and argumentations on experimental movements, that he is "somewhat at loose ends" (Kleist 1972 [1810]: 26). It is not only the attention that is distracted; the image of the body in movement is also distracted, displaced and criss-crossed by fissures of reflection. Kleist's *Marionette Theatre* is a text on crises of categorisation in the relationship between (dance) praxis and theory. Balance and dis/balance in these (changing) relationships are no longer controllable – and perhaps therein lies the fascination and the potential of a relationship between both *in* motion.

"One who dances never stands with both feet planted firmly on the ground of reality" (Waldenfels 2010: 235, translation: Brandstetter), the philosopher Bernhard Waldenfels has written. And he juxtaposes this with Husserl's dictum that philosophy must "start from below" ("bodenlos anfangen") (ibid). An – admittedly unstable – linkage of dance and theory could then be described as (this too being only a trope of 'displacement'): "An expression in the form of dance that consists in a testing of the ground (ein Abtasten des Bodens) and an execution of groping movements (eine Ausführung tastender Bewegung)." (Ibid)

REFERENCES

Arendt, Hannah (1958): *The human condition*, Chicago, IL: University of Chicago Press.

Beckett, Samuel (1964 [1952]): "Waiting for Godot," London: Faber and Faber.

——— (1976 [1952]): "Warten auf Godot." In: Elmar Tophoven/Klaus Birkenhauer (eds.), *Samuel Beckett. Werke. Dramatische Werke. Theaterstücke*, Frankfurt am Main: Suhrkamp (Werkausgabe Edition Suhrkamp, Vol. 1), pp. 7-99.

Blamberger, Günter (2011): *Heinrich von Kleist. Biographie*, Frankfurt am Main: Fischer.

Brandstetter, Gabriele (1995): *Tanz-Lektüren. Körperbilder und Raumfiguren der Avantgarde*, Frankfurt am Main: Fischer.

——— (ed.) (2003): *leichtigkeit/lightness, figurationen 1*, Köln: Böhlau.

——— (2007a): "Kleists Choreographien." In: Id./Günter Blamberger/Ingo Breuer (et al.) (eds.), *Kleist-Jahrbuch 2007*, Stuttgart and Weimar: Metzler, pp. 25-37.

——— (2007b): "The Virtuoso's Stage: A Theatrical Topos." In: Theatre Research International 32/2 (July), pp. 178-195.

——— (2008): "Kinetische Explorationen. Oskar Schlemmer – Gerhard Bohner – Dieter Baumann." In: Helmar Schramm/Ludger Schwarte/Jan Lazardzig (eds.), *Spuren der Avantgarde: Theatrum machinarum. Frühe Neuzeit und Moderne im Kulturvergleich*, Berlin: de Gruyter, pp. 376-390.

——— (2011a): "Kleists Bewegungsexperimente. Choreographie und Improvisation." In: Günter Blamberger/Stefan Iglhaut (eds.), *Kleist/Krise und Experiment. Die Doppelausstellung im Kleist-Jahr 2011*, Berlin and Frankfurt (Oder): Kerber, pp. 62-70.

——— /Neumann, Gerhard (eds.) (2011b): *Genie – Virtuose – Dilettant. Konfigurationen romantischer Schöpfungsästhetik*, Würzburg: Königshausen & Neumann.

Dunn, Douglas (1983): "Diese Art von Schichten zu bilden." In: Sylvère Lotringer, *New Yorker Gespräche*, Berlin: Merve, pp. 49-60.

Foster, Susan Leigh (2011): *Choreographing empathy: Kinesthesia in performance*, London and New York: Routledge.

Foucault, Michael (2004 [1966]): *The Order of Things. An archaeology of the human sciences*, London and New York: Routledge.

Greenblatt, Stephen (1988): *Shakespearean negotiations: The circulation of social energy in Renaissance England*, Oxford: Clarendon Press.

Hahn, Daniela (2012): *Epistemologien des Flüchtigen. Bewegungsexperimente in Kunst und Wissenschaft um 1900*, Freiburg i.Br.: Rombach.

Hegel, Georg Wilhelm Friedrich (1970): *Phänomenologie des Geistes* (Werke in zwanzig Bänden, Vol. 3), Frankfurt am Main: Suhrkamp.

Hodson, Millicent (1996): *Nijinsky's crime against grace. Reconstruction score of the original choreography for Le sacre du printemps*, Stuyvesant, NY: Pendragon Press.

Ingvartsen, Mette/Chauchat, Alice (eds.) (2008): *everybodys self interviews*, Copenhagen: everybodys publications.

Kleist, Heinrich von (1962): "Über das Marionettentheater." In: Helmut Sembdner (ed.), *Heinrich von Kleist: Sämtliche Werke und Briefe*, Vol. 2, Darmstadt: Wissenschaftliche Buchgesellschaft, pp. 338-345.

————— (1972 [1810]): "On the Marionette Theatre." In: The Drama Review: TDR 16/3, The "Puppet" Issue (Sep. 1972), pp. 22-26.

Lachmann, Renate (1982): *Dialogizität*, München: Fink.

LIGNA (2009): "Das Unbewusste der Sterne. Eine Demonstration." In: Gabriele Brandstetter/Sibylle Peters/Kai van Eikels (eds.), *Prognosen über Bewegungen*, Berlin: b_books, pp. 190-209.

Man, Paul de (1984): "Aesthetic Formalization: Kleist's Über das Marionettentheater." In: Id., *The Rhetoric of Romanticism*, New York, NY: Columbia University Press, pp. 263-290.

————— (1986): *The resistance to theory*, Minneapolis, MN: University of Minnesota Press.

Manning, Erin (2009): *Relationscapes: Movement, art, philosophy*, Cambridge: MIT Press.

Marwyck, Mareen van (2010): *Gewalt und Anmut: weiblicher Heroismus in der Literatur und Ästhetik um 1800*, Bielefeld: transcript.

Pasch, Johann (1978): *Beschreibung wahrer Tanz-Kunst*, Frankfurt 1707, Facsimile reproduction by Kurt Petermann (ed.), München: Heimeran (Documenta choreologica 16).

Promies, Wolfgang (ed.) (1968): *Georg Christoph Lichtenberg: Schriften und Briefe*, Sudelbücher I, Darmstadt: Wissenschaftliche Buchgesellschaft.

Rancière, Jacques (2007): "The Emancipated Spectator." In: Artforum, March 2007, pp. 270-281.

Reynolds, Dee (2007): *Rhythmic subjects. Uses of energy in the dances of Mary Wigman, Martha Graham and Merce Cunningham*, Alton, Hampshire England: Dance Books.

Rilke, Rainer Maria (1986 [1907]): "Spanish Dancer." In: Id., *Rainer Maria Rilke. Selected Poems*, New York, NY and Toronto: Methuen, p. 109.

Schlemmer, Oskar (1926): "Tänzerische Mathematik." In: Vivos Voco, Zeitschrift für neues Deutschtum 5/8,9, Sonderheft Bauhaus, pp. 279-281.

Schuster, Jana (2011): *Umkehr der Räume. Rainer Maria Rilkes Poetik der Bewegung*, Freiburg i. Br.: Rombach.

Theisen, Bianca (1996): *Bogenschluss. Kleists Formalisierung des Lesens*, Freiburg i. Br.: Rombach.

Valéry, Paul (1956 [1923]): "Dance and the Soul." In: Jackson Mathews (ed.), *The collected works of Paul Valéry. Dialogues*, New York: Pantheon Books (Bollingen series, Vol. 4), pp. 25-62.

———— (1964a [1936]): "Philosophy of the Dance." In: Jackson Mathews (ed.), *The collected works of Paul Valéry. Aesthetics*, New York, NY: Pantheon Books (Bollingen series, Vol. 13), pp. 197-211.

———— (1964b [1937]): "Aesthetics." In: Jackson Mathews (ed.), *The collected works of Paul Valéry. Aesthetics*, New York, NY: Pantheon Books (Bollingen series, Vol. 13), pp. 41-65.

Virno, Paolo (1996): "Virtuosity and Revolution: The Political Theory of Exodus." In: Id./Michael Hardt (eds.), *Radical thought in Italy: A potential politics*, Minneapolis, MN and others: University of Minnesota Press (Theory out of Bounds, Vol. 7), pp. 189-212.

Waldenfels, Bernhard (2010): *Sinne und Künste im Wechselspiel. Modi ästhetischer Erfahrung*, Berlin: Suhrkamp.

PANEL ARCHIVES

Steps and Gaps: Curatorial Perspectives on Dance and Archives

INTRODUCTION BY BEATRICE VON BISMARCK

I.

Archives and archival practices have become prominent within the cultural discourse particularly in the run-up to and the aftermath of the millennium turn. The search for an orientation guide to the future through a look back into the past would integrate not only the hope and speculations associated with the storing and processing potentials of the digital media but also with the research on the capacities and functions of the human brain. From here a number of links opened up into debates within the art field, among them those over the treatment of culture in terms of national heritage, the musealisation of contemporary society, the function of memorials and monuments in connection with processes of memory and remembering, and the aesthetic, social and political consequences resulting from digital image processing. They all converge over the roles and tasks of cultural archives in the age of economisation and globalisation. The claim is on the one hand directed towards the constitution of archives for those materials, which due to their material, social, regional, religious, or political conditions have hitherto been excluded from them. On the other hand what is at stake is the power of the rules and conditions under which archives are constituted, made accessible and put into use. The Foucaultian function of the archive as the precondition of 'what can be said' not only describes its enabling but also its restrictive potentials (Foucault 1981: 187). The hierarchies manifesting themselves within this archival condition rely on two demands: the survival of the past and present in the future due to it being documented and collected and the urge to a maximum degree of completeness. The universalizing approach that both strata betray is what has been under attack most heatedly in the recent debates that focused on the rules, conditions and perspectives of cultural archives in a globalized world. Under titles such as *an-archiving* and *de-archiving*, strategies have been developed to undermine the processes, in which archives help to produce single or collective identities and governable subjects as well as consumable and marketable goods (Goltz 2011: 6; Seibold 2011: 8).

Spatiotemporal dynamics can take up this critical resistance as modes of counteracting the universalizing claim by allowing for archival gaps, for changes, for the ephemeral and the particular. Furthermore, they direct the attention toward the processes of selecting, keeping, ordering, mediating and distributing, the exertion of power in their course and the relation between all 'actors' involved in them – people, archival materials and institutions alike. Thirdly these dynamics push those techniques of handling and using archives into the foreground that go beyond documentation and reminiscence work by enabling their conscious and formative participation in a societal presence and future. Completion, the claim to universal validity, the reaffirmation of existing social hierarchies through representation, inclusion and exclusion as well as its dedication to the past in terms of its material and its attitude manifest the contrasting backdrop to the desire for destruction of cultural archives which has been articulated with differing emphases ever since the museum critique of the historical avant-garde.

A spatiotemporal perspective consciously opens the field of the visual arts towards that of the performing arts, taking the time-based characteristics into account such as storing capacities of the moving body, dynamic relations, material ephemerality and performativity. It relates to the de-differentiation of the arts after the 1960s in the course of which also the curatorial has developed as a field of transdisciplinary cultural practice (Bismarck 2010: 50-57). When for the following remarks the curatorial will be understood as a mediator between dance and the archival, – a filter through which the relation between them is observed and defined – it is for the purpose of focusing particularly on those political perspectives of the archive that are supported if not in the first place enabled by the constellational, the process oriented and the relational as main characteristics of curatorial practice.

II.

The background to this perspectival focus is the development of the curatorial in recent years. Originally established since the beginning of modernity as a professional field and set of tasks in relation to art and art museums, the curatorial has over the last almost 50 years increasingly gained a certain independence from the professional assignment. From the task areas that were initially tied to the curator's institutionally anchored position in art institutions, the curatorial now primarily pushes mediation into the foreground. With its orientation towards making cultural materials, information, and procedures perceivable, curatorial activity no longer has relevance only for the field of fine arts, but also for dance, theatre, or film, as well as for the humanities, the social and natural sciences. Artists of various disciplines, critics, gallery owners, dramaturges, and theoreticians of different disciplinary backgrounds, not only from the established areas of art history and cultural studies, but also from philosophy, for example, or from the theory of literature, film, theatre, and dance, from ethnology, political sciences, or

sociology – they all have the curatorial procedures at their disposal if they want to participate in the processes of the meaning production.

Structurally defined by the activity of making connections, the curatorial sets the archive in motion. The acts of collecting, assembling, ordering, presenting, and mediating – the professional specificities of curators – refer to objects of differing origins, to information, persons, sites and contexts, between which they establish relations. The options of those relations are multiple and constantly open to redefinition. Thus instead of understanding an archive as a sum of collected and institutionalized materials the curatorial identifies it as an on-going never to be finalized process of the afore mentioned activities, which in its present state is always temporary. Making an archival collection accessible takes on performative qualities in which, not dissimilar to exhibitions, the collected gets reinterpreted through its different forms of use. Memory is transformed into re-membering, the passive storage of the mind turns into an active, selective act of re-combination and -constellation (Assmann 1999: 408). The central issue becomes the mode in which the archive has been generated and structured, in which it has had been made accessible and how the access was put into action or use.

III.

The curatorial techniques of making connections gain a specific social significance in its overlapping with the post-fordist conception of labour, which the Italian social philosopher Maurizio Lazzarato has termed "immaterial" (Lazzarato 1998: 40 et seq.). According to Lazzarato, with immaterial labour in the New Economy the source of wealth has shifted to conceptual activities. Know-how and skills in dealing with information and culture have taken the place of the goods producing processes. In accordance with the development from an industrial economy to a service economy, particularly activities in the so-called secondary service sectors, – management, organization, consulting, publishing and teaching – have increased disproportionately. Hand in hand with this change the distinctions between conception and execution, between painstaking routine and creativity, and between author and public begin to dissolve in such work processes. As a realm of practices encompassing organization, social networking, content management and assignment, motivation, enabling and interpretation, the curatorial thus connects social- and self-technologies with one another, which comply with the contemporary demands on economic management. Furthermore, this happens under the auspices of a notion of 'creativity' consisting in 'innovative connectivity' as, according to the German communication and media theoretician Siegfried J. Schmidt, part of the personality and action structure in demand within post-fordist economy (Schmidt 1988: 42-45).

In the context of dance and archives, the relations between curatorial practices and post-fordist labour point to a certain ambivalence concerning the proc-

esses of meaning production constituted by acts of connectivity. Through them on the one hand, the individual archived materials transform independent of their nature and materiality into objects that are never fixed but always in a state of becoming. While they encapsulate the history, experiences and meanings of their former contexts they transform in the process of being used, of appearing in new relations with other objects, persons, spaces and discourses. When Krysztof Pomian in his study on the origin of the museum speaks of "semiophores" as bearers of signs, he refers to the objects in the collection (Pomian 1988: 50 et seq.). Expanding this notion to all the actors within a field in sociological terms (Bourdieu 1993: 109), the archived document, the notation, the collected artefact, the dancing body or the reader her/himself can each be understood as potentially partaking in a performance of the archive by setting their respective contextual meaning in relational motion with that of all other participants in the curatorial field.

On the other hand, the risk inherent in post-fordist labour relations of self-exploitation and appropriation suggests the necessity of participating in the setting up and the defining of the rules and regulations of those processes of connective meaning production (Bismarck 2003: 85 et seq.). Contemporary art has taken up this ambivalence both as an issue and as a technique by relating to those strategies of institutional critique that focus on the conditions and relations within archival institution (Bismarck 2002). Pointing to the rules, mechanisms and hierarchies, structuring not only the constitution but particularly the use of archives (Speak 2011) – the constantly changing and rearticulated relations between the materials, the people, sites and discourse involved in it – the archival performativity allows for a critique and re-definition (cf. Osthoff 2009). By taking up curatorial modes of critique, of reshaping the tasks, roles, the disciplinary and professionally defined methods and forms of knowledge as well as the relations between the 'actors' in terms of heterotopic spatiotemporal (Foucault 1967: 39) installations, the archival allows for an institutional critique which puts the conventions, rules, criteria and targets of and within archives under debate. Dance with its embodied knowledge appears in this context, potentially like any other artistic or cultural practice, as subject and object of archival critique, while the archive itself gains the function of an arena rather than a depot and repository. In its critical actualization, the archive takes on the function of a site as well as medium for negotiation.

IV.

In this context the term 'set,' used to describe the curatorial product (Bismarck 2010: 53), might also be applicable for an archive mobilized in such a way. The notion of the set combines the idea of a presentational arena with that of performativity. Furthermore, it implies a structure of a physically, socially and discursively defined space which for a limited period of time assembles different kinds

of objects, but also people. As such it bears associations to the sphere of dance as well as to that of theatre and film and denotes that a scene has been put up in form of a stage. With this connotation, the archive's ephemeral nature in terms of its constantly changing content and meaning gains in prominence by comparison to the conventional conception of its lasting validity and legitimizing character. The archive exposes itself through its materials as well as the processes and activities taking place in the course of the building up and the use that is being made of it by the different personal involved. Similar to the procedures in theatre or dance, the phases of construction and presentation of the archive are foregrounded as are the relational dynamics during the developmental stages and performances.

With a curatorial perspective on this spatiotemporal structure of the archive above all the processed relations get accentuated. Thus techniques that are informed and trained by notations and documentations of the performing arts might be needed to assist in expanding the archive towards an archive of relations in flux. Furthermore, it is those processed relations which shift the understanding of the archival gap: It is no longer a lack and deficit in relation to the collection's claim to comprehensive completion but rather – with all the political implications this might have for identity processes – participates as a formative and performative in-between space in the archival meaning production.

Body, Archive

FRANZ ANTON CRAMER

This contribution for the *Archive* panel originally presented several hypotheses intended as a frame within which specific questions could be considered more closely. Subsequently, from both the panellists' articles and the plenum discussion, two main topics emerged which seem to demanded closer attention:

Firstly, the question of whether the body can be regarded as an archive and which epistemological consequences and aporia this would bring. And secondly the question of the correlation between the historicity of dance as a formation of the performative and its contemporary vigour. Naturally, neither question could be answered. The following article will, however, venture to formulate them more precisely.

I.

In terms of its function and the process of recording it, i.e. in the forming of dance archives, dance takes on a dual role. While it concerns the transitory, at the same time it is a practice of radical embodiment, hence of becoming material.

The idea that the body itself could take on the character of a collection is not new. What is meant by this is primarily how the body is shaped by use. Marcel Mauss (1950) introduced the concept of body techniques to indicate the cultural and social moulding that everybody, as an object of society, undergoes, even before it becomes a subject, or more precisely, which steers the process of it becoming a subject: How one sleeps, how one eats, which sitting position has been learned etc. In this sense, the body is a repository of forms of usage. Numerous questions arise concerning this material, which reach beyond the individual body to reveal additional significance (Baxmann 2005, 2008).

This general observation is confirmed in a specific manner in the field of dance, i.e. the artistic use of bodies in the medium of movement. For the knowledge of movement, the knowledge of the potentials and articulations of various anatomical and physical systems, such as the skeleton, musculature, lymphatic system, which is gained from movement, forms the backbone of the dancer's education and training. The many awareness techniques and somatic practices,

such as Klein Technique, BMC, Experiential Anatomy, Skinner Release Technique and so on, locate kinetic knowledge in the body and strive towards establishing a specific link between subjective action and objective realization (Clarke et al. 2011). As forms of physical usage, they also determine the specifics of performance by their combining of cumulative knowledge with spontaneous action.

Dancing could be regarded as a form of body use in the sense of Marcel Mauss, just as dancing is an accumulation and updating of elements which only ever actually make sense at the moment of their realization, by suggesting forms, energies and meanings which are completed in the instance of the performance or the dancerly act. *Knowledge in motion* (Gehm et al. 2007) has indeed become an epistemological manifestation of the late modern age and contemporary art precisely because concepts of knowledge derived from both the natural and social sciences are now fluidized and destabilized (Huschka 2009; Cramer 2008).

The metaphor of the 'body as archive' or 'body archive' in this context seems twofold. It refers to the separation between the tangible, physical being of the body and its largely consciously practiced use of meaning structures, reaching beyond the body and necessarily presupposing knowledge of physical potential. In this conception, the materiality of the body becomes an accumulation of documents, so to speak, which in combination can suggest meanings that refer to more than mere physical activity but also hold the possibility of referring back to traces of knowledge stored in the body. Dance creation can in fact only unfold its individuality if accumulated physical knowledge is available as a basis. The body's potentiality thereby becomes a source for, a site or a documentation of each of the updates and statements that are made by the dancing body.

II.

Performative aspects exert a fundamental influence on our contemporary culture. The practice of 'performance' has become a hybrid medium of contemporaneousness, encompassing issues far beyond dance, drama and aesthetics. Stability, normativity and authorship are concepts that are called radically into question by 'performance.'

This mode of realizing possibilities in a present moment contradicts the historical model, which is not only inherent to the concept of dance but is also a central aspect of the archive concept. Dance here would be a paradox mixture of knowledge of the past and performative self-formulation in the present. The act of depositing – the sedimentary archival tradition – is certainly a factor in the process of training and in dance education; it is even a requirement (in the technical sense, in the sense of acquiring kinetic skills, cf. Sennett 2008; Varagnac 1948). However, in this model of a simultaneously historically and presence-oriented cultural technique, there is an inherent contradiction which was animatedly discussed by the panel.

To describe this peculiar relationship between archiving and creating something new in contemporary dance, the French curator François Frimat has attempted to promote the concept of the hybrid (Frimat 2010). At the centre of Frimat's observations is the production (rather than the mere generation) of a specific, innovative physical practice (as a mode of being), from which work-like objects or processes can be derived, which then become visible as dance. Yet Frimat's approach does not consider the process of intellectualizing, i.e. of de-organizing, which shapes contemporary conceptions of dance in such a profound way. Boyan Manchev has frequently pointed out that in the context of "perverse capitalism" (Manchev 2010), the body's individuality is distinguished precisely by its remoteness from the organic and that dance actually goes against the often-cited naturalness of physical activity. The body's essence lies in its changeability, in its shaping by the human technè. The organic or the biological does not exhaust the (sense-giving) dynamics of dance (Manchev 2009). From this point of view, the body's physical conditioning is an accidental property of the body as an archive, whose transformation processes are stored within it and open up the possibility of creating meaning, i.e. of adapting or reinterpreting.

However, Frimat also clearly points out that the body is a 'battlefield' where thought patterns, ideologies, relative strengths meet. Because these contradictions tend to remain invisible, it is the task of dance to lend them visibility: "Tout le travail en danse contemporaine est d'inverser le rapport et de donner visibilité aux forces qui font signe" (Frimat 2010: 55).

From Marcel Mauss' sociological and ethnographical interpretation to regarding the body as a repository of its movement history is not as huge a step, then, as it may seem in terms of history. Both models acknowledge that to speak of the natural is not very helpful in view of the complex interplay between knowledge of nature and form making in the medium of body movement on the stage of history.

The Constructive Compromise

FLORIAN MALZACHER

> "Give me your material and I will show you what you are not doing with it" (deufert & plischke quoting a light technician)

How to archive a work that refuses to be archived? How to document live arts? For the performing arts, namely theatre and dance, in this regard there is not much to learn from the classical performance art: It simply is a misunderstanding to think that the video and photo documentations of the latter are just done for archival or notating reasons. Performance art is usually not really a live art, or to be more precise: it only very partially is a live art – for the brief moment before the immaterial work congeals into an object. Since the 1970s, performance artists have taken much care, together with their galleries, to ensure that the supposedly ephemeral aspect of their work should not be to their financial disadvantage – and have elevated documentations to the status of artefacts. The photos of the performances by Abramović and Ulay as perhaps the most prominent examples, but even the seemingly carelessly made film fragments of Chris Burden's *Shoot* from 1971: They might camouflage themselves as mere photographic proof, but they just feed themselves of the aura of the real – planned from the beginning as independent art works. The performance itself is needed, but it is not the main goal.

This is exactly what discerns performance art from the performing arts where the distrust in documentation is constitutive. This partially might have to do with the fact that the free market of visual arts, this form of old age insurance, anyway is almost inaccessible: The scene of independent, experimental dance and theatre is too small, the audience too marginal, the profit too limited, and the genre not sexy enough for big time investors. The subsidised market of the performing arts on the other hand gives the freedom to embrace the quality of its ephemeral character, to insist on the very fact that it only can exist in a moment of shared space and time.

Many documentations and notations in dance and theatre are less attempts to conserve the un-conservable than to make it communicable to those who were not there. Since choreography or theatre stagings are usually not conceived for the camera eye, their documentations are necessarily compromises – and this is

precisely what the better examples of them are supposed to tell. The compromise of dance and theatre, that finds its continuation in the documentation, is not just a lack but also a constituting mark of live and collaborative art forms. Therefore the (not exactly pleasant to watch) static all-stage-registrations from the last row, therefore badly comprehensible rehearsal notes, improvised snap shots are often not only more honest but also more productive than theatre- and dance documentations of the French-German cultural TV-channel *Arte* that cover their helplessness rather clumsy by forcing film aesthetics and techniques onto another medium. It is a thin line and one reason why video registrations even for informal use (e.g. to be sent to programmers) came surprisingly late into fashion. And it is the reason why some artists (usually the ones that can afford it financially) are very restrictive about their documentations: William Forsythe or the Wooster Group for example protect videos of their shows like contaminated material and make it almost impossible to access. The opposite strategy is used by Forced Entertainment: Hundreds of video tapes registering their rehearsals are archived in the British Library. So they are at least able to communicate that there is not one version that is legit, that all is in flux.

Understanding this impossibility of documentation it also becomes clear that many complaints about the German pavilion in Venice 2011 mostly missed the point: They were rather complaints about the fact that Christoph Schlingensief died than about the exhibition itself. Yes, the exhibition was not the real thing anymore; it did not evoke the strength of Schlingensief's live presence; it was too ordered; the pathos of his films, set design and sounds was too massive without him constantly breaking it. All of this is the necessary consequence of his death – so it was only consequent of the exhibition not even to try to cover that fact. Live art ends as life does. It cannot be timeless. Unfortunately it is true: If Schlingensief's art is supposed to survive not only in memory, it has to survive without him and outside of the theatres: In the field of visual art.

The reasonable distrust towards documentation in the performing arts has a price which is also inherent to the genre: Local context here plays a much more crucial role than in other arts; even the rather small audience that is interested in advanced forms of theatre is far less informed about the actual art field as a whole than its counterparts in the visual arts, film or music: theatre travels less well and its artworks are more difficult to access, respectively not reproducible in catalogues. As a rule (except for a few big cities), it is – if at all – a single venue or a single festival that alone defines the horizon of the audience (as well as that of the local professional critics). The curator himself demarcates the terrain of its judgement – only the art that he is showing actually exists. Thus, international artworks are forcedly localized and placed into relation with what is familiar. The state of the art is different in each town.

Repertoire dance and drama theatre once offered an audience the chance to understand and to contextualise the work. It was based on certain canonical choreographies and on certain canonical texts. For devised forms of the performing arts this obviously does not function as a general concept – but still: without con-

text, without knowledge about the before and the next-to, many performances are not understandable anymore. This paradoxical dilemma of current theatre and dance practices produced different attempts to deal with this situation in a productive way. While for some companies (e.g. Anne Teresa De Keersmaeker's *Rosas*) at least the own repertoire offers a chance to produce some kind of live-archive, others investigate their roots with more distance towards the material: Re-enactments offer a chance to use what is not at hand anymore and test it out for the presence. Especially in Southeast Europe where the own art history was officially reduced to the ideologically fitting, this form of artistic research offers a powerful tool; less to copy something that has been lost but rather to investigate the past with the aim to connect, to approach, to understand something that is clearly gone forever. The works for example of *BADco* from Zagreb or Janez Janša from Ljubljana are exactly embracing the constituting compromise of performing arts and turn it into something new.

These works of course rather make use of archival material than offering it to others for their own purposes – as a good archive should do. This is one of the motivations of the choreographers deufert&plischke, for whom the interplay of dance and theory, bodies and memory play an important role. In their project *Anarchiv* they re-visit their own material of the past ten years: Topics and motives are reformulated, what they present is not a best of, but the active use of the material. Also other artists and theoreticians are invited to use the archive and to re-define it to their liking: „Give me your material and I will show you what you are not doing with it.": The archive fuels new artistic processes and finally dissolves in them. For the visitors the single archival materials might not be re-traceable anymore. But this is exactly what enables them to engage in an active dialogue.

Dance/Archive/Exhibition?
Moving between Worlds

RUTH NOACK

I spent a long time thinking about what contribution I can make to this conference, because it seems to me that the approach taken here stems from a genuine thirst for understanding, rather than prestige, networking or a functionary impulse. I understand and appreciate the need among dance experts to form theories and so I am willing to participate in this discourse, despite certain feelings of revulsion towards the thoroughly commodified theorizing that's so common these days, at least in my field – art.

But precisely because I take seriously the underlying motivation of this conference, I'd rather not speak about dance. I could, of course, cite my own experience in this field: as curator I was jointly responsible for staging the world premiere of Yvonne Rainer's *RoS Indexical* at *documenta 12* in Kassel in 2007, and for restaging two earlier choreographies by Trisha Brown, which were integrated into the exhibition and were linked to several other exhibits, including Charlotte Posenenske's *Vierkantrohre* from the Sixties. The exhibition also included dance performances in various stages of documentation, as well as drawings of the dance by Trisha Brown. Rather than discussing these works or theorizing my experience, it would probably be more productive to explain the fundamental approach I adopted as curator of this exhibition. It was a procedural approach, in that sense comparable to dance as a temporal medium. Medium, in this case, simply signifies the specific link between the artistic means and conventions that guide a creative process.

By defining the exhibition as a medium we align it with a series of actions that produce a particular response from an audience, similar to an act of speaking or performance, except that in this case the performance is not dependent on the physical presence of its initiator or producers, because there are works of art that are, on the one hand, materializations of the will to create, yet are not subject to that will. Works of art sometimes resist or even counteract the intentions of the curator. It is not clear to me whether one can find a similar object in dance, whether this might be the individual body that is marked and influenced by lifestyle and experience, by psyche and environment, and that occasionally does not wish to conform to the choreography. Perhaps there is a fundamental distinction

here between the dance and the exhibition, or perhaps the comparative intra-disciplinary viewpoint is valuable. Works of art (i.e. objects that facilitate aesthetic experiences under favorable conditions) and documents collected in an archive differ by their very natures. That is not to say that archives may not contain works of art and that exhibitions or museums should refrain from collecting documents. Works of art and documents may both don the appearance of the other, depending on which stage is available and what the nature of the performance is. This is because works of art and documents are not essentially bound to a material form, but rather connected to convention and classification. And these are liable to change. This is what makes the archive and the museum's collection, as well as the presentation of the exhibition, so politically charged; because they involve definitions and taxonomies that cause some things to become visible and others to disappear, determining at the same time the conditions and limits of visibility and disappearance. Generally, however, an object is, at a given moment, either a document or a work of art (although contemporary artists play with these boundaries – examples include the work of Walid Raad and surrealist photography). In most cases the object is either mothballed in an archive or spruced up in an exhibition.

We understand the taxonomy of archives, arising from the desire to capture history through documents that have a claim to truth, or at least as materializations of what occurs in a context of reality. The process of archiving is ultimately determined by the idea of creating order and coherence, and reproducing the past. (It is not surprising that the sixteenth-century order to graphically record and archive the entire architecture of the world, starting in Rome, came from the Vatican. All that remain of this project today are drawings of a few hundred buildings in Rome, and these are archived at the *Albertina Museum* in Vienna.)

But archives, too, may wish to hide things. The significance of what we place in the archive may not be clear to us at the time. (Not least because the meaning of moments and events and things changes over time, as our perspective alters.) But we continue to build archives in the hope that the object may later reveal a significance that we are not yet aware of. Perhaps the idea of a living archive was too rashly conceived because it is incumbent upon future users to breathe life into the archive (or not, as the case may be); while we must be content with the role of creating the potential for future understanding. We hide documents in the hope that their truth will be discovered and recognized at a later date; we archive something now for it to later become part of history. Somehow (and in this case the term is meant literally), somehow, we hope, that the material which we classify – aware that classification is impossible, knowing that any anticipation of meaning is false because order, too, can only come from the future – can somehow, at some time, be matched to a narrative, which we may call history, a narrative to which we were hitherto blind. I think of archiving as a form of dreaming. Knowledge seems to be close enough to grasp, yet we are afraid of reaching for it lest it will vanish in that moment. Nevertheless, the message of the dream is clear, albeit not always usable in a discursive context. It is something that resists

theory. This non-discursive precision, which I am unwilling to locate within the archive as such, but rather in the projection that may be linked to the act of archiving, is integral to working with art. The reason for this may be that works of art remain structurally interminable, oscillating between thing and symbol ('Ding' and 'Zeichen') (Rebentisch 2006). This may, in one way or another, be connected to our psyche (Silverman 1996). In any case, it teaches us to trust in the abilities of other and the other. After all, I can build my archive with a view to the visible field, and I may even have an interest in the political power of meaning, yet whether my act of speaking as curator remains narcissistic or stimulates my counterpart – as is my intention – to critically engage with the topic of the archive or exhibition, is ultimately down to the relationship formed between the documents, the works of art and the users/viewers.

The Archive in Motion

MARION VON OSTEN

I would like to link the *Archive* panels questionnaire to a specific practice that is not directly related to dance practices but to an artistic research project that examines modernism as a transnational and transcultural project. This particular archival/curatorial practice is embedded in an on-going research process that is based on the manifold relationships and actors involved in the implementation and realization of three architectural projects that served as exemplary standard models for Western societies and beyond, which were built in Israel, India and China during the time of decolonisation in the 1950s and 1960s. Until now, this high-modernist projects were mainly examined and described from the perspective of Western or nation-centred historiography.[1] The research project "Model House – Mapping Transcultural Modernisms" investigates and maps out the network of encounters, transnational influences and local appropriations of Architectural Modernity as manifested in various ways in translocal contexts. The basic question of the research is formulated in a deliberately open way: Who or what builds a city or a city district (Avermaete/Karakayali/Osten 2010; King 2003)? The assumption that spaces/places are characterized by the constant interaction of many different actors under unequal conditions implies that Model House chooses a praxeological perspective that initially grasps everything as action, i.e., regards everything that exists as furnished with agency. The built environment is not just simply built and inhabited, but is formed based on and in interaction with the given political, social, technological, and economic conditions, public discourses, concepts, artistic and scientific production. While research on the theory of transculturality has until now concentrated on the comprehensive

1 "Model House" investigates building projects as sites and spaces of transculturality in three case studies located at a distance to each other: 1. the migration of modernist housing projects from Casablanca (Morocco) to Be'er Sheva (Israel) during the period of decolonization and the exodus to Israel; 2. Productions of feminist/queer visible and audible features during the construction of Chandigarh (India) and beyond; 3. the transcultural aspects of two campus universities in China: Tsinghua University in Beijing and Tongji University in Shanghai. Questions of embodied difference and non-human actors traverse these spaces and expand the concept of transculturality towards dis/ability, posthumanism, and animal studies.

space of the *Black Atlantic* (Gilroy 1993), the project responded to Eurocentric discourses on modernism with a multiperspectival and polycentric form of artistic and cultural knowledge production informed by postcolonial critique. It develops and pursues forms of practice and presentation distinguished by the equal use of artistic, theoretical and empirical methods in their respective networks. Most important in the process is the fact that different empirical data and artefacts, from historical documents, to interviews with experts, to photographs, films, research studies, and artistic productions, are placed in a jointly developed system of references by the individual researchers. This process of mapping is represented on a web platform especially developed for this purpose by the media art collective Labor k3000 from Zurich/Berlin (www.transculturalmodernism.org).

Mapping is a strategy that has become important in artistic practice in the past years to enable decentralized and collaborative forms of knowledge production (Labor k3000/Spillmann 2010). The linking of different empirical data on the web platform allows capturing the migration of people, concepts, practices, and discourses, and analysing and visualizing connections, influences and encounters, as well as political and cultural events. The digital database is thus a crucial part of the project, because it not only represents and produces the network of various actors and their relationships between each other, but also visualizes the research process itself and makes it accessible for each researcher in the process but also visible for an interested public. In this manner, the exchanges between researchers in the research team as well as at different places and from different disciplines are enabled.[2] And most important the participation of non-academic experts and the integration of a multiplicity of text forms, media, and aesthetic practices are made possible and can be intensified in the process. The result of this constellation is a polylogical and multiperspectival narration by a number of speakers. The gained data and findings are questioned in regard to their common features and differences. This, in turn, should lead to new text and narrative forms as well as experimental aesthetical-artistic productions that can go beyond the analysis of the data material, its content-related links and the resulting propositions. The potentials of the dialogical method do not primarily consist in the publication of information but in the artistic tactical possibilities of including underrepresented relations between actors as well as diverse vectors of transnational transfers and localizations in the representation. In the sense of Dipesh Chakrabarty, this means making the project of modernism describable from the perspective of a series of localized events and specific actors, instead of continuing to tread the heroic path of universalism (Chakrabarty 1992). In his

2 The research team consists of the artists and architects Eva Egermann, Moira Hille, Christina Linortner, Peter Spillmann and Marion von Osten, the social scientists Fahim Amir, Christian Kravagna, Johannes Köck, and Jakob Krameritsch. It is financed by WWTF (Vienna Science and Technology Fund) and hosted at the Academy of Fine Arts Vienna at the Department Art & Communication.

concepts of border thinking, Walter Mignolo additionally points out the necessity of determining the demarcation lines (the borders) of inequality in an exchange (under colonial and postcolonial conditions), which are inherent to the power relations, class differences or racist and gender-specific attributions (Mignolo 2000). These borders can only be identified when taking the asymmetrical encounters into consideration that occur in specific contact zones, as Clifford (1997) and Pratt (1992) call them. Planning, research, government action and control by the ruling social classes must always also be read in regard to subversion, the struggles and resistance of marginalized social groups. The resulting conflicts and tensions can thus be grasped as a form of transculturality, as a site of continuous negotiations that are constantly in motion and cannot be represented as a single or fixed relation.

By means of an experimental archival constellation established in the research process, situated, localized and subjectivised data (visual, audio or textual) can be continuously condensed and expanded in new 'topographies of interests' on the one hand by the research team and by building up a network of correspondents outside Austria/Europe. The archival practice thus simultaneously establish dialogical relations between different knowledge producers as well as between specific places and times and thus create chronotopical forms of narration in the sense of Mihael Bakthin's concept, that in the literary artistic chronotope, spatial and temporal indicators are fused into one carefully thought-out, concrete whole (Bakthin 2008). Thus, chronotopes are specific space-time relations embedded in artistic strategies – with Bakhtin particularly in narrative constructions –, in which interrelations between specific places, events, persons undermine the factual time continuum of chronology. Thus an artistic chronotope can be understood as a process of assimilating material historical time and space. The chronotopical narratives created in an archive in motion of the 'Model House' project, move through and connect public and private textual and visual documents and archives of the past and the present. The past, present, as well as a place, persona and their particularities are re-imagined in relation to concrete social time-spaces. Thus, this project specific artistic chronotopes are able to create a rupture into the heroic presentism und social boundlessness of the concept of Modernism. The chronotopical 'text' created in the Model House project thus constitutes a specific aesthetic form of transdisciplinary knowledge production that is reflected not only in the selection and collection of images and texts, but as well in the connectivity of them as well as in the relational practice of the research process itself.

"Mal d'Archive" – in a Different Sense than Jacques Derrida's

Frank-Manuel Peter

I.

A panel focusing on the topic of archives is, in my opinion, compelled to address the archive's role as an interface between dance and theory. In order to make use of dance, i.e., to be able to perform, discuss or write about it, some form of archive is always required: regardless of whether this is the dancer's muscle memory, the viewer's visual memory, or one of the diverse media used to record dance. And when considerably more theorists than dancers are in attendance at an academic symposium, then the focus should be more on the relationship between dance science and the archive.

In her introductory theses, Beatrice von Bismarck directed the focus towards "curating," hereby mentioning the archive and dance separately, without taking the specific form of the dance archive into consideration.[1] Her point of departure is the archive as a site "permeated by relationships of power" (Bismarck 2011). This view undoubtedly plays an important role within cultural discourse: we are familiar with it from the work of Michel Foucault, Michel de Certeau, Arlette Farge, Gilles Deleuze, Jacques Derrida, Wolfgang Ernst and others. When one writes about the archive of the Bastille, or about traditional national, city, church, police or aristocratic archives, it is highly relevant. But what 'relationships of power' could possibly permeate a dance archive in a democracy to such an extent as to serve as the point of departure for a discussion? Hence, we can only turn to the past to discuss such topics, to the *Deutsches Tanzarchiv* in Berlin during the 'Third Reich' and to the *Tanzarchiv Leipzig* in the GDR. And while a few letters and administrative documents provide some indication of existing power structures and attempts at exercising political influence during the 1930s, the *Tanzarchiv Leipzig* has apparently preserved virtually no administrative documents or items of correspondence that could provide present-day researchers with exciting new information of this sort. The political restraints upon the

1 The panel members were to engage with these theses – which they received in advance, but which are not reprinted in this volume.

collection of archival material related to dance that resulted from the focus on 'socialist realism' are well known, although we know almost nothing about the context of any concrete activities.[2]

The absence of administrative documents that provide information on the political context is, however, the only indication of the possibility that material that should be in dance archives was intentionally destroyed. The "desire for their destruction" perceived by Beatrice von Bismarck, one "that has been repeatedly rearticulated since the criticism of museums launched by the avant-garde in the 1920s with the most diverse goals," (Bismarck 2011) has never been articulated in relation to dance archives. The criticism of museums formulated by avant-garde artists in the 1920s can also hardly be applied to dance archives, since the avant-garde of that day took exception to the conservative academic canon of art exhibited in what they termed 'museum temples.' In the field of dance, a 'desire to destroy' on the part of the avant-garde would thus be directed towards the established national and municipal theatre companies and their possibly conservative conception of dance, and in the field of dance theory towards the established professors and their perhaps antiquated, ivory-tower theories of discourse: towards theatres and universities as "sites permeated by relationships of power" (Bismarck 2011). Since the modern-day dance archive, by contrast, always attempts *per se* to archive and disseminate what is contemporary, they are, by nature, not likely to incite any such desire to destroy.

II.

The preliminary remarks and theses regarding "curatorial activities" are formulated quite generally – and have been previously formulated by Beatrice von Bismarck in other contexts (Bismarck 2011: 8-9; Bismarck 2009: 4-5; Bismarck 2009). There is no reason to doubt them and, fundamentally, they represent generally recognized facts. However, in relation to the curating of exhibitions, in particular, a perspective based exclusively on post-Fordist concepts of "immaterial" work (Bismarck in this volume: 215) proves lacking: with the exception of virtual exhibitions, not much has changed in the last 100 years beyond the increase in the number of exhibition makers who are no longer closely connected to individual institutions. There are still, as a rule, many ("Fordist" or "pre-Fordist") manual tasks to be performed in the process of staging an exhibition.

2 The *Tanzarchiv Leipzig* was established at the *Zentralhaus für Volkskunst*, later the *Zentralhaus für Kulturarbeit* of the GDR. It is possible that those documents missing from the *Tanzarchiv* might still be found at the Archiv of the *Zentralhaus* (*Staatsarchiv Leipzig*, 20298, and *Academy of the Arts*, Berlin). One of Kurt Petermann's colleagues at the *Zentralhaus* was Norbert Molkenbur, who later became the director of the Press and Publication Department as well as the writer's collective that published the *Lexikon der Tanzkunst* (1970-1972).

Unless one intends to philosophize abstractly on the topic of whether it is possible to archive dance, then it is imperative that dance archives are dealt with in a concrete sense. In relation to the focus on 'curating,' this means discussing curatorial activities undertaken by dance archives. In a panel consisting solely of dance archivists and experts from the field of dance science, one could discuss the strategies chosen for collecting and organizing. Considering the composition of the current panel, a discussion on curating exhibitions in dance archives would seem more appropriate. This, however, is doomed to failure simply by virtue of the fact that the other five members have not, to my knowledge, seen any of the over 90 exhibitions curated by the *Deutsches Tanzarchiv Köln* in the last 25 years.

In the current situation, one must, unfortunately, also pose the question as to whether it makes any sense to devote any thought to curating in connection with (German) dance archives, since they are insufficiently funded and the very existence of the institutions in Leipzig (Tanzarchiv) and Bremen (Tanzfilminstitut) is in danger. Complete ignorance regarding the work and the responsibilities of a dance archive were demonstrated in Leipzig, when the responsible ministry attempted to reduce the cost of the dance archive by equating it solely with its holdings and suggesting that they could simply be stored in the university archive. The loss of its own space, staff and its various budgets, would have ended all of the curator's activities and nothing would have remained but the holdings collected to date – which the university archive would have preferred to see markedly reduced.

III.

Why do dance archives no longer have a lobby? The archives represent an essential interface between dance and theory, yet they are severely neglected by both sides. In the past, dance theorists in Germany were mainly also practitioners; this was the case in the 18th, 19th and in the first two-thirds of the 20th centuries. They promoted the preservation of publicly accessible information on dance: in the form of literature, then libraries, and finally dance archives, and they also mediated the flow of information between the fields of dance and theory. They also raised the funds needed to make information related to dance accessible to the public: in the 18th century this could only be realized in the form of grants and subscriptions from local aristocrats to help finance the publication of research, in the 20th century this took the form of public funding for the archives they helped to establish.

During the last third of the 20th century, however, dance and theory appeared to be drifting apart. Dance science in Germany, which has been developing as a discipline within an academic context since the 1980s, began focusing on forms of discourse already familiar to us from established disciplines. Dancers and choreographers of the same generation found little that appealed to them in the infla-

tionary efforts to apply the work of Michel Foucault, Jacques Derrida, Gilles Deleuze, Roland Barthes, Jacques Lacan, Jean Baudrillard, Marcel Mauss, Pierre Bourdieu etc. to dance theory. The two fields, dance and new theory, rarely came together.

Parallel to this, both sides began to abandon the idea of the public dance archive, as it had evolved historically, as an institution with close ties to one's own metier, one that is 'responsible' for both dancers and researchers. To the extent that the lack of communication at this point left dance with any interest in archives – beyond dance history and dance technique – it manifested itself in the establishment of private archives to document a dancer's own career, and these were generally established for private use. These were, and still are, subject to choices made by the artists to reduce the holdings – for example when documents are destroyed because they no longer value their early work, or material is simply discarded, rather than donated, when there is less space after a move, not to mention the wide range of problems related to conservation. On the other side, many theorists have also established private archives to help them with their own work, whereby there are a disturbing number of cases in which they not only contain information, but also original documents procured directly from the artists or their heirs, which are ultimately kept from public collections and then used in their own publications at some convenient opportunity, accompanied by a note indicating that the material is from the 'author's private archive' or, even worse, the material is sold for profit.[3]

IV.

If we do not succeed in sustainably re-establishing the ever weaker connection between public dance archives and 'theory,' i.e., researchers in dance science, it is, from the perspective of the dance archives, pointless to discuss the act of curating. In the future, experts in dance science will possibly engage in a manner of curating completely independent of actual dance archives, if the latter even still exist, one that will deal with the researchers' private archives, or archives from other disciplines, within the context of academic discourse.

An important approach to a possible 'reunification' can be seen in courses of study that train more contemplative dancers or theorists that think with their bodies or teach applied dance theory. A prerequisite, in this context, is the integration of the archive into the program of training as an important interface between theory and dance from the very beginning.

3 On the other hand, another practice has now become common in the way dance critics deal with public archives. To name just a few: Horst Koegler, Klaus Geitel, Jochen Schmidt and Hartmut Regitz have begun to donate their archival holdings to public collections during their lifetimes and have entered a partnership of which they correspondingly make use, as needed. This is also true of dance photographers.

The criterion of 'opening' archives was already mentioned. This by no means refers to closed, previously inaccessible holdings, but rather aims at developing more convenient services, costing little or nothing, i.e., online access to an archive's holdings from home. A younger generation has now come to expect this – with fatal consequences for research, in cases where researchers only take information into consideration that is conveniently accessible on the Internet. The previously common practice of visiting an archive in person in order to assess and study the archive's holdings or view a film, or even going to a library in order to read books on site, has now become inconvenient. Yet, a willingness to adequately remunerate others for services that make one's own work easier is also only rarely encountered.

It is not just the painstaking work involved in archiving, and not only the curatorial work related to the holdings, that must be performed and paid for, but also digitalization and the preparation of material for the Internet as well as remuneration for any existing third-party copyrights. In this context, the question as to who should pay for these services and provide remuneration for copyrights has yet to be answered.

In order to steer archives in the desired direction of more convenient use, present-day researchers in the field of dance science must learn how the archive can become 'their' archive again, to connect it to their own work. Universities and other academic institutions must enter into partnerships with the archives and establish Intranet connections that enable their teaching staffs and students to view (not copy) films and other documents online at relatively low cost. Professors must petition the ministries of education to introduce legal regulations allowing modern means of external access to films and other documents on dance for the purpose of education and research at little or no cost. Europeana and Deutsche Digitale Bibliothek have long since initiated a general discussion on this topic. Hence, the conditions are favourable.

The "mal d'archive" in the field of dance can only be combated through a strong interest in dance archives on the part of dance science and the field of dance. Policy makers and ministries will hardly recognize the need to take action when confronted with philosophical discourses regarding archives as sites permeated by relationships of power.

Translation: Maureen Roycroft Sommer

Leaving and Pursuing Traces
'Archive' and 'Archiving' in a Dance Context

RESPONSE BY CHRISTINA THURNER

"May a fresh breeze of attention blow away the dust that clings to the archives,"[1] writes Berlin culture and media theorist Wolfgang Ernst in his book *Das Rumoren der Archive*[2] (Ernst 2002: 7). According to him, the archive as a place of research and object of cultural theory has never been as relevant as today (ibid: 7; Thurner 2010). Since Michel Foucault's transformation of the 'Archive' shifted the focus from institution to distinct historiographical practice (Foucault 2010: 146), the rumblings of the archives and those surrounding the 'archive' seem to have become all the more animated, so that dust has had little chance to settle. On the contrary, Ernst warns us that the term 'archive' "may have already evolved into a universal metaphor for cultural technique, a catch-all term that has deteriorated beyond all recognition" (Ernst 2002: 7). However, it is precisely the iridescent meaning of archive as both a place housing a historic corpus, as well as the movement that accesses that same corpus by taking the body of the user as a starting point, that concrete as well as the metaphoric archive, which offers an important practical and theoretical basis for academic research in dance. It forms the foundation of a "space of realities and possibilities" (Gehring 2004: 65) in which, upon entering, kinetic visions appear between the past, the present and the future.

The interdisciplinary *Archive* panel allowed for dialogue between various persona, researchers and artists from the fields of visual and performance art, as well as dance. In addition to a discussion on the similarities and differences to be found in archival practices of the different fields, various general questions and problems concerning the 'archive' and the 'archival' were brought up. The texts preceding this article are reflections of the debate involved. They address the divergent definitions of terms and their usage, the processual versus the static, questions of power, aspects specific to dance and the precarious status of the 'archive' institution. The following commentary will therefore again – selectively – take up these issues and attempt to focus them as a quasi-archival echo of the preceding essays.

1 All quotations in the text, except those by Foucault, Garafola, Jordan are translator's own translation.
2 The Rumblings of the Archives.

THE TERM 'ARCHIVE'

While general dictionaries define 'archive' as a "place of storage for public re-
cords and documents" (Kluge 2002: 54), the (post)modern historiographic sci-
ences define it not as a static place, "a lethargic place of storage [...], where an
abundance of tradition ages or sediments as sheer matter," but rather as a dy-
namic space, a "deep space that is opened up via analysis and through which
analysis moves" (Gehring 2004: 63). The archive – says Petra Gehring in refer-
ence to Foucault – does not lie in wait "like a huge, motionless past only to be
reactivated by external analysis. In truth, the archive is instead equal to the
movement that opens it up" (ibid: 63). So he or she, who enters the archive to
work there actually updates the archive, animates it and makes it what it should
be. Inside the archive, a never-ending practice is generated, which is motivated
more by the contemporaneity of tradition than by the fact that it is bygone (ibid:
64); a practice that – as Foucault defines it in his book *Archeology of Knowledge*
– "causes a multiplicity of statements to emerge as so many regular events, as so
many things to be dealt with and manipulated" (Foucault 2010: 146). The things
literally want to be brought out, revealed and turned into the statements of him or
her, who enters the archive because of them.

Artistic and scientific practices thus become the subject and the object of ar-
chives (Bismarck, in this volume). And the definition of 'archive' allows for a
broad range of meaning: it can stand for a place in which material is gathered,
such as an institution that brings order(s) into the collected material and makes it
accessible to the public. But the 'archive' can also be a metaphor for a way of
dealing with history and historiography or act as a label for a practice that con-
cerns itself with the history of things.

THE ARCHIVE IS NEVER STATIC, ALWAYS PROCESSUAL

The archival operation always involves multiple movements of inspection: things
are made visible, insight is gained and the past presents itself (anew).

But it is more than a purely visual practice: he or she, who searches the ar-
chive, finds and evokes statements. These statements are characterized by the
fact that they are never a priori existant, but rather subsequently made. Ernst
notes, in referring to this practice and act of configuration, that working in the
archive does not simple mean "to make an immense data base speak and to give
a written voice to the silence of a forgotten past, but to transform things of a by-
gone world into material for a world that has yet to be made" (Ernst 2002: 12).
He or she, who works in and with the archive, hence creates his or her own cos-
mos of found knowledge and perceptions; creates, organizes, interprets, exposes
traces and fills gaps with his or her own imagination. His/her work creates a nar-
rative in the here and now, which itself emerges as a spatial figuration out of the

space of the archive by allowing for or establishing references and links, connections and contradictions.

Thus in and with the archive, it is all about how we as 'users' deal with the material, how we (invariably) set up new connections and which focus we choose for the material we have found. Even with the highest aspirations towards scientific objectivity, we cannot but take a subjective view on the archived material or at least a subjective perspective – not in the sense of it being individual or personal, but rather contextual.

"If we focus more on the activities of a historian or even a philosopher, the archive is a workplace in which the desire for a past is interwoven with the desire to take into consideration the specific reality of one's own day and age." (Gehring 2004: 65)

What is eventually 'made' with and out of the salvaged material or rather extracted from what has been the unearthed or discovered, is thus not 'only' an object of the past, but a distinct contemporary narrative or production of knowledge. These are performative constructions of the past (Cramer in this volume), re-imaginations and chronotope narratives as a specific form of knowledge production (Osten in this volume). The aspect of communication, of communicability is always present and this in turn influences curatorial practice (Bismarck and Noack in this volume). The curatorial, like the archival, makes connections – and exhibits them.

A QUESTION OF POWER

Let us take a step back: What is available in the archives literally depends on what is and what is not made available for archiving. Which material is made available and how determines what can be found in what way in the future and what and how it re-enters historiography or the historical narrative. The archive is based on conscious or unconscious acts of recording: actions that are power-related. It's a power exercised in a respective present with an impact on the future concerning knowledge of the past. It concerns important domains such as cultural heritage, monuments and memorials – with all the possible social and political implications (Bismarck in this volume). Archives collect material just as much as blank spaces. Between the full shelves are yawning gaps. Marion von Osten spoke of a 'power-gap-issue.'

There are incidental gaps, as well as deliberately generated ones, and they have many different causes. The archives incorporate what someone has defined as knowledge and deemed important enough to be preserved for the future, or what simply found a place or fit in, what already had certain significance in the present or was related to important events or persons, what somebody liked or what was just left over. But even when something has entered the archive, it is still subject to power processes, for it depends on its traceability if a thing or a

body of knowledge will (re-)appear at all, if it can be reconstructed and therefore, continues to be present or gives evidence of the past (Bismarck in this volume). Objects and inventory can however also be concealed from the public: if someone locks them up or stores them away secretly, does not catalogue and classify them and thus not even potentially draws attention to the fact that this object, these bodies of knowledge exist and could be brought out again.

THE DANCE SPECIFIC ARCHIVE

An art form such as dance raises awareness of a fundamental inherent paradox of the archive: A (dance or other) archive does not store (the dance or) the art itself, but merely traces thereof. Scholars and artists must follow these traces on their contingent path in and through the archive (Cramer in this volume). "For the reality of the past," says Ernst, "can only be grasped within the context of the signs and attributions of the archive in that very moment in which we find its traces" (Ernst 2002: 55). Therefore, art is not conserved through archiving, but rather made communicable. However, this inevitably calls for compromises that never live up to the 'actual event' (Malzacher in this volume).

The criteria used to classify a critical accounting of the past are: partiality instead of totality, plurality and difference instead of homogeneity, contingency instead of teleological necessity, and finally discontinuity instead of linear narrative continuity (cf. Gumbrecht/Link-Heer 1985; Thurner 2008). In the field of artistic dance on stage, this has already been general consensus since modernity and especially since the postmodernism. Many creations break with a totalitarian perspective and focus on pluralistic differences in place of harmonious units; they reject an all too clear-cut point of view and widen audience perception, instead of simply satisfying it affirmatively; last but not least, in doing so, they critically reflect their own artistic tradition(s). The result is a natural concurrence of the asynchrony as a choreographed coexistence of moving scenes. This choreographic juxtaposition could also be seen as paradigmatic for the usage of the archive as well as for historiography itself.

But how are – as Ernst also asks – "historiographic choreographies produced from the fragmented bodies of the archives?" (Ernst 2002: 27). One possible answer is given by dance scholar Lynn Garafola: "Writing about the past, one has many [...] gaps to fill, places to imagine, people to resurrect, and frames of reference to inhabit" (Garafola 2005: ix). He or she, who deals with the history of dance in or with the archive, is thus doing nothing less, but bridging the (imaginary) gaps between particular layers of time and place. He or she revives the people or agents and places them in – explicitly or implicitly defined – frames of reference. Stephanie Jordan even sees this historiographic process – based on the art form of dance – as a "political manoeuvre to establish a power base for cultural identity as well as for the art itself" (Jordan 2000: n. pag.).

Art forms therefore also establish themselves through archiving, i.e. through the possibility of and via their historiography. (Dance-)History makes spirits talk (Ernst 2002: 37) and dance. Thus when the archive oscillates "between the graveyard of facts and a 'garden of fictions'" (ibid.: 60), the dance historian brings movement and life to this cemetery. Through the artistic or scientific retrieval of material discovered in archive into the present, through their (re-)telling, these spirits are given (back) a body, a text or a performance corpus. This corpus is agile and dynamic, because the narrative in and from the dance archive is always about movement, even though the concrete physical gesture, of which the archive source is quasi a substitute, may date back centuries. Dance concerns the ephemeral and is at the same time also a practice of radical embodiment (Cramer in this volume).

THE PRECARIOUS STATUS OF THE 'ARCHIVE' INSTITUTION

The sources found in the archive – and this should be duly emphasized – form the basis of the narrative and production of knowledge described here. If they are not (any longer) in existence, the narrative movement lacks an impulse, a fundament. That is why the archives as institutions, as places in which source material is gathered, are so important. However, their (further) existence is in danger, especially nowadays – e.g. in the field of dance (Peter in this volume). On the one hand, the archives are apparently not being used enough by scholars. On the other hand, the existing (dance) archives are not sufficiently politically acknowledged, legally protected and financed. That is why important issues need to be addressed now, before the archives disappear, are closed for lack of financing or sold off as inventory to libraries: What do we need archives for? And how do we want to use them? These questions stand at the end of my observations in order to mark a beginning or at least another new attempt. Archives are not remote, dusty places, but literally essential and central points of reference in the field that spans the poles of dance and theory – no matter if this is meant metaphorically or concretely. Let's question, rummage through, explore and use the archives! So that dance – theoretically, metaphorically and concretely – can leave traces that can be taken up anew and pursued over and over again.

Translated by ehrliche arbeit – freelance office for culture

References

Assmann, Aleida (1999): *Erinnerungsräume. Formen und Wandlungen des kulturellen Gedächtnisses*, München: C. H. Beck.

Avermaete, T./Karakayali, S./Osten M. von (2010): *Colonial Modern. Aesthetics of the Past: Rebellions for the Future*, London: Black Dog Publishing.

Bachtin, Michail M. (2008): *Chronotopos*, Frankfurt am Main: Suhrkamp.

Baxmann, Inge (2005): "Der Körper als Gedächtnisort." In: Id./Franz Anton Cramer (eds.), *Deutungsräume. Bewegungswissen als kulturelles Archiv der Moderne*, Munich: Kieser, p. 15-35.

――― (2008): "Ein Archiv des Körperwissens: Ethnologie, Exotismus und Mentalitätsforchung in den Archives Internationales de la Danse." In: Id. (ed.), *Körperwissen als Kulturgeschichte: Die Archives internationales de la danse 1931 bis 1952*, Munich: Kieser, pp. 26-46.

Bismarck, Beatrice von (2003): "Kuratorisches Handeln. Immaterielle Arbeit zwischen Kunst und Managementmodellen." In: Marion von Osten (ed.), *Norm der Abweichung*, Zürich: Edition Voldemeer, Wien and New York: Springer Verlag, pp. 81-98.

――― (2009): "Kuratorisches Handeln." In: Christine Peters/Barbara Schindler (eds.), *Tanz/Kuratieren zwischen Theorie und Praxis*, Berlin: Tanzplan Deutschland, pp. 4-5.

――― (2010): "Relations in Motion. The curatorial condition in visual art – and its possibilities for the neighbouring disciplines." In: Frakcija, Performing Arts Journal, 55 (Curating Performing Arts), pp. 50-57.

――― (2011): "Tanz und Archiv. Einige Vorbemerkungen, Fragen und Thesen zur Sektion." (unpublished manuscript)

――― /Feldmann, Hans-Peter/Obrist, Hans Ulrich/Stoller, Diethelm/ Wuggenig, Ulf (eds.) (2002): *Interarchive. Archivarische Praktiken und Handlungsräume im zeitgenössischen Kunstfeld/Archival Practices and Sites in the Contemporary Art Field*, Köln: Verlag der Buchhandlung Walther König.

Bourdieu, Pierre (1993): "Über einige Eigenschaften von Feldern." In: Id./Hella Beister/Bernd Schwibs (eds.), *Soziologische Fragen*, Frankfurt am Main: Suhrkamp, pp. 107-114.

Chakrabarty, Dipesh (1992): "Postcoloniality and the Artifice of History: Who speaks for 'Indian pasts.'" In: *Representations*, No. 37, pp. 1–26.

Clarke, Gill et al. (2011): "Minding Motion." In: Ingo Diehl/Friederike Lampert (eds.), *Dance Techniques 2010 Tanzplan Deutschland*, Berlin: Henschel, pp. 197-229.

Clifford, James (1997): *Routes: Travel and Translation in the late Twentieth Century*, Cambridge, Mass.: Harvard University Press.

Cramer, Franz Anton (2008): *In aller Freiheit. Tanzkultur in Frankreich zwischen 1930 und 1950*, Berlin: Parodos.

Ernst, Wolfgang (2002): *Das Rumoren der Archive. Ordnung aus der Unordnung* (The Rumblings of the Archive. Order from Disorder), Berlin: Merve.

Foucault, Michel (1967): "Andere Räume." In: Karlheinz Barck (ed.) (1993), *Aisthesis: Wahrnehmung heute oder Perspektiven einer anderen Ästhetik; Essais*, Leipzig: Reclam, pp. 34-46.

——— (1981): *Archäologie des Wissens*, Frankfurt am Main: Suhrkamp.

——— (2010 [1969]): *Archeology of Knowledge*, transl. Sheridan Smith, London: Routledge.

Frimat, François (2010): *Qu'est-ce que la danse contemporaine?* (Politiques de l'hybride), Paris: Presses Universitaires de France.

Garafola, Lynn (2005): *Legacies of Twentieth-Century Dance*, Middletown, Connecticut: Wesleyan University Press.

Gehm, Sabine et al. (2007): *Wissen in Bewegung. Perspektiven der künstlerischen und wissenschaftlichen Forschung im Tanz*, Bielefeld: transcript.

Gehring, Petra (2004): *Foucault – Die Philosophie im Archiv*, Frankfurt am Main: Campus.

Gilroy, Paul (1993): *The Black Atlantic: Modernity and Double Consciousness*, Cambridge, Mass.: Harvard University Press.

Goltz, Sophie (2011): "Archival Practices, die Akten verlassen das Archiv." In: Bildpunkt. Zeitschrift für IG Bildende Kunst, Autumn/Winter, pp. 4-7.

Gumbrecht, Hans-Ulrich/Link-Heer, Ursula (eds.) (1985): *Epochenschwellen und Epochenstrukturen im Diskurs der Literatur- und Sprachhistorie*, Frankfurt am Main: Suhrkamp.

Huschka, Sabine (ed.) (2009): *Wissenskultur Tanz. Historische und zeitgenössische Vermittlungsakte zwischen Praktiken und Diskursen*, Bielefeld: transcript.

Jordan, Stephanie (ed.) (2000): *Preservation Politics. Dance Revived, Reconstructed, Remade*, London: Dance Books.

King, Anthony D. (2003): "Writing Transnational Planning Histories." In: Joe Nasr/Mercedes Volait (eds.), *Urbanism: imported or exported? Native aspirations and foreign plans*, Chichester: Wiley-Academy.

Kluge, Friedrich (2002): *Etymologisches Wörterbuch der deutschen Sprache* (Etymological Dictionary of the German Language), 24th revised and updated edition, Berlin: W. de Gruyter.

Labor k3000/ Spillmann, Peter (2010): "Der kartografische Blick versus Strategien des Mapping." In: S. Hess/B. Kasparek (eds.), *Grenzregime. Diskurse, Praktiken, Institutionen in Europa*, Hamburg/Berlin: Assoziation A.

Lazzarato, Maurizio (1998): "Immaterielle Arbeit. Gesellschaftliche Tätigkeit unter den Bedingungen des Postfordismus." In: Id./Toni Negri/Paolo Virno, *Umherschweifende Produzenten. Immaterielle Arbeit und Subversion*, Berlin: ID Verlag, pp. 39-52.

Manchev, Boyan (2009): *L'Altération du monde. Pour une esthétique radical*, Paris: Lignes.

————— (2010): "Der Widerstand des Tanzes. Gegen die Verwandlung des Körpers, der Wahrnehmung und der Gefühle zu Waren in einem perversen Kapitalismus." In: Corpus, Internetmagazin für Tanz Choreografie Performance, January 2, 2012 (http://www.corpusweb.net/der-widerstand-des-tanzes.html) (first published on 11 August 2010).

Mauss, Marcel (1950): "Les techniques du corps." In: Id., *Sociologie et anthropologie, précédé d'une introduction à l'oeuvre de Marcel Mauss par Claude Lévi-Strauss*, Paris: Presses universitaires de France, pp. 365-386.

Mignolo, Walter (2000): *Local Histories/Global Designs: Coloniality, Subaltern Knowledges, and Border Thinking*, Princeton, New Jersey: Princeton University Press.

Osthoff, Simone (2009): *Performing the Archive: The transformation of the archive in contemporary art from repository of documents to art medium*, Dresden and New York: Atropos Press.

Pomian, Krzysztof (1988): *Der Ursprung des Museums. Vom Sammeln*, Berlin: Wagenbach.

Pratt, Mary Louise (1992): *Imperial Eyes: Travel Writing and Transculturation*, London: Routledge.

Rebentisch, Juliane (2006): "Autonomie? Autonomie! Ästhetische Erfahrung heute." In: Sonderforschungsbereich 626 (eds.), *Ästhetische Erfahrung: Gegenstände, Konzepte, Geschichtlichkeit,* July 4, 2012 (http://www.sfb626.de /veroeffentlichungen/online/aesth_erfahrung/aufsaetze/rebentisch.pdf).

Schmidt, Siegfried J. (1988): "Kreativität aus der Beobachterperspektive." In: Hans-Ulrich Gumbrecht (ed.), *Kreativität – Ein verbrauchter Begriff?,* München: Wilhelm Fink Verlag, pp.33-51.

Seibold, Stefanie (2011): "De-Archivierung!" In: Bildpunkt. Zeitschrift für IG Bildende Kunst, Autumn/Winter, pp. 8-9.

Sennett, Richard (2008): *The Craftsman*, Newhaven, CT: Yale University Press.

Silverman, Kaja (1996): *The Threshold of the Visible World*, London: Routledge.

Speak, Memory (2011): "On archives and other strategies of (re)activation of cultural memory," Townhouse Gallery, Cairo, October 28, 2011 (http://speakmemory.org/index.php?p=0).

Thurner, Christina (2008): "Zeitschichten, -sprünge und -klüfte. Methodologisches zur Tanz-Geschichts-Schreibung." ("Layers, Jumps and Gaps in Time. On the Methodolgy of Writing Dance History") In: Forum Modernes Theater. 23/1, pp. 13-18.

—— (2010): "Tänzerinnen-Traumgesichter. Das Archiv als historiografische Vision." ("Dream Faces of Dancers. The Archive as a Historiographical Vision") In: Tanz und Archiv: ForschungsReisen. Biografik, 2, pp. 12-21.

Varagnac, André (1948): *Civilisation traditionnelle et genres de vie*, Paris: Michel.

PANEL NEXT GENERATION

Thoughts on the Now in the Future

INTRODUCTION BY SUSANNE FOELLMER

> "Perhaps all we can ask is not what the future will
> be or will bring, but how we can face towards the
> future [...] the future is only ever a shift of atten-
> tion in the present." Ric Allsopp (2009: 254, 247)

A group of dancers in straight-cut clothes circles to futuristic sounds. The movement vocabulary is characterized by the isolation of body parts, slow inter-rupted motions that don't follow the movement flow, geometrically angled arms and straight legs used to dance a bit to the front, then left and right. Sometimes they mobilize their spines; little jumps augment the round dance of exclusively heterosexual pairs.

A dance scene is portrayed here; it takes place in the so-called Starlight Casi-no from the German TV series *Raumpatrouille* (1966). The seven-part series de-velops the utopia of a world that is no longer divided into nation states in an un-defined future era. If one analyzes the social dances, which are meant to repre-sent behavior in a future world, it becomes evident that all forms of movement correspond to aesthetic forms of (stage) dance as they appeared in the past. Sup-ported ballet arm positions are combined with Cunningham-like motions; the flexible spine is reminiscent of movements from the beat scene and the circular form conjures up Baroque dances.[1] The whole scene becomes a 'dance of the fu-ture' by intermingling different styles and combining them with a rather synthet-ic and almost coincidental music. The idea of the future can apparently only be served by what's available in the present. In this case it simply holds up a mirror to the relevant movement aesthetics of the time.

Speaking about the future, about what we can expect next, about the next or new generations and their visions – all is fraught with a fundamental paradox: the return of the known in the future as well as the perspective on transitions and gifts from one generation to the next.

1 One of the dances is appropriately called *Mars Menuett* (music: Peter Thomas). Simi-lar dance pieces are shown three years later in the film *Sweet Charity* (1969, direc-tor/choreography: Bob Fosse). I would like to thank Mariama Diagne for this infor-mation.

A (PARADOX) GIFT: FROM WHERE TO WHERE?

A gift begins the confrontation with the idea of a 'next generation' in dance. As described in the introduction (Brandstetter/Klein in this volume: 13) the panels of the conference are all dealing with a subject, such as 'aesthetics' or 'archive.' 'Next Generation' is thus an exception to the other fields' structure of content. Here, the discussion about dance and theory is not based on any aesthetic, social or political filter, but rather on something that has yet to take place. It is the gift of a title, and, at the same time, a transfer of coming reflections and possible actions in and around dance – in art, science, in free scenes and in institutional contexts.

It is a gift that makes you happy at first, since it seems to be based on the faith that you will even be able to play a role in dance and science sectors in the future. However, giving is a complex ritual; as soon as you begin to think more specifically about the meaning of this gift, you realize that you can't accept it. Questions and doubts arise. Who or what defines the next generation, and who does the term refer to? Should the participants in this panel have seen themselves as such? Should there be a distinction between art and (scientific) institutions? And how can we deal with the paradox: a supposed next generation labels[2] itself and already speaks of itself with an own future identity? And what should we talk about, if thinking and acting – it is yet to come – has not occurred yet?

Such considerations give birth to multiple time planes when we provisionally talk about a potential future generation from today's perspective, which in turn can only rest on foundations which were laid in past aesthetic, political and ethical discourses. Thus the potential of a next generation is also always subjected to its own 'post hoc' nature, in being belated in what it is able to do or postulate. This is so, because if it is to create itself in the future, it can only speak of what has now already occurred.

This gift thus includes an inherent fundamental deferral; it is an event that basically can't occur. Jacques Derrida emphasizes the impossibility of a gift, since it is an event that should cause surprise by breaking through the "economic circle of exchange" (Derrida 2007: 448). The gift's crux, however, is that it evokes thanks:

"To be able to receive the gift, in a certain way the other must not even know that I'm giving it, because once the person knows, then he or she enters the circle of thanks and gratitude and annuls the gift." (Ibid: 449)

Derrida accentuates the impossibility of the event as such, which infiltrates all of his ideas of the "primacy of the text" (Mersch 2010: 64), and concludes:

2 Kai van Eikels formulates it accordingly in his response (Eikels in this volume).

"there is no more eventful event than a gift that disrupts the exchange, the course of history, the circle of economy. There is no possibility of giving that is not presented as not being present. It's the impossible itself." (Derrida 2007: 449)

The concept of the next generation inherently seems to imply a posture basically directed towards the future as well as a promise and expectation of new potential – it cannot happen now. What is remarkable about this is that the utopian vision (if one considers the dance scene from *Raumpatrouille*), the promise the future is expected to redeem, is usually rooted in some kind of present. If, for example, 'new' strategies of artistic collaboration or the primacy of openness – whether in thinking patterns, aesthetics or artistic practices – are marks of contemporaneity, what is the big new development that a (new) generation will have to face? What will be expected of its protagonists? Will a next generation be found at some nebulous location far removed from modernism and postmodernism?

The following thoughts touch on a meta-discourse that also traces the paradoxes of the self-reflexive 'yet to be' and 'new' in the context of postmodernism.

(RE)THINKING WHAT'S NEXT

Reflecting on what is to come implies speaking about potentials, about what could take place – or possibly should take place – in the future. Bojana Kunst, in citing Giorgio Agamben, understands this phenomenon as an appearance of a something preliminary: "Potentiality can come into light only when not being actualized: when the potential of a thing or a person is not realized" (Kunst 2009: 357). At this point, things become difficult because, according to Agamben: "For what can it mean to think neither a thing nor a thought, but a pure potential, to name neither objects nor referential terms [...]?" (Agamben 1999: 216).[3] Therefore failure is inherent in potentiality, as Kunst continues, the non-actualized is practically the necessary prerequisite – otherwise one could no longer speak of potential (Kunst 2009: 357). Once it is "realized" (ibid), potentiality is nullified. At the same time, it is precisely this potential that is valued as an important resource in scientific and artistic fields. It is the 'new,' the not-yet-thought-of, not-yet-aesthetically-formed that circulates as creative capital in the economic veins of both spheres. They are "dis-balances of comprehension and knowledge transfer," for example, or the "loss of hermeneutic control" that generates the potential of future other (aesthetic) appearances, as Gabriele Brandstetter formulates (Brandstetter in this volume: 204).[4] Insecure and rejected knowledge meet in these time periods, in a delay in which other new paradigms have not yet been

3 Agamben formulates his thoughts on the basis of Derrida's idea of the trace, in the sense of a potentiality of unwritten writings.

4 Brandstetter is making reference to Heinrich von Kleist's Text *On the Marionette Theatre*, the focus of which is doubt.

established. It is a temporary stretching of the present that still considers the past but does not yet grasp the future.[5]

The yet-to-come implicit in the next generation is a constitution that – especially in dance – is already inherent in the object. André Lepecki makes a distinction in so far as he assigns what can be planned or predicted to the term 'future' and correlates it to an idea of choreography that recalls what can be expected: "[...] choreography participates in the logic of the future – since choreography both demands and prepares the fulfilling and arrival of anticipated, preplanned, and expected movements, gestures, steps, and positions" (Lepecki 2009: 342).[6] This imperative is opposed by an unplanned, unexpected what is to come: "*[W]hat is to come* expresses unsuspected arrivals of what we could only have hoped for" (ibid: 341, emphasis in the original). In the process, the 'what is to come' pushes itself between the levels of time – it extends into the present and effects what is now through the desire for its arrival: "*What is to come* then names the a-predictable [...] inventiveness of the present" (ibid: 342). Lepecki thus connects 'what is to come' with dance, which is open to this yet-to-come in every moment. At the same time, dance then exempts itself from the economic system, in the sense of not being predictable (ibid: 342).

It is then a question as to what extent the inestimable or not-yet-updated is precisely the motor of an economy of knowledge that academic institutions as well as artistic projects feed into – whereas artistic projects, if they want to be shown, must at least enter the programmers' market circulation.[7] The actions and projects from the cultural field correspond even more to economic mechanisms in a particular way, as Boris Groys postulates: "Due to its dynamics and ability to innovate, culture is the field par excellence in which the economic logic can have its greatest effect" (Groys 1992: 15). The actions and productions in contemporary dance are especially often characterized by a refusal to join the aesthetic economy's apparatus. The (dance) project *Untitled* (2005) by an unknown group of performers who tried to avoid an identification by name and thus a categorization in particular artistic discourses is one such example (Foellmer 2009: 11 et seq.).[8] The dynamics of the innovative accompany a refusal to become a

5 In the context of art and performance, Ric Allsopp speaks of Marcel Duchamp's example *Large Glass* of an evoked delay of what is to come by means of an extreme deceleration of movement, "postponement of the yet-to-come" (Allsopp 2009: 251).

6 Of course, one could discuss here if choreography is always really tied to its realization and success, or whether it is more of a direction that inherently allows for imponderabilities (in its actualization).

7 See also Gerald Siegmund's critique of Peggy Phelan's ontological determination of performance as an irreproducible event that represents a critical position to the dominant economy. The postulated presence makes performance predestined for the market that always demands something new (Siegmund 2006: 67).

8 The project was shown in the context of the dance festival *Tanz im August* in Berlin among other places.

member of the circle that is repeatable, representative, normative and often affirmative.[9]

WHAT IS NEW?

At this point I would like to pause and ask: where do we stand? In what time do contemporary dance artists, dance researchers or dramaturges find themselves? After all, they are influenced and informed by the theorems and practices of 'postmodern knowledge,' which opposes the modus of the true and right, the "metanarratives," with the "heterogeneity of elements" – as Jean-François Lyotard formulated it (Lyotard 1984: xxiv et seq.). As Groys states, in furthering Lyotard's ideas, postmodernism is connected to a "rejection of everything new" (Groys 1992: 35); it distances itself from the strategies and the products of modernity. Universal truths are abjured, as are the creation of utopian visions that are associated with specific names. Groys diagnoses a "crisis of utopianism" in which the primary goal is no longer striving to the fore or having a vision of a coming generation, but rather placing oneself in relation to "theories and methods in cultural economy" (ibid: 38 et seq.). Given this context, it's no longer the aim to create something 'original'; instead, 'originality' results from the new connections between existing things in the respective methods of citation (ibid: 40). This is demonstrated in the relational and certifies the new as an issue of difference:

"Each event of the new is in essence the completion of a new comparison to something that had not previously been compared. [...] The new is produced and recognized as such, i.e., as different and simultaneously culturally valuable, on the basis of certain, traditional, inner-cultural and cultural economic criteria." (Ibid: 49)

He then concludes, a bit polemically, that, after a "self-protection from the future," an escape into a discourse about the 'other' instead of the new follows (ibid: 40). The discourse about the 'other' is generated out of the (cultural) inaccessibility to it; this occurs in a dearth of a possible discourse about the new, and places the 'other' in a position of value (ibid: 30; 43).

According to Groys, thought about the 'other' occurs in reference to a departure from the idea of a community of identity, which modernity still seemed to provide. The modus of difference as a characteristic of postmodern reflection circulates around an alterity that, though it was once extra-discursive (so the punch line), can now have a norm-giving effect: "Here, the other is the time and its power" (ibid: 43). Searching for the 'other' as the new is therefore a genuine-

9 Pirkko Husemann terms the resulting aesthetic strategies as an expression of a "negativity" that had its beginnings at the Judson Dance Theater in the 1960s (Husemann 2002: 16 et seq.).

ly "cultural operation" (ibid: 44); it thus proves its originality only when it has been fed into discourses.

Jacques Rancière takes a slightly different path by replacing the often chronologically implemented categories of modernity and postmodernity – both traversed by issues from the fields of aesthetics and politics – with the description of various "regimes" in art (Rancière 2006: 20). The "lines of rupture" are not to be drawn between the "the old and the new" (ibid: 24); instead, art must be observed within its various fields of identification that traverse all epochs (ibid: 20). Rancière names three types: the "ethical regime" that questions the use of art; the "poetic regime" that focuses on the representation of art (in the sense of mimesis, for example); and the "aesthetic regime" that includes the phenomenal character of the artwork, its "sensibility" (ibid: 21 et seq.). These regimes would be veiled by a simplifying assignment to modernism or postmodernism; for example, "the aesthetic regime of the arts is first of all a new regime for relating to the past" (ibid: 25).

However, the question remains: what is the 'old' that is being referred to, especially if even the 'new' cannot qualify itself through something original?[10] And now, in reference to the next generation in dance: who or what could be referred to as 'old'? Academic objects, aesthetics or theories? What 'traditions' can we reference in such a young academic field as dance studies are – at least in the German-speaking countries? This also applies to the level of art: is there already something traditional in (European) contemporary dance?

SWAPPING THE (NEXT) GENERATIONS

To claim the existence of a next generation in the field of German-language dance studies is thus difficult for the simple reason that the field has just begun to establish itself in the last 30 years.[11] The panel's participants work with the field's representatives, there are no radical breaks from an established canon that must be destroyed and then replaced by completely different aesthetic or theoretic positions – instead, canons or dance research methods are critically examined and are still in a phase of emergence. In addition, at the beginning of their research, representatives from the developing institutional field of dance studies

10 It is also remarkable in this context that one still mostly makes reference to male, usually European theoreticians.

11 An understandable point of departure for (independent) dance studies and its visibility could be marked by the publications that appeared in this field. For example: Jeschke 1983; Müller 1986; Oberzaucher-Schüller 1992; Klein 1992; Brandstetter 1995 as well as later Huschka 2002. Add to this the emphasis on dance in the field of theater and literature studies (Brandstetter, Siegmund, Thurner), sociology and cultural studies (Klein) or historiography and movement analysis (Jeschke, Hardt), only to mention the main areas.

such as Gabriele Brandstetter or Gabriele Klein found themselves in the midst of knowledge shifts that were termed postmodern. In this sense there is no opposition at first, no rebellion of the 'young' against the 'old.' Instead, superimpositions, shifts and co-operations are taking place in a 'now generation' far more than in a 'new generation'; this generation is attempting a sustainable implementation of dance as an art form in the academic and artistic regimes.[12] Practices in contemporary dance such as self-questioning, physical fragmentation and delimitation, and democratic strategies in work methods have yet to be turned into 'names of epochs,' with the exception of the insufferable 'concept dance' label. We are still in a "crisis of categorisation" (Brandstetter/Klein in this volume: 13); it must be determined, who is speaking from what place, or who will do so in the future.

However, one could ask oneself to what degree postmodern vocabulary, which is especially infiltrated by the modes of the indeterminate, open and unexpected in the field of dance, already demonstrates hegemonic effects in art and science, for example, in reference to the invitations granted by international festivals or the direction of scientific thought.[13]

Though we hold on to the ideas of the insecure, undirected and open with a certain vehemence (even during the panel), detour around positions and affirmations to which one would have to commit and avoid orientation towards linearity such as the future (the way Lepecki suggests with his differentiations; Lepecki 2009), we are still permanently occupied with placing ourselves in precisely this uncertain future. Artists and researchers, dramaturges and curators: we are in a constant state of announcement.[14] We write applications for projects that will take place in the future, but they have to be so clearly formulated that they practically attain the status of a future perfect: the application shapes what will have happened if the desired and designed project is realized. We thus create a condition of assertions and potentials; it is not only a signum of the economy of university knowledge today, as Bernhard Waldenfels criticizes sharply.[15] It is precisely this potential, as described above – the proclamation of the unknown as a

12 For example, in Germany there is still no independent institute for dance studies at a university; contemporary dance is still usually dependent on temporary production venues or those that do not have a long-term, guaranteed budget.

13 As the "iconization" that can be assigned to the fluid movements in Xavier Le Roy's piece *Self unfinished* (1998), so Siegmund (2008: 29). See also Foellmer 2009: 17. Krassimira Kruschkova speaks here of an "example that has already become 'classic'" (Kruschkova 2006).

14 This aspect was introduced into the discussion by Laurent Goldring before the panel took place.

15 "Instead of researching and presenting research results, one writes project applications. [...] sketches that are supposed to elucidate a path of research and questions get bigger and bigger – as though one already knew what one hoped to find" (Waldenfels 2009: 18).

kind of promise of possibility – that gives dance and dance studies a dynamic, but also allows an integration into economic circulation. Thus our generation is also the one that must always already think about and pre-formulate what will come next. The 'new' correlates (and gets mixed up with) the 'next' in the mode of a constant re-design (of it/oneself).

In addition, it would certainly be misleading to assert the existence of an un-broken community of contemporaries, since the approaches and positions are quite varied in artistic as well as research fields. For example, Isabelle Schad criticizes the standard practice of having to declare a new work in dance as open, processual and collaborative in order to be recognized when applying for support or requesting invitations. The context – once thought to be open and accessed through one's own working method – has become a contest in which terms must be mastered on the keyboard of the contemporary: "Within the market of presen-tation, those notions are much promoted but often without any (of its original) meaning" (Schad in this volume: 280). Krassimira Kruschkova thus formulates the current sensitivities in contemporary (dance) aesthetics as attempts at "de-scribing" that occasionally lead to an attitude of "renouncement of action" in the sense of an "I prefer not to" (Kruschkova in this volume: 99). However, this should be understood less as a defiant renouncement, but rather as a possibility to (paradoxically) escape previously set and determined ideas of the open. Thus one can observe a "resistance to belonging," an aesthetic of being together as a group in dissension, as is described in a similar way by Jean-Luc Nancy (Kruschkova 2011). It is a dissonance expressed in the attempted debate as a difficulty of wanting to speak about what cannot be said (yet). And it is aggravated by the fact, if one agrees with Schad, that the process-oriented approach has already created normative vocabulary that has infiltrated entities which decide on wheth-er one will be included in the economy of the visible as an artist or researcher.

Citing Groys, one could turn this into a political issue: if the new/other (next?) can only be seen if it has already been integrated into a dominant dis-course, then a next generation is – in the moment it calls itself such – always al-ready part of the hegemony of what it constantly negates. It is a complex situa-tion, especially since the so-called 'now generation' is concerned with the critical questioning of knowledge in dance whose form is yet to be developed. The im-portant influence of postmodernism pronounces the "seperati[on of] the idea from [...] presentation" (Rancière 2006: 29) as Rancière points out by citing Lyotard, and lands in dance research's questioning of physical means of repre-sentation that Gerald Siegmund summarizes in the mode of "absence" (Siegmund 2006), or in the mode of choreography that appears less as a fixed score and more of a memoria that occurs (again) reflexively in the audience's memory – according to Brandstetter (2000) – up to the loosening of 'Schrift,' away from the guarantee of the fixated towards a fleetingly moving "texture," as Isa Wortelkamp points out (Wortelkamp 2006: 234, 249).

What positions must one then temporarily take up, for example, in order to make the anti-categorial, which eludes all, understandable? Are limits necessary

to be able to think of the delimited, the 'other'?[16] How can the open and undetermined be taught at (art) universities? Deadlocks happen, as they did in Meg Stuart's *Auf den Tisch* project in the context of the *Tanz im August* festival 2005. It was an experiment that intended to literally combine dance and theory. The assignment was, to put it simply, to improvise and to (critically) reflect what one was doing in that very moment. However, certain immobility was the result, since one of the prerequisites of improvisation apparently is the willingness to take risks – a situation that at first seems to be diametrically opposed to the mode of reflection.

So at first glance the attempt failed, since there was no movement that could have been contemplated. However, this project shows the threshold we are now at. The foundation is (was) made up of a constant questioning while observing 'great' future designs with skepticism. These are moments of deceleration in art and science that keep the gap open in which action and thinking can develop polyphonically in multiple directions without immediately being caught up in the mills of institutions and categories. Simultaneously, this time/space is becoming increasingly tight, since – as described above – any hesitant act already becomes a 'signum' of something anticipated and with potential that is to be produced.

GENERATIONS IN-BETWEEN:
THINKING CHOREOGRAPHIES/-ERS

So, where (and when) are we? First off, in an indeterminate space that is already infiltrated by determining spaces such as the university or the art market – demarcations of this were described above.[17] As Kruschkova also notes, Gabriele Klein characterizes the critical attitude of difference – a thinking or acting in dissent as the sole 'signum' of a commonality – as a critical "practice of 'disordering,' 'disordinance,'" which, however, recreates (temporary) order in the contingencies (Klein in this volume: 144). So, what does one do with all of these imponderables?

Dance and science, as I see it, are both characterized by protagonists that often find themselves in spaces in-between (that are often previously demarcated): between being a curator and a university researcher, between research and dram-

16 Thus Judith Butler emphasizes the "constituitive outside," that cannot be said without simultaneously being prescribed; it is, however, a necessary prerequisite for discourse (Butler 1993: 12). Thus one could ask, to what extent Lepecki's singularities (in the sense of the "always unexpected") are prerequisites and thus parts of existing dominant orders (Lepecki 2009: 342).

17 Isabelle Schad thus asks: "Can we also talk about a next generation in dance, or about a new one? Or conversely, are we rather witnessing a popularization and institutional recognition of concepts that many artists have been individually for decades?" (Schad in this volume: 278).

aturgy, between the so-called independent scene and theaters with annual budgets. The panel had been assigned to reflect on these strata, these folds in dance and (as) theory with representatives of all of these fields. After all, the thesis is: the 'now generation' operates in locations that not only try to make the respective regimes of art visible, but also those of science. Other perspectives on dealing with – and dealing within – art and science are created in the cultural conventions that are negatively determined,[18] at the interfaces between institutions and areas with a more process-oriented order – whereby the thesis would be that dance research also attempts to process these events at the universities. If these modalities already create "regime[s] based on the indetermination of identities, the delegitimation of positions of speech, the deregulation of partitions of space and time" (Rancière 2006: 13 et seq.), then they still represent a possibility to reflect and shape the (common) language in and between the levels of artistic and scientific practice, of reception and politics. It is a mode that Rancière terms the "distribution of the sensible": it

"reveals who can have a share in what is common to the community based on what they do and on the time and space in which this activity is performed. [...] [I]t defines what is visible or not in a common space, endowed with a common language [...]." (Ibid: 12 et seq.)

An attribute of the *now generation* in dance is that knowledge and research are no longer the universities' exclusive right, the same way in which artistic practice has gained entry into the study programs in a friction between testing and reflecting actions.

I thus see the actions in these interim spaces and times as a conception of *choreographic thinking*. In the meaning of the words, 'choreographic' demarcates distancing oneself from a movement, the moment of writing and thus reflecting what is to be danced, and is therefore also a space in which movements can be conceived with their realization as the objective, an imagination of what it could look like – in a performance, for example. This should not be understood in the sense of a classical author-performer position. In my opinion, *the choreographic* takes place in the moment of artistic work in which the choreographer or the collective reflects on what was done, independent of how formed or unformed it is presented later. In this way, such an idea of choreography contradicts the idea of a planned future in the way Lepecki proposes it, but rather projects a space of possibility that juts into scientific thought in/about dance. Here, the named attempts appear choreographic: attempts at keeping the traces of what has occurred (necessarily fixating and categorizing them in the process) in a state of limbo and enlightening and ordering – without normatively determining – what paradoxically often only shows itself in denial. This takes place in spaces of fric-

18 Groys calls the new an "act of negative adaptation to cultural traditions" (Groys 1992: 19).

tion between writing and movement that could, in Lepecki's sense, possibly achieve that what has been seen and reflected upon will dance once again.[19]

If there are then markers for current developments of a 'next' in the 'now generation,' then one of them would be *acting on trial* – an act of testing what could be thinkable and speakable in the fields of dance, research and science in the future; a sketching and disposal of possible models of a (coming) generation that is currently (still) in a testing phase; a test that has already once again major influences on contemporary discourses, art, science and their economies.[20]

Thus one should ask less about a next generation, but rather more concretely what contemporary dance and dance studies require so that they can continue to meet at their points of conversion. Spaces of movement and thought are needed that allow knowledge to be flexible, that allow moments of foundering, and that offer dance the possibility to question itself and to develop its art. These are choreographic spaces, "space[s] of contemplation that open[s] to the future" as Ric Allsopp formulates it (Allsopp 2009: 253), and periods of time assigned to contemplation. Places of exchange. Artistic and scientific residencies, for example, could be such places, provided with independent and sustainable budgets that facilitate these processes in an appropriate scale.

Such considerations turn the gift referred to at the outset into a political demand: there is no next generation that is already speaking. But we can develop visions and prepare the foundations for what can be.

"What's next? The future is already here, and now. Slow down, look closely, pay attention, stay engaged, think and be together, always." (Nicole Beutler 2011)

Translation: Christopher Langer

19 Hartmut Böhme and Sabine Huschka thus sketch the choreographic in its classical geneology as an articulation and framing of "bodies in movement" that are "*in tune* with one another." At the same time, the "graphic moment in dance" prepares for its transferal into other media, for example script or images (Böhme/Huschka 2009: 12 et seq., emphasis in the original).

20 Regardless of whether the representatives of this generation will play a role in the (insitutional) field of art and science in the future.

A Relational Perspective on Dance and Theory – Implications for the Teaching of Dance Studies

Yvonne Hardt

With this paper, I would like to opt for a relational perspective in regard to dance and theory – for positionality in the understanding of dance and theory as it surfaces in different artistic as well as educational contexts. Depending on the context of how, why, for whom, with whom dance and theory is understood, practiced or transmitted, it might be necessary to draw on and borrow quite different theoretical standpoints and methods. This can mean both theorizing dance in regard to openness, instability and border challenging questions, as well as a focus on stability, the categorical and the hierarchical. Such a perspective of positionality necessarily tackles the process and construction of knowledge, which I consider highly paramount in the teaching of dance and theory. And it is within the educational realm where I would like to place the discussion of the paradox term 'next generation' within an academic setting that has deconstructed notions of linearity, accumulation and progress of knowledge. It implies that we do not only ponder the construction, the forms and aesthetics of knowledge, but also of teaching and education.

In this light, this paper is not so much interested in an ontological or philosophical discussion on the possibilities of defining a 'next generation' or generally what 'nextness' or 'future' might mean (although these are important discussions of this panel)[1] but rather to see these reflections as one specific (of course important – if not to say dominant) approach within a dance studies field that has become more clearly institutionally established within the last decade in Germany. As such, I see this paper as a possibility to raise questions for the future of teaching dance studies as they relate to terms of this panel and to ponder along this way the implications of current approaches for students.

1 See for instance Foellmer, Stamer, Wortelkamp in this section of the book. I take this perspective only in relation to this panel and to open a discussion – and it is not the standpoint I might follow in a different context.

POSITION I: BRINGING KNOWLEDGE INTO MOVEMENT?

Usually I argue along the lines of a quite established position, which assumes that knowledge is a construct and that dance has a specific 'mobilizing' characteristic in regard to this construction. This makes dance the ideal site for its own theorization both as a topic as well as the means by which it can be studied (Brandstetter 2007; Klein 2007). Such a position inherently needs to scrutinize the methods and understanding of dance as an object of study. However, assuming this position requires an interest into inquiring the very nature of reflection and science a stance that can be problematic in certain educational contexts in which theory is not cherished for the sake of itself but more in regard to how theory applies to practice. The question is: How to raise an interest in different concepts of knowledge and to facilitate different modes of understanding and working with texts?

One of the reasons dance has such a critical potential for its own theorization is that is necessitates a reflection of how to verbally capture it. However, the problematization of the gap between dance and language is a difficult starting point in a context where dance is mystified as the 'other' of verbal expression, and has often been considered a 'natural,' physical mode that stands in opposition to reflection: a dominant argument within the dance field at least since the early modern dance movement. For the beginning dance or dance studies student[2] the difference between a discussion on the inability to capture dance verbally and the constant reiteration of the problematisation of describing dance might not be immediately transparent and it might be very helpful to provide them with a clear vocabulary and analytical tools to describe dance.

More so, a focus on the non-static concept of knowledge (as it is also presented within this panel) that presumes also a plurality of perspective subdues a discussion about the inherent hierarchies and values attached to different forms of knowledge within specific academic settings. The insight that knowledge is always unstable might obscure differences that could be made clearer if there was an open treatment of the academic trajectories through which individual dance scholars have arrived at their current standpoints. In contrast to dance formation, where the previous training of teachers and students is an omnipresent topic (here, it is quite visible in the qualities of movement and inscribed in the body that it is hard to alter), such a trajectory of learning is hardly the topic in theoretical study programs and in regard to the incorporated schemata of thinking.[3] A reflection of the constitution of knowledge more often happens on the

2 When I speak of 'beginning students' I do not want to suggest that they are a homogenous group (the same applies to a term like 'practitioners'). However I would like to use these terms here to hint at general tendencies and to point schematically to differences for the sake of this discussion.

3 Here I refer to Pierre Bourdieu's understanding of habitus as it intertwines schemata of thinking with a corporeal practice and his theory of practice. (Bourdieu 1977).

level of the argument. This may include dealing with methodological problema-
tisation, theoretical connections and tracing inductive procedures in generating
an argument. However, it rarely includes a reflection of one's own formation in
the sense of the structures that form or stabilize our thinking.

As a result, many practitioners or students who start to get interested in the-
ory still perceive the academic product (most often a text) as quite static, even if
the content or the 'how' of the text suggests a quite different understanding of
knowledge. Usually students require help in learning to see 'how' texts function,
which in turn leaves them with a feeling of knowledge hierarchy (not in a bad
sense) despite wanting to transmit or encourage independent enlightment by al-
lowing the contingency of the teacher's own position to surface.

Accordingly, a few questions arise: From which position can one teach the
understanding of a non-static concept of knowledge? And if we assume that there
are prerequisites, how would we conceptualize them as a non-accumulative con-
cept of knowledge? In the end, are we not– and have to be – schizophrenic in the
teaching of a non-static understanding of knowledge, by categorically asking for
it and strategically transmitting it?

POSITION II: CONSIDERING STABILITY

Paradoxically, the focus on the instability of dance and of knowledge might also
be counterproductive in an educational context where critical theories have been
well established and students have learned from the beginning to cherish per-
spectives that challenge stable categories or the notion of a given 'object' of
study and focus on the 'arepresentational' or representation challenging charac-
teristics of contemporary dance. In a field were key terms are: transformation,
transgression, withholding, etc., one encounters students who consider Deleuze
their main theoretical point of reference and have established very clear aesthetic
preferences – to the extent that some consider everything else outdated and un-
worthy of consideration. Susanne Foellmer has made transparent in her study *Am
Rande der Körper* (2009) how much the transgression has become an articulately
recognizable form in contemporary dance. It also seems necessary to transpose
this back onto the field of dance studies where theories of instability, notions of
the subversiveness and arepresentational function in parallel. Historically, the
notion that dance is politically subversive is quite new – tracing for instance the
history of ballet and its representational function; as well as the institutional and
hierarchical development at the royal courts; or investigating the function of Folk
Dance in different political systems; not to speak of the involvement of 'Aus-
druckstänzer' under National socialism; or newer dance performances as part of
huge cooperate commercial tours. This list reveals that insisting, per se, only on
the critical potential of dance would exclude quite a field of inquiry. More so,
what would be the theoretical frames that would allow us to deal with these is-

sues in the light of a discourse on dance that prefers to perceive dance as onto-logically defined by instability and its representation challenging nature?

Similarly, a critical reading in regard to notions of the 'unpredictable' – that have surfaced at this panel – is possible, if one considers, for instance, the idea of improvisation as linked to 'unpredictability.' Older notions which perceived improvisation as being less artistically formed or which upheld a dichotomy between choreography and improvisation have both been deconstructed, both on the grounds that the unpredictable becomes something valued and that choreography has itself become understood as a process and is much less fixed (both in practice as well as in theory). While these are very important aspects, they also hide the enormous stability inherent in improvisation and the technique required to perform it. If put to practice with students without clear feedback, rules or inhibitions, improvisation will often lead to a reproduction of the movement potentials (or movement patterns), aesthetics and belief systems already incorporated within the dancers (Hardt 2008). More often, students will reproduce in exercises what they canalready do. It is not the site for unpredictability. However, this is where theory and practice can come together and learn from each other. And it is with the next pragmatic position that I present, where I would like to demonstrate how to work from practice into theory and back.

POSITION III: PLEASE, BE TRUE TO THE MOMENT! CORPOREALITY IN THEORY AND PRACTICE

On one hand, I argue along well established positions of body theory that perceive the body – its movement, abilities, and dispositions – as a social, cultural and historic product (Bourdieu 1977; Lorenz 2000). This also involves an understanding that our perception, our preferences for certain physical senses, and understandings of what we consider 'natural' or even 'authentic' is shaped accordingly and not A-priori given. Accordingly, something 'authentic' cannot be found but is always a construct of the context.

On the other hand, in a teaching context where I would like to encourage processes of experimentation and reflection, I presume that the body is a site and source for 'true' perception. For instance, I am very much interested in teaching students (both in practice and in theory) how to see and experience dance through challenging a schemata of perception that is still dominated by vision. In such a context, I will ask students to really investigate and sense a movement instead of acting it out (an instruction very familiar to many contemporary dance classes). I try to avoid words such as 'natural' or 'authentic' by simply saying, "please, be true to the moment!" In practice, when I am searching for a specific quality of movement and perception, e.g. when I ask to sense the exact force of a partner that is trying to push me down, and not to fall or move until there is a real physical need to it (for instance because the face of the person pushing might suggest a lot more force than actually put to action), I indirectly work with a

schemata of perception that evaluates despite the fact that I allow space for experimentation. While I try to avoid categories, even though they exist, in order to encourage a change in perspective. More so, when asked to reflect what they perceived, the students will use a terminology to describe the experienced differences along the lines of 'authentic' or 'not authentic.' At this moment, it does not seem appropriate to discuss their wording, because I am predominantly interested in a different perception.

Of course, such exercises do not stand in opposition to my theoretical reflections on the body. Simultaneously, I am thinking of two directions such a reflection can take: one focus is towards the process of discipline our sense of perceptions. The other direction points towards the tactile dimension as an alternative to the dominance of visual perception. A repetition of such exercises can be understood as a disciplination, that happens along the lines of a specific technical-aesthetic preference that prefers factualness more than meaning or interpretation of movements. Another effect of practicing these exercises goes beyond the sense of an experience and reflection, but also leaves physical and material traces in the body which in turn allow a greater awareness and potential of the tactile senses. These exercises can also be linked to phenomenological approaches to dance and theories of the performative, which give more value to tactile information as a basis for knowledge and meaning making.

As such, the paradox can be theoretically captured: even though the modes of perception mirror the disciplination of the senses, there is, nonetheless, also the potential for "sensory dissent" (Banes/Lepecki 2007: 3) as Sally Banes and André Lepecki have called this by drawing on Foucault. The visual – as much as questions of visibility and invisibility (in a literal and figurative sense) – is political, as long as the objectivising gaze has a higher symbolic standing than the other senses in relation to how knowledge is constructed both in academia and society more generally. Without the possibility of a new form of disciplination – in the Foucaultian sense of being a productive rather than subjection power – the dominance of the visual cannot be broken. Accordingly, where the regime of the visible and representation dominate – or a bodily training that is oriented along the standards of lines, forms and outside perception – the tactile and the entire spectrum of physical senses need to be fostered in order to open new dimensions of perception. In this case one needs to challenge the political dominance of the distancing gaze (as much as the system of knowledge that relates to it). However, where the tactile, personal sensations, and phenomenological modes of doing research reign and are stylized as an alternative (detached from representational aspects); where they are cherished and utopically charged as a 'de-bordering'; they need to be questioned in regard to the disposition on which such modes of perception are grounded and through which contexts (both artistically as well as academically) they are legitimized. It is here then that I come back to my beginning plea for a positionality that always opts for challenging the current few of thinking and making sense of the world. Teaching dance studies to future scholars and artists is not about finding one relation of senses in regard to theory, but

about the moments when we change the schemata of perception. And there are many paths to this.

CONCLUSION

Depending where we are and for or with whom we argue, we might see 'the' dance as epitomizing the unstable: a metaphor and analytical model for society and academia at large that is increasingly focused on movement, flexibility and unstable categories of knowledge. This point of view is especially important in contexts where we need to prove that dance and dance studies are valid contributions to our knowledge society and where we want to have it sponsored. Sometimes, it can be simply luscious to enjoy the transfer of the sensual into knowledge, and yet at other times we need to articulate, especially the predispositions it might require, how to enjoy such as understanding of world making. What is required to construct our world outside of the dominant mode and to cherish a phenomenological way of making sense?

dé-position. Or How to Move in(to) the Future?

SANDRA NOETH

The matter of the future of dance research, addressing a 'next generation,' associating oneself and being associated with something new causes new departures but also restlessness, malaise, yes, it seems to be uncomfortable. Is it the public promise given to oneself or to an existing or yet emerging academic system that needs to be fulfilled? Or do we fear the necessity to decide and to assign ourselves within a texture of affiliations and references, do we worry about our ability to decode and correspond to the expectations brought forward with the invitation into a 'new generation'? Although we might always only think about it as something upcoming, the promise of the 'new' implies a varied agenda of change, transformation, reconfiguration, transmission and transport, of appropriation and begetting, of property.

"If someone speaks to us, we verify what we heard with what we know; we need a point of reference in order to recognise, by which we assess what we heard, whereupon we agree or disagree. This technique rather aims at stability and fixation than at mobility and flexibility. Would it be possible to imagine just listening, without aligning what we have heard with 'what-one-thinks,' 'what-one-is,' and 'what-one-thinks-is-right-or-wrong.'" (Ritsema 2010: 193)

Within this game of references, the lieu of articulation that dance research takes seems to be an uncertain one, too. It is not a sovereign but a heterogeneous one, marked by the simultaneity of its influences, processes and roles, stretched in between the dispersal of what already exists and the wish to make sure of oneself. It is a combination of all kinds of things "where thoughts which can only be thought together were throning at the door while their diversity blocks the passage" (Blanchot 2007: 16 et seq., trans. by D. Ender). Therefore, how can we – as dance researchers, choreographers, dancers, dramaturges and as public – move in, move into the future? What are the lines, structures, classifications and fields that we will keep hold of after this first phase of establishing dance research in the European academic system on the basis of categories and methods that have been developed historically within different disciplines (Foellmer in this volume). And: How can we speak about ourselves? Or do we need the fiction of a 'next generation' to enable us to accredit a community and to construct affini-

ties? A fiction that, like a container that contains nothing but itself, does not provide an alternative draft to the real (which anyway emerges itself alongside the strategies of the fictive), but that provides a means of critical examination, of establishing a common memory and a common process of rehabilitation and reworking.

"Nothing is more disquieting than the ceaseless movement of that which appears to be motionless" writes Gilles Deleuze in *Pourparlers* (Deleuze 1990: 141, transl. by D. Ender). Our discussion and thinking on the panel becomes unbalanced as well, circling around different things without ever seriously pausing at some point. While searching for something to be shared beyond the individual statements, it gets stuck and slips up in the mode of approaching, difficult to grasp, difficult to attack. This gives rise to the thought that it is maybe exactly this interruption, this hesitation that is joined much more profoundly to the question of the future and that the unsettling and disquieting movement of what seems to be set is all about taking position oneself and positioning the Other. About taking a standpoint and leaving it again.

In his concept *Über das Zaudern [On hesitation]*, philosopher Joseph Vogl describes art as a kind of 'hesitation system'

"that extends from an aesthetic figure through a correlation of events into a principal dimension and in the process produces a specific balance: through counter-acting forces that simultaneously motivate and block one another; through a movement and affect image that throws up a moment of hesitation between perception and action."(Vogl 2008: 22)

This figure of hesitation that historically has always been accompanying contemporary dance and performance art in a quite specific way as well: not as passivity or non-decisiveness but rather as on ongoing process of rewriting and reshaping, as a grown media-hybrid interested in transitional moments that render visible the paradoxes and inner contradictions of choreographic practice as a field of continuous reciprocity between formality and socio-political topicality, between everyday experience and aesthetic appearance, between immediate affective involvement and the more distant formation of discourse. At the same time, this refers to the attempts of the relatively young institutionalization of an academic discipline to emancipate itself and to an environment where e.g. working biographies tend to become more and more complex. Consequently it is even less sufficient to locate and respond to dance research exclusively in the context of universities and academies or in terms of institutional affiliations and to lose sight of the research that historically has been initiated and fostered by the artists themselves. Amongst others, various recent discussions try to grasp and take into account the specific potential of openness and hybridity in dance and call at the

same time for our attention in order to not stylize the body and the body knowledge into an 'always-other.'[1]

However, it is not up to art, up to dance, to replace life or to be satisfied with illustrations and representations. Following this, the idea of hesitation is not meant to be a description of a space of potentiality, of vagueness or carelessness but it is much more about introducing a moment of interruption into a theoretical as well as practical system of art which develops alongside different chronologies of reception and description.[2] Thus it is about a hesitation system that sneaks into a forward oriented logic that aims at efficiency, obstructs it and organizes, welcomes and demands moments of hesitation and stumbling. Moments that in the slowing down and lingering, in their awkwardness and overexcitedness, challenge us to change perspectives and to investigate and revisit our own decision, to search for a pause that would force our associations into affirmations without being interested in its fixation, to mark an interruption which would oppose representation and pre-fixed assumptions in order to strengthen the seeking as the gesture of art and as an obligation of its actors – the artists, theoreticians and spectators – , its venues and its institutions.

What if the movement in(to) the future contrary to the new and to continuation would rather consist in a step aside? In choreographic terms, the French term *déposition* offers us a possible and perhaps helpful description. Basically, it means a binding, oral testimony before court, which authorizes the subject as a civil and legal subject. If we spin a bit further along the word's etymology, it describes a movement which makes leaving one's position a prerequisite for being able to take a standpoint, and thus pronouncing, articulating ourselves, making testimony possible at all. More than projections into the future or turning towards the past, the decisive factor here is the responsivity of one's own act, which by the step aside, by moving away from it but simultaneously staying connected, marks one's position regarding the other, and which through the interplay of response and responsibility, in the very moment of mobilization sets one's thinking and doing in motion.

Besides its illustrativeness, the idea of 'dé-position' puts the problem of positioning and classification at the focus of reflection on a 'next generation' as well. On the backdrop of a diversity of resources, methods and places of scientific research in dance, this is not to express a general mistrust towards concepts or to promote a general anti-categorical thinking. Much more and instead of understanding choreography as a forward-oriented movement of inscription, we have

1 Cf. Yvonne Hardt and Susanne Foellmer on a critical practice of artistic research within dance research (Hardt and Foellmer in this volume).

2 Cf. e.g. the lack respectively the absence of visibility of contemporary choreographic practice in different countries in East- and South-East-Europe in the context of a dominant Western-European and North-American system of writing dance history which develops alongside specific personalities and tendencies. See: Hochmuth/ Kruschkova/Schöllhammer 2006.

to seek a starting position again and again in order to disclose the premises of our artistic and theoretical concepts, our thoughts and words, our expectations and preferences as well as the prerequisites of our encounter, to view our own position anew, to review it and to make it visible.[3]

The issue is resistance against too quick or too simply designed, comfortable ideas and structures in order to develop a being-with-each-other which is not simply based on architectures, topographies or boundaries of pre-existing discursive systems or structures. While following the body in interaction as an agent (and not as representation) of action, it is exactly by utilizing the differences of transmission that opens the possibility to review our perspective.

Thus, the challenge of a new generation is maybe to avert the gaze from the obligation of the new, of what has not yet been written or danced or imagines and to focus on the politics of our decisions. To confront openness when it risks to fall into indifference, to not give in the logics of progress in the name of consensus, communication or change, to think and to create a place of inconsistency that doesn't content with a common idea of dance or a too hasty metaphor of the body. The challenge, however, is to use the dynamics of counter-punctual moves, to take position, to state things in order to discuss and to re-investigate them, in order to call for dialogue: To create a space where the potential of hesitation becomes clear.

The choreographic space always is a space of shared responsibilities, a potentially political space. By the gesture of choreographing, the body in interaction refreshes societal and social spaces and draws attention to the body's capacity for action. It opens up spaces for trying out life itself: how can we conceive sharing and participation in creative and development processes? Which counter-models regarding the investigation of social and economical distribution processes, the relation of art and work does dance engender? How can we deal with our responsibility for our own ideas, words and actions, and how with their repercussions? How can the co-existence of multiple and heterogeneous voices be organized? How can we say 'we'? And which voices are included?

The idea of something 'next' or 'new' sets out from an act of accepting and acknowledging something as such as well. This common act of legitimizing, this wish of saying 'we,' introduces a social, an ethical experience into the discussion which philosopher Simon Critchley describes as an always necessarily circular experience: the recognition of a demand, a demand that calls for recognition (cf. Critchley 2008: 23).

In analogy to that, addressing the future means continuously positioning and re-positioning oneself, taking a standpoint and moving away from it again. Thus, a kind of resistance is constantly reformulated. The part of art and the body is to remind us in their interruptions, in breaking up with the consensus machine, in

3 Cf. Isabelle Schad's remarks on the relationship between the attention drawn to certain movement practices, images and choreographies and distinct generational premises and experiences (Schad in this volume).

their step aside, that truth is not true enough. As the collapse the concept of a 'next generation' illustrates, these moments of hesitation ask us to constantly re-think the way we design and set up our research and methods and to invite cri-tique and dialogue actively into our practice. This implies shifting the question from where dance research goes in terms of something 'new' or 'next' towards understanding the basis of our discourse. How and on which artistic, methodo-logical, cultural, historical and other grounds do we choose our point of view, put it in relation to the other, mark, affirm and burst territories?

Following the disquietude and the spiral of thinking, the question 'What is next?' ultimately reminds us to follow the disquietude and the spirals of thinking and to enter hence the field of dance research never as a familiar but always and again as a foreign terrain: As a field that by tracing the existing and still to be imagined protocols of encounters and by making them visible, unfolds a poten-tially political understanding of choreography as practice of methexis and inter-vention – alike a circle that would never close.

"Most people suffer from an incapacity of saying what they see and think. Purportedly nothing is more difficult than defining a spiral with words. For this, again purportedly, one has to use one's hand and no literature to outline a movement constantly circling up-wards which makes this shape peculiar to springs and some stairways apparent to the eye. Yet as soon as we recall that saying means renewing it is easy to define a spiral: it is an ascending circle that never closes." (Pessoa 2006: 125, trans. by D. Ender)

Embryology as Choreography

Isabelle Schad

When the body and its materiality becomes the work itself and the work itself becomes experience and process, the question of generation – and the question of looking into the future – become relative to the complex interdependencies between the making of work and the mechanisms of production. Thus the pertinence of re-inventing our practices and re-considering the finished by putting the emphasis on continuous learning processes may be disturbed or challenged.

Thinking about the 'Next Generation,' the first question that came to my mind was whether interest in the body and its visibility is specific to a generation. The second was, why are we looking into the future? In considering the work (on the body and its movements) by artists and choreographers around the Judson Dance Theatre, such as Yvonne Rainer, Trisha Brown, Carolee Schneemann, Anna Halprin, Steve Paxton, Simone Forti, Deborah Hay and many others, or painters such as Francis Bacon[1], writers and practitioners working in the fields of theory, philosophy and many other disciplines (related to the body), I began to formulate other questions:

Does the awareness of ideas and concepts generated by numerous people in numerous domains in recent years represent a generation of investigators in the field of contemporary choreography? If the phenomenon of awareness suggests social change, then we are talking about a cultural movement rooted in time? Can we also talk about a next generation in dance, or about a new one? Or conversely, are we rather witnessing a popularization and institutional recognition of concepts that many artists have been defending individually for decades?[2]

And then: Where am I talking from? What is my position as part of the present generation and what is the desired 'next,' the things we are not yet aware of? And if we do not know yet what is going to come how can we talk about it?

1 I'm going to stop quoting people here, as it is unclear where to start and where to end: the notion of the generational explodes into small pieces so easily.

2 The notion that there is nothing *new* – that is we are not discovering new things but rather create concepts – if there is something *new* or singular in a work – is it then the *creating* of a concept with sincerity that comes from within? And it is therefore about the *person* behind, becoming a question of *personal process or work*.

I remember well the day of the Panel, which was just three days before the premiere of my recent group piece *Musik (Praticable)* in Berlin. I also remember the energy I was putting into not following the agenda of the announcement, the promises one is obliged to fulfill within the context of writing an application and the expectation this creates (that this work/piece should conform to the announcement). I remember trying not to fall into the trap of making the piece conform to the announcement, as this would mean – paradoxically – to be caught in the past as if the piece was already completed at the time of the announcement.

So, in a way – and this is at least a starting point for having my own perspective on the 'next generation' – I could eventually talk about my current experiences and attempts at looking for the potential within what is usually considered the end of a process just before a premiere.

I could begin by talking about my work on forgetting what I know already, on strategies of re-discovering an experience rather than repeating the predominant images the body re-members, on daring not to polish the work, or 'fix' it in any other way, but rather slide between the present and the near future, where we can be connected to an un-known space; where we can indulge the joyful creativity emerging within a working process (even if it is supposedly towards an *ending* of the process) once we no longer feel obliged to 'finish.' In a way, this desire to stay in a process whilst heading towards a premiere, including all the difficulties and psychological phenomena coming with the increased pressure, is closely connected to my interests in the body, my ways of working, and how I would like to share my work with others.

ON CELLS, PRACTICE AND CHOREOGRAPHY

What happens in the process of choreographing a public presentation?

In my work, I am looking for answers in somatic practices such as Body-Mind-Centering, which was developed by Bonnie Bainbridge-Cohen. The emphasis here is on the perceptions and sensations of one's body – towards understanding who we are by understanding our past processes, and how we are by embodying physiological or embryological processes.

And it is by understanding where we are coming from that we understand our present selves and space; as in very early embryological developments, everything is about space: location is the important factor.

Since we are created by our own space as well as by our process, the body becomes the space and simultaneously the place where space and time coincide. The origins of movement are in the body and its becoming itself. Each single cell has its (own) double membrane: one looking to the inside, the other facing the outside. This may be the origin of all interior/exterior dialectics. We re-member our membranes through our own memory and we re-member what informs a structure by studying and embodying cellular processes (cellular communication, division, differentiation, migration of cells, cellular membranes and fluid). If re-

membering past processes of our first cells gives us information about who/how/where we are, it also in-forms us about our environment and how we create our own environment through (cellular) relationships.

Applying this approach to choreography means questioning its form – looking at what in-forms the form. Re-membrance not only becomes a meditation, but a work on the membrane itself: permeable and ever-changing, membranes and spaces get drawn to the inside, folded, becoming again the outside. Invagination and rebound, inside becoming outside: fluid processes becoming structures. Endoderm, ectoderm and mesoderm become all the structures – all the body systems of our present body.

This understanding of the (moving) body is based on both experience and process. When such processes become choreography, the choreography is based on both experience and a working process. If the choreography is based on score-writing, like a partition in music, the body then becomes the music (the voice) – and the score indicates how to re-find the experience and the process in *present* time, producing a *present*ation. Along the way within a creative process the writing of the score is enriched, becomes more and more complex and precise in relation to (inner/outer) space, initiation of movement, rhythm (time), intensity, etc.

In my current project *Musik (Praticable)*, the score I wrote serves as a timeline and consists of graphics/drawings that give information about space and time, and about where in the body movement is initiated. It also works as an additional text document where those descriptions are formulated more explicitly. The fourteen dancers, who are at the same time co-choreographers, produce this text within the process. They make notes and write about their own perceptions of inner/outer space, their body experiences, their strategies, the impact and influences they gain from their environment. Step by step, the score becomes more like a piece of writing itself, which has its own logic, almost like a poem, from which everyone can nourish her/himself in her/his own way. Therefore the dancing of the piece may become a meditation on the score as well as a piece of writing that helps the performer to be in present time whilst meeting an audience. The audience provides feedback to the performer about her/his activity, which in turn informs the score, which may be re-written after this experience.

Which words might describe those bodies and (body) images that emerge if those bodies and images are beyond what we know already, what we recognize as known images; beyond dance style, narratives, symbols or representation? Or could the movement itself be the meaning? The body as the meaning, similar to the body as the medium dealing with and as its movement. What/who moves while seeing? Can seeing be beyond action? What happens to the body of the spectator in the 'act' of watching?

The described approach of writing dance whilst focusing on the body as a medium and on (somatic) body practice(s) has recently become more contemporary. There seems to be a need to re-define principles and concerns that have already been negotiated in relation to the movement of the Judson Dance Theatre.

It is a movement *back to the body and back to dance*, which I happen to be part of myself, following choreographies that were dominated by conceptual dance from the 1990s onwards.

The difficulty is to avoid, within a movement towards common interests, the exploitation of notions that create tendencies rather than a movement. As a way to reflect upon present tendencies, politics and mechanisms of production, I may formulate the question: What could happen if mechanisms of production did not (too often) prevent it from becoming?

ON EMPTYING OUT WORDS AND CURRENT TENDENCIES IN DANCE AND PERFORMANCE

The mechanisms are the locus of all the contradictions in making work and presenting it. Related notions such as open space, practice-orientated work, work-in-progress, process versus product, collective work, networking, collaboration intermingle, so that intention and reality rarely fit together anymore.

Indeed those notions are the ones everyone is working around and in, but through the development of a market around these notions it is impossible *not* to mention them as part of your work anymore. They become both: a reality of working and a fertile ground for misunderstanding and commercial instrumentalism, in which meaning is lost. Within the market of presentation, those notions are much promoted but often without any (of its original) meaning.

The 'market' doesn't really value the work of artists that resist the lie(s). If the main reasons for a piece being presented or not, for being part of dance festivals or not, are still name, size of production/money involved and/or agreement on consensual curating, as applied by many of those who run the market, it may be hard to resist and not play the game. Here the notion of 'next generation' unfortunately becomes valid again in a not very interesting context, or shall we say contest?

It is therefore not only about finding truthful solutions for how to work with each other without anybody losing her/his body of work, but also about discovering strategies to transform and resist the conditions of the market. Taking the specific case of collaborations in the field of dance/performance into account, collaborations often end up becoming one person's artistic property. Everybody involved works only for this personal property. If the same process comes from several individual processes that interconnect and nobody loses her/his own body of work, we could do away with the notion of *working for* and start to speak about *working with,* and therefore imagine a real meeting.

ON TRYING TO RESIST

Having co-initiated several work structures/groups such as *Good Work* (2003) and *Praticable* (2005)[3] over the last 10 years, and having looked for ways to organize ourselves, to work together (collaboration has been a 'real' topic), explore different possibilities of functioning within groups of artists working in the field of dance, I now look back on our initial intentions and realize that I now avoid using certain terms, such as networking, collaboration, horizontal work structure, for the reasons mentioned above; these expressions have been emptied of their original meaning. How do we wish to defend them and put them into practice?

I would like to thank everyone I have met and from whom I have learned in this search to understand how best to work together. Two recent encounters, in particular, helped me to realize the extent to which cooperation can be implicit in a practice.

It was through my work with Laurent Goldring and the research on our pieces *Unturtled* (in 2007) that the work on the image as an organ became an ongoing process. By separating our working practices as much as possible, to avoid mingling one medium into the other, we attempted to understand how far this parallel work on body, image and representation informs us about the 'truth' of an image that becomes an organ of the body and not a representation of the whole. As we approached completion of a first presentation (of one of the pieces), I began to understand the relativity and the meaning of *(un)finishing*.

Bonnie Bainbridge-Cohen's workshops on embryology helped me discover the potentials in the *how and what*: how to work and what to say with it. A practice that makes people form, for example, a social organization from within makes a big difference: a social organization or community as a truthful experience that becomes a real encounter.

Giving workshops has become a major part of my work and an opportunity to deal with *(un)finishing* again. In every workshop I am astonished how easily people connect through a practice: cells are relational, as *we* are apparently, once we connect back to where things originate from. I am surprised how a group of people forms, as if the people had been working together forever. Simultaneously, every person remains a subject within the group. Subjectivity does indeed have a self, and practicing subjectivity within a group might be considered a utopian form of being together.

I am also continually astonished by how much people like each other. Dancing and dancing together becomes a pleasure. This very archaic and deep pleasure is located in the body.

3 Both work structures have a similar attempt proposing ways of working that are non-hierarchical; 'Praticable' with a focus on body practice, 'Good Work' on practices coming from different fields, both of them deal with modalities of working and thinking (together) and their effects on (re)presentation. Cf.: www.isabelle-schad.net and www.praticable.info.

To be able to propose a counterpoint to the world's daily competition, power/ego-problems or wars, by sharing experience-based work and knowledge of the body/dance with all kinds of people in contrast to selected groups of people was one thing. Realizing that this way of working from body to consciousness and vice versa brings back the potential for the body/dance to be a site of resistance, as much as for an emerging community (to be a site for resistance) was another. It was, perhaps, the most important discovery of my long and not yet finished struggle to reconcile my own process with the production mechanisms we are confronted with. It is there that I find the potential for surprise, even though the concepts are perhaps not new. Yet they need to be re-invented and rediscovered as new, over and over again. Here lies the difference between a practice and a technique, between practice and repetition, between practicing and rehearsing. Practice as a sharing of knowledge is becoming a place that allows us to (re)think the body.

Transmission of information is a function of our nervous system that allows us to form responses and not just reactions. My work is not about transmitting information as a teacher does. It is about sharing experience and allowing people to learn from each other. It is about bringing knowledge and experience together. This is where writing practice and body practice meet and nourish each other. It is an internal form of learning rather than an external one. Giving back pleasure to the body of the performer. The spectator. The dance. The image. The text. The unknown. The next.

Hypothesis Number Nine:
The Image Is an Organ

LAURENT GOLDRING

It is strange to have to speak about the next generation, probably because I have the feeling that I am part of this one, and, oddly enough, both at its centre and the margins of it.

I am using this word 'centre,' because my studio in Paris has been a meeting point for choreographers whose work has been of real relevance to the present generation. It is there that certain reference pieces have been created. But my main focus has not been dance but representation, and my works have been based on experimentation with images created before the body they represent. This reversal could hardly be acknowledged by a dance scene that emphasized the body itself with a naturalistic ideology that left it unprepared later to deal with mass media images.

This is why my experimentation remained at the same time marginal. If, for example, the exact title of *Self Unfinished* (1998) by Xavier Le Roy is *Self-Unfinished, based on collaboration with Laurent Goldring*, it was because Xavier felt this aspect was important enough to bring represent in the title itself. What this exactly means remains an open question.

The reversal of the relationship between representation and object implies that it is the body that resembles its image. It, in fact, a deconstruction of the whole structure of meaning around political and aesthetic ideas of presence, presentation, representation, etc. As a result, the current generation has, consciously or otherwise, developed in part around this simple idea: the image of a body is not a representation, it is an organ of the body, exactly like other organs. Tattoos, plastic surgery, animal mimicry, symbolic wounds and haircuts are a few hints of what could make this idea understandable.

But this very simple idea is probably too harsh and too disturbing to be easily grasped, and even though it has been around since the beginning, it was only recently, that is to say much too late, that this idea has become totally explicit. Its impact, nevertheless, has been practically enacted and formulated in a body of work, precluding its full understanding, which is still to come.

The idea that the image is an organ should have led to a new reading of what a body is, of what an image is, and of the relationship between the two. Something had happened with the body, in relation to images.

Dance and (new) media were about to come up with a new deal, with dance crediting the body as the source of all images, and ever-circulating images depicting the glamorous body as new master of truth. The body is now that which must be listened to, believed in and taken care of. After a few centuries during which the body was to be tamed and reduced to silence, it is now a garrulous oracle whose faintest sounds dictate to an obedient subjectivity, eager to obey and to fulfil its duty towards its new true being.

This generation has built itself not only around these new practices, but even more in opposition to them. It was built on the concealment and denial of image as organ.

The following frenzy around logos, icons, manipulation of perception and everyday representations has been a successful attempt to ignore this relation and what it meant. The growing importance given to the spectator, the backlash embodied in the return of spectacularity and symbol (signature, quotation, storytelling), and the return of the choreographer as a little tyrant were both causes and by-products of this denial.

The new relationships in the working world created by the Thatcherite revolution, (i.e., local meaningless democracy versus real exploitation at the level of the global network by project initiators) in fact contradicted the political effects of the concept of image as organ.

What got lost, of course, was the ambiguity of bodies. Image as organ or prosthesis meant opening up the meaning of bodies, which could not be solely glorious anymore, nor useless failures to be destroyed. We know how 'Riefenstahlian' the current dominant representation of bodies has become. It was important to underline that a similar ideology was the source of the heroization of the Olympian body and of the extenuation of forbidden races. Images as organs made it possible to see the deep solidarity between those two types of bodies, which can merge into one image, this demonstrating how close they are.

Paradoxically, after fifteen years the situation is still the same. It is always necessary to discover afresh the explosive dimension of the image as organ, in order to disrupt accepted hierarchies and allow for the emerging new corporality. The very same questions point in the same direction and to new tracks, namely about faces and about the relationship between organ and prosthesis.

This exploration follows the same methods, in the same place and with the same materials. *Unturtled* (2009) with Isabelle Schad has been developed in Podewil, just like *Self-Unfinished based on etc.*, using a film protocol very close and with the same black fabric I found at this time; and this simply means that everything has always to be reconsidered right from the bottom. This re-founding led to a new equation: naked = dressed, not unlike the preceding one which had demonstrated the equation body = face.

In the meantime, however, two major changes have taken place: the first is that whereas in the past I did not feel that co-signing was a solution, because this led to much misunderstanding, I now do it, though this will probably give rise to new misunderstandings. The second change is that the form of the project has now successfully imposed the norms of commercial creation and has successfully destroyed any kind of unofficial collective work. The experiments that took place in the studio were strongly opposed to any notion of project.

What's 'next'?

PETER STAMER

The term 'next generation' seems to suggest a homogeneous and definable stratum of artists and academics who follow similar strategies or aims – which is not the case, neither now, nor in the future. I am more interested in discussing the adjective 'next' that supplements the title. Therefore, I am not turning to the question about who this next generation might be, but *what* 'next' as an aesthetic perception could offer us. For elaborating on 'nextness' seems to hold more promises for engaging in an aesthetic discourse than for prognosticating the future.

At first, perceived from the perspective of temporality, the notion of 'next' secures the time axis in two ways: the 'next' is always already conditioned by what we call the now. The future is already present now for the present conditions and thus represents the possibility of the future. At the same time, the future confirms the factuality of the present in such a way as, for example, fear or hope, promises or threats (modes of relating to the future) have some effects already here and now. The impact of the figure of the next is of much greater importance for the present than for what is to come. For the present can no longer just be seen as the cause for the future. On the contrary, it is somehow becoming increasingly important to deal with the notion of future as a cause for the present. Since many (social, economic, epistemic, emotional, monetary) systems are currently in a state of crisis, talking about the 'next' gives birth to the future – by uttering a promise. 'Promising,' being a commissive, illocutionary speech act, commits the speaker to some future action. A promise is not just a moral obligation (and thus privatized), but foremost a motor for social improvement and therefore systemic cohesion. Promises, having a discursive effect, provide social bonds and maximize economic, emotional, social output and prospect. The future then appears to be integrated into the logic chain of events, of before and after, of now and next: a promise *pre-dicts* the next in such a sense as it discoursifies the future. Connecting the 'next' to a discourse, the next holds a promise to what is to come and performs its socially soothing effect at the very moment of the utterance.

Within the production of aesthetic experience the 'next' takes on a different function. It rather opposes the logic of calculability. Not knowing what is going to happen, leaving blurred what is to come, the logic of surprise seems to rule the

aesthetic condition of, say, dance performance. Concatenating steps and movements follow a "logic of sense" (see Deleuze: 1990) where the sense of a (precedent) phrase (be it discursive or structurally composed) is uttered by the following, the next one. The production of sense thus works both back and forth; forth since sense is not fulfilled in the moment of utterance and needs a complementary unit, back since every complementary unit reveals the precedent one. Everything that is uttered, that is 'said' is never said now, but always suspended to a next time. It's in the essence of aesthetic appreciation to leave the next in the realm of suspension, to leave it incalculable.

Thus, we are dealing with two different concepts of 'nextness': One is already being realized in the present, while the other remains unrealized in the present; one creates the future, the other continuously suspends the future; one is a figure of the performance of promise, the other a figure of aesthetics; one reduces contiguity and introduces meaning, the other produces contiguity and introduces sense.

Jacques Derrida's distinction of the future and 'l'avenir' helps to look at these differences from another perspective:

"In general, I try to distinguish between what one calls the future and l'avenir. The future is that which – tomorrow, later, next century – will be. There's a future which is predictable, programmed, scheduled, foreseeable. But there is a future, l'avenir (to come) which refers to someone who comes, whose arrival is totally unexpected. [...] That which is totally unpredictable." (Dick/Kofman 2002)[1]

In Derrida's concept, the 'future' resides where the present is not, whereas the 'avenir' (what is to come) is moving towards the present. Whereas the 'future' resides in a different space that cannot be shared but is calculable, the space of 'l'avenir' merges with the space of the present, enters its presence. The future is absent right now and will take place at another time, l'avenir is potentially present right now, but might never take place. The concept of the future needs to be placed in the present to tame the next to be, in the words of Derrida, calculable, "programmed, scheduled, foreseeable" (ibid). Whereas the called future is invited to have an effect on and in the present, the uncalled future resides outside a horizon of predictability, suspended, unexpected, unpredictable.

Looking at the future and l'avenir this way, we are somehow dealing with aesthetic categories. André Lepecki applies this distinction to discern choreography and dancing as two different logics:

"We could say that choreography participates in the logic of the future – since choreography both demands and prepares the fulfilling and arrival of anticipated, pre-planned, and expected movements, gestures, steps, and positions. [...] Meanwhile, dancing (even when

1 Quotation taken from the documentary 'Derrida' by Kirby Dick and Amy Ziering Kofman, USA 2002.

dancing the most strict choreography) is always and simultaneously a flight into and an opening up towards what is to come: an always renewed production of micro or macro events, manifested as singularities, on the most outward edge of any conglomerate of moment-matter." (Lepecki 2009: 342)

In this equation, choreography would follow the logic of the future as it is to be realized in the present, whereas dancing's (not dance!) singularity remains incalculable and uncalled, even if the actualization executes the choreographic map. In other words, choreography would have to be considered as being determined (a scripted next), while dancing on the other hand as being unpredictable (an uncalled next). Drawing from this, in both choreography and dancing, a more complex interplay would now allow us to look at 'nextness' as an aesthetic category rather from a double perspective of un/determination and un/predictability. We all know of not scripted or not planned choreographies as well as of not-uncalled dancing(s), where the 'what is to come' of dancing was/is predictable, where the 'demand and preparation of choreography' to fulfill expectation was/is not predictable.

Thus, the concepts of choreography/the determined and dancing/the unpredictable merge into four variables that negotiate modalities of aesthetics and dance genres. To discern different aesthetic styles dealing with different understandings of the next, this filter would allow to combine the parameters as a) determined – predictable; b) undetermined – unpredictable; c) determined – unpredictable; d) undetermined – predictable. Therefore, we might be able to discern at least three different types of aesthetic 'nextness.'

a) Determined choreography – predictable dancing: 'Nextness' as an aesthetic category doesn't seem to be of interest in repertoire pieces like classical ballet. The choreography being determined and demanding dancing to be an actualization of what has been determined (a scripted next) renders the performance predictable in such a way that any (uncalled) deviation would be considered as failure of the genre. Not just perfection of dance, but hardcore predictability is an intrinsic part of the genre of ballet (as well as in any scripted pieces). Nothing unexpected, no surprises are needed to grant aesthetic appreciation: an understanding of *dance as oeuvre* draws from a determined choreography and predictable dancing.

b) Undetermined choreography – unpredictable dancing: 'Nextness' gains importance in dance forms where both choreography and dancing are unscripted and not called forth, uncalled, as in free dance or improvisation. Not knowing what's next, but waiting to be 'inspired,' being moved rather than move, following the flow of energy (to use some of the keywords) rather than merely adhering to compositional decisions, these qualities coin an understanding of *dance as event*.

c) Determined choreography – unpredictable dancing: 'Nextness' in scores or manuals for movement, the rules of which are known by both the audience and dancers, emerges through the tension between knowing the map and claim-

ing the performative freedom to deviate from it; performative actualization of applying scores or rules remains purposefully unpredictable. Not knowing what comes next despite of a given score coins the appreciation of performativity where the practice of individual and negotiated decision-making 'on the go,' suspending the map, sets forth aesthetic surplus. This category most fits Lepecki's distinction between choreography and dancing, and elucidates the concept of *dance as game*.

Combining un/determination and un/predictability in such a way enables us to look at 'nextness' not as a given (aesthetic) premise, but as being historicized, dependent upon dance styles and genres. The understanding and application of 'nextness' is subject to change. E.g. the predictability of dancing a choreographic score forms a constitutive part in a canonized oeuvre, in contrary to unpredictable inspirations of dancers in set game structures – and vice versa. The distinction between choreography and dancing is less an essential given than an aesthetic category that needs to be historicized due to the codes at stake. Looking at the four variables that provide a (rather heuristic) filter, one might be willing to discover a tendency of contemporary genres (improvisation, rule-bound performative games) toward a conception of dance that advocates a suspension of the scripted next and fosters unpredictability as its main aesthetic motor – if one wants to draw a line from dance as oeuvre to dance as event and game. Yet this would dismiss the fact that all three types are equally used and performed in the world of contemporary dance. 'Nextness' thus is not a matter of linear progression, simply following concepts of futurity. 'Nextness' is rather a code intrinsic to the given aesthetic format and its reading. Which also may account for a possible fourth combination of the variables that should be mentioned here for the sake of completeness: d) a dance genre the choreography of which is undetermined, its dancing nevertheless predictable. A dance that will not have been, the dance of the future perfect ...

In the Making. On the Generation of Movement between Dance and Theory

ISA WORTELKAMP

I.

Raised alongside the question of a 'next generation' is the question – to those it is put – of time and place. It seems barely possible to localise the question from any specific discourse, institution, congress or publication. This also means that one cannot consider them outside of their historical dimension. To put it another way, discussion of a 'next generation' is connected to notions of a following generation. The next generation is bound to the previous, develops from it. And yet it presents something that is not yet there, but that will or is anticipated to come. In this sense, a next generation has no present, is between past and future, is always moving between timeframes.

These paradoxical forms also pertain to the performative experience of dance and theatre. The performance of dance and theatre moves between past and future and, in these movements, refers to a present that has always been and is always still to come. Perpetually becoming, the performance generates a continuous next. This generating thus provokes the question of how to speak of it, and – within the framework of studies of dance and theatre, for example – of how to write about it and about them. This question has preoccupied generations of scholars of every discipline for whom the performance is central.

With the performance-analytical praxis of 'my generation' – not only through a reinforced reference in dance and theatre to the processuality of the perform-ance – every how appears to have increased in meaning. Moreover, in a dual re-spect: In the sense of the type and manner of how, and in the sense of how at all: under which conditions should performances be described?

As such, in writing I see less the impossibility and rather more the possibility of capturing the paradoxical temporality of a generation that is always inherent in it: an approach to writing that in its orientation towards the past is (still) open to a future that itself remains open: because nothing is certain; what the reader makes of it – how he or she reads it.

Perhaps herein also resides the potential to speak about the next generation, one that is moving out of the past and pointing to the future – in the question of

the how that so preoccupied us in our previous panel discussion of temporal paradoxes: How, in what manner and method, and under which conditions can we speak of a next generation?

II.

In the following, I would like to attempt to discuss each condition that for some years now has developed out from the 'next generation' of students and scholars of dance. This discussion takes place before the background of my own praxis as scholar in the Dance Studies programme at the Institute for Theatre Studies of the Free University of Berlin.

Unlike myself, those students have the possibility to study Dance as an independent academic discipline in German contexts.[1] This development brings with it challenges for the scholars of Dance Studies, who (must) move between dance and theory. This is already underlined by the fact that the students themselves come from the most varied artistic and academic backgrounds.

Amongst these are dancers trained in the field of classical ballet and modern/new and contemporary dance at such places as the School for New Dance Development in Amsterdam, the ArtEZ Dance Academy in Arnheim, the Academy for Music and Performing Arts in Frankfurt, and the Laban Conservatory of Music and Dance in London. Also among them are many graduates of Theatre Arts and Literature, Media and Cultural Studies, Sociology and Philosophy, alongside less close disciplines such as Molecular Biology and Economics. As well as academic qualifications, some of those studying have actual qualifications in dance. Equally as heterogeneous as the background and qualifications are the countries of origin, such as Argentina, China, Denmark, France, Greece, Italy, Iran, Japan, Russia, Switzerland, Taiwan, and Hungary. This cultural and disciplinary spectrum thus requires a study course that builds bridges between the various 'languages,' and which creates space for the dialogue between dance and theory. Therein, precisely in the heterogeneity of those studying, lies the po-

1 Also founded in the last few years alongside this Master's program, which has been in place since the 2007/2008 winter term, have been study courses at a range of German language universities. Although these have different emphases and objectives, they also programmatically include the connection of dance and theory in their curricula. This pertains to both the primary academically-oriented Masters programs, such as at the Free University of Berlin, the Academy for Music and Dance in Cologne, and the University of Salzburg, as well as the artistically-oriented approach of the inter-university Dance Centre in Berlin, the Performance Studies at the University of Hamburg, and the Degree in Choreography and Performance, in cooperation with the Justus Liebig University in Gießen and the Academy of Music and Dance in Frankfurt am Main.

tential for a study of dance that promotes and challenges not only reflection about the connection between dance and theory, but also a work on the connection of dance and theory: Namely, in a continuous questioning of the boundaries between art and science – boundaries that are reflected not only in research, but also in teaching.

III.

In my view, this is to be achieved not only through the growing and widely recognised integration of artistic praxis, as performed in the programs of various dance- and performance-related courses of study, and taking place through the invitation of guest professors and experts, as well as through teachers at university institutions. The challenges and demands lie far more in the 'next generation' of dance students, in a reflection not only of artistic but also academic praxis. But how can the impulses of choreographic dance technique be made visible for the processes of the academic study of dance? Which kinds of scholarly work and ways of thinking suggest closeness to an artistic exploration of dance? How is a study of dance to proceed; one that moves between (and with) dance and theory? And: what kinds of movement between art and academic study are possible within university structures?

Questions such as these preoccupy me in my teaching with my students, who wish to reflect upon their choreographic and dance praxis within the different fields of research in dance studies, as well as with those whose interest is in the theory, aesthetics and history of dance from other academic disciplines. They engage me also in every change made to the studies that demand an increase in efficiency with respect to teaching, which, in its 'academic praxis,' must assert itself against the rules of university pragmatism. Alongside the imperative and imposing rush towards the communication and transfer of knowledge, there is also an idea of 'professional praxis,' which is less about education and more about training.

Against this background, what can and what must an academic praxis of dance achieve? An interaction between dance and theory, as demanded by every 'next generation' of scholar and student, entails in my opinion a reflection of praxis that refers not only to the art of dance but also to 'its' science. This entails conceiving of praxis as a critical and performative act of art *and* science, one that is applied at every interface between theory and dance that founds a 'next generation' of dance education. A concept of praxis that understands itself as artistic praxis alone and, when limited to dance, threatens however an understanding of art that records and bears away, and, according to whose academic approach requires (is required) and/or the reverse, serves and develops a concept of scholarship in which the art alone is the object of viewing and application. It can also not be enough to explain science as art and art as science, as has at times occurred in the proclamation of formats such as lecture performances and perform-

ing science. Rather, in every course that approaches dance in a 'practical' or 're-search-oriented' manner, the question should be asked of the connection between theory and practice, also in their effects and impact on a work of dance science. This requires a comprehension of a praxis that goes beyond one concrete and verifiable action, and which searches for justification for the theoretical through practical work, as is manifested through the frequently asked question: 'Do you dance too?' This appears much less often to be required in the study of art ('Do you paint too?') or in the study of literature ('Do you write too?'). It cannot be denied that 'practical experience' can also be instrumental and sometimes essential for certain questions in dance studies. However, we cannot move beyond the fact that the integration of artistic praxis must also be considered in terms of its consequences on scholarly praxis.

IV.

A possible praxis that moves between dance and theory emulates, in my view, the writing that carries with it the paradoxical temporality of 'its' subject, and which produces a result that is open to the future. I will now refer to a description as variously put forward by Roland Barthes in his theory: "but in the solitude of the act of criticism, which is now declared to be a complete act of writing, far removed from the excuses of science or institutions" (Barthes 2005: 24).[2] This appears to happen namely, at a place where the interests of the different disciplines of art and science meet – such as in the study of dance.

Writing against the backdrop of these and other thoughts, in projects with students in recent years, it has became possible to follow the approach of writing as a creative and configured praxis; to make understandable the different yet connected sides of dance and theory. An example of this approach is the 'scream project' *Cards of Memory*, part of the Retrospective by Christina Ciupke, entitled *a lot of body, a lot of work*, which took place in the Ufa Studios in Berlin from October 21st October until 26th 2011. On 100 index cards, the students of the Masters Program in Dance recorded their impressions during the individual performances. These were then displayed in the foyer, and viewers could thus see into a work of memory, bringing closer every work of reconstruction. Brought together in one typeface, these notations captured the connections between the choreographic process and the process of writing and developing.

A scholarly praxis that reflects upon its own process in its performative movements becomes a contribution to a meeting of art and science, without at all needing to communicate its process. In my opinion, such an idea is founded and was comprehensible before the concept of a university, as Jacques Derrida indicates in *Without Alibi* (Derrida/Kamuf 2002). A university that does not refer to

2 Transl. by Katherine Pilcher Keuneman.

discourse, "that calls not upon a discourse of knowledge but upon performative discourses that produce the event of which they speak" (ibid: 209). To question the movements between dance and theory at such a place means to be positioned at a point where both processes meet: in a production of events. Such a university would be

"what it always should have been or always should have represented, that is, from its inception and in principle autonomous, unconditionally free in its institution, in its speech, in its writing, in its thinking. In a thinking, a writing, a speech that would not be only the archives or the productions of knowledge but also performative works." (Ibid: 213 et seq.)

An Institution Is only as Good as the People who Work there Can be. No?

RESPONSE BY KAI VAN EIKELS

In his *Philosophy of History* (Hegel: 1986), Hegel turns Julius Caesar into living proof of historical necessity. It is a repetition of his lifetime achievement, however, that extricates the necessary from the arbitrary. 'Caesar' at first was but the proper name of an individual whose deeds, although "a model of Roman purposefulness," (ibid: 379, author's translation) remained fortuitous: each of them contingent upon accidental circumstances, their connectedness a singular, merely biographical one. Duly celebrated by his followers among his contemporaries, those glorious feats could still have easily been in vain (since glory means to live "from one forgetting on to another,")[1] as the German poet Jean Paul aptly stated (Paul 1996: 242, author's translation). In Hegel's logic of repetition, it is Augustus, the successor, who must ultimately be credited for the fact that what Caesar accomplished could never be lost to posterity. Augustus helped the truly historical act be performed: to convert the name Caesar into the title of an office, and thus institutionalizing the power Julius Caesar had been able to accumulate throughout his career. Augustus was the man of the next generation, the man whose conduct permitted history to stamp its seal on the current of coming and going. Augustus' readiness to take over provided a human vehicle for the endeavor of 'dwelling upon the finite,' of establishing a fortress of adhering-to in the midst of passing time. Half-sacrificing his own name when he adopted the name of Caesar as the title of an Emperor, Augustus' self-denial translated Caesar's measures to solidify the power he'd obtained into something that could outlast his death, even against his assassinators' intentions (cf. Hegel 1986: 379 et seq.).[2] This done, Augustus' own death did not matter that much.

1 "Unsterblichkeit ist Leben in einem Gedächtnis, das selber stirbt – man lebt von einem Vergessenden zum anderen." (Paul 1996: 242)

2 Slavoj Žižek has repeatedly referred to the Caesar/Augustus example and Hegel's concept of repetition. He also maintains that in order to proceed from Caesar to Augustus, there must be a killing, at least on the symbolic level: "In this sense, Blair repeated Thatcherism, elevating it into a concept, in the same way that, for Hegel, Augustus repeated Caesar, transforming-sublating a (contingent) personal name into a

For the panel *Next Generation* and the question of Dance Studies' present and future, Hegel's example is doubly instructive: because it shows the power inherent in coming second; and because it shows how unattractive the historical act is, given the personal cost at which that power comes. The institutionalizer will have more power than the one who, in retrospect, appears as the pioneer ever had. And more is different – i.e., a new quality evolves from this 'more.' But the newly gained stability of power must be paid for with the sacrifice of one half of one's own proper name, and that half would have been the glorious part. Precisely because *their* successes will all be valued and evaluated in respect to the effectiveness of institutionalization, the members of a next generation cannot rise to glory, awe-inspiring as they may become with their institution.[3]

Moreover, the next generation knows no magnificence, just leading positions. Hegel's Augustus generates an office that can be inhabited but by one person: one at a time. But even so, time will see many more emperors. It will see the division and separation of the Emperor's power, and finally its redistribution to a complex system of institutions and executives. Once the monopoly of power has been broken up, it is rendered evident that only for the first generation does the person really make a difference. For all subsequent generations, the alternative between one representative and another, or between one and several, is a mere functional one: People may compete for the position(s) of preeminence or divide the task of institutional improvement and the prestige it holds among each other in equal or unequal shares. Nobody honestly cares as long as the process is running. Transience has, once and for all, become absorbed in history, the very institution of time.[4]

If somebody appoints you a member of a "next generation" in Dance Studies, therefore, it probably feels like it has been decided that your own name will be sacrificed in exchange for a piece of institutional history. You have inherited an office – if one that has only been created by the act of passing on this responsibility to you: to speak, for the two-hour present of a panel presentation, as a member (and, for lack of subordinates, as a leading member) of an institution. For this short period of time at least you have been endowed with the authority to

concept, a title. Thatcher was not a Thatcherite, she was just herself – it was only Blair (more than John Major) who truly formed Thatcherism as a notion. The dialectical irony of history is that only a (nominal) ideologico-political enemy can do this to you, can elevate you into a concept – the empirical instigator has to be knocked off (Julius Caesar had to be murdered, Thatcher had to be ignominiously deposed)." (Žižek 2007)

3 Wherefore they must, as Agamben describes in *The Kingdom and the Glory*, institutionalize the glorification as well: compel their people to revere them in ceremonies which follow a protocol of acclamation (Agamben: 2012, 167-194).

4 "The concrete in the character of the Emperors is therefore of itself of no interest," writes Hegel, "because it is not the concrete which is of essential concern." (Hegel 1986: 383, author's translation)

forecast the future of Dance Studies, or why not: of dance. Even a journalist is sitting in the audience, eagerly waiting to record your prognostication.[5] What do you say in the name of something that has just cost you the glorifiable half of your name?

For *Tanzwissenschaft*, the German version of Dance Studies, this situation – to which six panelists found themselves exposed at the conference *Dance [and] Theory* in Berlin, April 2011 – comes with an additional complication because the two organizers of the conference, Gabriele Brandstetter and Gabriele Klein, who through the panel title *Next Generation* prompted us visitors to identify them as members of a first generation, were and are successful in already playing both parts, that of Caesar *and* of Augustus. They have gone to great lengths to establish Dance Studies as a discipline in German universities, to secure funding, to build international networks, to gain the respect of their colleagues from the more traditional academic disciplines they themselves come from. In their introductory lectures to the *Dance [and] Theory* conference they presented their distinctive concepts of the discipline, constructing different genealogies and arriving at variant accentuations of the present and its potentials (cf. Brandstetter and Klein in this volume). If two leading scholars use their institutional power to label a group of younger colleagues *Next Generation*, it seems difficult to not interpret this as part of a strategy. What could that strategy have been, though? And what did it aim for? Did the two seek to withdraw from the institutionalizer's sacrifice, hoping to regain their full, proper names and thus reclaim their right to the glory of splendid individuals? Were they offering their office to the younger in the manner of artist Peter Halasz who hosted his own funeral while he was still alive so he could siphon off the honors people would pay to his finite existence? And if so, was this move – carried out within the framework of institutional collaboration – an attempt to inhabit the position of 'the sublated one,' the legendary progenitor of the institution, together?[6]

5 The renowned (former) dance critic Nadja Kadel reported on the conference – and as she did not get to hear the expected forecasts in the 'Next Generation' panel, wrote in disappointment: "This was followed by a rather weak panel on the topic of 'Next Generation.' While an excerpt from the film 'Space Patrol Orion,' where actors performed a futuristic dance, would have been an apt, ironic intro, the panelists *unisono* did not consider themselves members of the 'next' but of the 'now generation.' [...] save for Yvonne Hardt, who carried out a thought experiment about a possible future choreography, nobody dared to take a look at the future. Is nobody interested in what, from a choreographic point of view, a further development of movement languages, future concepts of performance, or the core research topics for a Next Generation may look like?" (Burchart/Kadel 2011; author's translation)

6 From another point of view one may argue, of course, that they already belong to a next generation – one that also includes Claudia Jeschke and draws on research and endeavors to establish a discipline of scientific knowledge dedicated to dance which

In their contributions to this book no less than in their panel talks, the six people who came to be appointed as *Next Generation* representatives – the panel chair Susanne Foellmer directly, and the others through her – unanimously display a dissatisfaction with the allocated role. 'I don't want to be (another) Augustus,' is what every one of them seems to say where they express the wish to "hesitate," to "make a step aside" rather than having to move forward, or to be able to enter the field of dance research again and again as a "foreign terrain" (Noeth in this volume: 275); to forget what one knows already, to 'sit in a synapse,' locate oneself in a gap between channels that distribute information (Schad in this volume); to investigate and inhabit a time-space configured by recombinations of the predictable "futur" and the unpredictable "avenir" (Stamer in this volume: 288); to be "outside of my own body" as someone who is, emotionally and intellectually, moved by dance (Wortelkamp 2011). Even the image of Dance Studies as a spider that dissolves into the constructive secretions of its own net (ibid) holds more appeal than the prospect of inheriting the net including the post of the spider. Only Yvonne Hardt, speaking from the position of the teacher, admits a dilemma, an almost "schizophrenic" tension between "a discourse on dance that prefers to perceive dance as ontologically defined by instability and its representation challenging nature" (Hardt in this volume: 268) and the requirements for passing on theoretical and practical knowledge to other, younger, people.

More or less explicitly, the panelists refer to two types of problems that may be reasons for their disinclination to do the job of a next generation woman or man and tell the world where the future will take Dance Studies. The first argument, summed up roughly, is that dance, the art of movement, a volatile phenomenon, requires something akin to itself as its adequate discursive environment: safe enough to keep dance performances from going unnoticed and ending up unarchived, perhaps, but certainly not as rock-hard as a Hegelian institution built on the sacrifices of its builders and developers. Susanne Foellmer acknowledges the necessity to have some sort of financial support in order to maintain an open space for "choreographic thinking" (Foellmer in this volume: 262). However, the supporting system shall apparently have as little influence as possible (ideally: zero) on the configuration of the space itself and on the activities which happen there. Things, like thoughts, shall be kept "in floating" ("in der Schwebe," ibid.).

The second argument has to do with the status of prognostication in our society and its implications for being requested to speak as 'dance experts of the future': The invocation of a 'next' that could be determined in a way so as to enable an ongoing process of successful institutionalization may, in itself, be a poisoned bait one ought better not to swallow. Having to speak about yourself in the future tense of what comes next – forecasting your own accomplishments through pointing out the exciting prospects you envision for the association of

date back much further (cf. fn. 11 in Foellmer in this volume: 258). The conference setting did not deny such a point of view, but neither did it encourage it.

others that includes you – is not a privilege granted exclusively to an elite of leaders today. It is effectively something a project-oriented capitalism demands of everybody who wants to be recognized as a competent work performer. Laurent Goldring avers that in our time the present of performance all but vanishes between the predictions of project results in applications for funding and the reviews that address the performed work as a past incident (and are carefully collected to go as attachments with future proposals). Self-prediction and self-documentation are standard tools for surviving in a world where German sociologist Arnold Gehlen's statement that a personage was a single case of an institution[7] defines not a particular social reality but a general socio-economic objective. 'Make sure you become your own successor!' is an imperative a whole lot of us work performers must heed in order to make a living on what we do. Appointing people to a 'Next Generation' at once exploits and conceals this normality of constantly promoting ourselves as members of some next generation. It pretends, not intentionally, perhaps, but structurally, not to know to what extent the ones who got appointed as much as those who did not are already caught up in attempts to institutionalize themselves for (the just) fear that no institution will take care of their future for them. The external institution, which exists and persists outside of people's respective successes in self-institutionalization, may very well be the lie of twenty-first century neo-liberalism. It may merely be a symbolic arrangement laid out to rake in sacrifices, yet offering to its chosen few no higher degree of reliability than the many who struggle on elsewhere will find. Hence, the best defensive reply to requests for participating in processes of institutionalization, in such a situation, might be: 'I would prefer not to.'

It would, of course, be easy to reproach the panelists for such timid, evasive ways of dealing with the prognostic or prophetic agency the conference invitation conferred to them, soured as though the offer had been. Yet, since their reactions were what was called for, we should be ready to recognize the message those reactions convey: Apparently, Dance Studies, as a running institution or process of institutionalization in Germany, is currently nothing to connect strong future-oriented wishes and desires to; at least not if you are already working there.[8] The stance 'contra institutionem' may be partly subject-specific, partly related to a set of theories Dance Studies scholars like to draw on – theories that have been emphasizing states of collectivity 'in coming,' while they did not care much to ask how we can re-organize institution-based work according to a con-

7 "Eine Persönlichkeit: das ist eine Institution in einem Fall" (Gehlen 1957: 118).

8 It would have been interesting to hear reactions from younger players in the field of Dance Studies. If there was a next generation in the more innocent sense of 'young people who are still preparing for the future to hold something in store for them,' it could be found on the other side of the Uferstudios' entranceway, where Elena Basteri, Elisa Ricci and Emmanuele Guidi had organized an exhibition and a series of lectures under the title *Rehearsing Collectivity* – see http://www.rehearsingcollectivity.net.

cept like 'potentiality.' Self-critical voices from within this field of theoretical discourse have remarked that certain ideas by Bataille, Blanchot, Deleuze and Guattari, Derrida, or Agamben, and even more so the affective dispositions they correspond to, infelicitously coincide with the post-Fordist project economy's urge to get rid of everything stable and durable, transforming structures which have taken decades or centuries to build into reversible assemblages of projects. Boyan Manchev even proposes to replace the word 'resistance' with 'persistence' today, because to go on doing something, to carry on a collective effort beyond the limits of project financing and spotlight-minded mass media attention is, he infers, the true anti-capitalist act (cf. Manchev 2011).

But is there really a shortness of ways and means to go on today? Have the dynamics of networked collectivity in the twenty-first century not shifted the accent from the spectacle of envisioning-creating-beginning (and the ensuing strife to implement the great idea) to a more casual flow of picking-up, trying again, modifying slightly? Haven't revolutionary changes been effected from the exponentiation of such minor adaptations? Hasn't increasing the number of participants in a knowledge process proved a good alternative strategy to ensure that valuable paths will not cease to be walked upon – an alternative without the disadvantages of secluded institutional practice, and one that does not condemn people to be conservative *unless they are*? Isn't this alternative to be preferred because it supports assiduity and responsibility based on trust in people's appreciation instead of a panic-driven consolidation against an imagined corrosion of cultural structures?

Post-Fordism did not invent dynamic networks, after all; it only skims off their socio-economic profits, making us believe that what is not profitable according to its notion of 'creative initiative' is powerless and meaningless. Sustainability and processual longevity have not fallen prey to networks replacing institutions, but to an ideological devaluation of – and hence, ignorance to – the reality of *transmission*, the broad distribution of handing down and taking up in every networked undertaking. To opt for a return to institutionalism in the name of continuity and safety, be it with the best intentions, only confirms such ignorance. What would be needed, rather, is a transvaluation of values that helps us understand that the present era is really one where the people (in the looseness of this very plural) have been sufficiently equipped with technologies and techniques to perform tasks for which earlier epochs needed institutions. With one exception: supplying money.

Against this background, the *Next Generation* panelists' wriggling reluctance indirectly betrays a fearlessness in respect to the future: In their respective ways of saying 'I would prefer not to,' they all seem to assume quite naturally that they will be able to pursue the kind of work that is important to them in the future as well as they are now. As do I, for that matter, whether with good reason or not. Indeed, if I am looking for a point of inclusion for myself in the generation of those six, it appears to me that our generation is very little buying into the fears and panic that today's institutionalism nurses in an all-too-symmetrical cor-

respondence to neo-liberalism's deregulation craze: the fear that we will not be able to achieve our goals unless we 'invest into the future' now; the fear that if we don't 'occupy' the hot topics and answer the urgent challenge of whatever opportunity turns up, someone else will; the fear that should we not prevail against competitors, the conditions in the long run won't be good enough for us to do what we want. Unlike the generation before us, and maybe unlike a generation that will come after us, we do not give much on conditions. Neither out of strong worries nor out of strong hopes do we indulge in "that great purpose of human life which we call bettering our condition" (Smith 1976: 50). We complain, but mildly, (and mainly in the fashion of social gymnastics) when the conditions are suboptimal – but we are not willing to postpone our present pleasure in doing what we do for the promise of more perfect conditions tomorrow. Despite flatter or slower careers in the case of some, hardly any one of us seems eager to sacrifice the real for the promise of the possible. For one reason, because we have not such a burdened opinion of the possible as our elders who, laden with utopianism, had to discharge it inconspicuously on their 'long march through the institutions,' while we are still less absence-fed than the teenagers of today who grow up in a time pervaded in its entirety with prognostication, measured not by clocks but by alerts to chances and warnings of possible failure to grasp them. But also because we like what is real. Because we are, to an extent that must be unimaginable to Caesars, satisfied with the present. Agamben, in passing, calls 'sufficiency' the guiding value for a politics that has happiness as its goal.[9] If our generation has made a valuable discovery, it is that freedom consists in a certain degree of indifference toward conditions of possibility; and that such freedom is available on every level of the socio-economic stratum, as long as one keeps at a distance demands to accept present constraints in exchange for future gains.

Boris Groys is scarcely wrong when he claims that underfinancing is the only form of finiteness capitalist society knows (cf. Groys 2009). Yet the impression I receive from the *Next Generation* panelists' reactions advises me to invert this: The only thing that binds us to an institution today is money, or such is the implicit morale of what they say, and avoid saying, about Dance Studies' present and future. If it weren't for the danger of ending up not being able to pay the rent, the members of this generation might well tell the institutions they are working for to leave them alone – because they know they would *not* be alone without institutionalized forms of togetherness and againstness. They probably want a label like Dance Studies to attach to things they do, alone or with others, but none of them communicates a need for a solid institutional frame in order to work together. Quite the opposite, the preparations for the conference panel, as far as I can tell from the parts I witnessed, provide an example of institutionally

9 "And when modern political thought was born with Marsilius of Padua, wasn't it defined precisely by the recovery to political ends of the Averroist concepts of a 'sufficient life' [*vita sufficiente*] and 'well-living' [*vivere bene*]?" (Agamben 2000: 114)

enforced collaboration failing because the people involved, when left to their own devices, would have chosen a much more varied scheme of distances among one another than the group they eventually found themselves assembled into: different angles from which to approach one another's lines of thinking and different folds of attention to devote to the thing. Some would have worked closer together, some taken more peripheral stands, with the odd one probably reducing participation to an email or two. And maybe the output would have been richer that way.

In the context of a conference, and now a book, on *Dance [and] Theory*, the 'Next Generation' figures as a reality supplement to scholarly discussions about artistic research, the image, the archive, aesthetics, and politics – discussions stirring the possible and advocating the results to be tasted for real. Without any other topic than themselves, the *Next Generation* panelists knew right from the beginning that their utterances would be read as symptoms rather than taken for concepts. And, I'm afraid my response up to this point has done exactly that. Having been rather bland and impolite in my diagnosis of these symptoms, I nevertheless recommend a careful analysis for the findings: Those who initiated Dance Studies should spare a moment to reflect on what kind of institutionalization process they want to entrust to the people they work with, and what in the case of a discipline that is still young at German universities and will need further fostering helps to generate intergenerational trust. Those who belong to the generation of the six panel members, or feel like they do, may want to reconsider the attitude towards institutional forms of organizing work their theory score has made them adopt – should it be only to arrive at a less vague understanding of the reasons why they indeed desire potentiality instead of potestas, conflux instead of consolidation, community in coming instead of corporate identity; and to realize what, based on their penchants and disinclinations, they expect from a university.[10] And we all ought to ask ourselves what to make of knowledge institutions after the most substantial arguments in favor of institutionalization – the battle against the vanity of human efforts, the belief in bettered conditions being an indispensable prerequisite to happiness in action, and the conviction that outside of instituted order is all selfishness and isolation – have lost a large part of their plausibility, and mainly money remains as that which is left to keep people in line. I seriously consider this an open question. And I commit this question to the conservativism of readers' likes and dislikes: to the assiduity and responsibility of how it really stands with their appreciation.

10 Starting with a German translation of Judith Butler's essay "Critique, Dissent, Disciplinarity" (blogs.ubc.ca/ewayne/files/2010/01/butler2009.pdf), the German publisher Diaphanes has been issuing a series of books under the title Unbedingte Universitäten (Unconditional Universities), which provides a rich sample of documents for an investigation of aversions against (a certain type of) institutionalism and possible alternatives.

Additionally, there is one thing I, the casual companion to the panel group, may be in a much more comfortable position to do than they were: to prophesy what will come next in Dance Studies. I can do this without hesitation because I am no dance specialist, and hence my words will carry no authority at all – unless someone judges them to be true for his or her own reasons (and since I *am* a little bit of a specialist on prognostication, let me add that nobody, not even the most sophisticated specialist, ever knows enough about the future to be acceptable as an authority). Should the panelists' contributions to this book constitute a singular-plural 'No Manifesto,' then let this little addendum to my response be the corresponding 'Yes Manifesto,' or more precisely, the 'Yes-Yes Manifesto,' whickered in the voice of Nietzsche's ass.

For this is what awaits us, as of January 14, 2012:

1) A Next Generation representative of Dance Studies shall never have to pronounce the words 'the body' with a heavy emphasis and a pause following, as though these words were an incantation, a magic formula that activates the secret powers of an imagined community, a 'mana' whose very vocalization draws an invisible line and separates the initiated from outsiders. "Thinking about the 'Next Generation,' the first question that came to my mind was whether interest in the body and its visibility is specific to a generation," writes Isabelle Schad in her contribution (Schad in this volume: 277). While I do not want to interfere with Schad's own answer in her text and in her choreographic work (and the question may be rhetorical, after all), I imagine for myself a Next Generation representative of Dance Studies who verifies that the interest in 'the body' is – was – indeed the concern of a previous generation. That Next Generation representative of Dance Studies uses 'body' without the definite article. I hear her speak of "a body," "your body," "my body," "parts of our bodies." Sometimes she will even count bodies and assume, if merely for the sake of testing an assumption, that a number of bodies matters. More importantly, the word "body" will refer to *something* in her ways of employing it, and not to 'that ... which is beyond the some inasmuch as it escapes the I.' This will be possible, and easy, to be sure, because neither Dance Studies nor dance must defend themselves against exclusive occidental reason anymore, wherefore the discourse of dance can let go – not of irrationality as a part or dimension of everything we do (and of reason, as goes without saying), but of 'the body' as an empty center.

2) After a long period of modernism, which in the case of dance was extended and further distinguished rather than interrupted or made fun of by postmodernism, the aesthetic expansion of dance will come to a halt, putting the Next Generation representative of Dance Studies in the position of someone who, in the face of the strongest source of innovation having run dry, must either produce the new herself or become interested in something other than newness. Instead of searching for new, original movements or movements to aestheticize, to integrate into the concept of what dance can be, choreographers and dancers will conceive of different performances increasingly by re-defining the values and effects of such dance movements as are already in practice and are, for the

majority of them, *generally* practiced. Choreography, in other words, will become another technique of using the general intellect. Its fashioning will draw on a kinetic-practical knowledge that is broadly distributed in our society, available to many and defined as, for example, 'art' or 'professional entertainment' or 'hobby' only by the way it is employed. I suggest to take a second look at Mette Ingvartsen's *To Come* (2005)[11] as an omen of what Susanne Foellmer calls "choreographic thinking" (Foellmer in this volume: 262): Choreography as a craft of organizing dance will, in this next generation, be an *application* – in a sense of the word sloppily and happily opposed to that of 'creation' – of *the choreographic*, which is an intelligence that enables you to redirect the cultural, social, political, economic, psychological, pedagogical etc. forces of existing patterns and habits of moving. Like a Next Generation choreographer, a Next Generation representative of Dance Studies shall therefore find nothing strange in turning her attention to dancing (the practices) and to dance (the art event) in one same move. Thanks to the First Generation's success in installing dance movement as a decent academic subject, Next Generation Dance Studies will be free to admit to the line between a 'social reality' and an 'aesthetic phenomenality' becoming permeable. And then Dance Studies will be at the forefront of the collapse of the social (or socio-economic) and the aesthetic. They will observe and explore this collapse, waves of which we can start to perceive today, in all its exciting and disastrously sane consequences.[12]

3) A Next Generation representative of Dance Studies will give less credit to the distinction between 'expected' and 'unexpected,' which Peter Stamer systematizes in his contribution. The process of institutionalization in her field at once advancing and becoming indifferent to the Next Generation representative of Dance Studies will finally enable her to relate her experience of dance performances (of art in general, we might say) to her own real behavior without fear. From the split life of the old-school art knowledge manager who craves being surprised by aesthetic events while hating the unscheduled in her social and occupational interactions, the Next Generation dance scholar will proceed to a more realistic appreciation of organization as a way of synchronizing one's intentions (inclinations) with the turns things take. Reconfigured by a realism that stems from the courage to step onto the scene of aesthetic experience with a healthy dose of daily maturing social and professional know-how, her attention will discern the world between such idealizations as 'expected' and 'unexpected,' 'execution' and 'event.' For neither of these categories has much bearing on reality where people are living together. Also, she will recognize that risk isn't as terribly interesting a topic as it used to be in the era of pre-financial market capitalism. Whereas the dancing body, naked as it was in its concentration on

11 Cf. http://vimeo.com/26911196.

12 For further thoughts about this I may refer to the Performance Research Journal 16:3 (Sept 2011) issue On Participation and Synchronization, and my article there: van Eikels 2011.

movement alone, may have fascinated nineteenth and twentieth century audiences as an embodiment of the kind of risk that had come to rule people's lives in many respects, risk today has its reality precisely in the absence of a principle such as embodiment: The material consequences of financial markets booming or breaking down due to highly self-referential dynamics are of an arbitrariness that does not lend itself to bodily enactment. The repercussions of a risk economy – one that has discarded even the symbolic – on our physical reality disclose a meaning neither in jump nor in fall. There is no body with the power to embody in all of this, not even at the end of its effect chains (the body odor of the man who is homeless now because he lost his job after the last economic crisis or the nervousness and insomnia of the post-Fordist work performer do not tell 'the truth' about economic risk: the truth is that some are dirty, some are nervous, while others are clean and sleep well). The Next Generation Dance Studies representative's gaze shall fall upon dancers' bodies, where these move along lines of moderate uncertainty, lines which permeate a common ground between dance performers and various other (social, economic, political, technological) performers. For the very reason that the dancing body does not and cannot embody what takes place outside the sphere of art anymore, dancers' bodies will enter side-by-side with other bodies the shared reality of bodies performing movements. On- or off-stage, dancers will find themselves *among others*. And the Next Generation representatives of Dance Studies will be among the dancers, or among the others, or both.

To whom this may concern.

References

Agamben, Giorgio (1999): "Pardes: The Writing of Potentiality." In: Id./Daniel Heller-Roazen, *Potentialities: collected essays in philosophy*, Stanford: University Press, pp. 205-219.

—— (2000): "Notes on Politics." In: Id., *Means without Ends. Notes on Politics*, Theory out of Bounds Vol. 21, Minneapolis and London: University of Minnesota Press.

—— (2012): *The Kingdom and the Glory. For a Theological Genealogy of Economy and Government*, Palo Alto CA, Stanford University Press.

Allsopp, Ric (2009): "Still Moving. 21st Century Poetics." In: Sigrid Gareis/Krassimira Kruschkova (eds.), *Uncalled. Dance and Performance of the Future*, Berlin: Theater der Zeit, pp. 247-255.

Banes, Sally/Lepecki, André (eds.) (2007): *The Senses in Performance*, New York and London: Routledge.

Barthes, Roland (2005): *Criticism and Truth*, London: The Athlone Press.

Basteri, Elena/Ricci, Elisa/Guidi, Emmanuele: "Rehearsing Collectivity," July 7, 2012 (http://www.rehearsingcollectivity.net).

Beutler, Nicole (2011): "Program for the Performance 2: Dialogue with Lucinda," Tanz im August, Berlin.

Blanchot, Maurice (2007): *Die uneingestandene Gemeinschaft*, Berlin: Matthes & Seitz.

Böhme, Hartmut/Huschka, Sabine (2009): "Prolog." In: Sabine Huschka (ed.), *Wissenskultur Tanz. Historische und zeitgenössische Vermittlungsakte zwischen Praktiken und Diskursen*, Bielefeld: transcript, pp. 7-22.

Bourdieu, Pierre (1977): *Outline of a Theory of Practice*, Cambridge: Cambridge University Press.

Brandstetter, Gabriele (1995): *Tanz-Lektüren – Körperbilder und Raumfiguren der Avantgarde*, Frankfurt am Main: Fischer.

—— (2000): "Choreographie als Grab-Mal. Körper-Bilder in Bewegung." In: Id./Hortensia Völckers (eds.), *ReMembering the Body: Body and Movement in the 20th*, Ostfildern-Ruit: Hatje Cantz, pp. 102-13.

—— (2007): "Tanz als Wissenskultur, Körpergedächtnis und wissenstheoretische Herausforderung." In: Sabine Gehm/Pirkko Husemann/Katharina von Wilcke (eds.), *Wissen in Bewegung, Perspektiven der künstlerischen und wissenschaftlichen Forschung im Tanz*, Bielefeld: transcript, pp. 37-48.

————— (2011): "Dis/Balances Dance and Theory," lecture in the context of the Dance [and] Theory conference, Berlin, Uferstudios, April 30th (unpublished manuscript).

Burchart, Kati/Kadel, Nadja (2011): "Der Kongress tanzt – Die Tagung 'Tanz (und) Theorie in den Uferstudios," July 19, 2012 (http://www.tanznetz.de/kritiken.phtml?page=showthread&aid=39&tid=2015)

Butler, Judith (1993): *Bodies That Matter: On the Discursive Limits of Sex*, New York and London: Routledge.

————— (2009): "Critique, Dissent, Disciplinarity." In: Critical Inquiry, Vol. 35/4, pp. 773-795, July 11, 2012 (http://blogs.ubc.ca/ewayne/files /2010/01/butler2009.pdf)

Critchley, Simon (2008): *Unendlich fordernd. Ethik der Verpflichtung, Politik des Widerstands*, Berlin/Zürich: diaphanes.

Deleuze, Gilles (1990): *Pourparlers 1972-1990*, Paris: Les Editions de Minuit.

————— (1990): *The Logic of Sense*. New York: Columbia University Press, pp 28-29

Derrida, Jacques (2007): "A Certain Impossible Possibility of Saying the Event." In: Critical Inquiry, Vol. 33, pp. 441-461.

————— /Kamuf, Peggy (2002): *Without Alibi*, Stanford: University Press.

Dick, Kirby/Kofman, Amy Ziering (2002): "Derrida," documentation, USA.

Eikels, Kai van (2011): "What Parts of Us Can Do with Parts of Each Other (And When)." In: Performance Research Journal 16:3 (Sept 2011) issue "On Participation and Synchronization," pp. 2-11.

Foellmer, Susanne (2009): *Am Rand der Körper. Inventuren des Unabgeschlossenen im zeitgenössischen Tanz*, Bielefeld: transcript.

Gehlen, Arnold (1957): *Die Seele im technischen Zeitalter. Sozialpsychologische Probleme in der industriellen Gesellschaft*, Reinbek: Rowohlt.

Groys, Boris (1992): *Über das Neue. Versuch einer Kulturökonomie*, München: Hanser.

————— (2009): *The Communist Postscript*, trans. Thomas Ford, New York: Verso.

Hardt, Yvonne (2008): "Denkende Praxis, bewegende Wissenschaft: Reflexionen zu einer angewandten Tanzwissenschaft." In: Ralf Stabel/Claudia Fleischle-Braun (eds.), *Tanzforschung und Tanzausbildung*, Jahrbuch der Gesellschaft für Tanzforschung, Bd. 18, Berlin: Henschel, pp. 238-245.

Hegel, Georg Wilhelm Friedrich (1986): *Vorlesungen über die Philosophie der Geschichte*, Werke 12, Frankfurt am Main: Suhrkamp

Hochmuth, Martina/Kruschkova, Krassimira/Schöllhammer, Georg (eds.) (2006): *It takes Place when it Doesn't. On Dance and Performance since 1989*, Frankfurt am Main: Revolver.

Huschka, Sabine (2002): *Moderner Tanz. Konzepte – Stile – Utopien*, Reinbek bei Hamburg: Rowohlt.

Husemann, Pirkko (2002): *Ceci est de la Danse. Choreographien von Meg Stuart, Xavier Le Roy und Jérôme Bel*, Norderstedt: Books on Demand.

Jeschke, Claudia (1983): *Tanzschriften – ihre Geschichte und Methoden*, Bad Reichenhall: Comes.

Klein, Gabriele (1992): *FrauenKörperTanz*, Weinheim: Quadriga.

—— (2007): "Tanz in der Wissensgesellschaft." In: Sabine Gehm/Pirkko Husemann/Katharina von Wilcke (eds.), *Wissen in Bewegung, Perspektiven der künstlerischen und wissenschaftlichen Forschung im Tanz*, Bielefeld: transcript, pp. 25-36.

—— (2011): "Dance Theory as a Practice of Critique," keynote for the *Dance [und] Theory* conference, Berlin, Uferstudios, April 29th (unpublished manuscript).

Kruschkova, Krassimira (2006): "Defigurationen. Zur Szene des Anagramms in zeitgenössischem Tanz und Performance." In: Corpus, Internetmagazin für Tanz, Choreographie, Performance, July 19th, 2012 (http://www.corpusweb.net/defigurationen-3.html).

—— (2011): "Tanz mit/entlang Theorie" Lecture in the context of the *Panel Aesthetic* within the Dance [and] Theory conference, Berlin, Uferstudios, April 29th (unpublished manuscript).

Kunst, Bojana (2009): "What Will Not Happen." In: Sigrid Gareis/Krassimira Kruschkova (eds.), *Uncalled. Dance and Performance of the Future*, Berlin: Theater der Zeit, pp. 357-364.

Lepecki, André (2009): "Given Premise. The Future will be Confusing. Predicting Dance/Performance." In: Sigrid Gareis/Krassimira Kruschkova (eds.), *Uncalled. Dance and Performance of the Future*, Berlin: Theater der Zeit, pp. 341-345.

Lorenz, Maren (2000): *Leibhaftige Vergangenheit. Einführung in die Körpergeschichte*, Tübingen: Edition Discord.

Lyotard, Jean-François (1984 [1979]): *The Postmodern Condition: A Report on Knowledge*, Manchester: University Press.

Manchev, Boyan (2011): "Puissance, Exploitation et Résistance des Corps-Sujets," July 11, 2012 (http://eipcp.net/transversal/0811/manchev/fr)

Mersch, Dieter (2010): *Posthermeneutik*, Berlin: Akademie Verlag.

Müller, Hedwig (1986): *Mary Wigman. Leben und Werk der großen Tänzerin*, Weinheim: Quadriga.

Oberzaucher-Schüller, Gunhild (ed.) (1992): *Ausdruckstanz – Eine mitteleuropäische Bewegung der ersten Hälfte des 20. Jahrhunderts*, Wilhelmshaven: Noetzel.

Paul, Jean (1996): *Ideengewimmel*, Frankfurt am Main: Eichborn.

Pessoa, Fernando (2006): *Das Buch der Unruhe*, Zürich: Ammann Verlag.

Rancière, Jacques (2006 [2000]): *The Politics of Aesthetics. The Distribution of the Sensible*, London: Continuum.

Ritsema, Jan (2010): "Eigentum als etwas Flüchtiges." In: Tilmann Broszat/Sigrid Gareis/ Julian Nida-Rümelin/Michael M. Thoss (eds.), *Woodstock of political thinking. Im Spannungsfeld zwischen Kunst und Wissenschaft*, Berlin: Theater der Zeit, pp. 193-204.

Schad, Isabelle (2011): Discussion Paper before the Panel *Next Generation* (unpublished manuscript).

Siegmund, Gerald (2006): *Abwesenheit. Eine performative Ästhetik des Tanzes. William Forsythe, Jérôme Bel, Xavier Le Roy, Meg Stuart*, Bielefeld: transcript.

—— (2008): "Zur Theatralität des Tanzes." In: Claudia Fleischle-Braun/Ralf Stabel (eds.), *Tanzforschung & Tanzausbildung*, Berlin: Henschel, pp. 28-44.

Smith, Adam (1976): *Theory of Moral Sentiments*, The Glasgow Edition of the Works and Correspondence of Adam Smith, vol. 1, Oxford: University Press.

Vogl, Joseph (2008): *Über das Zaudern*, Berlin/Zürich: diaphanes.

Waldenfels, Bernhard (2009): "Universität als Grenzort." In: Ulrike Hass/Nikolaus Müller-Schöll (eds.), *Was ist eine Universität? Schlaglichter auf eine ruinierte Institution*, Bielefeld: transcript, pp. 11-25.

Wortelkamp, Isa (2006): *Sehen mit dem Stift in der Hand. Die Aufführung im Schriftzug der Aufzeichnung*, Freiburg i.Br./Berlin: Rombach.

—— (2011): Positionierung zum Konzept "Next Generation" (unpublished manuskript).

Žižek, Slavoj (2007): "Mao Zedong: The Marxist Lord of Misrule," July 11, 2012 (http://www.lacan.com/zizmaozedong.htm)

WEBSITES

Schad, Isabelle: July 19th, 2012 (www.isabelle-schad.net)

Practicable: July 19th, 2012 (www.praticable.info)

Ingvartsen, Mette (2005): "To come," July 19th, 2012 (http://vimeo.com/26911196)

Notes on Contributors

BARRIONUEVO ANZALDI, FRANCO

Research Associate and PhD Candidate at the Department of Human Movement at the University of Hamburg. He studied Political Science and Latin American Studies at the University of Hamburg and at the Universidad Torcuato Di Tella, Buenos Aires. Main areas of research: popular dance, urban culture and tourism. His PhD project is entitled: *La ciudad del tango: Aficionados und ihr tourisischer Blick auf Buenos Aires* (*La ciudad del tango: Aficionados and their Tourist Gaze on Buenos Aires*). Recent book publication: *Politischer Tango. Intellektuelle Kämpfe um Tanzkultur im Zeichen des Peronismus* (*Political Tango. Intellectual Battles over Dance Culture in the Sign of Peronism*) (2012).

BISMARCK, BEATRICE VON

Professor at the Academy of Visual Arts Leipzig for Art History, Visual Culture and Cultures of the Curatorial. Main areas of research: the curatorial, modes of cultural production connecting theory and practice, definitions of artistic labour, effects of neo-liberalism and globalization on the cultural field, postmodern concepts of the 'artist.' Recent book publications: *Interarchive. Archival Practices and Sites in the Contemporary Art Field* (2002, ed. with H.-P. Feldmann, H. U. Obrist, D. Stoller, U. Wuggenig), *Grenzbespielungen. Visuelle Politik in der Übergangszone* (*Performing the Border. Visual Politics in Zones of Transgression*) (2005, ed.), *Globalisierung/Hierarchisierung. Kulturelle Dominanzen in Kunst und Kunstgeschichte* (*Globalization/Hierarchization. Cultural Dominances in Art and Art History*) (2005, ed. with I. Below), *Nach Bourdieu: Visualität, Kunst, Politik* (*After Bourdieu. Visuality, Art, Politics*) (2008, ed. with T. Kaufmann, U. Wuggenig), *Auftritt als Künstler* (*Performance as Artist*) (2010), *Cultures of the Curatorial* (forthcoming 2012, ed. with J. Schafaff, T. Weski).

BRANDSTETTER, GABRIELE

Professor for Theater and Dance Studies at the Freie Universität Berlin. Main areas of research: history and aesthetics of dance from the 18th century until today, theater and dance of the modern age and the avant-garde, contemporary theater, dance, performance, theatricality and gender, virtuosity in art and culture, body – image – movement. Recent book publications: *Tanz-Lektüren. Körper-*

bilder und Raumfiguren der Avantgarde (1995 and forthcoming engl., *Poetics of Dance. Images of the Body and Figurations of Space in the Avant-garde*), *Bild-Sprung. TanzTheaterBewegung im Wechsel der Medien* (*Image-Jump. Dance-TheatreMovement in the Transmission of Media*) (2005), *Tanz als Anthropologie* (*Dance as Anthropology*) (2007, ed. with C. Wulf), *Prognosen über Bewegungen* (*Prognoses on Movement*) (2009, ed. with S. Peters, K. van Eikels), *Improvisieren. Paradoxien des Unvorhersehbaren. Kunst – Medien – Praxis* (*Improvising. Paradoxes of the Unpredictable. Art – Media – Practice*) (2010, ed. with H.-F. Bormann, A. Matzke), *Notationen und choreographisches Denken* (*Notations and Choreographic Thinking*) (2010, ed. with F. Hofmann, K. Maar), *Theater ohne Fluchtpunkt. Das Erbe Adolphe Appias: Szenographie und Choreographie im zeitgenössischen Theater* (*Theatre without Vanishing Point. The Heritage of Adolphe Appias: Scenography and Choreography in Contemporary Theatre*) (2010, ed. with B. Wiens).

CRAMER, FRANZ ANTON

Lecturer at the Inter-University Centre for Dance Berlin and fellow at the Collège International de Philosophie in Paris. Main areas of research: digital media and dance archives, historiography of contemporary dance, interactions between local and global notions of culture in dance. Recent publications: *In aller Freiheit. Tanzkultur in Frankreich zwischen 1930 und 1950* (*In total Freedom. Dance Culture in France from 1930 to 1950*) (2008), www.perfomap.de, vol. 3: *Performing Sound* (2012 ed. with B. Büscher), „Warfare over Realism. Tanztheater in East Germany, 1966 – 1989" (2012, in: *New German Dance Studies*, ed. by S. Manning, L. Ruprecht).

CVEJIĆ, BOJANA

Lecturer at Utrecht University, Theater Studies, and P.A.R.T.S. Brussels. PhD Candidate at Centre for Research in Modern European Philosophy, Kingston University. Her PhD project is entitled: *Choreographing Problems: Expressive Concepts in European Contemporary Dance*. Founding member of TkH (Walking Theory) editorial collective. Author, dramaturge and/or performer since 2000 (with J. Ritsema, X. Le Roy, E. Salamon, C. De Smedt). Recent book publications: *Beyond Musical Work: Performative Practice of E. Satie, J. Cage, Fluxus, La Monte Young, John Zorn* (2007), *A Choreographer's Score: Fase, Rosas Danst Rosas, Elena's Aria, Bartók* (2012, with A. T. De Keersmaeker).

EIKELS, KAI VAN

Research Associate at the Center for Movement Studies at the Freie Universität Berlin and lecturer at various German and International universities. His work combines theater and performance studies, philosophy and art theory. Main areas

of research: volatile, self-organizing forms of collectives like 'swarms' and 'smart mobs,' virtuosity and labour in Post-Fordism, art and practices of collaboration from Romanticism to 21st century, participation in contemporary art. Recent publications: *On Participation and Synchronization*, Performance Research 16:3 (2011, ed. with B. Brandl-Risi, R. Allsopp), *Die Kunst des Kollektiven. Performance zwischen Theater, Politik und Sozio-Ökonomie (The Art of the Collective. Performance between Theatre, Politics and Socio-Economics)* (forthcoming).

EVERT, KERSTIN

Artistic Director of K3 – Zentrum für Choreographie/Tanzplan Hamburg and Co-Director of the PhD program *Versammlung und Teilhabe (Assemblies and Participation)*. She did her doctorate on the topic of DanceLab Contemporary Dance and New Technologies. Main areas of work: artistic research, cultural politics, dance and technology. Book publication: *Dance Lab. Zeitgenössischer Tanz und Neue Technologien (DanceLab Contemporary Dance and New Technologies)* (2003).

FOELLMER, SUSANNE

Assistant Professor for Dance and Theater Studies at the Institute for Theater Studies at the Freie Universität Berlin. Main areas of research: dance and performance from the 1920s until today with respect to theories of aesthetics, embodiment and gender. Further research fields are dance and performance in connection to archive, media and visual arts. Recent book publications: *Valeska Gert. Fragmente einer Avantgardistin in Tanz und Schauspiel der 1920er Jahre (Valeska Gert. Fragments of a Vanguard Dancer and Actress in the 1920ies)* (2006), *Am Rand der Körper. Inventuren des Unabgeschlossenen im zeitgenössischen Tanz (On the Edge of the Bodies. Inventories of the Unfinished in Contemporary Dance)* (2009).

FOSTER, SUSAN LEIGH

Distinguished Professor in the Department of World Arts and Cultures at UCLA. Main research areas: dance history and theory, choreographic analysis, and corporeality. Recent book publications: *Dances that Describe Themselves: The Improvised Choreography of Richard Bull* (2002), *Worlding Dance* (2009, ed.), *Choreographing Empathy: Kinesthesia in Performance* (2011).

GEBAUER, GUNTER

Professor for Philosophy and Sport Sociology at the Freie Universität Berlin. Main areas of research: historical anthropology, social philosophy, language theory, and theory of sports. Recent book publications: *Sport in der Gesellschaft des Spektakels (Sports in the Society of the Spectacle)* (2002), *Habitus* (2002, with B. Krais), *Mimetische Weltzugänge. Soziales Handeln – Rituale und Spiele – ästhe-*

tische Produktionen (*Mimetic World Accesses. Social Action – Rituals and Games – Aesthetic Productions*) (2003, with C. Wulf), *Pierre Bourdieu: Deutschfranzösische Perspektiven* (*Pierre Bourdieu: Franco-German Perspectives*) (2005, ed. with V. Colliot-Thélène, E. Francois), *Poetik des Fußballs* (*Poetics of Football*) (2006), *Wittgensteins Anthropologie* (*Wittgenstein's Anthropology*) (2009), *Philosophie als Arbeit an einem selbst* (*Philosophy as Working on Oneself*) (2009, ed. with F. Goppelsröder, J. Volbers), *Selbst-Reflexionen. Performative Perspektiven* (*Self-Reflections. Performative Perspectives*) (2012, ed. with E. König, J. Volbers).

GOLDRING, LAURENT

Philosopher and Artist, works since 1995 on representation in general and of the body in particular. He questions the actual domination of analogical image (photo, movies, and video) by insisting on its great indigence. His work demonstrates that the body has very scarely been shown and seen apart from very specific codes. He goes on with the same principles and the same effects by working on portrait and on the representation of everyday life. Many choreographers with similar questions have been interested and their collaboration allowed the emergence of a new body in the field of the dance with pieces that have become major references. Germana Civera, Xavier Le Roy and Benoît Lachambre were among the first to confront with these new conceptions. *Is You Me* (2008) is the recent continuation of this work on the level of choreography through drawing, and led directly to *Unturtled #1-#4* (2008) with Isabelle Schad, a piece about the design of human bodies.

HARDT, YVONNE

Professor for Dance Studies and Choreography at the University of Music and Dance Cologne. Main areas of research: dance history and the critical investigation of its methodology and use in performative practice, body and media in dance as well as postcolonial and political theory. She also works as a choreographer investigating the possibilities of linking her scholarly research with her choreographic endeavours. Recent book publications: *Politische Körper. Ausdruckstanz, Choreographien des Protests und die Arbeiterkulturbewegung in der Weimarer Republik* (*Political Bodies. Expressional Dance, Choreographies of Protest and the Cultural Labour Movement in the Weimar Republic*) (2004), *Tanz – Metropole – Provinz* (*Dance – Metropolis – Province*) (2007, ed. with K. Maar), *Choreographie und Institution: Zeitgenössischer Tanz zwischen Ästhetik, Produktion und Vermittlung* (*Choreography and Institution: Contemporary Dance between Aesthetics, Production and Mediation*) (2011, ed. with M. Stern).

HÖLSCHER, STEFAN

Research Associate and PhD Candidate at the Institute for Applied Theatre Studies at the University of Giessen. Main areas of research: aesthetics, biopolitics,

Deleuzianism, postoperaism, speculative realism. His PhD project is entitled *Potential Bodies: Contemporary Dance between Aesthetics and Biopolitics.*

HUSCHKA, SABINE

Guest Professor for Theatre Studies and History at the University of the Arts in Berlin (UdK). Main areas of research: dance, body and knowledge in western theatre pedagogy and science, dance history and aesthetics in the 18th and 20th century, the aesthetics of contemporary dance and performance. Recent book publications: *Merce Cunningham und der Moderne Tanz* (*Merce Cunningham and the Modern Dance*) (2000), *Moderner Tanz. Konzepte – Stile – Utopien* (*Modern Dance. Concepts – Styles – Utopias*) (2002), *Wissenskultur Tanz. Historische und zeitgenössische Vermittlungsakte zwischen Praktiken und Diskursen* (*Knowledge-culture Dance. Historical and Contemporary Acts of Mediation between Practices and Discourses*) (2009, ed.).

KLEIN, GABRIELE

Professor for Sociology of Movement and Dance at the Department of Human Movement and Director of Performance Studies at the University of Hamburg. Main areas of research: dance and performance theory, popular dance culture, urban performance cultures, transnationalisation of dance cultures. Recent book publications: *Stadt-Szenen. Künstlerische Produktionen und theoretische Positionen* (*City-Scenes. Artistic Productions and Theoretical Positions*) (2005, ed.), *Performance* (2005, ed. with W. Sting), *Tango in Translation* (2009, ed.), *Methoden der Tanzwissenschaft* (*Methods of Dance Studies*) (2007, ed. with G. Brandstetter), *Emerging Bodies. The Performance of Worldmaking in Dance and Choreography* (2011, ed. with S. Noeth), *Is this real? Die Kultur des HipHop* (*Is this real? The Culture of HipHop*) (2003, 5th edition 2012, with M. Friedrich), *Performance and Labour*, Performance Research 18:1 (2013, ed. with B. Kunst).

KRUSCHKOVA, KRASSIMIRA

Professor for Performance and Theatre Studies at the Academy of Fine Arts Vienna and head of the Department of Theory at the Tanzquartier Vienna. Recent book publications: *Ob?scene. Zur Präsenz der Absenz im zeitgenössischen Theater, Tanz und Film* (*Ob?scene. On the Presence of Absence in Contemporary Theatre, Dance and Film*) (2005), *It takes place when it doesn't. On Dance and Performance since 1989* (2006, ed., with M. Hochmuth, G. Schöllhammer), *Ungerufen. Tanz und Performance der Zukunft/Uncalled. Dance and Performance of the Future* (2009, ed. with S. Gareis), SCORES #0. The Skin of Movement (2010, ed. with W. Heun, S. Noeth, M. Obermayer), SCORES #1. Touché (2011, ed. with W. Heun, S. Noeth. M. Obermayer), SCORES #2. What escapes (2012, ed. with W. Heun, S. Noeth. M. Obermayer).

KUNST, BOJANA

Guest Professor for Performance and Dance Dramaturgy at the Department of Human Movement/Performance Studies at the University of Hamburg. Main areas of research: performance theory, contemporary choreography, political theory, dramaturgy, philosophy of art. She is a member of the editorial boards of the journals Maska, Amfiteater, and Performance Research. Recent book publications: *Impossible Body* (1999), *Dangerous Connections: Body, Philosophy and Relation to the Artificial* (2004), *Processes of Work and Collaboration in Contemporary Performance*, Maska/Amfiteater, (2010, ed.), *Performance and Labour*, Performance Research 18:1 (2013, ed. with G. Klein).

LEPECKI, ANDRÉ

Associate Professor at the Department of Performance Studies, Tisch School of the Arts, New York University. Main areas of research: critical dance studies, performance studies and critical theory, political philosophy and post-colonial theory in dance and performance studies, continental philosophy and experimental dance, curatorial studies in performance, dance and the visual arts from 1950s to contemporaneity. Recent book publications: *Of the Presence of the Body* (2004), *Exhausting Dance: Performance and the Politics of Movement* (2006), *The Senses in Performance* (2007, ed. with S. Banes), *Planes of Composition: Dance, Theory and the Global* (2009, ed. with J. Joy), *Dance* (2012).

MALZACHER, FLORIAN

Co-Programmer of the interdisciplinary Steirischer Herbst Festival in Graz/Austria, and designated Artistic Director of the theatre biennial Impulse in North Rhine-Westphalia/Germany. Founding member of the independent curators' collective Unfriendly Takeover in Frankfurt and freelance dramaturge/curator for Burgtheater Vienna. Dramaturgic collaborations with Rimini Protokoll, Nature Theatre of Oklahoma, Lola Arias, Mariano Pensotti et.al. Member of the advisory board of DasArts-Master of Theatre, Amsterdams Hoogeschool voor de Kunsten, and advisor for the Schillertage at Nationaltheater Mannheim. Recent book publications: *Not Even a Game Anymore – The Theatre of Forced Entertainment* (2004, ed. with J. Helmer), *Experts of the Everyday – The Theatre of Rimini Protokoll* (2008, ed. with M. Dreysse), *Curating Performing Arts* (2010, ed. with T. Tupajic, P. Zanki).

MATZKE, ANNEMARIE

Professor of Contemporary Experimental Theatre at the University of Hildesheim. Main areas of research: rehearsal studies, acting theories, artistic research, theatrical space and improvisation. She is a performance-artist working with the Performance-Group She She Pop. Recent book publications: *Improvisieren. Paradoxien des Unvorhersehbaren. Kunst – Medien – Praxis* (*Improvisation. Paradoxes of the Unforeseeable. Art – Media – Practice*) (2010, ed. with H.-F. Bor-

mann), *Das Buch der Angewandten Theaterwissenschaft (The Book of Applied Theatre Studies)* (2012, ed. with I. Wortelkamp, C. Weiler), *Arbeit am Theater. Zu einer Diskursgeschichte der Probe* (*Theatre at Work. A Discourse History of Rehearsal)* (2012).

MANCHEV, BOYAN

Professor of Philosophy at the New Bulgarian University, Guest Professor at HZT Berlin and former Program Director and Vice-President of the International College of Philosophy in Paris. Main areas of research: ontology, political philosophy and philosophy of art. Recent book publications: *The Body-Metamorphosis* (2007), *L'altération du monde: Pour une esthétique radicale* (*Alteration of the world: For a radical aesthetics*) (2009), *La Métamorphose et l'Instant – Désorganisation de la vie* (*Metamorphosis and the Instant – Disorganization of Life*) (2009), Rue Descartes 64: La métamorphose (Rue Descartes 64: The Metamorhosis) (2009, ed.), Rue Descartes 67: Quel sujet du politique? (Rue Descartes 67: What about Politics?) (2010, ed. with G. Basterra, R. Ivekovic), *Miracolo* (2011), *Logic of the Political* (2012).

MEDURI, AVANTHI

Reader in Dance and Performance Studies at Roehampton University, London. She is a graduate of the Tisch School of Arts, New York University, where she obtained her PhD in Performance Studies, with a thesis on the transnational traditions of Bharatanatyam. As a Ford Fellow, and Academic Director of the Centre for Contemporary Culture, New Delhi, Meduri curated the Rukmini Devi Arundale (1904-1986) photo-archived and presented it in India, Sri Lanka, Malaysia, Singapore, Australia, Japan and the UK (2003-2004). Trained in Bharatanatyam and Kuchipudi, two classical forms of Indian Dance. She works with theatrical and choreographic projects that explore the intersections between academic theory and practice, and locates her performance work within the intellectual framework of what is known as 'practice as research' in higher education. Recent publications: "The Transfiguration of Indian/Asian Dance in the United Kingdom: Contemporary Bharatanatyam in Global Contexts" (2008, in: Asian Theatre Journal), "Labels, Histories, Politics: South Asian Dance on the Global Stage" (2008, in: Dance Research), "Global Dance Transmission(s) in London" (2010, in: *Memory and Dance*, ed. by S. Franco, M. Nordera), "Traces and Trails: Bruise Blood and Faultline in London and India" (2011, in: http://www.rescen.net/Shobana_Jeyasingh/HmH/delhi.html), "Enhancing Dance Careers through Research and Reflection" (2011, in: Pulse).

MEZUR, KATHERINE

Dance Theatre Research Fellow (2010-2011) at the International Research Center Interweaving Performance Cultures at the Freie Universität Berlin. Main areas of research: contemporary dance theatre/art performance in the Asia Pacific

region and the migration of Asian artists, particularly Japanese women artists who are engaged in interdisciplinary performance practices (butoh, contemporary dance theatre, art performance, new media, duration art). Performance dramaturgy: focusing on issues of gender, migration, and transnational technology/corporeality. Education: PhD in Theatre and Dance, emphasis on Asian Performance, from the University of Hawai'i, Manoa; MA Dance Studies Mills College, CA. Academic appointments: University of Washington Seattle, California Institute of the Arts, Georgetown University, UC Santa Barbara, and McGill University. Recent publications: "Fleeting Moments: The Vanishing Acts of Phantom Women in the Performances of Dumb Type" (2001, in: Women and Performance), "Nowhere Girls: 'Mutantcy' and Reversibility in Japanese Performance Art" (2003, in: Discourses in Dance), *Beautiful Boys/Outlaw Bodies: Devising Female-likeness on the Kabuki Stage* (2005), "Sex with Nation: The Ok Girls Cabaret" (2005, in: *Bad Girls of Japan*, ed. by L. Miller, J. Bardsley), "Cold Burn: Touch in Japanese Contemporary Performance" (forthcoming 2013, in: *Touching and to be Touched. Kinesthesia and Empathy in Dance and Movement*, ed. by G. Brandstetter, G. Egert, S. Zubarik).

NACHBAR, MARTIN

Performer and Choreographer based in Berlin. He trained at the SNDO, Amsterdam, in New York and, for one semester, at P.A.R.T.S. Brussels. In 2010 he received a master's degree at the AMCh. Nachbar collaborated in different functions with artists of different fields (Thomas Plischke, Vera Mantero, Les Ballets C. de la B., Meg Stuart, Thomas Lehmen, Jochen Roller, Martine Pisani a.o.). Recent productions: *Urheben Aufheben* (2008), which includes a reconstruction of Dore Hoyer's *Affectos Humanos*, *Repeater – Dance Piece with Father* (2007), in which Nachbar invited his non-dancer father to dance with him, and *Incidental Journey* (2006-2008), a series of performances that took to the streets to investigate events traumatic to various cities. He also teaches choreography, contact improvisation and, together with his colleague Jeroen Peeters, physical dramaturgy.

NOACK, RUTH

Art Historian, Critic and Exhibition Maker. She was curator of Documenta 12 in 2007. Other exhibitions include: *Scenes of a Theory* (Vienna 1995), *Things we don't Understand* (Vienna 2000), *Organisational Form* (Lüneburg, Ljubljana, Leipzig 2002-2003), *The Government* (Lüneburg, Miami, Vienna, Rotterdam 2003-2005). From 2000 to 2010 she taught courses on film, contemporary art and curating at art schools and universities in Vienna, Lüneburg and Kassel. Currently, she is working on an exhibition called *Sleeping with a Vengeance, Dreaming of a Life*. Recent publication: *Sanja Ivekovic's Triangle* (forthcoming 2013).

NOETH, SANDRA

Head of Dramaturgy at the Tanzquartier Vienna. From 2006-2009, she was research associate at the Department of Human Movement/Performance Studies at the University of Hamburg. Recent publications: *MONSTRUM. A Book on Reportable Portraits* (2009, with K. Deufert, T. Plischke), "Dramaturgy, Mobile of Ideas" (2010, in: SCORES#0. The Skin of Movement, ed. by W. Heun, K. Kruschkova, M. Obermayer), *Emerging Bodies. The Performance of Worldmaking in Dance and Choreography* (2011, ed. with G. Klein).

OSTEN, MARION VON

Professor at the Academy of Fine Arts, Vienna and founding member of *Labor k3000* Zürich, *kpD* (*kleines post-fordistisches Drama*) and the Centre for Post-Colonial Knowledge and Culture, Berlin. Recent book publications: *Norm der Abweichung* (*The Norm of Deviation*), *T:G 04* (2003, ed.), *Projekt Migration* (*Project Migration*) (2005, ed.), *The Colonial Modern* (2010, ed. with S. Karakayali, T. Avermaete).

PETER, FRANK-MANUEL

Director of the Deutsches Tanzarchiv Köln (German Dance Archives in Cologne), lecturer at the University of Music and Dance Cologne. He studied Theatre Studies, Art History, German and Library Science at the Freie Universität Berlin (M.A.; Dr. phil.). He is responsible for a number of serial publications: *Studien und Dokumente zur Tanzwissenschaft* (*Studies and Documents for Dance Studies*), the Internet journal Tanzwissenschaft, the mailing list Tanzwissenschaft (Dance Studies) as well as a number of Internet bibliographies, including Deutschsprachige Hochschulschriften zur Tanzwissenschaft/Tanzforschung (Germanspeaking university publications for Dance Studies/Dance Research). Recently he has established websites related to master's theses and dissertations currently in progress (see: www.tanzwissenschaft.eu). Recent book publications: *Valeska Gert* (1985, 1987), *Beyond Performance: Dance Scholarship Today* (1988, ed. with S. Au), *Dore Hoyer* (1992, with H. Müller, G. Schuldt), *Harald Kreutzberg* (1997, ed.), *Birgit Åkesson* (1998, ed.), *Isadora and Elizabeth Duncan* (2000, ed.), *The Sacharoffs* (2002, ed. with R. Stamm), *Giselle* (2008, ed.).

PETERS, SIBYLLE

Scholar, Researcher, Performance Artist. She founded the Forschungstheater situated at the Fundus Theater Hamburg, a theatre, where children, artists and researchers meet, she is Co-Director of the PhD program *Versammlung und Teilhabe (Assemblies and Participation)* and freelancing theatre director (often together with Geheimagentur). Recent book publications: *Der Vortrag als Performance (Lecture as Performance)* (2011), *Das Forschen aller. Wissensproduktion zwischen Kunst, Wissenschaft und Gesellschaft* (*The Research of all. Knowledge Production between Art, Science and Society*) (forthcoming 2013).

PÉREZ ROYO, VICTORIA

Assistant Professor at the Faculty of Philosopy of Zaragoza University/Spain, Co-Director of the MA in Performing Arts Practice and Visual Culture (Madrid) and ARTEA researcher (www.arte-a.org). Main areas of research: dance and performance theory, artistic research, performance and public space, dance and image. Recent book publications: *¡A bailar a la calle! danza contemporánea, espacio público y arquitectura* (*Dance in the Street! Contemporary Dance, Public Space and Architecture*) (2008), *Practice and Research* (2010, ed. with J. A. Sánchez), *To be Continued* (2011, ed. with C. Jerez).

REBENTISCH, JULIANE

Professor for Philosophy and Aesthetics at the University of Art and Design in Offenbach/Main. Main areas of research: aesthetics, ethics and political philosophy. Recent book publications: *Kreation und Depression. Freiheit im gegenwärtigen Kapitalismus* (*Creation and Depression. Freedom in Contemporary Capitalism*) (2010, ed. with Ch. Menke), *Willkür. Freiheit und Gesetz II* (*Arbitrariness. Freedom and Law II*) (2011, ed. with D. Setton), *Ästhetik der Installation* (2003, 4th edition 2011), *Aesthetics of Installation Art* (2012), *Die Kunst der Freiheit. Zur Dialektik demokratischer Existenz* (*The Art of Freedom. On the Dialectics of Democratic Existence*) (2012).

RITSEMA, JAN

Theatre Director, directed repertoire from Shakespeare, Bernard-Marie Koltès, Heiner Müller, James Joyce, Virginia Woolf, Rainer Maria Rilke a.o. He also works with Meg Stuart, Boris Charmatz, Jonathan Burrows and Xavier Le Roy. Teaches at P.A.R.T.S. Brussels. In 1978 Ritsema founded the International Theatre Bookshop and publishes more than 400 books. In 2006 Ritsema founded the PerformingArtsForum in France, an alternative artist's residency, run by artists, in which every year 700 artists exchange their experiences and knowledge and create work. Recent productions: *Ça* (2010/11), *Oedipous, my foot* (2010/11).

SCHAD, ISABELLE

Choreographer and Dancer/Performer, lives in Berlin, works in many places, co-organizes a working space at Wiesenburg in Berlin-Wedding. Main areas of research: the body and its materiality, the body as process, place and space, origins of movement deriving from the body and its (embryological) developments, relations between body, movement, choreography, image, (re)presentation, form and experience, somatic practices like Body-Mind-Centering, practice as site for learning process, community (implied in the practice), political engagement. Co-initiates Good Work and Practicable that explore different ways of working together, questioning modes of production. Her teaching is based on the areas of research mentioned above, takes different shapes such as open practice sessions, workshops or short period projects that take place worldwide. Recent produc-

tions: *Unturtled #1-#4* (2008 with L. Goldring, Valenciennes*), Glazba (Pratica-ble*) (2010, Zagreb), *Communicare* (2012, Lima), *Musik (Praticable)* (2011, Berlin), *Experience #1* (2012, Berlin).

SCHNEIDER, KATJA

Lecturer at the Institute for Theatre Studies at the Ludwig-Maximilians-Universität München and freelance as dance instructor and writer (Süddeutsche Zeitung, Deutschlandfunk a.o.), editor of the dance magazines tanzdrama (1996–2002) and tanzjournal (2003–2009), co-editor of the dance magazine tanz (2010–2012). Main areas of research: history and aesthetics of dance, contemporary dance and performance. Recent publications: *Reclams Ballettführer (Reclams Ballett Guide)* (2002, 2009, with K. Kieser), "Bewegung wird Bild. Der freie Tanz der Wiesenthals und die Tanzfotografie" ("Motion gets Picture. The Free Dance of Wiesenthal and the Dance Photography") (2009, in: *Mundart der Wiener Moderne. Der Tanz der Grete Wiesenthal/Dialect of Viennese Modernism. The Dance of Grete Wiesenthal*, ed. by G. Brandstetter, G. Oberzaucher-Schüller), "Die 360-Grad-Drehung des Kopfes. Maß und Transgression in 'Biped' von Merce Cunningham" ("The 360-degree-rotation of the head. Measure and transgression in 'Biped' by Merce Cunningham") (2009, in: *Das Experiment der Grenze. Ästhetische Entwürfe im Neuesten Musiktheater/The Experiment of the Border. Aesthetic Designs in the Newest Musical Theatre*, ed. by J. Schläder), "Messer, Gabel und Papierschwäne. Zu Reformulierungen von Klassikern in zeitgenössischen Choreographien" ("Knife, Fork and Paper Swans. To the Reformulations of Classics in Contemporary Choreographies") (2009, in: *Tanz im Musiktheater – Tanz als Musiktheater/Dance in Musical Theatre – Dance as a Musical Theatre*, ed. by T. Betzwieser et. al.), "'Think of them as words' – Bewegung und Text in 'Homo Ludens' von Richard Siegal" ("'Think of them as Words' – Movement and Text in 'Homo Ludens' by Richard Siegal") (2010, in: *PerformingInterMediality. Mediale Wechselwirkungen im experimentellen Theater der Gegenwart/PerformingInterMediality. Media Interactions in Experimental Contemporary Theatre*, ed. by J. Schläder, F. Weber).

SIEGMUND, GERALD

Professor for Applied Theatre Studies at the Justus-Liebig University in Giessen. Main areas of research: theatre, dance and performance theory, intermediality, concepts of the body, the relation of theatre to the visual arts, theories and models of memory and their relation towards the performing arts. Recent book publications: *Subjekt: Theater. Beiträge zur analytischen Theatralität (Subject: Theatre. Contributions to analytical theatricality)* (2011, ed. with P. Bolte-Picker), *Theater des Fragments (Theatre of the fragment)* (2009, ed. with A. Bierl), *Abwesenheit. Eine performative Ästhetik des Tanzes (Absence. A performative aesthetics of dance)* (2006), *William Forsythe – Denken in Bewegung (William Forsythe – Thinking in Motion)* (2004), *Theater als Gedächtnis (Theatre as Memory)* (1996).

STAMER, PETER

Freelance Dramaturge and Curator. Main areas of research and artistic practice: exploration of discursive power within performative and artistic setups, dance theory, knowledge production, hospitality, performative story-telling, intercultural encounter. Recent projects: *Path of Money* (performance & installation 2008-2010), *Drama Queens* (tv-project 2009), *The Village* (dance community project 2010), *On Hospitality* (festival 2011), *For Your Eyes Only* (performance 2012). Book publication: *Incubator* (2005 with P. Gehmacher, A. Glechner).

THURNER, CHRISTINA

Professor for Dance Studies at the Institute for Theatre Studies at the University of Bern. Main areas of research: history and aesthetics of dance from the 18th century until today, contemporary dance and performance, historiography, gender, theories of physicality and temporality. Recent book publications: *Beredte Körper – bewegte Seelen. Zum Diskurs der doppelten Bewegung in Tanztexten* (*Speaking Bodies – Moving Souls. On the Discourse of the Double Movement in Texts on Dance*) (2009), *Original und Revival. Geschichts-Schreibung im Tanz* (*Original and Revival. Historiography in Dance*) (2010, ed. with J. Wehren).

WORTELKAMP, ISA

Assistant Professor for Dance Studies at the Institute for Theater Studies at the Freie Universität Berlin. Founder of the dance and performance collective ArchitekTanz. Main areas of research: relation of recording and representation, choreography und architecture, picture and movement. Recent book publications: *Sehen mit dem Stift in der Hand. Die Aufführung im Schriftzug der Aufzeichnung* (*Seeing with the Pen in the Hand. The Performance in the Writing of the Recording*) (2006), *Bewegung Lesen. Bewegung Schreiben (Reading Movement. Writing Movement)* (2012), *Das Buch der Angewandten Theaterwissenschaft* (*The Book of Applied Theatre Studies*) (2012, ed. with A. Matzke, C. Weiler).